MONUMENTS and
MASTERPIECES

Donald Martin Reynolds

MONUMENTS and

Histories and Views of Public Sculpture

MASTERPIECES

in New York City

Thames and Hudson

Copyright © 1988 by Donald Martin Reynolds

First published in paperback in the United States of America in 1997 by
Thames and Hudson Inc., 500 Fifth Avenue, New York, New York 10110

Library of Congress Catalog Card Number 96-61457

ISBN 0-500-01774-3

Printed and bound in the United States of America

To my wife,
Nancy Zlobik Reynolds

Contents

Preface: Monument or Masterpiece

A monument is something permanent that reminds the public of something notable. It usually employs the arts of painting, sculpture, and landscape design and it often incorporates such decorative arts as mosaics, wrought iron, and stained glass. Monuments give meaning to life by providing communities and groups with a way to communicate their traditions and beliefs from generation to generation.

A masterpiece, on the other hand, is a superlative work of art. Monuments can be masterpieces, as is the *Sherman Monument* at Fifty-ninth Street and Fifth Avenue, but they do not have to be. The *Statue of Liberty,* for example, does not rely on its artistic merits for its significance as America's most important monument. Through Miss Liberty an entire nation communicates its emotions, values, and traditions. She is an integral part of this nation's image, and she is an embodiment of the noblest aspirations of the American spirit.

Whether a work of public sculpture is a monument or a masterpiece, or both, it is determined by the ideas it embodies or reflects. Monuments deal with lasting ideas, which stand the test of time. As such, monuments have been considered by some students of human nature to be measures of people's progress along the road of civilization because they commemorate those principles they preserve, honor, and cherish. Thus, with monuments it is the conception of the work, "Not marble nor the gilded

monuments/Of Princes," that is timeless and celebrated, as Shakespeare reminds us, when all is said and done. Other public sculpture decorates our buildings, enhances our parks, squares, and public spaces, and ennobles our civic architecture.

This book is an introduction to the public sculpture of New York City through the consideration of a variety of the city's monuments, masterpieces, public furniture, and architectural decoration. Although it is not a comprehensive and chronological survey of New York City's public sculpture, the selections range from the colonial period to the Second World War, when the nature of public art underwent profound changes. It would require another volume to address the public sculpture of New York City from the end of the Second World War to the present.

The public sculpture of New York City in many ways parallels the development of sculpture in America because of New York City's central role in the arts since the colonial period. For example, a wide range of tombstones and furniture that represent the earliest work of immigrant and native carvers is found in New York City's public spaces and museums. Also in the city's museums and public buildings are some of the finest marble portraits of America's early leaders by some of Europe's principal sculptors of the eighteenth century, who came to America to model them. Those sculptors and their works had a profound influence on America's first sculptors. Some of the finest works of America's leading neoclassical sculptors, its Beaux-Arts masters as well as its self-taught sculptors, are found in New York City's public parks, municipal buildings, and museums. And New York City's architectural sculpture is a veritable encyclopedia of architectural decoration from ancient to modern times.

Public interest in preserving and celebrating the city's sculptural riches has recently increased. Some people believe that if those treasures are to be saved, they must receive increased and regular attention, corroborating The Monuments Conservancy's aphorism "The wise man preserves that which he values and celebrates that which he preserves."

Preface to the Second Edition

As we move about the city and explore the amazing variety of its monuments and public sculpture, it is apparent that this enormous compendium of work from the Colonial period to the present reflects universal and eternal values. Its presence keeps us ever mindful of our material origins and our spiritual aspirations. The emergence of life from matter and its transcendence in the human spirit, which began with the origins of the earth more than four-and-a-half billion years ago, unites all of creation. Its most enduring expression is the human figure.

From earliest times, artists have found insights on the beauty, mystery, and dignity of the person through the human figure, because the figure personifies all that is human. It is the one form in art with which we totally, uniquely, and immediately identify—physically, emotionally, and intellectually. That empathy reveals the significance of the human figure in art and, shining through it, the human spirit.

New York City's collection of public sculpture is one of the richest in this figurative tradition. From Neoclassical ideal nudes and portrait busts in marble and limestone that enrich our civic and cultural centers to medieval fantasies carved on cathedrals, schools, and skyscrapers, and Romantic bronzes of heroes, saints, and poets in our parks, squares, and streets, the variety of styles and expression in New York City's public sculpture surveys the whole of Western art. The largest compendium of New York City's public sculpture derives from the Beaux-Arts tradition of the nineteenth century (see page 5) and con-

sists largely of historical portraits and reliefs by many of America's leading sculptors. For example, Augustus Saint-Gaudens's monument to William Tecumseh Sherman at 59th Street and 5th Avenue (p. 72) and the monument to Joan of Arc by Anna Vaughn Hyatt Huntington at 93rd Street and Riverside Drive (p. 118) are among the world's finest equestrian portraits.

Many works at once beautify our public spaces and enhance our lives. In embellishing and articulating the cityscape for us with their sculptural excellence, they also conspire to ennoble us with their psychological, narrative, and historical power. So, Philip Martiny's Michelangelesque World War I bronze doughboy in Greenwich Village (p. 200), wounded yet pressing on in the throes of battle, honors patriotism, loyalty, and commitment to service and high purpose, while Olin Warner's elaborately detailed terra-cotta relief of a Viking warrior on the facade of the Brooklyn Historical Society building (see cover illustration and p. 372), celebrates the courage, adventure, and intelligence of those Norse explorers whose boats may have been among the first to touch the New World. William Ordway Partridge's intimate study in bronze of Thomas Jefferson in contemplation (p. 85) stands in front of the School of Journalism on the campus of Columbia University in Morningside Heights. It honors one of the country's most illustrious founding fathers and was created by a distinguished Columbia graduate. Partridge was also a gifted poet and actor.

Across the street from Columbia University and overlooking Amsterdam Avenue, the sculpture program of the Cathedral Church of St. John the Divine includes an engaging collection of gargoyles embellishing its massive twin towers that unite sense and spirit in playful whimsy as well as remarkable insight into the complexities of the human psyche. One gargoyle (see cover illustration and p. 166), for example, holds his fingers to his ears keeping out the traffic noises below, while the figure of Saturn devouring his sons (p. 164) explores the fruits of man's cannibal nature transformed by Christian ritual into the transubstantiation, the faithful's consumption of bread and wine as the Body and Blood of Jesus Christ in the sacrament of Holy Communion.

Thus, the best of New York City's public sculpture invites us to reflect upon our noble aspirations that enhance the human spirit as well as the dark forces that dwell within us and threaten humanity's survival.

The *Firefighter's Memorial,*
A Paradigm of Commemoration

Integration of the sister arts of architecture, sculpture, and painting along with symbolic ornament was a fundamental principle of the Beaux-Arts tradi-

tion. It produced some of New York City's grandest and most notable public buildings, such as the New York Public Library (p. 304), the Appellate Court House (p. 295), and the U. S. Custom House (p. 328), as well as some of New York City's finest public monuments, which are the physical embodiments of our traditions, beliefs, and values. Of them all, the *Firefighter's Memorial* is the city's quintessential commemorative monument. It holds a special place in the hearts of New Yorkers, because it honors not only the more than 750 "noble souls"[1] who gave their lives in the line of duty but also all those firefighters, who continue to risk their lives "in a war that never ends." Moreover, it is a superlative union of architecture, sculpture, and symbolic ornament in a profound commemorative ensemble that celebrates universal values to which firefighters are dedicated and that are essential to the existence of civilized society.

Unveiled in 1913, the *Firefighter's Memorial* was designed by H. Van Buren Magonigle, architect, and Attilio Piccirilli, sculptor. Facing Riverside Park and the Hudson River beyond, the monument is composed of a great stone cenotaph (a monument honoring the dead, whose remains lie elsewhere). It is faced on the west with a bronze relief of firefighters in action portrayed above an elaborate fountain with Triton's head jetting water into the basin. Inscribed directly below are the words "TO THE HEROIC DEAD OF THE FIRE DEPARTMENT." Ornamental carving encircling the monument, flames alternating with ancient scrolls, reads like a classical frieze of ocean waves quenching tongues of fire.

On the east facade is the dedication, composed by a noted art critic of the time, Royal Cortissoz: "TO THE MEN OF THE FIRE DEPARTMENT/ OF THE CITY OF NEW YORK/ WHO DIED AT THE CALL OF DUTY/ SOLDIERS IN A WAR THAT NEVER ENDS/ THIS MEMORIAL IS DEDICATED/ BY THE PEOPLE OF A GRATEFUL CITY." Beneath is a relief of Phoenix, the bird of ancient legend, rising from the ashes through the flames, which symbolize the promise of immortality. Two sculpture groups, colossal in scale, flank the cenotaph and personify the ideological foundations of the fire service, Duty and Sacrifice. On the north is Sacrifice, a seated woman, portraying a firefighter's widow and holding the body of her dead husband. On the south is Duty. She is shown seated and consoling her young son, while holding her dead husband's hat in her lap.

Because giving one's life for another is the ultimate act of human love ("Greater love hath no man than this, that he lay down his life for his friends." John 15:13), and because the human conscience is the ultimate tribunal of right and wrong, the firefighter's commitment to duty and sacrifice rests upon love and morality. But love and morality have been the spiritual and ethical pillars of enlightened societies throughout the broad sweep of human history. So, the

firefighter's commitment to duty and sacrifice carries a civilizing and ennobling message beyond the fire service to society at large. And the *Firefighter's Memorial* imparts to that commitment and its universal message of love and morality a physical and permanent presence within the community.

Monuments to Neglect

The *Firefighter's Memorial* was recently restored, reportedly at a cost of more than two million dollars. Unfortunately, many more of our public monuments are in equal need of restoration. The Washington Arch in Washington Square Park in Greenwich Village (p. 356), for example, has had a fence around it since 1988 to keep people from being injured by pieces of marble falling from the deteriorating surfaces of the sculpture and the arch. That monument is not only an important memorial to the father of our country, it is also one of the nation's architectural and sculptural gems of the City Beautiful Movement.[2] Now, it has become a monument to the city's neglect of its public monuments.

There have been laudable efforts to rectify the deterioration of our public monuments on an individual basis, such as the Adopt-a-Monument program begun in 1986, and recent efforts, which include the re-patination of the statue of the Marquis de Lafayette in Union Square Park and the restoration of the historic fence at the General Worth Monument across the street from Madison Square Park.

The magnitude of the problem, however, requires a comprehensive approach to arrive at a long-term solution. A program should be developed and implemented through the cooperative efforts of the Art Commission, the Department of Parks and Recreation, and the Central Park Conservancy. It should be organized around four objectives:

1. *Maintenance, Preservation, and Restoration.* To assure that the city's monuments are maintained, preserved, and restored, in perpetuity, a scope of work should be prepared and a budget formulated to address the needs of our public monuments throughout the city. An advisory panel made up of artists, writers, architects, scholars, conservators, and laymen should be appointed to guide the city agencies in artistic, historical, cultural, and conservation matters related to each monument and in developing a philosophy of public monuments and a policy to implement that philosophy.

2. *Inventory and Archives.* To facilitate the systematic study and evaluation of New York City's public monuments, the city's inventory of monuments should continue to be updated, and a catalogue should be published and distributed to the city's libraries. Moreover, it is imperative that the monuments'

archives be properly curated and made accessible for research by qualified professionals.

3. *Research and Scholarship.* Because monuments embody human values, their study is by its nature interdisciplinary and, therefore, should be developed by the appropriate city agencies in cooperation with New York City's colleges and universities.

4. *Education.* Education programs at the elementary and high school levels should be developed to produce a generation of New Yorkers, who are familiar with New York City's public monuments and who are instructed in the historical, cultural, and aesthetic principles they embody. A Continuing Education program for the adult general public should address historical, as well as contemporary issues related to our public monuments.

Through a comprehensive program of perpetual care, research, and education, the city's public monuments, which celebrate our traditions and riches of the past, can become vital forces for cultural growth within our communities. "The past is not dead history," the Pulitzer Prize-winning scientist René Dubos has declared, "It is the living material out of which man makes himself and builds the future."[3] Our public monuments, in their embodiment of that "living material," the past, speak to us with an eternal voice. If, through our neglect of them, we permit our public monuments to deteriorate, posterity must hold us accountable for their ruin and for silencing that voice.

–Donald Martin Reynolds
New York City
January 1997

NOTES

1 Author and psychologist Peter Micheels has called firefighters the last of the noble souls, which was the title of his talk ("Firefighters–Last of the Noble Souls") delivered at the annual Samuel Dorsky Symposium on Public Monuments, March 18, 1994, Time & Life Building, Rockefeller Center, New York City.

2 The turn-of-the-century City Beautiful Movement had its origins in the village improvement societies in pre-Civil War New England, which addressed sociological and technological, as well as aesthetic issues. In New York City, the movement led to the establishment of the Municipal Art Society in 1893 to provide decoration for public buildings and parks and to promote the beautification of the city's streets and public places. Remnants of the City Beautiful Movement in New York City are all about us in our comprehensive park and boulevard systems and our great civic structures such as

our libraries, museums, and court houses, as well as in our unparalleled array of public monuments, which are deteriorating through neglect. For the most comprehensive and readable account, see William H. Wilson, *The City Beautiful Movement* (Baltimore: The Johns Hopkins University Press, 1989).

3 René Dubos, *So Human and Animal* (New York: Charles Scribner's Sons, 1968), pp. 67, 224.

Acknowledgments

Besides the artists, architects, designers, and craftsmen who made the works of art that I have selected for this book, I am grateful to many other people who were helpful in a variety of ways to my writing and research.

This book would never have been written if my mother had not opened my eyes to art at an early age and if my father had not been at first tolerant and then supportive of my enchantment with the "unnecessary" things of life. Nor would the book have taken its present form if I had not been blessed with a publisher who shared my interest in the public sculpture of New York City.

Charles Levine, formerly director of general reference books at Macmillan, was responsive to the material from the very beginning. Under the executive care of William Rosen, editorial director of Macmillan Books, the book received astute critical direction at every level of its development. Joyce Jack edited the manuscript and provided essential direction in its organization. Her sensitive insights contributed to both the substance and the form of the book. Sona Vogel copyedited the manuscript; the book was designed by Laura Rohrer; Barbara Greenberg and Tony Davis handled production. And I am indebted to Modern Age Photographic Services for the cooperation of their professional and technical staff.

Among those who make and care for public art who were helpful in my research, some deserve special mention: Francis Whittaker, Jack Andrews, Louis Boccanera, Dimitri Gerakaris, Joel Schwartz, and David Zatz,

blacksmiths and ironworkers; Kenneth Lynch, president, Kenneth Lynch and Sons; Joseph Fiebiger, president, P. A. Fiebiger Iron Works; Richard Wattenmaker, director, Flint Institute of Art; Charles Weaver, Jr., deputy director for administration, American Museum of Natural History; Ralph Bauer, exhibition manager, American Museum of Natural History; Steven Quinn, senior principal preparator, American Museum of Natural History; David Schwendeman, taxidermist, formerly with the American Museum of Natural History; Gerald Allen, architect; Quennell-Rothschild Associates, landscape architects; Earl Tucker, arts associate, Wave Hill; Paul Stimson, curator, J. Walter Thompson Company; Louis Agrusa, restorer; Schulmerich Carillons; Greg Wyatt, sculptor in residence, the Cathedral Church of St. John the Divine; Cynthia Corbett, executive director, Troy, New York Federation of Historical Services; Cammie Naylor, photographic services, New-York Historical Society; Ellen Wallenstein, photographic archives, Museum of the City of New York.

Many individuals whose lives and work, in one way or another, are involved with continuing or preserving the materials and ideas this book is about were generous with information, sources, and suggestions. They include Wilson Duprey, former curator of prints, New-York Historical Society; Wendy Shadwell, curator of prints, New-York Historical Society; Robert Rainwater, assistant director, art, prints, and photographs, New York Public Library; Margot Wittkower; Herbert Mitchell, Avery bibliographer, and William O'Malley, architecture bibliographer, Avery Library, Columbia University; Gloria Normann, registrar of the Diocese of New York, the Cathedral Church of St. John the Divine; Edith McKitrick, archivist, Grace Church; Phyllis Barr, archivist and museum curator, Parish of Trinity Church; Marian Yellin, Yellin Iron Works; Hazel Storer, writer; Arvin William "Bill" Turner, General Worth historian; Dr. Joseph Ernst, archivist, Rockefeller Family and Associates; Clare Stein, executive director, National Sculpture Society (retired); Gwen Putzig, executive director, National Sculputure Society; Barbara Conklin, registrar of collections, American Museum of Natural History; Mary Genett, library associate, American Museum of Natural History; Roberta Geier, technical information specialist, Library of the National Museum of American Art; Canon Edward West of the Cathedral Church of St. John the Divine; the Reverend J. Robert Wright, professor of ecclesiastical history, General Theological Seminary; the Reverend Anthony Racundo, pastor, Queen of All Saints Church; Reverend C. Burns, former pastor, Plymouth Church of the Pilgrims; Robert McKay, past president, Sons of the Revolution in the State of New York; Peter Nemiroff, registrar, Sons of the Revolution in the State of New York; Terry Ariano, assistant curator, prints and photographs,

Museum of the City of New York; Faith Illava Running, Clarence Barnes, and John Geraghty.

Members of the corporate community provided access to materials and spaces and in numerous other ways aided me in my research. I am particularly indebted to Ralph Cann, III, vice president of planning and control function, Federal Reserve Bank of New York; Peter Bakstansky, vice president public information, Federal Reserve Bank of New York; Gail Donovan, staff member, Federal Reserve Bank of New York; E. John Quinn, editorial consultant and former district manager, New York Telephone Company; Anthony Pappas, director of media relations, New York Telephone Company; Laura Fischer, office manager, Containership Agency; Rene Girod, executive vice president, Rolex Watch USA; Robert Stevens, general manager for advertising and public relations, Seiko Time Corporation; Grace Weitman, sales manager, Kenneth Lynch and Sons.

While the bibliography provides my sources, I am particularly indebted to key works that have shaped the study of American sculpture. Wayne Craven's *Sculpture in America* has become the standard survey, which offers indispensable chronologies, major works, and stylistic trends, as well as significant insights into the sculptors' lives and works.

Through his pioneering studies in American neoclassical sculpture, William Gerdts not only provides an extensive bibliography and informed methods to deal with iconography and style, but he also draws on the full breadth of American and European art to demonstrate a catholic approach to the subject.

Studies of individual sculptors have provided useful data and perceptive insights into their lives and works, which guided me in assessing the artists' contributions to the public sculpture of New York City. Lewis Sharp's *John Quincy Adams Ward, Dean of American Sculpture,* Michael Richman's *Daniel Chester French: An American Sculptor*, and James Dennis's *Karl Bitter, Architectural Sculptor, 1867–1915* were particularly enlightening.

Burke Wilson's biography (1985) and Kathryn Greenthal's critical study (1985) provide recent surveys and insights into Augustus Saint Gaudens's life and work, while Louise Tharp's informed blend of written and oral history and human interest (1969) continues to offer a rewarding interpretation of the man and his work in the Gilded Era. John Dryfhout's rich compendium of publications on Saint Gaudens, however, remain the standard source.

In American art, studies of the decorative arts have, for the most part, remained separate from those of painting and sculpture. Richard Wattenmaker's penetrating studies of Samuel Yellin's iron work, to which I am indebted, may help to bridge that gap.

Several people who have profoundly influenced my work deserve special acknowledgment: Nancy Zlobik Reynolds, my wife, companion, and friend; Charles Sarner, physician and friend; James Beck, professor of art history and chairman of the Department of Art History and Archaeology, Columbia University, friend and former teacher and adviser; the late Howard McParlin Davis, Moore Collegiate Professor of Art History at Columbia University (retired), former teacher and longtime supporter; the late George Collins, professor of art history and archaeology, Columbia University (retired), former teacher; Barbara Novak, professor of art history and archaeology, Columbia University, former teacher and adviser; and Harry Cloudman, vice president (retired), Macmillan Publishing Company.

As always, I am mindful of my students over the past twenty-five years, whose questions, research, and views have continued to influence my vision of the art that I have photographed and written about here.

———

For extending the life of *Monuments and Masterpieces,* I am indebted to Thames and Hudson and especially to Peter Warner, publisher, and Laurance Rosenzweig, production coordinator. And I am gratified that Liz Trovato's cover design has captured the aesthetic strengths of New York City's public sculpture. I am singularly obliged to John Thornton of the Spieler Agency for the re-birth of the book in its second edition.

MONUMENTS and MASTERPIECES

Introduction

Sculpture began in New York City, as it did in America, as the most permanent way to honor the dead and to make life more pleasant. The immigrant and native craftsmen, who carved the city's gravestones and furniture laid the foundation for sculpture in America and prepared the New World for the monuments and public art that would follow.

The artisan carvers in colonial New York brought their designs with them from Europe or copied them from pattern books and prints, as well as from imported goods.

As economic conditions in the Colonies improved, so did the quality of the carving and decoration, and more costly things were imported, including finely carved funerary reliefs in marble. A higher standard of living attracted itinerant carvers from Europe in ever-greater numbers, whose hand-carved fireplaces, lintels, and mantels enriched the colonial home. Indigenous carvers joined the ranks of the entrepreneur, and the carving trade thrived.

A Market for Monuments

With America's victory over the British, there was suddenly a flurry of activity to produce likenesses of its new leaders and monuments to its heroes. New York's first public monument to a revolutionary hero still stands in St. Paul's Chapel on lower Broadway in Manhattan. America's promise was sufficient to attract to her shores such outstanding European artists as France's leading sculptor of the eighteenth century, Jean-Antoine Houdon. His portraits of Franklin, Washington, and other Founding Fathers were important models for both patrons and sculptors and helped to establish standards of excellence in the arts in America.

The European Tradition

With the dawn of the nineteenth century, appropriate sculpture decoration was required for the nation's new Capitol in Washington, D.C., and a small contingent of Italian sculptors, followers of the great Antonio Canova, were imported, who delivered the neoclassical style firsthand to our shores.

Academies of art were formed, particularly in New York and Philadelphia, after European models, which had great influence in establishing the European tradition in this country. Plaster casts of ancient Greek and Roman statuary were imported to establish greater awareness of the classical tradition in the new nation and to provide models of the human figure for training native artists.

The Expatriates

By the 1820s and 1830s, the first wave of American expatriate sculptors had settled in Italy to be close to its ancient models, marble quarries, its artisan tradition of marble carvers, and an international community of artists. They were followed by a second generation of American sculptors, including a group of women, who worked primarily in marble, which inspired Henry James to dub them whimsically the "White Marmorean Flock." Those words became the title of an exhibition and a publication by William Gerdts that remain landmarks in American sculpture.

Already, however, the Americans had shown their independence. Instead of copying the Greek gods and goddesses, which had no meaning

for their age, they used the ancient models for Old and New Testament figures as well as for contemporary historical and literary subjects to produce a Yankee classicism that satisfied them and their patrons.

A Shift

The art center in Europe shifted from Florence and Rome to Paris around midcentury, and the expatriates went to the Ecole des Beaux-Arts to learn a blend of ancient, Renaissance, and baroque called the Beaux-Arts tradition. Bronze replaced marble as the popular medium, providing American sculptors both at home and abroad with new flexibility in producing the great outdoor monuments to its heroes and leaders that the post-Civil War era demanded.

Foundries in America that had been originally engaged in military and domestic production were now making sculpture—even such monuments as the equestrian statue of George Washington in Union Square Park. Advances in bronze-casting techniques in European foundries made it possible to reproduce subtleties in modeling never before achieved. American foundries started to compete, and the domestic quality of casting improved.

The Age of the Beaux-Arts

The grand age of the Beaux-Arts tradition was between the Philadelphia Centennial of 1876 and the First World War. That was the era of the great world fairs, which provided sculptors with unprecedented opportunities for dramatic and expansive figural and decorative sculpture. The National Sculpture Society, founded in 1893, institutionalized the Beaux-Arts tradition in the United States, and the style and the society dominated sculpture for public works until the beginning of the next century.

End of an Era

With the advent of direct carving in the first decade of the twentieth century, the preference for simplified form and abstraction replaced the naturalism and idealism of the Beaux-Arts tradition and a new era was born.

PART I

From Carving to Sculpture

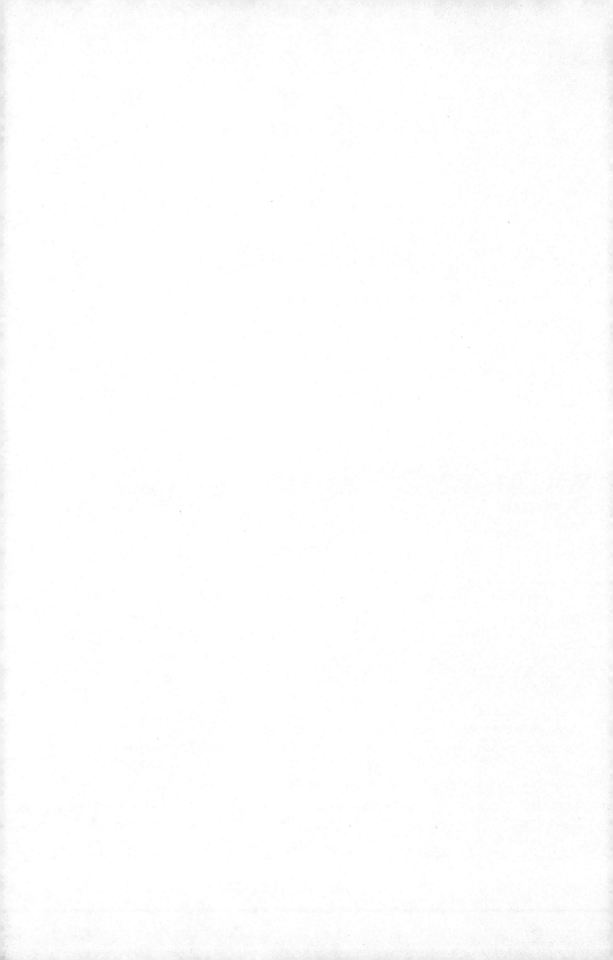

CHAPTER 1

Master Carvers and Masterpieces in Stone and Wood

U ntil the second half of the eighteenth century, sculpture in colonial America—and New York City was not excepted—was relegated largely to gravestones and furniture executed by carvers in stone and wood.

Fugit Hora—for the Simple and for the Haughty

To commemorate the deceased, artisan stone-carvers inscribed on the face of the gravestone the name of the deceased, dates of the person's birth and death, and a brief statement of the individual's achievements during life.

From ancient times, people have marked burial sites with a stone. At first it was a great boulder. Then it was shaped. Finally it was inscribed. For centuries the tombstone has been people's way of coping with their own transience and their yearning for immortality. Ancient and medieval symbols of skulls, skeletons, classical figures, and hourglasses conveyed the threefold message of death's triumph over life, fame's triumph over death, and time's triumph over fame. These symbols carried over into colonial America. For the pagan, time was the ultimate victor. For the Christian in

colonial America, the cherub's head with wings, symbol of the soul's ascent to heaven, expressed the Christian's belief in an afterlife, and that promise of immortality and message of hope for the future set the Christian apart from pagan ancestors. But the message of Christian hope in earliest colonial days was not one of earthly delights perpetuated into eternity.

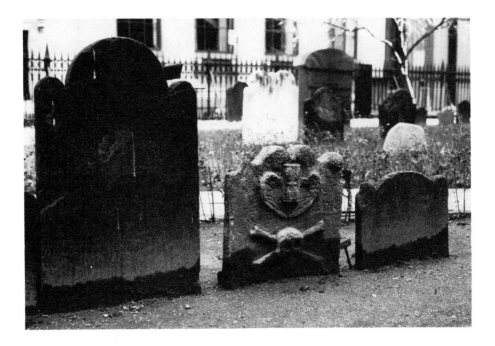

Fugit hora and *memento mori* are the two dominant themes carried on gravestones in colonial America.

The dominant message conveyed in the earliest colonial gravestones of the seventeenth century was the terror of the grave and the passage of time. From the Stoic preachings of Persius (A.D. 34–62) to the ancients *"Vive memor leti; fugit hora"* (*Satires:* v, 1.153) ("Live mindful of death; the hour flies") came the colonists' watchword—*"Fugit hora."* A cryptogram on a tombstone in Trinity churchyard at Broadway and Wall Street in lower Manhattan is deciphered "Remember Death," a principal phrase in colonial funerary symbolism, which in Latin is *memento mori.* The *memento mori* became a popular funerary theme in Italian art in the mid-fourteenth century, when the bubonic plague, called the Black Death, swept Europe and

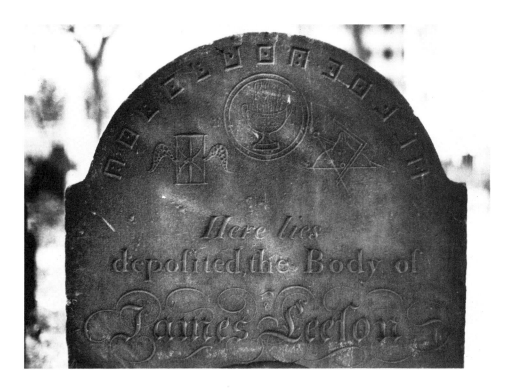

Cryptogram of right angles translates: Remember Death. Beneath are Masonic funerary symbols: winged hourglass; plumb, square, compass; flame rising from open vessel.

parts of Asia and killed three-quarters of the population in less than twenty years. The theme was often illustrated by an open grave with a skeleton. The *memento mori* reminded the viewer that life is short and eternity long, and that one should prepare to meet one's Maker by living a virtuous life.

The *memento mori* took on many forms, and its long life carried into the twentieth century in such practices as the open grave in Cistercian monasteries. With each burial a new grave was dug, awaiting the next monk to die.

Symbols and Shapes

Funereal carvings in mid-seventeenth-century America were simple, and their symbols and decorations often merged. Rosettes, radiating sun motifs, and other variations of pinwheel designs, for example, derived from the medieval wheel of fortune, symbolizing the changing nature of man's fortunes and the transience of both his successes and his failures. The early

carving was shallow, in part because the stone was often slate, stratified in thin layers and therefore suited to two-dimensional carving. If carved too deeply, the image shattered. Many slate gravestones survive because the stone is not porous and is therefore less vulnerable to the attack of environmental pollution. Gravestones of such porous stone as brownstone have not survived as well.

The shapes of colonial gravestones changed over time. Up to the mid-eighteenth century, they were thin slabs with straight sides and slightly rounded tops. Later, variations on the triptych became fashionable—a stone three panels wide. The center panel was surmounted by a circular crowning motif, and sometimes the flanking panels were similarly ornamented.

The minimal decoration on the early gravestones was the result not only of the material restrictions of the stone and the limited vocabulary of the colonial carvers, but of contemporary morality. Although not the only view of art in the colonial community, the concept that art distracted and even corrupted the innocent was dominant. There was nothing new in that idea. Bernard of Clairvaux (1090?–1153), founder of a monastery in France, believed the monks should not be distracted by decorative objects while they meditated, and his ideas gave rise to a highly influential style of architecture in the Middle Ages that was devoid of sculptural decoration.

FUNERARY ART

The colonists were not monks, however, and as personal wealth in the Colonies increased, merchants replaced churchmen as the ruling class, and art emerged. The notion that art was created by the devil gave way to new concepts of the relation of art to life—and to death. As the Age of Reason dawned in the Colonies, a more worldly philosophy allowed people to enjoy honestly gained material pleasures, and new attitudes found their way into the graveyard.

The more worldly morality brought with it richer decoration, more elaborate carving, and wider use of carved likenesses of the deceased—our first portraits in stone, which began to be popular early in the eighteenth century. Marble memorials, imported from England, were placed in the walls of churches, not only following the latest European fashion in funerary monuments, but also emulating the sacred tradition of funerary monuments in Westminster Abbey. Examples of such wall monuments in St. Paul's Chapel in New York City on lower Broadway across from City Hall Park illustrate the fashion. Local carvers learned the craft, too, and firms such as Norris and Kain specialized in grave monuments. In St. Paul's Chapel their names may be seen as the carvers of George Warner's memorial.

As European pattern books were introduced in the New World with their improved building techniques, and as Thomas Jefferson's classical ideas caught on, architecture improved and Roman models had a broad influence, which affected the country's funerary art. Following the revolutionary war, the Americans patterned their new government after the Roman republic. George Washington was called the new Cincinnatus, after the fifth-century B.C. Roman hero, who left his farm to lead his people against an invading army and returned to his land when they were vanquished. When Washington's officers, the veterans of the Order of Cincinnatus, who compared themselves with Roman soldiers, were buried, ancient symbols were adopted for their memorials as well as for the memorials of others. The most popular motif was the draped urn, classical symbol of death, and the weeping willow, symbolizing that nature also mourned the passing of the veteran.

THE AMIABLE CHILD—TRIBUTE TO GENTLENESS

The urn, emblematic of the soul, became one of the most popular grave markers. A particularly cherished funerary urn stands near the Hudson River.

Memorial to St. Claire Pollock. The urn became one of the most popular grave markers.

A short distance to the north and west of Grant's Tomb stands a small granite monument to a child: "For one who led no cause/Who only lived and died," wrote a visitor to the grave site.

On this site in the eighteenth century, wild strawberries grew so abundantly that the place was known as Strawberry Hill, a favorite spot of young St. Claire Pollock. While playing there one day, the child apparently lost his footing and fell to his death in the Hudson River below. While his identity is unclear, according to some sources the child and his parents, from Ireland, were visiting his uncle, George Pollock, a linen merchant, whose home was near Strawberry Hill. Other accounts identify the child as George Pollock's son, who was baptized on November 11, 1792 by the rector of the old Trinity Church at Broadway and Wall Street (the second church on that site, not the present building; see chapter 19).

All accounts agree, however, that the child is buried here, the spot he loved so much. George Pollock then marked the grave with a marble monument consisting of a base supporting a funerary urn, carved by Mr. Darley, stonecutter, and inscribed with the following words:

> Erected to the Memory of an
> Amiable Child
> St. Claire Pollock
> Died 15 July 1797
> In the Fifth Year of His Age

On the base is carved a prayer from the Book of Job (14: 1–2): "Man that is born of woman is of few days and full of trouble. He cometh forth like a flower and is cast down, he fleeth also as a shadow and continueth not."

In surveying the site for Grant's Tomb a century later, removal of the Amiable Child's monument and grave was considered, but the public demanded that it remain, because they felt that an amiable child was equal to a national hero. And an anonymous reporter observed that the presence of the monument ". . . is so fine a tribute to the gentleness that underlies the apparent brutality of a great city that the little stone has come to be almost a national institution."

The pollutants in the atmosphere and "relic seekers" chipping away pieces of marble eventually all but destroyed the white Vermont stone of the monument, and in 1967, the monument was replicated in the more durable Vermont granite. The replica was installed at the exact location of the original. The Parks Department then offered the original marble monument to the Museum of the City of New York, where it could be properly exhibited.

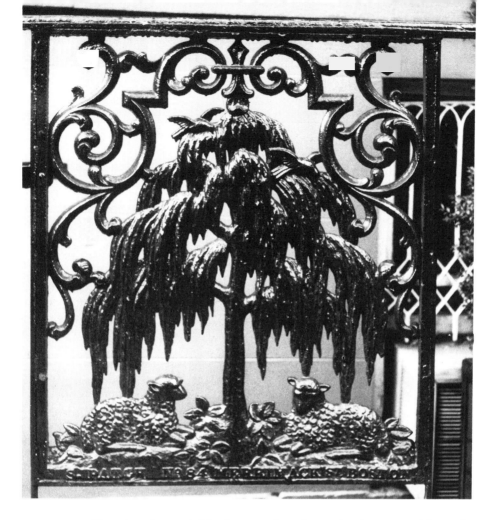

Funerary motifs, such as the paschal lamb, were adapted to such other uses as this gate in Greenwich Village.

MOTIFS ADAPTED

Funerary motifs were adapted to other uses. A paschal lamb, for example, at rest beneath a weeping willow, is the central motif in a cast-iron gate in Greenwich Village. The motif is quite common on gravestones of the eighteenth and nineteenth centuries.

The Funerary Monument

During the American Revolution, Americans wanted great sculpture to honor their martyred heroes, so they went to their friends in France. It was Benjamin Franklin and Thomas Jefferson, our representatives to the

court of France, who guided these efforts and, while doing so, provided American art with a substantial bridge to contemporary French sculpture.

The Montgomery Memorial

The first public monument in New York to honor an American revolutionary war hero who died in action was designed in 1777 by Jean-Jacques Caffieri in Paris, where it was exhibited at the Salon and widely acclaimed by the art community there for its "elegant antique simplicity of design and the various beautiful marbles used in its composition." Today, unfortunately, the "various beautiful marbles" are disintegrating from neglect and from the attack of pollutants in the atmosphere.

The monument honors Brigadier General Richard Montgomery, who was killed on December 31, 1775, in the Battle of Quebec, one of the nation's first martyrs to the cause of the American Revolution. Grandly installed beneath the great east portico of St. Paul's Chapel, the monument consists of two stone brackets supporting an ancient altar from which rises a broken column of rich variegated marble of pink, cream, red, and blue, now eclipsed by grime, supporting a funerary urn. The broken column is flanked by military trophies on the left and the palm branch of martyrdom and peace on the right. Behind the column rises a pyramid in low relief, a funerary image that has been traced back to Raphael, who first applied the Egyptian motif to a funerary monument in the Chigi Chapel in Rome in the early sixteenth century. Caffieri's selection of the Egyptian motif reflects the widespread fascination for Egyptian forms that prevailed in European art in the eighteenth century and that Rudolf Wittkower has called the Egyptomania of the eighteenth century. Under the altar, a once white marble tablet carries a dedication to the dead hero.

Benjamin Franklin had been requested by the Second Continental Congress to commission the artist to design the memorial. He therefore thought it proper that members of that Congress should have an image of the memorial, so he had it engraved and a print pulled for each patriot. One of those engravings hung on the wall of St. Paul's Chapel until the 1970s but today is unlocated.

General Worth and the Forgotten Designer

Another major monument to a national military hero in New York City that reflects the enduring influence of Egyptian forms in American

The first public monument in New York to honor an American revolutionary war hero, Brigadier General Richard Montgomery.

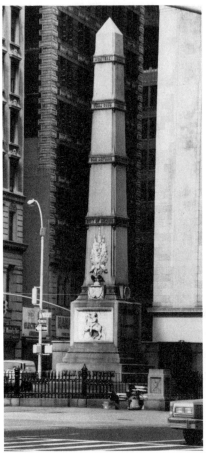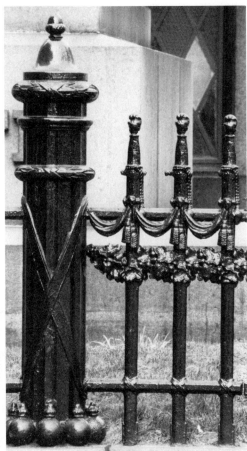

Left: The Worth Monument not only commemorates the bravery of a distinguished general, but also marks his grave. *Right:* The cast-iron pickets that make up the fence around the monument are replicas of the sword Worth received for his bravery. The Congressional Sword of Honor was replaced by the Congressional Medal of Honor during the Civil War. The year 1987 was the 125th anniversary of the medal.

sculpture and design is the Worth Monument at Twenty-fifth Street where Broadway and Fifth Avenue come together.

The Worth Monument, a fifty-one-foot-high obelisk surrounded by a cast-iron fence of swords, was designed by James Goodwin Batterson, one of the country's leading builders and authorities on stone of the period. Batterson designed monuments and supplied the stone, as well as the engineering expertise, for some of the country's leading buildings: the nation's Capitol and Library of Congress in Washington, D.C.; the old Waldorf-Astoria (on the site of today's Empire State Building); City Hall in Providence, Rhode Island; Vanderbilt mansions in New York and New-

port, Rhode Island; and the state capitols in New York and Connecticut. He also traveled to Egypt to study the engineering principles and stonecutting practices the ancient Egyptians used in their pyramids and obelisks, and he was recognized by scholars and specialists in the field as an authority on Egyptian structures and building techniques. Today, however, Batterson is remembered only as the founder of the Travelers Insurance Company. Following a trip to England, where he investigated accident insurance, Batterson fashioned his own version of the business, which he established in 1864.

GENIUS AND INGENUITY

The son of a stonecutter, Batterson had an unquenchable thirst for knowledge, nurtured by an enormous drive and gargantuan stamina. Unable to afford a college education, he took courses at night and sought out people to guide him in his quest for knowledge. He learned to write poetry, he studied Latin and Greek, and he translated the *Iliad,* the *Odyssey,* and the *Lyrics* of Anacreon.

When Batterson took over his father's stone business, he built it into a large and successful enterprise. He traveled to the quarries of Italy, Russia, Finland, Norway, and Scotland, where he personally selected the stone for his patrons' buildings and architectural decoration. During his travels, he made many sketches of the world's leading monuments and buildings, which served to influence and guide his own designs.

From his travels, his work in the quarries, and his studies with James Gates Percival, famous geologist of the time, Batterson became acknowledged as a leading authority in the field of stone construction and monument design. Through a close association with Isambard Kingdom Brunel, English engineer and authority on railway traction and steam navigation whose twelve-thousand-ton *Great Eastern* steamship had attracted world attention for its innovative design, Batterson gained experience and knowledge that led to improved methods of quarrying, cutting, and polishing stone, and he was made a Fellow in the American Society of Civil Engineers, the highest honor that august group could bestow.

THE GETTYSBURG ADDRESS

Batterson's Gettysburg monument was erected to honor the decisive Civil War battle there. The design was by Batterson, the sculpture was executed by noted American sculptor Randolph Rogers, and the monument appropriately bears a bronze plaque commemorating Lincoln's Gettysburg Address. Batterson was one of the first to recognize the importance of Lincoln's prose, and he published the address in 1865 as a literary masterpiece, long before it was considered to be one.

SELECTION OF THE SITE FOR THE WORTH MONUMENT

Selection for the site of the Worth Monument was Batterson's. He chose the location because it was near the old Fifth Avenue Hotel, where he used to meet a group of Greek and Latin scholars in the barroom regularly (Batterson was president of the Greek Club of New York). When city officials learned the size of the proposed monument, they forbade Batterson to erect the monument there, because they feared the weight of the stone for such an enormous monument would damage the street. Batterson defied the authorities and carted in the stone at 3:00 A.M. and had it in place by the time the superintendent of streets arrived. The monument still stands, even though the hotel has long since been razed.

THE WORTH MONUMENT

The namesake of the Worth Monument, Major General William Jenkins Worth (1794–1849), is portrayed in relief at the base of his monument on a rearing horse. Rearing horses with riders, cast or carved in relief, go back to ancient times. Panels with Roman cavalrymen are commonly found on sarcophagi, honorific columns, and triumphal arches. Among the best-known reliefs with rearing horses are those on the Parthenon at the Acropolis in Athens. The more immediate model for the rearing equestrian relief monument, however, is Gianlorenzo Bernini's monument of Constantine in the Scala Reggia in the Vatican. It shows Constantine at the Milvian Bridge at the moment he saw a cross appear in the sky, which, Bernini has shown, caused his horse to rear. Bernini's monument has inspired many artists since then.

Fort Worth, Texas; Lake Worth, Florida; and Worth Street, formerly Anthony Street, in downtown Manhattan were named for this illustrious military hero who lies buried beneath one of New York City's busiest thoroughfares. The General Worth Hotel, also named for him, stood in his hometown of Hudson, New York, until 1969, when it was razed.

"HAUGHTY BILL"—HERO AND LEADER

Worth was born March 1, 1794. He joined the army at age eighteen and fought in the War of 1812. In Canada, soon after joining up, he distinguished himself in both the attack upon Fort Green and the battle of Chrysler's Field on the St. Lawrence River. He was aide to General Winfield Scott in 1814, when in the Battle of Chippewa he was breveted a captain for his gallant conduct, and on July 25 of that year, in the memorable Battle of Lundy's Lane, he was lamed for life when he carried a message through enemy lines, refusing to be repelled by a wall of enemy fire.

Not only a courageous fighter and an effective leader on the field of battle, he had the ability to inspire the best in his troops. After the war Worth was appointed commandant of cadets at West Point, where he earned the nickname "Haughty Bill" for his good looks and proud bearing. He was the third officer to hold the post, but the first to have the title. Worth served in that capacity from 1820 to 1828. Robert E. Lee was Worth's adjutant in 1828.

In 1840 Worth took charge of the army in Florida fighting the Indians there. Through a balance of diplomacy, tactical skill, and courage, he subdued Wild Cat and Halleck Tustenugge, the principal hostile chiefs, and helped the Indians establish their farms and pursue their crafts. For his success, he was promoted to brigadier general, and President Polk himself presented Worth with his commission. Worth maintained high standards of discipline, and peace followed.

THE WAR WITH MEXICO AND WORLD FAME

When war with Mexico broke out in 1846, Worth's keenly tuned regiment was ordered to that country. A succession of dramatic victories brought the surrender of Monterrey, and newspaper accounts of Worth's glorious achievements in Vera Cruz, Cerro Gordo, Cherubusco, Molino del Rey, and the fortress of Chepultepec brought Worth national prominence. These names and those of his former battles are inscribed on the Worth Monument across from Madison Square Park. With the surrender of Mexico in 1848 and his promotion to major general, Worth was placed in charge of the new territory with his headquarters in San Antonio. In establishing several forts at strategic points, Worth's delegate, Major Ripley Arnold, named one on the Trinity River for his commander. Worth was dying of cholera in San Antonio when the fort was named. He never saw Fort Worth nor had any idea it would become a thriving metropolis of south Texas. Arnold learned only later that Worth died on May 7, 1849.

THE CONGRESSIONAL SWORD OF HONOR REPLACED BY MEDAL

Among the honors Worth received were four military swords, a traditional way to reward outstanding military achievement. The swords came from the president of the United States, the state of Louisiana, Worth's hometown of Hudson, New York, and the state of New York. Unfortunately, all four swords were so badly damaged in a fire in the State Library in Albany in 1911, where they were exhibited, that they were returned to the family and are today unlocated.

The sword that New York awarded Worth in 1835 was a dress sword with gold scabbard. The handle, also of gold, was fashioned to represent

a knight with a helmet and closed visor. On the handle were inscribed the names and dates of the battles against the British in which he distinguished himself. The cast-iron pickets that make up the fence surrounding the Worth Monument are replicas of that sword. The sword presented to Worth by the president of the United States according to congressional resolution, March 7, 1847, was awarded for his gallantry at Monterey in the Mexican War. In 1862 the Congressional Medal of Honor replaced the Congressional Sword of Honor when Abraham Lincoln signed the institution of the medal during the Civil War.

POSTHUMOUS RECOGNITION

On learning of Worth's death, the Common Council of the City of New York, in recognition of an outstanding native of the state, took it upon itself to transport his remains to New York for interment. It was almost a year from the time of Worth's death to the placement of his remains in the receiving vault of Greenwood Cemetery in Brooklyn. No doubt the coffin was honored at numerous locations en route from San Antonio to New York, which would account for the delay. Worth's body remained in the receiving vault until 1857, when, after three years of discussion among the Common Council of New York City, the Worth family, and the military, Worth was buried in the triangle between Twenty-fourth and Twenty-fifth streets where Fifth Avenue and Broadway come together.

The Common Council resolved not only to provide for interment but to erect a monument to Worth's memory. The council advertised for designs, inviting drawings and plans for the monument. Batterson's design was selected by the council on December 5, 1854, and completed three years later, a monument consisting of an obelisk above a rectangular base. The smooth shaft of the obelisk is broken by raised bands and in bronze letters names of the battles in which General Worth distinguished himself. At the base, a bronze relief shows Worth seated on his rearing steed holding his saber aloft. That saber is reproduced in the relief affixed to the obelisk. Inverted flames symbolizing death serve as brackets supporting the bands along the shaft of the obelisk.

Evacuation Day, November 25, 1857, was selected as the day to bury General Worth, that being the day New Yorkers celebrated the evacuation of the British army from the city of New York following the American Revolution.

WORTH MOURNED

On the morning of Thursday, November 24, 1857, the body of General Worth was removed from Greenwood Cemetery, brought by ferry across

the East River, and placed with its coffin in the Governor's Room in City Hall. There, under the honor guard of the Seventy-first Regiment, all through the night a constant stream of people viewed the coffin. It is ironic that in October 1848, seven months before Worth died, that very room had been tendered to him and to Major General John E. Wood, both New Yorkers, in recognition of their outstanding service in the war with England and the Mexican War, to receive the congratulations of their fellow citizens.

Between ten and twelve o'clock the following morning, the catafalque and coffin were placed in front of City Hall for the public to view one last time. At noon the procession moved up Broadway to Fourteenth Street, to Fifth Avenue, and up Fifth Avenue to Twenty-fifth Street and the site of the monument. Twenty carriages carried the mourners: family, relatives, and friends. Sixteen white horses pulled the catafalque, and 6,500 soldiers marched behind.

Church and fire-alarm bells tolled from noon until the ceremonies ended, and the national colors were flown at half-mast on all ships in the harbor and on all buildings in the city. Businesses closed for the day.

THE DEDICATION

The ceremony at the monument consisted of placing a box of relics in the cornerstone, an oration by Mayor Fernando Wood, a religious ceremony and benediction by the Reverend Dr. Vinton, who had served under Worth, and the dedication of the monument by members of the Masonic fraternity, of which Worth was a member. The ceremony concluded with the firing of three volleys by the Seventy-first Regiment.

The monument stands today in good condition. The fence surrounding the monument, which had been missing some of its unique cast-iron pickets that replicate the sword New York awarded to Worth, has recently been restored. On June 9, 1987, the Veteran Corps of Artillery, descendants of the Seventy-first, provided the color guard for a ceremony at the monument to initiate a fund-raising campaign led by Worth historian Bill Turner to restore the historic fence.

The Wood-Carver and the Human Figure

The wood-carver brought the first three-dimensional forms and figures to the Colonies. Shop signs and ships' figureheads and decorations were colorful, and polychromed carving combined indigenous forms with classi-

cal decoration. Along with acorns and pinecones, the carver became comfortable with such forms as the acanthus leaf, egg and dart molding and dentils, Corinthian columns and pilasters, festoons, and a host of decoration learned from the pattern books imported from Europe and from the European artisans, especially those from Italy, who traveled the Colonies carving fireplaces, lintels, and assorted decorations. Plaster casts of the *Apollo Belvedere,* the *Laocoön,* and the *Venus de Medici* eventually opened the way to closer contact with the classical tradition, and prints of the works of such masters as Canova showed how the new classicism in Europe responded to the ancient works.

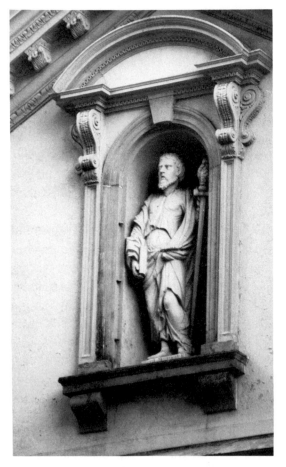

The statue of Saint Paul in the niche on the façade of St. Paul's Chapel across from City Hall Park is carved in wood and painted to look like stone.

William Rush—Carver, Sculptor

The twisting and turning contrapposto of neoclassical, Renaissance, and baroque figures not only appealed to the colonial taste, but made it easier for ships' figureheads to ride the prow comfortably and for statues of saints to fit easily into an ecclesiastical niche. One of New York City's best examples of such a figure is the oak statue of Saint Paul standing in his niche on the façade of the chapel named for him on lower Broadway in Manhattan. Painted white (now gray with grime) with a little sand added to look like stone, a common practice of the time, the figure may have been carved by Daniel Train, a resident carver in Manhattan. Because of the high quality of the carving, *Saint Paul* has also been attributed to William Rush, in whose freestanding figures the wood-carving tradition in the United States was transformed into sculpture. Enhancing his superior skill as a carver, Rush was able to incorporate the principles of composition and modeling or carving drapery and anatomy that approached the models of antiquity being introduced in the Colonies. Rush's full-length pieces included historical figures such as George Washington and mythological heroes such as Hercules, whose attributes he pressed into serving the imagery of the new nation. Hercules became symbolic of the new Republic's strength in its union of states, for example.

Rush was a successful portraitist, and his ability to capture a likeness coupled with his practice of using live models for his allegorical subjects also imparted even to his ship figureheads a compelling naturalism that was the hallmark of his art. It was said that before Rush carved figureheads, they simply rested above the cutwater. It was William Rush who set them in motion and imparted to them graceful attitudes of walking. Noted architect Benjamin Henry Latrobe, addressing a group of artists in 1811, marveled at the animation of Rush's figureheads. "They seem rather to draw the ship after them than to be impelled by the vessel."

RUSH AND THE NUDE

Rush used everything he learned of the new classicism and the antique. His copy of the *Artist's Repository,* an encyclopedia of classical and academic forms, contained illustrations of nude figures that Rush used for some of his works. For example, his reclining allegory of the Schuylkill River was taken directly from a reclining male nude personifying the river Nile in the *Repository.* Rush also used live nude models, for which he was severely criticized. It was only because of his high social standing in the community that he was able to use nude models. Nudity was frowned upon even in the service of art.

THE EAKINS EXPERIENCE

Later, Rush's use of the nude model became the subject of a painting in 1877 by Thomas Eakins, who was dismissed from his teaching position at the Pennsylvania Academy of Art for using a male nude model in a life drawing class made up of men and women. In order to show that the practice of using nude models had a long and respected history in America, Eakins painted the picture entitled *William Rush Carving His Allegorical Figure of the Schuylkill River* (not the reclining allegory mentioned above). The painting shows the sculptor carving his famous *Nymph with Bittern* (a small heron) for the fountain in Centre Square in Philadelphia. The model's chaperone is sitting nearby. Rush's wooden figure was destroyed by the water of the fountain. Installed around 1809, it was replaced in 1854 by a bronze replica.

Art and Craft

William Rush devoted his art to the principal and central theme of Western sculpture since antiquity, the human figure, and he learned from the classical models he knew how to reveal its nobility.

It has been noted that ever since the first sculptor made the first man and breathed life into him (Gen. 1:26), the human figure has been the central theme of sculpture and people's yearning for immortality its underlying principle. It should likewise be noted, that act of creation is the first distinction between art and craft. It is when the sculptor breathes life into his or her figure that it becomes art. William Rush was the first American to breathe life into the carved human figure and raise the craft of wood carving to a fine art.

The Monumental Tradition

New York had two examples of European monumental statuary well before the American Revolution, even though both were related to it. The works were public monuments commissioned in 1766 and were meant to satisfy differing public sentiment. Both monuments were executed by Joseph Wilton, who had studied under a highly respected French academic sculptor, Jean-Baptiste Pigalle, in Paris in the 1740s, then studied in Rome in the next decade. In 1764 he was appointed sculptor to His Majesty George III.

King George III

For those who were loyal to the king, Wilton executed a slightly over-life-size equestrian monument of King George III, cast in lead and gilded, which was erected in Bowling Green and dedicated in August 1770. It portrayed the king in Roman dress wearing a laurel wreath on his head. That the work was inspired by the famous equestrian monument in Rome of philosopher-ruler Marcus Aurelius was obvious, and it was supposed to be noticed. The wisdom and benevolence of the leader was to be conveyed to the colonists in this image.

William Pitt

The following month a standing portrait in marble of William Pitt was erected at the intersection of Wall and William streets to honor the statesman who had gotten the hated Stamp Act repealed. Wilton's composition of Pitt, who was known as the Great Commoner, also reflected the classical tradition. He portrayed Pitt in the robes of a Roman senator with his left hand raised as if addressing a crowd and his right hand holding a scroll of the Magna Charta.

When the Declaration of Independence was read in New York on July 9, 1776, patriots pulled down the equestrian monument of the king, melted it down, and used the lead to make shot to use against the British troops during the revolutionary war. In a belated retaliation in November of that year, British troops knocked off the head and arms of the monument to Pitt. Remnants of the base and part of the horse's tail were saved from the George III monument, and the head and arms of Pitt were salvaged. Relics of both monuments are in the New-York Historical Society and are exhibited from time to time. No attempt was made to restore the statue of William Pitt, and it was dismantled in 1788.

CHAPTER 2

Conduits of Classicism

The neoclassicism of the Italian sculptor Antonio Canova, a dominant force in European sculpture in the decades around the turn of the century, drew upon the art of ancient Greece and Rome with a preference for Hellenistic and classical Greece. It was introduced into America by Canova's Italian followers, the master himself, and American expatriate sculptors. Here again, Thomas Jefferson played a part.

Antonio Canova

Canova was a facile draftsman whose lyrical sense of line and composition in his early work infused the classical tradition with a decorative elegance that influenced many of his contemporaries, who called him the rival of Phidias and Praxiteles, then considered to be the greatest Greek sculptors of the fifth and fourth centuries B.C.

The elegant lyricism characteristic of Praxiteles' sculpture can be seen in Canova's original plaster *Armor and Psyche* in the Metropolitan Museum of Art in New York City (replicas of *Amor and Psyche* are still being made today in stone-carvers' studios in Europe) and in his marble *Perseus with the Head of Medusa* of 1801 (recalling the *Apollo Belvedere*), which stands in that museum's mezzanine overlooking the Great Hall.

Canova's Washington

Phidias' less lyrical style made Canova rethink his ideas of sculpture in 1803 and again in 1815, when he saw the Elgin marbles at the British Museum in London. There, in the marbles from the Parthenon, were the real principles of ancient art, Canova declared, and he prophesied that those principles would create a new era in the art of sculpture. And Canova helped that to happen. When he was commissioned to do a statue of George Washington for the State House in Raleigh, North Carolina, he chose as his model the Dionysus from the pediment of the Parthenon, one of the figures he had viewed at the British Museum two years earlier. The marble statue was installed in 1821, but fire destroyed it in 1830. To compensate for the loss of the statue, however, Italy made a gift of a plaster cast of the figure from Canova's studio in Possagno to the people of North Carolina, and it stands today in the Hall of History in Raleigh.

The Historic Sculpture Program

By March of 1805 Thomas Jefferson and architect Benjamin Henry Latrobe had agreed upon the sculpture program for the new Hall of Representatives for the U.S. Capitol Building in Washington, D.C. Both Jefferson and Latrobe saw the historical significance of building a great legislative chamber whose architecture and decoration would express the ideals of the new Republic dedicated to liberty. Latrobe's biographer and architectural historian Talbot Hamlin agreed with the throng of experts and laymen alike, who in 1811, when the hall was completed, called it the most beautiful legislative chamber in the Western world.

The commission was significant for American sculpture because it was the first full-scale sculpture program for an American public building, and it uniquely planted the new classicism of Canova in America. In addition to a statue of Liberty, there was a colossal American eagle with a wingspan of twelve-and-a-half feet and personifications of Art, Science, Commerce, and Agriculture flanking the entrance to the hall; overlooking the chamber was a colossal chariot of History with monumental clock, the Muse of History, and signs of the zodiac. A wealth of classical detail served as the setting for the new imagery, and capitals were carved for twenty-four Corinthian columns replicated from the capitals of the *Choragic Monument of Lysicrates* in Athens, considered then to be the most distinguished Corinthian capitals created in the ancient world. From the outset Jefferson in-

sisted that only the richest and most elegant effects would be appropriate for this hall.

America's Carvers Lacking

To execute the program, Jefferson directed Latrobe to import sculptors and carvers from Italy. They agreed the sculptors and carvers in America lacked the training and experience required for this work. Canova was asked to do the statue of Liberty, but his costs were too high. Through Philip Mazzei, an Italian physician, businessman, and historian who had assisted Jefferson in getting military supplies during the American Revolution, Latrobe imported a cadre of key sculptors and carvers from the Academy of Fine Arts in Carrara, Italy. More followed from other parts of Italy.

Some Notable Bearers of the Neoclassical Style

Giuseppe Franzoni did the statue of Liberty and the allegories of Art, Science, Commerce, and Agriculture. His teacher and brother-in-law, Giovanni Andrei, carved the twenty-four Corinthian capitals and was in charge of decoration. Tragedy struck, however, when the War of 1812 broke out and the British destroyed the legislative hall and the entire sculptural program. Undaunted, the contingent of sculptors and carvers re-created the program. Not only did Andrei recarve the entire set of twenty-four capitals, but a new wave of artists from Italy was brought in: Francisco Iardella, Carlo Franzoni (brother of Giuseppe, who had died), Giuseppe Valaperta, and Enrico Causici, who had studied with Canova. The sculptors worked also on projects throughout the South and East, from Louisiana to Maryland, Pennsylvania, and New York. Their work on banks, tombs, churches, and municipal buildings helped to extend the neoclassical tradition in America.

In 1822 Causici modeled a portrait of William Pinkney in Baltimore, then cast it in bronze, perhaps the earliest cast-bronze sculpture in America. He replicated Franzoni's statue of Liberty, destroyed by the British. It stands in Statuary Hall today, a plaster cast still waiting to be carved in marble. (The old Hall of Representatives remains a repository of sculpture. In 1864, when the hall had fallen into disrepair, legislation designated it the National Hall of Statuary, where each state can honor its heroes with statues.)

From 1825 to 1826 Causici was in New York City working on an

equestrian statue of George Washington. He made a full-size plaster of the monument, which was erected in City Hall Park. Although the statue was intended to be cast in bronze, sufficient funds were not raised for the casting, and eventually the weather destroyed the piece. Causici's best-known work is his statue of George Washington that crowns the Washington Monument in Baltimore.

Among the better-known and more influential Italian sculptors to arrive in America during the early nineteenth century, Luigi Persico (1791–1860), who arrived in 1818, reinforced the neoclassicism of Canova in the New World with his ideal sculpture and his portraits. Through a commission in 1825 to do John Quincy Adams's portrait (lost in a fire in 1851) Persico gained several important government commissions: heroic figures of *War* and *Peace,* the pedimental group *Genius of America,* and the *Discovery Group* for the U.S. Capitol Building. Replicas of *War* and *Peace* and of the *Genius of America* have replaced the originals, which were placed in storage in the 1950s for protection. The *Discovery Group* was also placed in storage but was not replicated.

CHAPTER 3

Foundations of an American Portrait Tradition

The bust or statue that captures a convincing likeness, and at the same time ennobles the subject, lives forever. Even when representational art is not fashionable, portraits that successfully balance the real and the ideal have always had their adherents. Such has been the case since the Greeks and the Romans perfected the art in ancient times. Over the centuries that Greco-Roman tradition spread throughout Europe, and it was introduced into the United States in the eighteenth century.

The Legacy of Jean-Antoine Houdon

When Benjamin Franklin was living in France, he had several portraits made. A 1777 terra-cotta relief profile by Jean Baptiste Nini shows Franklin with his favorite fur hat. A small terra-cotta figure of Franklin by François Marie Suzanne of 1793 portrays him in colonial dress with his three-cornered hat under his arm and buckles on his shoes. Jean-Jacques Caffieri made a serious-looking bust in 1777, and the following year the leading French sculptor of the period, Jean-Antoine Houdon, made not only the finest portrait bust of Franklin, but also one of the most successful portraits of the era. Houdon seems to have understood better than any other sculptor of his time that the essence of facial expression is found in the flesh and

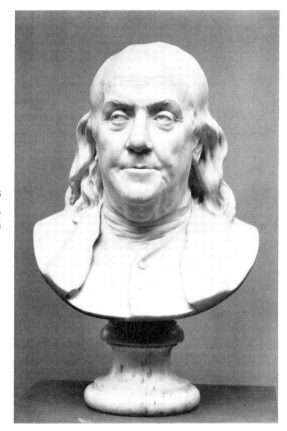

Houdon's portraits, such as that of Benjamin Franklin, helped to open a new era in portraiture.

muscles surrounding the mouth and eyes. Houdon's modeling captures the fleshy softness around Franklin's eyes and lids and about the mouth and slightly parted lips of the aged statesman and expresses the animated mobility of his aging brow.

Franklin leans slightly forward, and while he faces straight ahead, he glances sharply to the right, his head leaning to the left almost imperceptibly, but just enough that the gesture appears spontaneous and natural.

Artists use many devices to capture that spontaneous quality of their sitters—those, that is, who seek that aspect in their portraits. Houdon studied their expressions and movements as he engaged them in conversation, and he also made molds of their faces and hands and sometimes even of their clothing and accessories to study and to reproduce.

Gilbert Stuart, the American painter whose portraits of Washington are famous, used to research his sitters' interests by talking to their families, friends, and business associates before he started the portrait. Then the painter would sketch the changing features of the sitter as he introduced

subjects he was not expected to know anything about. Through this artifice, Stuart learned to generate a wide range of emotional responses—surprise, interest, alarm, even anger, but he always produced the desired spontaneity in his sitter that he sought to capture in his portraits.

Houdon's Washington

Houdon made portraits of leading patriots that caught the spirit of the individual, but his portrait statue of George Washington, from the outset, had an additional purpose—to create an image for all generations and a model for artists of the present and the future to follow.

When in 1784 the Virginia legislature requested Thomas Jefferson to get the best sculptor in Europe to make a portrait statue of George Washington for Virginia's State House in Richmond, there was little doubt in the minds of Jefferson and Franklin who that should be. Houdon was considered the best portrait sculptor living, and he had pleased many heads of state with their portraits. To accept the commission, Houdon withdrew from one for the empress of Russia, who failed to understand how Houdon could give up the advantages of her court to make a statue of a "colonial rebel." And many people marveled that Houdon decided to make the adventuresome or even dangerous ocean voyage to America to model Washington's likeness. After all, portraits of famous people were often made by well-known artists from paintings and the subject's clothing. Indeed, that was originally the method suggested to Houdon. Charles Willson Peale had painted a portrait of Washington, and a full suit of clothes was readied to send to Houdon with Peale's painting. Houdon would then find a model in France who fit into Washington's clothing, and provided with the painting, he could then make the statue. Houdon, however, elected to go to Mount Vernon and model Washington's likeness there on the "colonial rebel's" home ground, where the sculptor could get to know him and observe him in all the circumstances of his life.

Houdon's Incentive

Even though Lafayette's note to Washington that Houdon carried with him to Mount Vernon assured the "great man" that only "love of glory and respect for you" could induce the sculptor to cross the ocean, the stakes were considerably higher than Lafayette let on, which of course Washington knew. The year before, 1783, the U.S. Congress had proposed that an

equestrian monument of Washington be made, and Houdon wanted to make it. Houdon was also the most logical candidate, so he thought his chances at capturing the commission were reasonably good. Jefferson had pointed out to the Congress that Houdon had his own foundry, and in doing the statue for the State House in Richmond, he would have made all the casts and taken the necessary measurements, and therefore the United States would not only be getting the best and most prepared artist for the commission, but getting him at a bargain.

Unfortunately for Houdon, and for the United States, discussions became endless, and the equestrian monument was not done until the middle of the next century, long after Houdon's death, and by Clark Mills, an American sculptor of modest ability. Ironically, Mills used Houdon's statue in Richmond for the bust of his equestrian statue.

Houdon in America

When Houdon came to America to begin work on the Washington statue, he was accompanied by his longtime friend and compatriot in the Masonic Lodge in Paris Benjamin Franklin. Houdon also brought with him two assistants, one of whom was probably his master mold maker, who would make plaster molds of Washington's face, hands, spurs, watch seals, and walking stick. This was to be no ordinary portrait. This was to be an accurate record of the first president of the new nation, a record that Jefferson was determined would be an image for all generations and for all countries. It was to be the principal icon, that is, the ideal model of the venerated image of Washington, for the new Republic, and all nations, to follow.

Nature and Aesthetics

Jefferson had been careful to point out to the legislature that for public exhibition a statue should be enlarged slightly because when elevated it looked smaller than it actually was. Enlargement compensated for that visual shrinkage. Nonetheless, in the case of Houdon's statue of Washington, Jefferson explained it was necessary to make an exception to custom. He insisted that the statue be an exact replica of Washington's measurements, even though the size would be less visually satisfying, because "we think it important that some one monument should be preserved of the true size as well as figure, from which all other countries, and our own, at any

future day when they shall desire it, may take copies, varying them in their dimensions as may suit the particular situation in which they wish to place them."

Contemporary Dress

Instead of classical drapery, such as a Roman toga, Washington insisted on being portrayed in contemporary dress. He cited Benjamin West's famous painting of 1771, *The Death of General Wolfe,* as the precedent. That painting introduced the use of contemporary dress to history painting and thereby opened a new era in that genre. Washington's decision reflected a sophisticated understanding of West's innovation and a sense of what was right for his time and his world.

Two Statues of Washington

When Houdon returned to France, he carved two statues of Washington. The first, dated 1787, was exhibited in the Salon the same year; that statue is lost. The second one is in Virginia and bears the date 1788, even though it was not actually completed until 1791 or 1792 and was not shipped until 1796, the year the Richmond state capitol was finished. The confusion in dates may have something to do with the original plaster casts from which the marble statue was carved.

New York City's Replica in Bronze

Houdon's statue of Washington became famous and well loved. The accessories of spurs, walking stick, and the Roman fasces express his roles as both private citizen and military leader. He stands in classical contrapposto, and his features are modeled so as to strike a balance between the real and the ideal. In 1853 William J. Hubard, a Richmond artist, was granted permission to make six replicas of the statue for cities in the United States that wanted copies, including New York. New York's 1858 bronze copy is in the lobby of City Hall. If it were on a lower base, the figure would not look quite so diminutive.

Houdon's Life Mask of Washington

The life mask that Houdon or his master mold maker made at Mount Vernon is in the collection of the Morgan Library in New York City, where

A bronze replica of Houdon's statue of George Washington in the State House, Richmond, Virginia, stands in the lobby of City Hall.

it is on permanent exhibition. Of remarkably high quality and in excellent condition, the mask is the most accurate extant reproduction of Washington's features. A copy of a letter also in the Morgan Library, from Mrs. Washington's granddaughter, six years old at the time Houdon made the mask, describes the child's fright at beholding the general lying on the servants' hall table, his face covered with plaster and quills projecting from his nose (so that he could breathe).

At the auction of Houdon's possessions following the sculptor's death, Robert Walsh of Philadelphia bought Houdon's life mask of Washington. On his return home he gave it to John Struthers, a marble worker in Philadelphia. Struthers in turn gave it to Ferdinand Pettrich when the German sculptor was working in Philadelphia. Pettrich traveled to South America, where he proudly exhibited the mask, and later settled in Rome, where he continued to exhibit the mask to visitors, who were properly respectful. For special guests he would pluck out an eyebrow stuck into the plaster and present it as a kind of relic. When Pettrich died he left the mask to William Wetmore Story, a colorful and successful expatriate sculptor from Boston. In 1908 J. P. Morgan bought the mask from Waldo Story, William's son, which is how it got to the Morgan Library. That the mask has been well cared for is evident from its fine condition. Why the eyes are

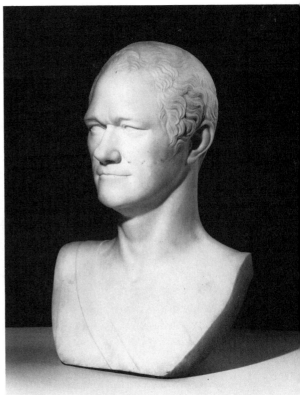

Left: John Dixey's copy of Giuseppe Ceracchi's bust of Alexander Hamilton was one of the most popular of the pirated portraits. *Right:* Giuseppe Ceracchi's marble bust of Alexander Hamilton became the standard likeness of the revolutionary hero.

open is not documented. It is possible that someone carved them open, possibly Pettrich, to illustrate that it was a life mask rather than a death mask.

The Pirated Portrait

Houdon's bust of Washington has always been the most popular of all Washington busts, hence the one most copied. How many copies were made may never be known because copies were even made of copies. In the eighteenth and nineteenth centuries, there was a thriving industry in the unauthorized replication of busts of famous people. One of the most successful practitioners of the pirated portrait was James Traquair in Philadelphia, who advertised and offered Houdon's busts of Washington, Franklin, and others in either local stone or imported marble, or even in plaster painted to look like marble, at different prices, of course. In further-

ing their own business interests, these entrepreneurs in stone and plaster introduced leading sculptors and major portraits to a broad public.

Giuseppe Ceracchi and the Influence of Rome

Traquair often employed European carvers and sculptors to carve his replicas, including Irish sculptor John Dixey, who executed the figure of *Justice* atop City Hall c. 1818. Dixey had studied at the Royal Academy in London and had won a Prix de Rome but decided to come to America instead of studying in Rome. Ironically, his most popular replica was of *Alexander Hamilton* by Roman sculptor Giuseppe Ceracchi, who came to America in 1790 and 1793 and who, through his portraits of Alexander Hamilton, Benjamin Franklin, Thomas Jefferson, John Paul Jones, and George Washington, became the principal force in establishing the Roman portrait tradition in America at that time.

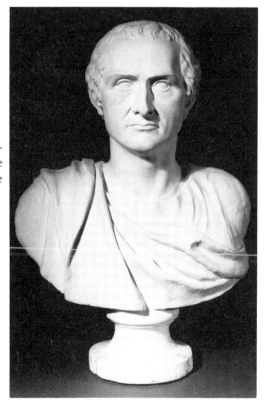

Ceracchi's bust of John Jay represents the characteristics of the Roman portrait tradition that the sculptor introduced to America.

Ceracchi and Houdon

Like Houdon's portrait busts, Ceracchi's busts are accurate likenesses. But whereas Houdon relied on changing aspects of the sitter's expression and upon the spontaneity of his or her gestures to capture the spirit of his subject, Ceracchi's portraits are an unchanging, solid, and permanent conflation of the real and the ideal. While his sitter's features are rendered from nature, the hairstyle is often based upon ancient models, and the Roman toga replaces contemporary dress. No tilt of the head and no sideward glance in Ceracchi's busts; the head fits squarely into a short, thick neck, the neck snugly into the torso, and the eyes look straight ahead. The gladiatorial proportions of torso and neck in Ceracchi's portraits provide a powerful foundation for the head, but the features are so masterfully modeled that the idealization is not immediately apparent, and the overall effect of his distortion of nature is one of imposing presence.

Valued and Preserved

Ceracchi's portraits continue the ancestral aspects of the Roman portrait tradition, which had its origins in ancient times. The ancient Romans believed that the portrait bust embodied the presence of the person represented—the closer the likeness, the greater the presence. The origin of that concept was in the Roman practice of making death masks in order to preserve the deceased's features, one of the ways the Romans dealt with the yearning for immortality. The wax masks were kept in cabinets with the family gods and publicly venerated on special occasions. To preserve and celebrate a citizen's distinguished lineage was an honorable family tradition.

Eventually the wax deteriorated, so around the third century B.C. the practice emerged of copying the wax death mask in stone. The public portrait was born, never to die. At first the portrait was an exact replication of the death mask. Later, imperfections were eliminated to conform to a more exalted idea (thus the term "ideal") of the deceased. Ever since then, changing tastes have dictated a preference either for the likeness or for its idealization.

The Romans so revered the early portraits that it was imperative they be carved in material, usually marble, that was without blemish. Patrons even drew up agreements with sculptors who carved the portraits that stipulated the bust would be carved with no wax fillings in the marble—that is, *sine cerra,* without wax, the origin of our word "sincere." When careless

sculptors discovered faults in the stone they were carving, or made mistakes, they would fill the cavities with wax mixed with marble dust so that the blemish could not be detected—until the weather changed. The wax would expand from the heat in summer and contract from the cold in winter. The fillings would fall out, leaving the unsightly blemish, and reveal an imperfect stone, an affront to the deceased.

Roman Realism

As any style of art is not simply one thing, so the Roman portrait tradition is rich and highly complex, as a visit to the Roman portrait collection on the main floor of the Metropolitan Museum reveals. In some portraits the faces are more naturalistic, the hair more idealized, in some the irises of the eyes are incised, in others the pupils are left smooth, and so on. Nonetheless, the common denominator that survived from ancient times to shape the portrait tradition of the eighteenth and nineteenth centuries in America was the all-pervasive realism of Roman portraiture, and Giuseppe Ceracchi was the most faithful conduit of that tradition at the turn of the century.

Dream and Demise

Although Ceracchi's formative influence on American sculpture was in portraiture, the dream that brought him to America was to build a monument to the glory of the American Revolution. "He was an enthusiastic worshipper of Liberty and Fame," wrote James Madison, "and his whole soul was bent on securing the latter by rearing a monument to the former, which he considered as personified in the American Republic." The monument was to be one hundred feet high with allegorical and mythological figures, portraits of the revolutionary leaders, and the goddess of Liberty descending in a great chariot drawn by four horses reminiscent of the quadriga atop the great Roman triumphal arches.

While Ceracchi was trying to get America's governmental leaders to finance his monument, he was collaborating with sculptor William Rush; Charles Willson Peale, American painter and founder of the first full-scale museum in this country; and other artists and art patrons to establish an academy of art, the Columbianum, for the encouragement of the fine arts through a program of instruction based on ancient models and of the exhibition of works of art. When plans for the monument and the Colum-

bianum failed, he returned to Europe. In Paris Ceracchi became embroiled in a conspiracy against Napoleon, which led to the sculptor's execution in 1802.

The English Portrait Tradition

The English school of portraiture made its mark in America especially following the American Revolution and the War of 1812, particularly in the work of Sir Francis Chantrey (1781–1841), who carved a standing figure of George Washington for the State House in Boston in 1826, and in the work of Robert Ball Hughes in New York.

The Hamilton Commission

In 1833 directors of New York's Merchants Exchange commissioned Englishman Robert Ball Hughes (1806–68), who had come to New York in 1829, to do a marble statue of Alexander Hamilton. Hughes had won medals for his works in England at the Royal Academy in London, where he studied with Edward H. Baily. Baily was a student of England's most renowned neoclassical sculptor, John Flaxman, whose art and theories of art had a long-term effect in both Europe and America.

Hughes's remarkable ability to catch a likeness while preserving a sense of the classical bust is exemplified in the portrait of the eminent New York jurist John Watts, one of Hughes's earliest works in America—c. 1830. Although the original plaster was destroyed, a faithful copy by Thomas Coffee is in the collection of the New-York Historical Society at Seventy-seventh Street and Central Park West, and the Metropolitan Museum of Art has a bronze cast of it. Hughes's realism appealed to American patrons who wanted to be able to identify the sitter.

The Hobart Relief

Hughes's 1831 marble relief of Bishop Hobart under the great window of the second Trinity Church (located in the room south of the main altar of the present church on the same site; see chapter 19), is more formal. Hobart is shown at the moment of death, slumping in an antique chair, his figure draped in the ample folds of his ecclesiastical robes, lending a classi-

cal air to the portrait. An allegorical figure of Religion stands behind the chair, one hand supporting the bishop's drooping head, the other pointing to the sign of the cross. Its location in the present Trinity, in the enclosure just off the main altar, provides neither space nor the benefit of the window (on which it depended for its full effect).

Washington and the Cincinnati

In 1838 Hughes entered a competition for an equestrian monument to George Washington. Financial difficulties doomed the project, but the sculptor's model is in Boston at the Society for the Preservation of New England Antiquities. It is the earliest surviving example of attempts at the equestrian monument in America.

The competition was sponsored by the Order of Cincinnatus. It is noteworthy that in 1783 Pierre L'Enfant, who organized a French branch of the society, designed the society's badge and its certificate and that Hughes incorporated both in his sculpture.

Hughes's portrait of Colonel John Trumbull, now in the Yale University Art Gallery, made clear that Trumbull was also a member of the Cincinnati—he is wearing the badge. Trumbull, an important early patriot and artist, was an aide to Washington early in the revolutionary war and was imprisoned by the British in 1780. In 1794 Trumbull served as John Jay's secretary during negotiations of Jay's treaty in England. One of America's leading painters of the period, he was president of the American Academy of Fine Arts. He left an important painting collection to Yale University. The Trumbull Gallery was the first to be affiliated with an educational institution in America and became the basis of what is today the Yale University Art Gallery.

The Hamilton Model

The same year that Hughes made Trumbull's portrait, Trumbull arranged for Hughes to use the American Academy of Art's statue gallery to make the model for the Hamilton statue. A wood engraving of the finished statue was published in the *New York Mirror* on October 24, 1835, and it shows Hamilton wearing a toga and holding a scroll, which is probably the certificate of the Cincinnati. On March 28, 1835, nine months after the statue was installed in the new Merchants Exchange Building on Wall Street, the classical revival structure was destroyed by fire and

Hughes's statue along with it. However, three sketch models (maquettes) for the statue still exist: one in the Detroit Institute of Art, another in the Museum of the City of New York, and a third in the Schuyler Mansion in Albany as Wayne Craven has noted. These show that Hughes's original idea was probably to have Hamilton dressed in contemporary clothing. But then a change was made—perhaps to compensate for a flaw in the Carrara marble he used. Hughes decided to portray Hamilton in a toga. Hughes probably modeled Hamilton's portrait from the bust of Hamilton in the New-York Historical Society, a replica by Irish carver John Dixey of Ceracchi's famous bust.

The Yankee Presence

A comparison of two portrait busts in City Hall, *John Jay* by John Frazee and *Pierre Cortlandt Van Wyck* by John H. I. Browere, provides insight into how the native carver, Yankee ingenuity, and the European portrait tradition came together in the emergence of an American portrait tradition in the nineteenth century.

John Frazee

John Frazee (1790–1852), a New Jersey stone-carver specializing with his brother in funerary monuments, moved to New York City in 1818. A memorial to Sarah Haynes in Trinity Church at Broadway and Wall Street of 1821 illustrates that Frazee could execute traditional classical decoration from examples he knew and from pattern books. In 1824 Frazee carved the bust of John Wells, lawyer, editor, and entrepreneur, for his wall monument in St. Paul's Chapel. Frazee Americanizes the monument by using acorns and oak leaves instead of the classical acanthus leaf. But the remarkable accomplishment is the lifelike portrait bust of Wells close enough to Ceracchi in carving and composition to be by the Roman master himself. Finally, Frazee's head of John Jay of 1831, commissioned by Congress and on display in City Hall, is so similar in execution to Ceracchi's bust of John Jay (c. 1795) that the two were often confused. Likeness and conformity to an accepted portrait standard were desirable at that time. The handling of Jay's hair by Frazee is slightly different from Ceracchi's, which may be attributed to the influence of the Latvian-born sculptor Robert E. Launitz (1806–70), who had studied with Bertel Thorvaldsen in Rome. Launitz had worked for Frazee and in 1831, the year Frazee finished the bust of Jay, became his partner.

Robert E. Launitz

Launitz was a gifted teacher as well as a successful sculptor. His pupils included the well-known Thomas Crawford, one of America's first sculptors to study in Italy, and the not-so-well-known Henry Baerer, whose busts of John Howard Payne (once in Prospect Park, now in storage) and Ludwig van Beethoven (in Prospect Park) enhance the city's collection of musical subjects. Launitz's portrait style is well represented in his bust of Peter Augustus Jay in the New-York Historical Society and his memorial relief of a grieving Indian brave marking the grave in Brooklyn's Greenwood Cemetery of the Indian woman Do-Hum-Mee of c. 1844, which reflects the blend of a neoclassical funerary design with a naturalistic rendering of the human figure. Launitz's monument was published in Cornelia Walters's *Rural Cemeteries of America* and is one of the earliest carved figures in this country placed in a garden cemetery.

John H. I. Browere

The bust of Pierre Cortlandt Van Wyck by John H. I. Browere also derives from the Roman portrait tradition but combined with Yankee

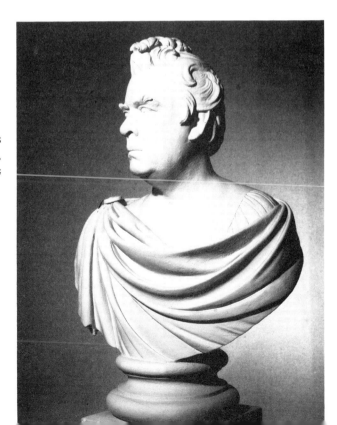

John H. I. Browere's busts, such as his portrait of David Hosack here, were combinations of life masks and modeled elements.

ingenuity. Van Wyck's portrait is a combination of a life mask of the subject and a draped bust. Seemingly straightforward in design, the technical achievement in uniting the mask with the rest of the anatomy and the upper draped torso required formidable skill and intimate understanding of a highly sophisticated casting and mold-making process.

Browere visited France from 1816 to 1817, where he learned the latest advances in techniques of casting and mold making, which enabled him to develop his own system. When he returned to America he conceived the idea of a national gallery with bronze portraits of the country's leaders. In 1828 he had completed enough portraits in plaster to open his Gallery of Busts in New York City. Unfortunately he could not raise enough money for the casting before he died at the age of forty-four. Outstanding New Yorkers whose busts by Browere are in the New-York Historical Society include, in addition to Van Wyck, Dr. Hosack, physician of medicine at Columbia College, and Philip Hone, mayor.

CHAPTER 4

Hiram Powers and a New Era in American Sculpture

The American sculptor Hiram Powers yearned to study in Italy. His plan was to spend two or three years studying ancient art and the new classicism there, then return to the United States to make a career as a sculptor at home. Instead he settled in Florence in 1837, never to return. He died in 1873 at the age of sixty-eight and was buried in the Protestant Cemetery in Florence.

Powers did learn from Italy, however, and through his realistic portraits and his ideal nudes he became the most successful and influential American neoclassical sculptor of the nineteenth century. Through the tools and processes Powers invented he initiated direct carving, which would revolutionize sculpture at the beginning of the twentieth century. And through his aphrodisian aesthetics, in a time when sexual expression was repressed, he united the venereal and spiritual natures of man in a unique sculpture that paved the way for such twentieth-century creations as the nudes of Gaston Lachaise, which celebrate the beauties of sex as an aspect of human love. New York City is fortunate to have two of Powers's most important works—the *Greek Slave* and his portrait of Andrew Jackson.

An American Portrait Tradition

How Giuseppe Ceracchi's Roman realism and Italian neoclassicism combined with a down-to-earth likeness to shape an American portrait

tradition is well illustrated in Powers's portrait of Andrew Jackson in the Metropolitan Museum of Art, which also has works by Ceracchi and Canova and ancient busts to provide instructive comparison. Later in his career, Powers looked to Houdon for models when he did portraits of Washington and Franklin. But in Washington, D.C., where he modeled the bust of President Jackson, he looked primarily to the Italians, whose work was around him.

Powers's Portrait of Jackson

Powers retains the toga, the formal composition, and the look straight ahead from Roman portraits, and he has even added some weight to Jackson's neck. But Powers borrows more from nature than from classical models, even though his bust of Jackson has the ruggedly naturalistic look

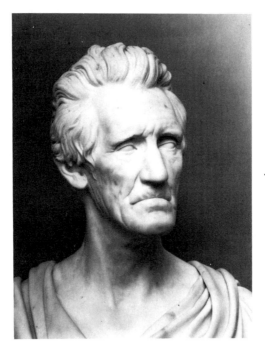

Hiram Powers's bust of Andrew Jackson helped to establish Yankee classicism in portraiture.

of some of the Roman busts in the decades around 20 B.C. He shows Jackson without his false teeth, as the president appeared in a contemplative mood after eating his usual ration of morning mush, when Powers was admitted to the president's office to make sketches. He portrays the president's weathered and wrinkled skin, ample brow, and bold shock of hair with such conviction that Jackson was delighted with its truth to nature, even though contemporary critics took Powers to task for failing to idealize Jackson's features. They felt it inappropriate to portray a head of state too naturalistically with all his physical imperfections.

Born in 1805 in Woodstock, Vermont, Powers moved with his family when he was thirteen years old to Cincinnati, where he learned from a German sculptor, Frederick Eckstein, to model, make molds, and carve; he also studied anatomy with a local doctor. Powers began doing portraits in Cincinnati of influential people, and over the years they became sufficiently impressed with his ability to arrange for him to model the president. As soon as Jackson's bust was modeled, Powers prepared to sail for Italy, where he planned to carve it in the white marble of Carrara.

Greenough and Crawford

Sculptors Horatio Greenough from Boston and Thomas Crawford from New York were already in Italy when Powers arrived, and they were becoming increasingly successful. Thomas Crawford (1813–57) had gotten his start in New York City with John Frazee, the stone-carver turned sculptor, and the Latvian Robert E. Launitz, who had studied with Thorvaldsen in Rome. Through Launitz, Crawford was introduced to the Dane, and Crawford became Thorvaldsen's pupil. Crawford remained in Rome, where he produced his first piece to gain acclaim, *Orpheus* (1839), exhibited in Boston, where it is now in the Museum of Fine Arts. A replica of his colossal *Indian* from the pediment of the Senate wing of the U.S. Capitol in Washington, D.C., is in the New-York Historical Society. When Crawford died tragically young in 1857, his casts were assembled in New York to form the nucleus of a museum, but fire destroyed them—and the idea also.

Horatio Greenough (1805–52) was America's first sculptor to be awarded a major U.S. government commission—a marble statue of George Washington for the Rotunda of the U.S. Capitol. The bust was based upon a conflation of Houdon's and Ceracchi's portraits, and the body for the seated figure of Washington was inspired by a reconstruction of the lost statue of Zeus by the ancient Greek sculptor Phidias and paintings by

J.A.D. Ingres of Jupiter and Thetis and of Napoleon I. The sculpture was too heavy for the Rotunda and unacceptable by Congress anywhere else, so it ended up in storage until the 1950s, when it was installed in the Smithsonian Institution, where it can be seen today.

Yankee Classicism

Greenough, Powers, and Crawford were the first wave of American expatriates to settle in Italy, and they produced a kind of Yankee classicism that combined Old and New Testament themes and saints, contemporary American and European literary themes, and historical themes with ancient sculptural models. They had many patrons, especially American and British, who delighted in visiting their studios on the Grand Tour of the leading cities and sites of the ancient world. Guidebooks even listed their studios along with those of the native sculptors, which enhanced their reputations and increased the marketability of their sculpture. Greenough and Crawford died young, but Powers continued the tradition. Although other American sculptors followed them to Italy and enjoyed success, it became apparent around midcentury that the next group of American sculptors to make a significant impact on the art world would be working in bronze and would draw inspiration from developments in France instead of Italy. Powers, however, had arrived in Florence at the right time.

Italy, the Source of Art

When the Yankee triumvirate arrived in Italy with its ancient models and marble quarries, its artisan tradition of marble carvers, and an international community of artists, Italy was the center of sculpture and classicism was the dominant style. Artists worked in the ancient method of making marble sculpture. The sculptor would make a clay model, which would be enlarged and cast in plaster by artisans. Next, marble carvers with the aid of a pointing machine, a device used to transfer the exact proportions from the plaster to the marble, would usually do most if not all the actual carving, replicating the plaster model in marble. Then the sculptor would finish the surfaces as the final step.

In going to Italy, the Americans were not only seeking the ancient tradition, they were also looking to the new interpreters of that tradition, Antonio Canova and Bertel Thorvaldsen, the leading practitioners of what

was then called the "correct style" or the "beau style." By the mid-1860s, when the style was losing favor, it was pejoratively dubbed by English critic Michael Rossetti as "pseudoclassicism" or "neoclassicism." Neoclassicism is the name that caught on and the one we use today to describe the style.

Neoclassicism, characterized by its conscious imitation of ancient models, originated in Rome in the mid-eighteenth century partly as a reaction to the excessively decorative rococo style and partly from the renewed interest in ancient Greek and Roman culture, fueled by the discoveries of ancient art at the excavations of Herculaneum and Pompeii. The *Venus de Medici* became the epitome of female beauty, the *Apollo Belvedere* became the epitome of male beauty, and these works became models, therefore, for painters and sculptors alike. Canova's *Perseus with the Head of Medusa* in the Metropolitan Museum of Art is borrowed directly from the *Apollo*. The *Apollo*'s influence had a long life on both sides of the ocean (see, for example, Frédéric-Auguste Bartholdi's 1873 statue of Lafayette in Union Square in Manhattan).

Thorvaldsen, the Danish sculptor who had settled in Rome and become the successor to Canova as the leading neoclassical sculptor there, had a calm and noble style. The angel in the baptismal chapel of St. Bartholomew's Church on Park Avenue at Fiftieth Street in Manhattan was once attributed to Thorvaldsen. Composed of calm and tranquil forms, it is based upon his works. Figures by Canova and Thorvaldsen were replicated in cast iron or zinc for such public structures as fountains. The small zinc figure of Hebe for the Temperance Fountain in Tompkins Square Park in Manhattan, soon to be renovated, is an example.

Powers's Ideal Nude

Thorvaldsen visited Powers's studio in Florence and praised the frankness of his portraits and the naturalism in his ideal figures, and he was impressed with Powers's Yankee ingenuity in his tools and techniques. He told Powers that the American had opened a new era in sculpture with his portraits, ideal pieces, and methods.

While Thorvaldsen spoke with Powers he adjusted the clay of Powers's *Eve* (Powers's favorite sculpture, which he never exhibited publicly), which Powers was modeling at the time. Powers often recalled how he regretted that he could not have recorded the print of the Dane's fingers in the clay.

The Greek Slave

Powers's *Greek Slave* was the first life-size statue by an American sculptor of a totally nude female to be placed on public exhibition, and it won worldwide fame. He made six versions, one of which is in the Brooklyn Museum. The slave, a youthful maiden, stands five feet five inches tall in a relaxed contrapposto. Her hands are chained (manacled in the version in the Brooklyn Museum), she gazes slightly downward past her left shoulder. Her right hand rests on a support that holds her clothing, and a small cross hangs in the fringe that drapes there. The statue is carved in the faultless white marble Powers selected from the Serravezza quarries. Powers's figure for the statue was probably based upon two models—his wife's teenage dressmaker and a model often used by Lorenzo Bartolini, the director of sculpture at the Academy in Florence who befriended Powers when the American first arrived in Italy. It was possibly through Bartolini that Powers was later made a professor of sculpture at the Academy. The composition for the *Greek Slave* derives from such models as the *Venus de Medici.*

Inspired in part by a newspaper account Powers read of how the Turks sold Christian women as slaves during the Greek war for independence, the statue also suggested to many observers the slavery issue in the United States. In fact Powers's friend in Florence the poet Elizabeth Barrett Browning admonished the statue in a poem to use the beauty the sculptor had bestowed upon it to respond to the slaveholders of the day: "Strike and shame the strong/By thunders of White Silence . . ." Browning's last two words became the title for Sylvia Crane's survey (1972) of the lives, works, and aesthetics of Powers, Greenough, and Crawford.

A Question of Nudity

The *Greek Slave* traveled to major cities in the United States and in Europe during the mid-nineteenth century. It was exhibited at the Düsseldorf Gallery in New York. In the United States, some cities scheduled separate showings for men and women to view the statue because nudity was frowned upon. That it was permitted to be exhibited at all in those cities was due to testimonials Powers was able to elicit from ministers, educators, and other professional people that the spiritual message of the slave outweighed any hint of prurience. The statue's sensuality, however well subsumed in its spiritual message, did not escape the critics. Marveling at the apparent softness of the flesh and the surfaces finished in sensuous

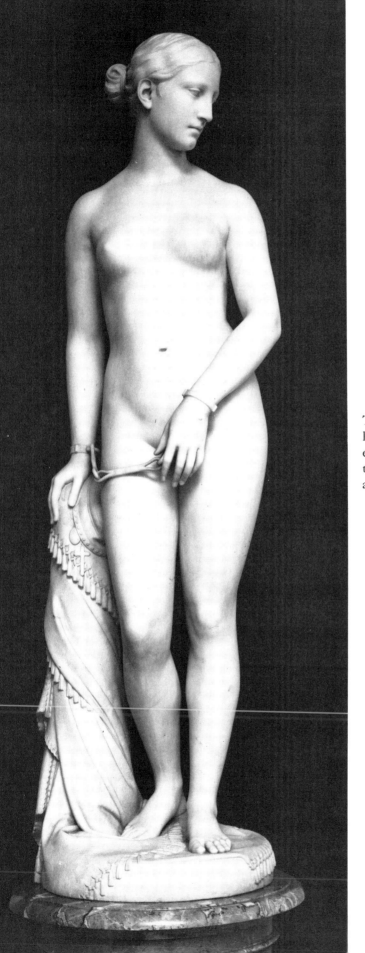

The *Greek Slave,* America's first life-size nude statue on public exhibition. An embodiment of the "Unveiled Soul," it opened a new era in sculpture.

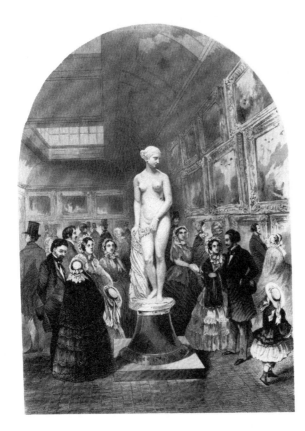

Greek Slave exhibited in New York City.

textures unprecedented in marble sculpture, one critic noted, "The statue seems rather to have been modeled than carved in marble."

The "Unveiled Soul," Powers's Aphrodisian Aesthetic

Hiram Powers not only created a nude statue that was morally acceptable, he created an erotic genre that came directly from the hand of God. He succeeded, therefore, in reuniting flesh and spirit, which people had separated through centuries of civilization. Powers accomplished that through the meticulous manipulation of marble to capture the matchless grace and infinite beauty of the human body and, shining through it, the human soul—the two great sources of human interest, a contemporary critic noted.

Powers wrote to Elizabeth Barrett Browning at Casa Guidi that "the legitimate aim of art should be spiritual and not animal" and that "the nude statue should be an unveiled soul." Powers got that notion from the teachings of Emanuel Swedenborg (1688–1772), the eighteenth-century scientist-turned-mystic, whose platonic idea that the material world

corresponded to the spiritual world appealed to Powers's literal turn of mind. When one dies, Swedenborg taught, one sheds the material covering (the earthly body) and exists in a spiritual body, through which one's soul shines—as if unveiled—in its radiant splendor.

If Powers needed further justification to carve nude statues, he found it in his sense of vocation. From childhood, he had a recurring dream of a beautiful woman he could never reach because she stood across a pond too deep to ford. When he crossed the ocean, settled in Florence, and began carving his ideal statues, the dream ceased, which Powers always interpreted as fulfillment of the prophetic dream that he was to become a sculptor.

Powers carved other nude statues, including several of the biblical Eve and a personification of California (in the Metropolitan Museum of Art). Beneath the narrative meaning, each is an "unveiled soul" and a surrogate of the unattainable woman.

Powers's Methods and Materials

Powers was not unique in the spiritual attitude he had toward his sculpture. "Sculpture is born in clay, dies in plaster, and is resurrected in marble" was an adage of the nineteenth century, attributed both to Canova and to Thorvaldsen (and that Ralph Waldo Emerson found compelling enough to write about). Inherent in this summary of the production of a statue is the frustrating recognition that what came from the sculptor's hand, the clay model, was destroyed in the process.

Hiram Powers invented a way of building a statue with plaster bricks bound together with wet plaster, which he then carved once the plaster was dry. He got the idea watching some Florentine laborers build a plaster wall.

Powers's new method meant that the sculptor's original conception was preserved as the original plaster. It also introduced direct carving, which a half century later would revolutionize public sculpture.

At first, Powers was frustrated because the carving tools he had were for marble, which were useless for carving plaster. The files became clogged with the plaster. However, Powers remembered as a child watching his mother grate nutmeg, and he recalled that the grater had perforations for the nutmeg to pass through as it was grated. This led to Powers's invention of the open file (patented in 1853), which works like a nutmeg grater and made it possible to carve the plaster model. The open file is still used by sculptors, but few know that Hiram Powers invented it.

Serravezza's Marble

Powers profoundly influenced the aesthetics of marble sculpture in the nineteenth century by rediscovering the quarries of Serravezza, first opened in the sixteenth century by Michelangelo for the Medicis.

Patrons in the nineteenth century insisted that their portrait busts and ideal statues be executed in pure material, and blemishes in the marble could mean either a reduced price for the sculpture or its rejection altogether. When a life-size figure in marble took from a year to a year and a half to produce at a cost of $10,000, such matters were serious to a sculptor who had to rely on his art for his living. The white statuary marble from the quarries at Carrara, where marble had been drawn for centuries, was not always predictable, and it was not uncommon for a sculptor to be forced to start over on a piece several times because of serious imperfections in the stone.

Powers went into the hills himself in search of a solution. He found it about eighteen miles from Carrara in the quarries of Serravezza, so called because the Serra and the Vezza rivers meet there near Pietra Santa—white marble with a grain so fine that it resembled porcelain. He noted, too, that the porosity and color of it were nearer to the color and texture of human flesh than was the traditionally used stone from Carrara, making the Serravezza marble more suitable for human figures and for portraiture when naturalism was the aim. To bring out the texture and porosity in the new marble so that it would approximate human flesh, Powers developed new tools, and he imported special pumices from Vienna to work and finish the surface of the stone.

Powers's Eve Tempted

His obsession with surface was nurtured and expressed particularly in one statue he exhibited privately in his studio and on which he continued to work almost from the time he arrived in Italy until he died—*Eve Tempted,* now in the National Museum of American Art in Washington, D.C. Although the statue, whose composition was inspired by ancient models and such Renaissance works as Albrecht Dürer's *Eve,* appears at first look to be finished, closer inspection reveals marks of the pointing machine, which are yet to be removed. And in numerous letters, referring to *Eve,* Powers stated that he could work on one statue his entire life.

On Exhibiting Sculpture

Powers insisted that the walls of the room in which white marble sculpture is exhibited should be cinnamon or reddish brown to impart a soft fleshlike glow and warmth to the surface of the marble. If the light source was gas, the flickering gaslight would add intensity to the experience.

John Gibson, a well-known English sculptor, had attracted wide attention by actually coloring the surface of his statues to make them appear more lifelike, and one of them became known as the *Tinted Venus,* which Powers immediately rejected as the "Tainted Venus," because putting color on the marble, he maintained, destroyed the purity of the surface.

PROPER LIGHTING

Direct light should be avoided. The light should be filtered through something like muslin, and it should fall from an angle so that the shadow cast by the nose falls at the edge of the upper lip. That method of lighting produces soft shadows over the face, providing a view of the facial features and enhancing the modeling of the marble surfaces. Direct and unfiltered light creates geometric patterns over the surface that conflict with the organic forms of nature, and light cast from an improper angle eclipses facial features and subtle modeling.

POWERS'S PEDESTALS

So that his figures could be viewed from all points to advantage in changing light, Powers designed his own pedestals and made them to rotate. They were created with his customary care. Unfortunately only one from his hand is known to exist, and it is in a private collection. But after a decade of being outside in East Coast winters and summers, the pedestal can still be turned with one hand by a child.

PART II

The Historic
Portrait in Bronze

American Masters of the Public Bronze I

As Hiram Powers was modeling the bust of Andrew Jackson in the White House, which would usher in a new era in the marble portrait, the U.S. government was the unwitting collaborator in introducing a new statue type in bronze in the nation's Capitol.

David d'Angers

Standing against the wall and partly shaded by the overhanging gallery, the tall (six feet seven inches), dark statue of Thomas Jefferson by David d'Angers goes almost unnoticed in the council chamber of City Hall in downtown Manhattan. Yet it is the plaster model for the first of a statue type that revolutionized bronze portrait sculpture in the nineteenth century: a naturalistic portrait of a historical figure cast in bronze and meant for public exhibition, presenting the subject in contemporary dress with attributes that identify his historic significance.

Pierre-Jean David, from Angers, France, called himself David d'Angers to keep from being confused with the famous French neoclassical painter of the period Jacques-Louis David. He won a Prix de Rome and was there from 1812 to 1815, beginning his career as the most prolific of

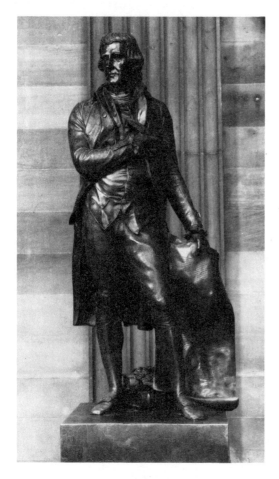

David d'Angers's statue of Thomas Jefferson introduced an historic statue type into America.

great portraitists, in a style that would make an indelible imprint on the monuments and masterpieces of American art.

Jefferson, the Nation, and New York

In his study of the nineteenth-century portrait, James Holderbaum has shown how a new era in American sculpture and a major contribution to New York City's collection of public monuments were occasioned by one man's gratitude to the city and to a founding father that took the form of a David d'Angers commission.

As a tribute to Thomas Jefferson's abolition of religious discrimination in the armed forces, a Jewish naval officer, Lieutenant Uriah Phillips Levy, commissioned David d'Angers to execute a bronze portrait statue of Thomas Jefferson to be placed in the U.S. Capitol. Levy was introduced to David by the marquis de Lafayette, whose portrait of Jefferson by the

American painter Thomas Sully served as d'Angers's likeness for the statue.

The statue virtually scintillates with inner vitality, produced by the torsion of Jefferson's twisting posture and the surface animation and articulation of detail, which was unprecedented in contemporary sculpture. This tour de force was achieved first by the sculptor's superlative modeling of the clay figure, which was then translated into bronze through the newly revived lost-wax process of casting. Mastery by modern founders of the ancient process, unknown since the Renaissance, made it possible to reproduce faithfully the sculptor's subtlest nuances of surface modeling.

Accepted by Congress in 1834, the statue was placed in the Rotunda of the U.S. Capitol, but its black "unmarmoreal" color made "Old Tom" look like a Negro so a group of influential senators had the statue placed in storage until President James K. Polk (1795–1849) resurrected it for the front lawn of the White House, where it stood until 1874 when it was moved to Statuary Hall in the U.S. Capitol. Then in 1900 the statue was placed in the Rotunda of the Capitol, its original site where it remains today.

The same year Levy gave the bronze statue to the country, he gave the original plaster (the plaster from which the bronze was made) to the city of New York, in gratitude for his financial success in New York real estate. He had the surface of the plaster treated to appear as dark bronze. Over the years the surface became chipped and discolored, so recently the city had the model restored as close to its original condition as possible.

Hallmarks of a Tradition

Although David d'Angers's down-to-earth naturalism, animation, and unprecedented crispness of detail were ahead of their time in 1834, those very characteristics were to become the hallmarks of American bronze monumental portraiture during the late nineteenth and early twentieth centuries. And when Auguste Rodin began to model in clay, it was to such portraits as d'Angers's tortured bust of the demoniacal violinist Niccolò Paganini that he went to find his own style.

It has been correctly observed that David d'Angers's *Jefferson* in City Hall and in Washington, D.C., appears surprisingly contemporary with the works of such leading American sculptors of the nineteenth century as John Quincy Adams Ward and Augustus Saint Gaudens, who were responsible to a large extent for establishing a tradition of American realism in monumental portraiture that prevailed until World War II.

A Monumental Medium

By the mid-nineteenth century, bronze became the popular medium for monuments to honor the country's leaders and heroes of the post-Civil War era. Its superior capacity for capturing detail combined with its durability in the outdoor environment to make it more suitable than marble for great public monuments.

At this same time, the sculpture center in Europe began to shift from Florence and Rome to Paris, and a sizable contingent of young Americans went there to study at the Ecole des Beaux-Arts (School of Fine Arts). The curriculum was a blend of Renaissance and baroque classicism, producing the Beaux-Arts tradition, which was to dominate American sculpture and decoration from the 1870s to World War I.

David d'Angers's Legacy

J.Q.A. Ward rejected European study, Augustus Saint Gaudens and Daniel Chester French were products of it, yet all three sculptors shared a devotion to truth-to-nature and to an idealized realism that prevailed in America in the late nineteenth and early twentieth centuries. And they created monuments and masterpieces in bronze that set the tone and standards for an era of bronze sculpture and for two generations of American sculptors.

J.Q.A. Ward

Two principles guided Ward's sculpture: artists should make American art in America, and the essence of art is in improving nature. Ward came to New York from a farm near Urbana, Ohio, when he was nineteen years old to study in the studio of Henry Kirke Brown. Even though Brown had studied in Florence and Rome, he believed American artists should stay home and make sculpture inspired by nature, ideas that helped to shape Ward's own philosophy of art. Ward went on to become the leading sculptor of his time. Some of his finest works are public monuments in New York City, and they provide insight into his art in the 1870s, when he practiced a restrained style of naturalism, and in the 1880s and 1890s, when he embraced a freer modeling technique and a more animated portrayal of his subject that was characteristic of the Beaux-Art style, as Lewis Sharp's critical study of Ward's sculpture reveals.

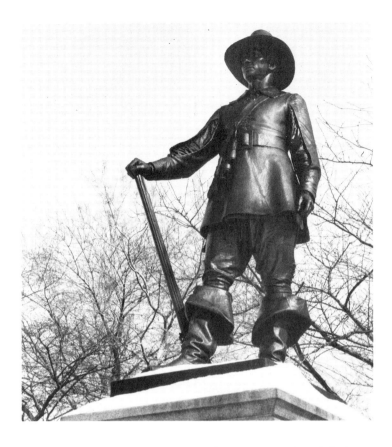

Top: John Quincy Adams Ward's *Pilgrim* in Central Park facing west at the Seventy-second Street transverse near Fifth Avenue. *Bottom:* The bronze relief at the base of Ward's *Pilgrim* that explains the meaning of the Pilgrim's gaze.

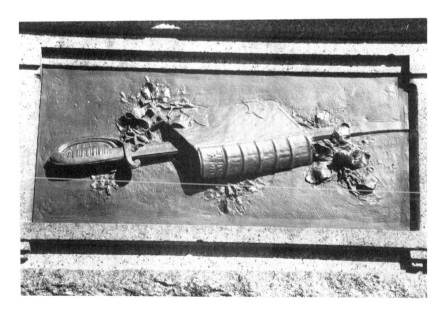

The Pilgrim

Ward's *Pilgrim* in Central Park, commemorating the early settlers of Massachusetts, has been criticized as a costume piece, implying it is a superficial interpretation of a seventeenth-century Puritan. Ward's simple and direct handling of his subject, however, is altogether fitting, which escaped his contemporary critics. The meaning of the restrained contrapposto and the Puritan's straightforward and penetrating gaze is revealed by the symbol directly beneath his feet. There, on the bronze in low relief, is the Bible with a sword—a well-known image indicating the sharp insights of the Bible. In the context of the statue, it is a reference to the Puritan's gaze and restrained mien. The same symbol is found in one of the reliefs over the main entrance to the Fifth Avenue Presbyterian Church, by architect Carl Pfeiffer. The church was built in 1875, just three years before New York City's New England Society proposed erecting the Pilgrim monument in Central Park. The distracting element of the monument is Richard Morris Hunt's base, which is itself a tour de force of monolithic design, totally out of keeping with Ward's simple and penetrating figure.

Ennobled Presence—Greeley and Conkling

In his monuments to Horace Greeley and Roscoe Conkling, a comparison between Ward's style in the 1880s and the 1890s reveals that his modeling takes on a slightly flickering quality over the surface of Conkling's beard and clothing. Ward ennobles the presence of the two subjects through personal recollections and life masks and photographs.

GREELEY REMEMBERED

The monumental seated portrait of Horace Greeley northeast of City Hall in downtown Manhattan was unveiled on September 20, 1890, in an arched niche in front of the New York Tribune Building, which stood at Printing House Square (now Franklin Square), across the street from its present location. Without its architectural framework, the monument appears exposed and alone. Aside from that, however, it is seen to advantage in its landscaped site.

One of America's best-known newspaper editors and most influential political leaders, Horace Greeley began publishing the *New York Tribune* in 1841 and retired in 1872 to devote his full time to run for the presidency

Top: This detail of Ward's seated portrait of Greeley focuses on the naturalism and psychological insight that interested American sculptors of the period. *Bottom right: Horace Greeley* in City Hall Park by J.Q.A. Ward was originally installed in front of the Tribune Building, which once stood across the street.

of the United States. The death of his wife just before the election, his resounding defeat by Grant, and his inability to regain a hold on the *Tribune* brought on the emotional and physical collapse that led to his death two weeks after the election. Ten years later Whitelaw Reid, Greeley's former business partner, commissioned Ward to do the statue of Greeley for the Tribune Building.

Ward had the benefit of a death mask and photographs—and the memory of going into Greeley's office one day when the editor was reading his newspaper. Greeley turned his head upward at an angle without moving his body, his right hand resting on his right knee, grasping the newspaper, wrinkling it a bit. The tilt of Greeley's head, his lips slightly parted as if to speak, and his alert glance made Ward feel Greeley was genuinely interested in what the sculptor was about to say. It is that moment remembered that Ward sought to capture. How Ward models cloth and flesh conveys a naturalistic sense of texture to the portrait, and how he composes the forms of his subject give *Greeley* a vitality that is rare in public sculpture on such a grand scale.

When the sculpture was installed, it projected slightly from its niche in the south bay of the Tribune Building out onto the sidewalk, and in 1915 an ordinance required all obstructions in front of the building to be removed, which included the statue. Possible sites included Battery Park, but subway construction at the time made officials uneasy about placing a five-ton sculpture on the ground above. In May 1916 the Art Commission approved the move to its present location.

CONKLING—VISION BEFORE PROPHECY

In 1893 friends of Roscoe Conkling, U.S. congressman, 1859–63 and 1865–67, and U.S. senator, 1867–81, commissioned J.Q.A. Ward to make a bronze statue of the city's former Republican leader. Conkling was known for his dramatic oratory, and according to contemporary reports his widow wanted to see him portrayed delivering an oration in the Senate.

It helped not only that Ward remembered Conkling's oratory style, but that shortly before the election of 1880, which Garfield won as the Republicans' compromise candidate, Conkling gave a speech in New York City that had made a lasting impression on the sculptor. In the middle of his speech, he suddenly stopped. Standing with his left hand on his hip, his thumb tucked into his pocket, a gesture Ward has caught in his statue, as was his custom, Conkling extended his right hand in a prophetic gesture, as if to calm the waters, stepped forward, and spoke in a measured stage whisper, "The die is cast. Garfield will be elected." Whether Conkling had

a vision or a sudden burst of insight, or whether his skill and experience as an orator explains his dramatic behavior, for Ward that was "the real Conkling," the Conkling he would portray in bronze. The moment Ward selected is the moment of vision before prophecy—as Conkling begins to extend his right hand and just before he moves toward his audience.

For the portrait likeness, Lewis Sharp has shown, Ward relied on a bust of Conkling (in the New-York Historical Society) he had executed the year before, and for the figure he selected Alfred Conkling, a cousin who was built like the lean, handsome senator.

The friends of Conkling who commissioned Ward to make the statue requested the city of New York to place the statue at the northwest corner of Union Square Park, near the then intersection of Sixteenth Street and Broadway, where Conkling had collapsed of exhaustion during the great blizzard of 1888, on the night of March 12. He later died of the pneumonia that resulted. Wishing to reserve Union Square for other subjects, city officials approved a site at the southeast corner of Madison Square Park near Madison Avenue and Twenty-third Street.

Augustus Saint Gaudens

When David Glasgow Farragut, America's first admiral, died in 1870, a committee was formed to erect a monument to the Civil War hero. The committee decided to assign the commission either to the mature and well-known J.Q.A. Ward or to the promising young sculptor Augustus Saint Gaudens. Ward was busy with numerous and sizable projects, so he recommended to the committee that they offer the commission to Saint Gaudens.

Born in Ireland, Saint Gaudens was brought to New York City as an infant. He grew up in New York City, where he apprenticed to cameo carvers and studied art at the National Academy of Design before going to Paris to study at the Ecole des Beaux-Arts. While in Europe, he traveled also to Italy, where he gained new understanding of Renaissance sculpture, which he could study firsthand. The low relief of the images and text on the exedra of the Farragut Monument owe a debt to the *schiacciatto* (flattened-out relief) of Donatello, the famous Florentine sculptor of the Italian Renaissance, which particularly impressed the young American. And the figures of *Loyalty* (left) and *Courage* (right) there are inspired by the sculpture and frescoes of Michelangelo, as Kathryn Greenthal has most recently noted in her critical study of Saint Gaudens's sculpture.

A New Kind of Monument

Saint Gaudens collaborated with architect Stanford White on the Farragut Monument to produce a new kind of public monument, one in which sculpture and architecture are integrated into a single form. Instead of a statue with a pedestal, the Farragut Monument was designed as a memorial in which the portrait figure and the base were envisioned as a single entity. Furthermore, the monument was conceived within an appropriate urban landscape setting—a small park that provided the statue and its base an attractive backdrop. In the use of these devices, the Farragut Monument became a model for many other memorials that followed, such as Karl Theodore Bitter's Carl Schurz Monument at 116th Street and Morningside Drive.

The monument was originally placed near the northwest corner of Madison Square Park. The statue of Admiral Farragut faced Fifth Avenue and so was provided with the ample foliage and sky of the park as its backdrop, the reason Saint Gaudens and White selected the site. That location assured the monument a prominent place for the city's many parades down Fifth Avenue, and the statue of Admiral Farragut faced the memorial to General Worth directly across the avenue.

Not only did White and Saint Gaudens create an historical precinct honoring two of the nation's major military leaders, but they also united two of New York City's major monuments in a distinguished urban design.

In the 1930s, the Farragut Monument was moved to its present location at the north central end of the park, thereby destroying the architect's and the sculptor's design and depriving the monument of its appropriate backdrop.

Saint Gaudens's over-life-size bronze figure of Farragut, inspired in part by Donatello's standing figures of saints on the exterior of the church of Or San Michele in Florence, portrays the admiral in his sixties. Standing on the deck of his ship the *Hartford,* his head turned slightly to the left, he glances to the side, the technique employed by Houdon that American sculptors since the early nineteenth century had used to convey a sense of "life" to their portraits. Dressed in the uniform that Congress prescribed

The Farragut Monument, a major masterpiece of the nineteenth century, became a model for other public monuments. In this photograph of 1913, the monument is shown in its original location. Saint Gaudens's *Diana* is visible at the left atop the old Madison Square Garden northeast of Madison Square.

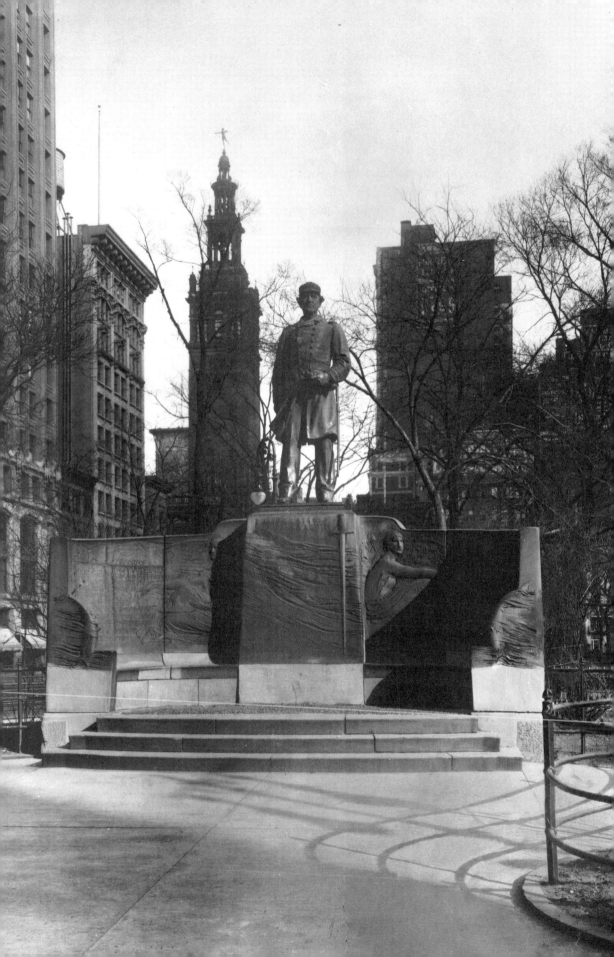

for the first admiral of the U.S. Navy, Farragut holds binoculars in his left hand close to his body, while his right leg is placed forward as the wind tosses the skirt of his double-breasted frock coat, a detail that further enlivens the figure. Naturalistic modeling of the head, clothing, and accessories help to animate Farragut's vital stance.

White's pedestal is a classical exedra—a semicircular base with bench above three stairs and surrounding it a floor of pebbles approximating a beach. In the center of the surrogate beach, a bronze crab contains the names of Saint Gaudens and White, their signatures on the monument. From the back of the monument, the exedra appears to be the bow of the *Hartford,* with Farragut silhouetted against the sky, as if surveying his fleet. Nautical motifs are disposed along its surface, enhancing the illusion of the ship.

Unveiled in 1881, at the beginning of an illustrious career, the Farragut Monument is recognized by scholars as one of Saint Gaudens's masterpieces. His other major work in a New York City park was executed by the master at the close of his life, the Sherman Monument.

The Sherman Monument

New York's most successful equestrian monument from the standpoint of conception, design, and technical execution is Augustus Saint Gaudens's monument to Civil War general William Tecumseh Sherman, at the southeast entrance to Central Park at Fifty-ninth Street across from the Plaza Hotel. It portrays Sherman on his famous march through Georgia, a turning point in this country's bloodiest fight. Symbolic elements celebrate this path of destiny, and the sculptor's new naturalism brings the subject to life.

Augustus Saint Gaudens portrays Civil War General Sherman appropriately facing south on his march to the sea.

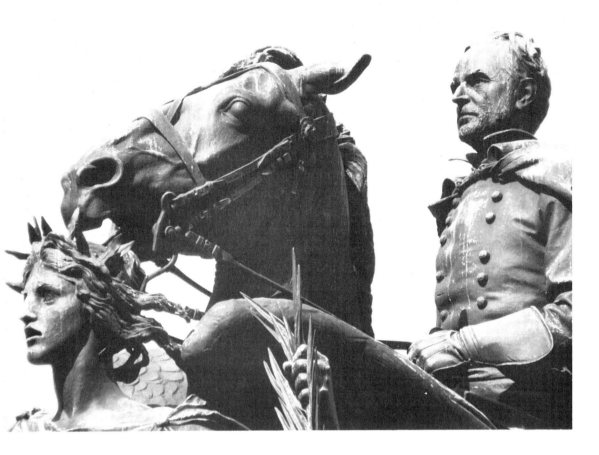

A triple portrait of Sherman, Ontario, and a composite of the sculptor's various models for *Victory*.

Nike-Eirene, winged figure of Victory, leads Sherman's spirited horse. She wears a crown of palm (in the first model she wore a crown of laurel, symbol of victory), carries a palm frond, and a branch is trampled under the horse's hoof—symbols of death. The bronze wreaths affixed to the base of the monument is a practice that goes back to early Roman monuments and recalls the custom of laying wreaths, still popular today. The horse's raised front leg symbolizes Sherman's victory. And the pedestal is shaped in the form of a sarcophagus placed on a ledge of convenient height for seating.

SAINT GAUDENS'S NATURALISM

Saint Gaudens gives the monument immediacy for spectators of all ages through his naturalism. His portrait of Sherman, for example, is a replication of the portrait bust Saint Gaudens modeled in 1888 when Sherman was visiting New York. For the figure of Sherman, Saint Gaudens selected a model of about the same build as the general and sat him on a barrel to capture the likeness of the man on horseback. Saint Gaudens used

several horses as models for Sherman's mount. For the elegant proportions and magnificent musculature his bronze horse has, Saint Gaudens relied on a famous jumper, Ontario, albeit retired and past his prime, but still a magnificent thoroughbred. He had the horse shipped to his studio, Aspet, in Cornish, New Hampshire (the studio was named for the town in the Pyrenees where his father came from). There the great animal could be placed in the landscape with trees around, one of the reasons the monument is so well sited with Central Park as a backdrop. So insistent on accuracy was Saint Gaudens that he enlisted Alexander Phimister Proctor, noted animal sculptor, to assist him in rendering the horse. Proctor is also represented in the city by a pair of proud pumas flanking the entrance to Prospect Park at Third Street in Brooklyn.

SCALE AND A FIGURE TYPE

Saint Gaudens was uncomfortable with the enormous equestrian statue commission. He therefore added another principal figure to the composition, *Victory,* a device revived in Europe by Rheinhold Begas, thereby reducing the individual figures closer to human scale while at the same time maintaining an overall colossal scale for the monument. That allowed him to create a sculpture group of lean and vigorous figures: a Winged Victory leading General Sherman astride his animated steed into battle.

Even though Saint Gaudens signed the contract on March 21, 1892, to do the monument, he changed his mind a number of times at critical points in the sculpture's development, leading to delays, according to the sculptor's biographers. The finished plaster model, for example, was completed in 1899 and exhibited at the Salon in Paris, where it received rave reviews, but he continued to make changes until it was finally cast in bronze.

For Nike, or Winged Victory, Saint Gaudens drew from several models, historians have noted. His original *Victory* was based largely upon his favorite model, Davida Clark, with whom he had a son. She had been the model for his famous *Amor Caritas.* However, the second version of *Victory,* and the one used for the monument, was a composite of several models. Although the figure retains the slender, willowy character of Clark, Saint Gaudens maintained that he used several models for the figure, probably including Julia ("Dudie") Baird, who also modeled for Saint Gaudens's *Diana* for Madison Square Garden and for A. A. Weinman's *Civic Fame,* atop the Municipal Building today. For Victory's head, Saint Gaudens relied on Elizabeth Cameron, a niece of Sherman, whose beauty had bewitched the great Rodin, and on Alice Butler, a young woman whom Saint Gaudens discovered in Windsor, Vermont. She was striking—tall and dark

with a classic nose and a short, curving upper lip that Saint Gaudens found irresistible.

Saint Gaudens slenderized and attenuated the features of his models, contributing to the grace of the monument. The wet-drapery effect Saint Gaudens employed in the clothing of the figures defines the details of the torso and limbs beneath and further enhances the sculptor's brand of naturalism. Saint Gaudens's technique was to model the nude figure in clay and then to drape the clay figure with lightly starched muslin or calico pinned at strategic points, as he explained it to his friend, the painter Abbot Thayer. He would shellac the surface to hold it securely in place. That model would then be cast in plaster to create the mold from which the bronze statue was made.

It is noteworthy that Saint Gaudens contributed appreciably to the creation of a female type that many artists emulated or copied. That type was based largely upon the artist's interpretation of the features of such models as Elizabeth Cameron, Alice Butler, and Davida Clark. The type is reminiscent of the Pre-Raphaelites' women, which were based to a large extent on Dante Gabriel Rossetti's wife, Elizabeth ("Lizzie") Siddal, and William Morris's wife, Jane Burden. *Victory* busts were cast by Tiffany's and sold for ninety dollars—one way Saint Gaudens's female type became widely known, Tharp has noted.

ART AND NATURE

Sherman's horse moves forward along a slightly inclined rocky plane at a spirited gait expressed by the raised front and back legs, leaving only two hooves on the ground, enhancing the sense of movement, a remarkable technical feat. The equestrian statue, by its nature, is made up of a horizontal mass and a vertical mass (horse and rider) held up by slender vertical supports, the horse's legs, and therefore always poses predictable but limiting and often difficult structural problems dictated by the composition of animal and rider. With two hooves off the ground, and the horse's head high, Saint Gaudens conveys a sense of brisk forward movement. His spontaneous modeling of details reinforces that sense of movement. The air catches the steed's mane and tail and Sherman's cape, and wind presses Nike's drapery in folds against her long, sinuous limbs as she leans forward into the wind. The press forward invites the spectator to view the group from the side as if it were marching by. The almost relieflike rendering is reminiscent of ancient narrative reliefs, which appealed to Saint Gaudens. Indeed, his relief portraits are among the most successful and engaging in all of Western art.

The inclined ground upon which Victory leads Sherman's animal is

carved of the same granite as the pedestal upon which it stands. The pedestal, designed by McKim, Mead, and White, is polished, however, and the rocky terrain is not—an added detail that is at once realistic and subtly transitional, unobtrusively uniting base and sculpture. The sarcophagus shape of the base unites it symbolically with the equestrian group.

A SITE REJECTED

McKim hoped the monument could be placed in front of Grant's Tomb, but Grant's family did not permit it, a controversy most recently reviewed by Wilkinson. McKim saw it as an important component to his development of the Upper West Side, of which Columbia University's Low Library was his acknowledged crowning achievement in 1897. The Hudson River to the west would have provided a historic association as well as a picturesque view for the monument. Other sites proposed were Times Square and the center of the Mall in Central Park. The site finally agreed upon was where it now stands.

THE GILDED SHERMAN

Until recently, the statue was dark, like many of Saint Gauden's earlier sculputres. When it was unveiled, however, on May 30, 1903, it was gold-leafed and shone brilliantly in the midday sun, as chroniclers of the event have noted. Although there were ancient precedents for gilded monuments erected by great Roman rulers, another reason Saint Gaudens wanted the monument gilded may have been to preserve it from the destructive pollution in the city's air. Since the advent of the Industrial Revolution in the eighteenth century, the world's atmosphere has become increasingly impregnated with its by-products, which corrode sculpture. Saint Gaudens was saddened by the poor condition of his Farragut Monument due to air pollution, along with neglect and vandalism. Gilding provides protection, and it is fortunate that in the early 1990s, largely through the generosity of a private benefactor, the Sherman Monument was regilded.

Saint Gaudens's Diana

Augustus Saint Gaudens left two of his major works in New York City parks and other examples of his sculpture in The Metropolitan Museum of Art in Manhattan, but only one of his sculptures graced the top of a building in the city—*Diana,* atop architect Stanford White's Madison Square Garden. Called *Diana of the Tower, Diana the Huntress,* and *Diana of the Crosswinds,* neither she nor White's building now stands.

Saint Gaudens's model for the head of Diana was a bust of Davida Clark he had modeled in 1886. Diana's body was produced from plaster casts made of Julia Baird. Baird was an elegant five feet six inches tall, with lithe Pre-Raphaelite proportions, who modeled for most of the best artists of the day, including Edwin A. Abbey, Kenyon Cox, Thomas W. Dewing, Edwin H. Blashfield, Robert Reid, and Edward Simmons.

The eighteen-foot-high gilded copper statue was installed in 1891, sixteen months after the Garden opened, on top of its graceful tower. Immediately Saint Gaudens and White realized the figure was too large for the tower, so they made a reduced version thirteen feet high, which was installed in November 1893. Standing on a base with ball bearings, *Diana* was a great weather vane, providing ever-changing views of her elegant proportions to passersby as she rotated, even at night—the first statue of its kind to be illuminated.

Diana's WHEREABOUTS

The first *Diana* was sent to Chicago, where it was placed on top of the Agriculture Building for the Columbian Exposition of 1893. Damaged by fire the following year, the piece was restored and formed part of a retrospective of Saint Gaudens's works in 1909 at the Chicago Art Institute, but it has since disappeared.

When Madison Square Garden was razed in 1925, the second *Diana* was put in storage in Brooklyn until 1932, when it was moved to the Philadelphia Museum of Art to form part of its permanent exhibition. A concrete version Saint Gaudens made for Stanford White's garden belongs to the Amon Carter Museum in Fort Worth, Texas, and it was recently restored by conservators Douglass Kwart and Jerry Jiritano.

Daniel Chester French

Although Daniel Chester French worked largely in stone, he had a formative influence on the historic portrait in bronze.

French regretted that he went to Florence to study rather than to Paris with the new wave of expatriates. In Florence he lived with Preston Powers, son of Hiram Powers, and he worked in the studio of the New England expatriate Thomas Ball, whose colossal bronze statue of Daniel Webster (erected 1876) stands in Central Park at the Seventy-second Street transverse west of Bethesda Fountain.

French's monuments in New York City include his tribute to architect

Richard Morris Hunt (1900) at Fifth Avenue and Seventy-first Street, directly across the street from the Frick Collection, *Alma Mater* (1903), in front of Low Library at Columbia University, the *Continents* on the façade of the U.S. Custom House across from Bowling Green (1907), and the personifications of Brooklyn and Manhattan from the entrance to the Manhattan Bridge, now flanking the entrance to the Brooklyn Museum (1913–16).

This group of monuments that French executed in New York City at the turn of the century are particularly significant, as D.C. French scholar Michael Richman has explained, in their expression of the Beaux-Arts principles embodied in the Columbian Exposition of 1893. *Alma Mater,* for example, was partly inspired by French's colossal figure of the Republic, a centerpiece at the exposition, and in all four of these commissions in New York City, French collaborated with leading architects to produce monumental masterpieces of civic architecture and sculpture.

The Lafayette Memorial

In the tradition of the historic portrait in bronze, however, French's Lafayette Memorial (1917) at the Ninth Street entrance to Prospect Park in Brooklyn merits special attention for its innovations in naturalism. The sculptor's pictorialism, his spontaneous modeling of a remarkably wide range of relief, and his collaboration with the architect in the illusionistic treatment of occupied space by which they so convincingly relate the monument to its site, create the conditions of a tableau vivant, those living pictures that bring a subject to life.

Lafayette's horse in high relief is riderless, and the marquis stands in front of his steed at the center of the composition, an almost freestanding figure. The horse is portrayed in profile standing still as Lafayette's valet, in low relief, holds the horse by the bridle. The animal's tail overlaps the trunk of the tree to the right of the composition, a pictorial device common in paintings to create the illusion of realistic space. The landscape background is rendered naturalistically in a Donatello-like *schiacciatto.* The combination of sculpture and pictorial devices in the composition at once brings the sculpture group of horse, rider, and valet forward in the parklike landscape and invites the spectator to step in. The great bronze relief is set within an elegant architectural frame, further enhancing its vision as a living picture. The relief is placed on a base and platform beneath a curved entablature and is flanked by classical pilasters, like an altarpiece, except that instead of an apse, Prospect Park is its niche. The architect was Henry Bacon, with whom French was at that time collaborating on the Lincoln Memorial in Washington, D.C. (1911–22).

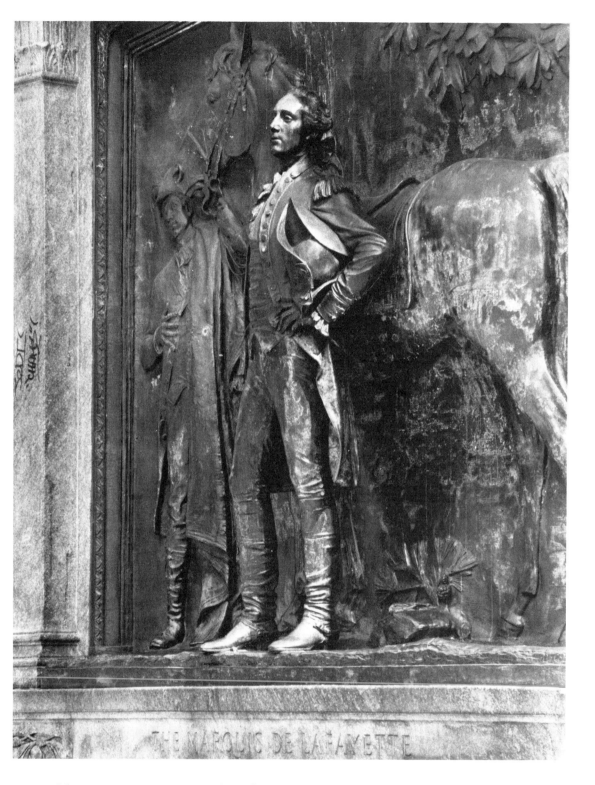

The monument to Marquis de Lafayette by D. C. French is a tour de force in uniting varying levels of relief at the Ninth Street entrance to Prospect Park in Brooklyn.

CHAPTER 6

American Masters of the Public Bronze II

The wave of Beaux-Arts sculptors that followed Augustus Saint Gaudens and Daniel Chester French developed the realism and idealism of the historic bronze portrait tradition in new directions of expression and monumentality.

Key selections in New York City of leading practitioners of the Beaux-Arts style illustrate how central to the historic portrait tradition remained the need well into the twentieth century to lionize the work and personalities of the nation's revolutionary heroes and Founding Fathers, and to create monuments to new heroes of war, civic leaders, and contemporary artists.

Frederick MacMonnies's versatility and facility in capturing a likeness, idealizing revolutionary and Civil War heroes, and creating great gateways is nowhere better represented than in New York City's parks.

William Ordway Partridge's responsive modeling and knack for creating an air or mien through believable gesture gives to the statues of his revolutionary heroes on the campus of Columbia University a blend of naive rapture and sophisticated insight rarely matched in American sculpture.

George Edwin Bissell, who came late to sculpture, consistently gives his historic figures appropriate comportment expressive of their position in society. He left significant pieces of sculpture in New York on its buildings, in its parks, and in its cemeteries.

Herbert Adams's ability to balance monumental architecture and his portraits without eclipsing the attitude or action expressive of the personal quality or emotion of his subject distinguished his best work, which is represented in Bryant Park.

Karl Bitter's early work in New York achieves a zenith in the traditional Beaux-Arts style. His mature work in the city looks anew to ancient Greece for inspiration in the face of the new European movements and their shift to nonobjective and abstract art.

The sculpture of Karl Bitter and Paul Manship overlap in both time and aspects of style, as the Beaux-Arts tradition comes to a close. With the advent of direct carving in sculpture before 1910, which establishes a preference for simplified forms, Manship's work is the principal link between the new art and the medium of bronze.

Frederick MacMonnies (1863–1937)

When Brooklyn-born Frederick MacMonnies was eighteen years old, he went to study with Saint Gaudens. Three years later, with the help of Saint Gaudens and architect Charles Follen McKim, MacMonnies went to Paris, where he studied at the Ecole des Beaux-Arts with Jean-Alexandre-Joseph Falguière (1831–1900), one of *Les Florentins,* a term used to describe a small group of romantic sculptors who turned their attention to Florence for their models. In his study of romantic bronzes, Jeremy Cooper has demonstrated how energetic modeling and animated composition distinguished their style from the restrained neoclassicism that had prevailed during the first half of the nineteenth century, and *Les Florentins'* spontaneity had a profound influence on the sculpture of MacMonnies. Then, after a brief period in Munich to study painting, MacMonnies returned to Paris to become an assistant of Falguière's.

It is noteworthy that Falguière took up painting in his mid-forties, which is curiously prophetic of MacMonnies's own rejection of sculpture for painting in his later years.

Early Commissions

In 1889 MacMonnies returned to New York to work on numerous projects with Saint Gaudens and while he was there was awarded one of his first major commissions through Stanford White, who had MacMonnies

produce three angels for St. Paul's Church in New York at Fifty-ninth Street and Ninth Avenue.

According to contemporary accounts, White designed the main altar and John LaFarge created murals and produced stained glass windows as part of an elaborate plan of the Paulist Fathers to create a repository of American religious art in New York City.

After the Paulist commission, MacMonnies then returned to Paris, where he worked on the angels and two other major commissions—the statues of Nathan Hale and James T. Stranahan (for Prospect Park). Mac-Monnies set up a studio and school in Giverny and remained in France until after World War I, when he returned to the United States to become a portrait painter, disillusioned with the avant-garde art of his time.

The Best Work

MacMonnies's best sculpture retains the animation and decorative quality of the French school exemplified in his *Bacchante* and *Infant Faun* (1893). The figure of Bacchante in the Metropolitan Museum of Art is a thinly veiled portrait of a French model, Wayne Craven has shown, which reflects MacMonnies's propensity for making even ideal pieces portraitlike.

Equestrian Lyricism

Early in Giverny, MacMonnies modeled an equestrian monument to General Henry Warner Slocum, a West Point graduate who distinguished himself at the Battle of Bull Run and Gettysburg. The monument stands near the entrance to Prospect Park in Brooklyn. One of Sherman's generals on the march to the sea, Slocum is portrayed on a high pedestal in uniform with sword (now missing) raised aloft as he commands his troops, and his horse appropriately displays the raised front leg, symbol of victory. Like Sherman's steed in Saint Gaudens's Central Park monument, Slocum's mount has two hooves off the ground, the tail extends behind, and the neck of the horse is tightly arched, all of which animates the sculpture and, combined with MacMonnies's spontaneous modeling, lends an air of lyricism to the composition.

Equestrian Gateway

MacMonnies's pair of *Horse Tamers* at the Park Circle entrance to Prospect Park on Ocean Parkway are remarkable not only for their sheer power, but also for the drama they provide to the entrance to the park. They were exhibited at the Pan-American Exposition in Buffalo in 1901 and in 1900 at the Paris Exposition. The *Brooklyn Eagle,* May 16, 1901, reported that the sculpture of a nude youth trying to tame two wild horses was concerned with interaction when "brute force is pitted against the mind of man." MacMonnies used two horses so he could connect them to allow the hind legs to come up off the ground. He turned the horses' heads to the side so that the whole composition reads as a solid mass. No light, therefore, shines through to dilute the force of the interaction. The base by Stanford White sets the group majestically above the pedestrian realm.

Nathan Hale Recalled

MacMonnies's statue of Nathan Hale, one of the nation's earliest martyrs, stands at Broadway and the edge of City Hall Park and reflects the nation's continued respect for its revolutionary heroes. It was erected by the Sons of the Revolution on the 110th anniversary of the British evacuation of New York City, called Evacuation Day. Stanford White designed the drumlike base in pink granite. He enlarged the Sons of the Revolution insignia in open relief so the bronze of the insignia and the pink granite of the base unite in the design.

Frederick MacMonnies chose to portray the twenty-year-old patriot at the moment before dawn on September 22, 1776, when Hale had just pronounced the words now famous: "I only regret that I have but one life to lose for my country." Historian Elizabeth McCaughey has recently noted that Hale borrowed the sentiment from English author Joseph Addison's *Cato,* a drama about the statesman of ancient Rome known for his honesty, incorruptibility, and devotion to the principles of the early republic. Hale stands on the gallows platform awaiting the hangman's noose. Ropes pin his arms to his body, a posture the French criticized when the plaster model for the statue was exhibited at the Salon in Paris in 1891. Critics of the new realism in sculpture also found fault with the literal representation of the ropes around Hale's arms and ankles.

Disguised as a Dutch schoolteacher, Nathan Hale infiltrated the British ranks to gather information about the British military installations on Long Island for General Washington. Discovered on the night of Septem-

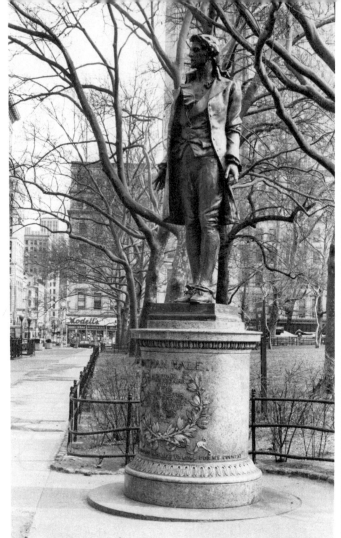
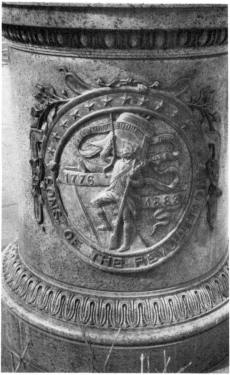

Frederick MacMonnies's bronze statue of Nathan Hale, which stands in City Hall Park near Broadway, was erected by the Sons of the Revolution on the 110th anniversary of the British evacuation of New York. Detail shows White's base.

ber 21, 1776, he was brought before General William Howe, commander in chief of the British army, at his headquarters at the Beekman mansion, approximately Fifty-first Street and First Avenue today. Hale was hanged for treason, without trial, the next morning, perhaps at a site near Sixty-third Street and First Avenue, even though a plaque marks the location at Forty-fourth Street and Vanderbilt Avenue, present home of the Yale Club. Hale had graduated from Yale College three years before he was hanged, and he was teaching school in Connecticut when the American Revolution broke out.

When MacMonnies's eight-foot-high bronze statue of Nathan Hale was unveiled in City Hall Park, not far from its present location, the

sculptor was enjoying international recognition for his magnificent fountain, the *Barge of State,* for the Columbian Exposition, the great world's fair in Chicago. He could not attend the unveiling of his Nathan Hale statue because he was in France, where he maintained his studio. It is noteworthy that another sculptor, William Ordway Partridge, commemorated Nathan Hale's sacrifice with a poem.

William Ordway Partridge (1861–1930)

Partridge was not only a sculptor and a poet, but also an author, critic, actor, and lecturer, and he graduated from Columbia University, where some of his most important monuments stand, two of which honor revolutionary heroes, Thomas Jefferson and Alexander Hamilton.

Patridge's Jefferson

Thomas Jefferson in front of the School of Journalism at Columbia on its Morningside Heights campus, illustrates the continuity of European realism in the twentieth century, and the statue shows how modern sculpture continued to celebrate revolutionary themes and to honor America's Founding Fathers.

The statue of Jefferson faces south with its pendant sculpture of Alexander Hamilton by the same sculptor across the campus in front of Hamilton Hall. The eight-and-one-half-foot-high standing bronze figure was erected with the bequest of Joseph Pulitzer and public subscription, and it was unveiled in 1914. Like many of the undergraduates today who pass by the statue, Jefferson first visited New York when he was twenty years old in 1763. Later, as first secretary of state, he took a small house in Maiden Lane when New York was the nation's capital.

SMALL VERSION

A statuette in the New-York Historical Society is a forerunner of the Columbia University monument. The small figure is sketchy. Its flickering surfaces show Partridge's spontaneous response to form, which characterizes his lively, fresh, and impressionistic style and his debt not only to the works of the modern master Rodin, but also to the works of Houdon, d'Angers, and Ceracchi, which he knew here as well as in Paris, Rome, and Florence, where he studied.

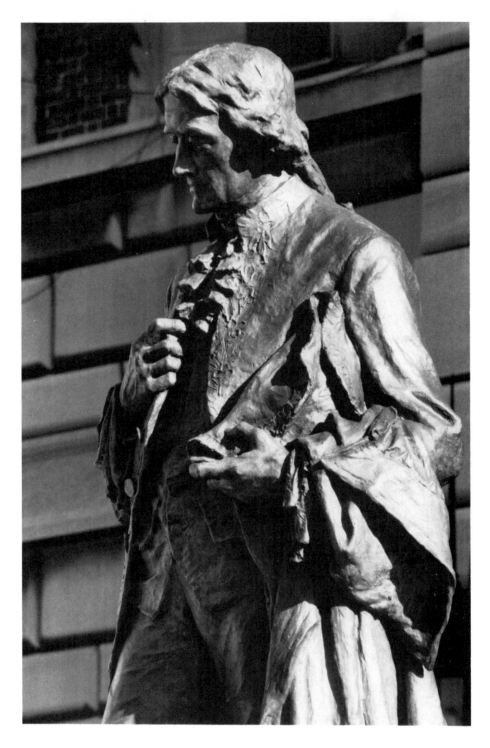

William Ordway Partridge's standing portrait of Thomas Jefferson in front of the School of Journalism at Columbia University, 116th Street and Broadway, is notable for its blend of the real and the ideal.

Partridge's Naturalism

Jefferson's stance is relaxed. He looks down reflectively—power and strength in repose. With a casual air, he holds his coat with the right hand, and he carries his cape over the left arm, his hat in the left hand. Jefferson's trousers cling to his thighs and reveal that he dresses himself on the left side—an observation rare in American sculpture (it was considered vulgar to be anatomically explicit).

Alexander Hamilton in New York

The bronze statue of Alexander Hamilton (1908) of heroic size stands on its pedestal in front of Hamilton Hall and faces Van Amringe Quadrangle. Partridge has represented Hamilton when he was thirty-one years old in the act of making his historic speech in the New York State Convention of 1788 in favor of New York's ratification of the federal Constitution. New York's ratification assured the Constitution's acceptance by the new government. The statue was unveiled in 1908. It became a rallying point in 1987 during the two-hundredth anniversary of the Constitution.

Hamilton's ties to Columbia go back to 1773, when he entered Kings College. And it was Dr. David Hosack, professor of medicine and botany at Columbia, who attended Hamilton when he was shot in the fatal duel with Aaron Burr on July 11, 1804.

AN EARLIER HAMILTON

An earlier statue by Partridge in 1889 shows an older Hamilton. It was exhibited at the Columbian Exposition in Chicago in 1893, then erected at the Crescent and Hamilton Club at Remsen and Clinton streets, Brooklyn. When the club was dissolved in 1936, the statue was donated to Hamilton Grange, Convent Avenue and 141st Street, Hamilton's home during the last years of his life. The statue was erected there by the Daughters of the American Revolution.

George Edwin Bissell (1839–1920)

George Edwin Bissell, who grew up in Connecticut, did not begin to make sculpture until he was in his thirties, when he started to work for his

father and brother in their stone business in Poughkeepsie, New York. Then in 1875 Bissell traveled to Europe to study the ancient art in Rome and the new developments in bronze being practiced in Paris. On his return to America the following year, he was successful in achieving a restrained portrait style reflecting the contemporary influence of the Beaux-Arts style in Paris and the naturalism of Roman portraiture.

Chester A. Arthur

Bissell's historical bronze portrait of Chester A. Arthur at the northeast corner of Madison Square Park presents the president in frock coat standing in front of his large armchair as if addressing a small group of people. Unveiled in 1899, the monument provides insight into both history and portraiture.

The statue stands between Augustus Saint Gaudens's portrait of Admiral David Glasgow Farragut, New York City's major Beaux-Arts monument of the nineteenth century, and J.Q.A. Ward's monument to Roscoe Conkling, one of Ward's major masterpieces. Bissell combines the solid naturalism he found in Roman portraiture with a fastidiousness in rendering detail that he observed in French decorative bronze casting into a portrait that captures not only a convincing likeness of his subject, but also the handsome and elegant Arthur's penchant for meticulous attention to his clothing and appearance. Anatomical inaccuracies in the figure of Arthur reveal Bissell's principal limitation.

James Brown Lord, architect, designed the base of dark granite, richly carved with classical embellishments. Egg and dart and bead and reel molding in bronze immaculately frame recessed panels that carry inscriptions in applied bronze letters.

AN IRONIC SITE

The location of Bissell's portrait of Arthur near Roscoe Conkling is symbolically significant and therefore historically instructive. An abolitionist, a supporter of civil rights, and an innovator in civil service reform, Chester A. Arthur was closely allied with Roscoe Conkling. Arthur served as collector of customs for the Port of New York from 1871 to 1878, but he was removed from the position by President Hayes in defiance of the Conkling machine. Then, to placate the Conkling group, Arthur was nominated for vice president on the ticket with James A. Garfield. On September 19, 1881, two and a half months after President Garfield was shot by the disgruntled office seeker Charles J. Guiteau, the president died, and his vice

president, Chester Alan Arthur, became the twenty-first president of the United States.

Portraits and Programs

Other portraits by Bissell in New York City demonstrate the high regard of influential patrons he enjoyed and acceptance by his peers in the prestigious National Sculpture Society. These commissions include the 1896 statue of Abraham de Peyster, mayor of New York, 1691–94, in Hanover Square (formerly in Bowling Green), and portraits in the New-York Historical Society and the Metropolitan Museum of Art of other members of the de Peyster family. In Trinity churchyard, Bissell's bronze statue of John Watts in the wig and robes of his office as the last royal recorder was exhibited in the Columbian Exposition of 1893, where it was acclaimed by contemporary critics. Watts's entire figure is concealed beneath his official robes, allowing Bissell to avoid anatomical pitfalls. He also collaborated in the sculpture program for the Appellate Court Building across the street from Madison Square Park, for which he did the figure *Lycurgus* (1900), and he executed the army and navy groups for the Dewey Arch in 1899. Bissell also did sculpture for the Pan-American Exposition in Buffalo and for the Louisiana Purchase Centennial in St. Louis. His debt to Renaissance masters is particularly evident in the composition of the seated figure of Abraham de Peyster, which is taken from Michelangelo's often-copied *Moses* in the Church of St. Peter in Chains in Rome.

Herbert Adams (1858–1945)

In 1911, the year the New York Public Library was completed on the site of the old Croton Reservoir, the Century Association erected just behind the library building a monument to honor one of their own— William Cullen Bryant (1794–1878), cultural leader and champion of the arts, who was one of the founders of the association.

How Bryant Is Remembered

Although Bryant practiced law in Massachusetts until 1825, when he came to New York, it is for his poetry, including "To a Waterfowl" and

Herbert Adams's figure of William Cullen Bryant remains a masterpiece of monumental portraiture.

"Thanatopsis," on nature and man's immortality, and his fifty years as editor of the *New York Evening Post* in support of such reforms as free trade and the abolition of slavery that he is remembered. America's first theorist in poetry, Bryant made his own translations of the *Iliad* and the *Odyssey,* which are still recognized as reflecting a rare sensitivity to the nuances of language. As a pioneer in American letters and as an early proponent for a "central park in the European tradition," it is fitting that Bryant is honored with a monument in a city park adjacent to a great library. It is also fitting that he is commemorated within the library building in *Kindred Spirits,* a painting by Asher B. Durand, which portrays Bryant with Thomas Cole, the father of the Hudson River school of American landscape painters, surveying the American landscape in the Catskills. The painting contributed to the crusade spearheaded by Bryant, among others, that led to the establishment of New York's Central Park.

The Monument by Adams and Hastings

The monument to William Cullen Bryant in Bryant Park behind the New York Public Library is composed of a bronze seated figure of the amply robed poet by sculptor Herbert Adams, set within a classical niche flanked by colossal urns and low balustrades, designed by Thomas Hastings of Carrère and Hastings, architects for the library. Hastings's elaborate marble design respects Adams's naturalistic and insightful portrait of Bryant, elevated on a two-tiered pedestal set within the niche, whose openings between the classical columns provide an interpenetration of form and space that allows attention to focus on the portrait.

The Bryant Monument is one of the city's rare examples of superior Beaux-Arts design and planning that remains intact. Approached by a broad, low stair with the library building as its backdrop, the monument achieves a quiet grandeur appropriate to the commemoration and to the site.

Herbert Adams was especially responsive to the naturalism of Augustus Saint Gaudens and the earlier master's genius for relating portrait to monument. The similarities between Adams's Bryant Memorial and Saint Gaudens's Peter Cooper Monument have been noted, especially in the handling of the portraits, the composition of the seated figures, and the relationship of figure to setting.

The Sculptor

Born in Concord, Vermont, Adams studied sculpture in Boston, then in 1885 went to Paris for five years, where he attended the Ecole des Beaux-Arts and studied with the highly acclaimed sculptor M.J.A. Mercié. When Adams returned to the United States, he taught at the newly established Pratt Institute in Brooklyn until the late 1890s, when commissions required more of his time.

Adams's wife, Adeline, was a respected author and critic. He exhibited his portrait of her at the Salon in Paris of 1888 and at the Columbian Exposition in Chicago in 1893. In *The Age of Enlightenment* for the Pan-American Exposition in Buffalo in 1901 and in the *Victory* for the Dewey Arch of 1899, Adams worked on a colossal scale, which prepared him for his monument to William Cullen Bryant, his crowning achievement in monumental portraiture. Adams's other works in New York City include a bust in the New York Public Library's Astor Hall of John Stewart Kennedy (chapter 21), president of the Lenox Library; bronze doors for St. Bartholomew's at Park Avenue and Fiftieth Street (chapter 18) and for the Judson Memorial Church in Greenwich Village, facing Washington Square from the south; statues for the Brooklyn Museum; and a memorial angel in the Emmanuel Baptist Church in Brooklyn.

Karl Bitter (1867–1915)

Karl Bitter's bronze doors for Trinity Church at Broadway and Wall Street remain one of New York City's most historically and aesthetically significant monuments and the sculptor's first major masterpiece from his early period (see chapter 19).

Bitter's mature art is well represented in New York City with his monument to Carl Schurz, unveiled in 1913 at 116th Street and Morningside Drive. The Schurz Monument provides a bridge between the past and the present—the Beaux-Arts style of the nineteenth century and the modern movements of the early twentieth century. Bitter's portrait statue of Schurz and the configuration of the monument are executed in the Beaux-Arts style, while his reliefs are based upon archaic Greek models in response to modern art's shift to primitivism and simplified form.

The Schurz Monument is historically significant in reflecting the continued need into the twentieth century of the nation's practice of honoring its civic leaders and heroes with public monuments in bronze and stone.

Carl Schurz Remembered

When Carl Schurz died in 1906, a committee was convened to select a sculptor to erect an appropriate monument to New York's foremost German-American leader in the fight for human rights. Karl Bitter was chosen to make the monument and select the site. After considering a location in front of the New York Public Library, Bitter decided on the present site.

The Carl Schurz Monument commemorates the activist in sculptural and architectural terms that express the dramatic character of his causes and the quality of his commitment to them.

Born in Germany, Carl Schurz came to the United States as a youth and immediately became an agitator for governmental reform. He was a Union general in the Civil War, an abolitionist, a champion of human rights, and a pioneer in recognizing and protecting civil liberties. As a statesman, politician, and German-American newspaper editor, he was a

The monument to Carl Schurz by Karl Bitter combines Beaux-Arts style with a new interest in the archaic Greek style.

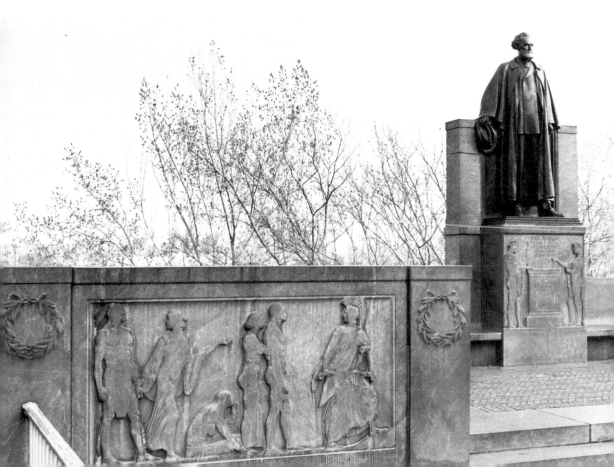

formidable voice for change. Schurz was U.S. senator from Missouri from
1869 to 1871 and helped to form the Liberal Republican party. In 1884
he led the mugwumps, the Republicans who rejected party nominee J. G.
Blaine to vote for Grover Cleveland, the Democratic nominee.

The Monument and Tradition

Bitter's bronze portrait statue, heroic in scale, portrays Schurz in a
pensive mood, his lank frame draped in a macfarlane, his favorite heavy
caped overcoat, whose deep folds almost hide the familiar felt hat he holds
in his right hand. Bitter's first design, with Schurz seated, gave way to the
present standing figure, which is more suitable to the image of the man the
sculptor wanted to honor and portray in the monument, "a master of
oratory," James Dennis has noted in his study of Karl Bitter's architectural
sculpture. For the head, Bitter relied on photographs, a death mask, and
his own memories of Schurz, whom he knew.

Schurz stands on a gray granite exedra, overlooking Morningside
Park. The panel beneath his statue salutes "Carl Schurz, a Defender of
Liberty, and a Friend of Human Rights." The combination of statue and
exedra was a design that had been pioneered in 1880 by Stanford White
and Augustus Saint Gaudens in their Farragut Monument in Madison
Square Park and was a model for many monuments to follow. The Schurz
Monument arrests the view eastward along 116th Street. A broad, open
stair echoes the curve of the exedra and winds down from the open plat-
form around cyclopean rough-faced blocks of the granite and schist founda-
tions into an Eden-like setting of the park below. From Morningside Park,
the monument appears to curve out—an enormous bay emphasizing the
sheer 175-foot drop from 116th Street to the trees and greenery of the park
below.

The Architect

Bitter was probably assisted in the design of the base and its setting
on the precarious site by Henry Bacon, the architect best known for the
Lincoln Memorial in Washington, D.C. Bacon's passion for Greek forms
and Bitter's respect for them, newly stimulated by a recent trip to Greece,
are evident not only in the exedra form of the base, but also in the carved

reliefs. Bitter wrote to his wife from Athens that he had seen some sixth-century B.C. stele reliefs that would be useful to his Carl Schurz Monument.

Service Commemorated

The low reliefs on the face of the exedra highlight Schurz's role in the cause of personal freedom. In the right panel, a lofty personification of Liberty, protected by the spirit of America (the American Eagle) guides a family of five, surrogates of the universal family of man, into the twentieth century. This panel salutes Schurz's relentless efforts in the defense of civil liberties.

An aggressive Liberty, in the left panel, looses the chains of slavery from the black man and the chains of ignorance from the American Indian. This panel pays tribute to Schurz's work as an abolitionist and to his service as a Union general during the Civil War. It also salutes his efforts as secretary of the interior to civilize the American Indian by providing him with education in the industrial arts and training in farming on reservations established for the Indians.

Once Bitter had modeled the reliefs, the Piccirilli's carved them for installation into the exedra. The Piccirillis were a family of stone-carvers from Massa, Italy, who helped revolutionize stone carving in America with their techniques that went back to ancient times.

Paul Manship (1885–1966)

Paul Manship's sculpture, which was indebted largely to the archaic art of the ancient world, was acclaimed in the same year that the Schurz Monument was unveiled (1913) when Manship exhibited his new work at the Architectural League of New York and at the National Academy of Design. That year the Metropolitan Museum of Art purchased Manship's *Centaur and Dryad* and then in 1918 commissioned him to do the J. P. Morgan Memorial relief for the museum's Great Hall. The relief was carved by Manship's studio assistant at the time, Gaston Lachaise (1920).

Ancient Art

From St. Paul, Minnesota, where he grew up, Manship traveled to New York and Philadelphia around 1905, when he began his studies with Solon Borglum, Isidore Konti, and Charles Grafly. He then studied in Rome at the American Academy and developed a passionate attachment to the ancient murals of Herculaneum and Pompeii, vase painting, and Roman bronzes. Like Karl Bitter, he rediscovered archaic Greek art with its linear geometric patterns, which replaced classical art as the modern artist's ancient models.

Manship borrowed smooth and round relieflike forms from Egyptian sphinxes and tomb art and from ancient Assyrian reliefs to create a vocabulary of simple and monumental shapes that made up his distinct brand of modern art. The bronze gates for the Bronx Zoo embody not only his figural style, but also his sense of design in the logic he makes of flora and fauna united in a single concept. The sinuosity of his line and the richness

Paul Manship's simplified style reflects the introduction of new standards of aesthetics.

of his geometric patterns captured the essence of ancient design and blended well with the modern preference for abstraction to gain him favor with patrons and critics and popularity with the public.

Commissions and Acclaim

In the mid-1930s, Manship was commissioned to do the colossal gilded figure *Prometheus* as the focal point of the sunken court at Rockefeller Center. An immediate success, the work has remained a favorite with New Yorkers, and it is one of the best-known pieces of sculpture in the world.

Even though Paul Manship did few portraits, the human figure, both colossal and diminutive, remained central to his art. Moreover, his distinctive interpretation of the figure influenced contemporary artists such as Elie Nadelman, whose twelve-foot-high geometric limestone figures of workers for the façade of the Fuller Building (1932) on Fifty-seventh Street at Madison Avenue reflect the ancient heritage of Manship's style.

End of an Era

Manship's popularity continued until World War II. A retrospective exhibition of his works at the National Institute of Arts and Letters in 1945 marked a fitting climax to a long and fruitful career and the end of an era.

As students of the period have noted, after the war figural art went from the outside of the building to the inside of the museum, and public sculpture would not reemerge with creative force until the 1960s. There is perhaps no better example of that shift indoors than the sculpture of Gaston Lachaise, whose exuberant female nudes, which celebrate sex as something respectable, require intimate space to understand them, as Daniel Robbins analyzed on the occasion of the Whitney Museum's bicentennial of American sculpture.

A comparison between Hiram Powers's *Greek Slave* in the Brooklyn Museum and Gaston Lachaise's *Standing Woman* in the Whitney Museum of American Art demonstrates that more connects the nineteenth and twentieth centuries than separates them.

CHAPTER 7

Little-Noted Historic Bronze Portraits on the Beaten Path

A selection of some not-so-well-known historic statues and busts exhibited prominently in our parks illustrates the rich variety of the city's sculpture collection.

Sir Walter Scott and Robert Burns

The seated portrait statues of Sir Walter Scott (1771–1832) and Robert Burns (1759–96) at the south end of the Mall in Central Park are by the Scottish sculptor Sir John Steell (1804–91), who was not only an accomplished wood-carver and sculptor, according to noted collector James Mackay, but also a pioneer in artistic bronze casting in Scotland, where he maintained his own foundry in Edinburgh, which served many late-nineteenth-century sculptors.

While the sculpture of Robert Burns is an original bronze statue made for Central Park in 1880, the statue of Scott, 1871, is a replica of the writer's portrait executed in marble by Steell for the Sir Walter Scott Monument of 1845 in Princes Street in Edinburgh, the first marble statue in Scotland commissioned from a native sculptor, which explains why the seated portraits look unnaturally elongated. In Edinburgh the statue of Scott is ele-

Robert Burns on the Mall, Central Park.
Detail: Burns's verse to his beloved Mary Campbell.

Sir Walter Scott on the Mall, Central Park.

vated on the monument, which requires the elongation of the figure if it is to appear naturally proportioned when seen from below. When the Burns statue was given to the city as a pendant to that of Scott, its composition had to match that of the earlier piece.

Both statues were gifts of Scottish residents of New York City to Central Park. The two writers were chosen to be honored with statues because they were innovators in English literature, and their work changed and enriched the genres in which they wrote.

Sir Walter Scott

Called to the bar in 1792, Walter Scott rarely practiced law. He was fascinated by the folk songs of his native land, which inspired his narrative poems *Lockinvar, The Lay of the Last Minstrel, Marmion,* and *The Lady of the Lake* and his later prose works *Waverly, Guy Mannering,* and *The Bride of Lammermoor,* which became enormously successful. *Ivanhoe* in 1820, the year he was made a baron, began the long series of historical novels of British history—*Kenilworth, Quentin Durwood,* and the *Talisman*—that popularized the romantic view of Scotland and England, which prevailed over the rest of the century and secured a lasting place for the historical novel in English literature.

Robert Burns

Among his best-known works, "Comin' thro' the Rye," "Tam o' Shanter," and "The Cotter's Saturday Night" are striking for their simplicity, humor, and spontaneity, hallmarks of Robert Burns's verse. Burns enriched English poetry by his use of dialect, which gave his work a freshness that enhanced the genuine emotion of his lines. In 1786, to finance his voyage to Jamaica with his companion, Mary Campbell, Burns published *Poems, Chiefly in the Scottish Dialect,* an immediate success.

A reference to Mary Campbell, his love who died young, not the Virgin Mary, is inscribed on the scroll that lies at the poet's feet in the Central Park monument—"To Mary in Heaven." Near the scroll is a plowshare, referring to his own unsuccessful attempt at farming and to his father, a farmer, who instilled in Robert a love of verse by reading both Scottish and English poetry aloud to the child.

Central Park's First Scottish Sculpture

Long before 1880, when John Steell's statue of Burns was erected along the Mall, Central Park already had a monument near today's Rumsey Playground, erected by the Scottish residents of the city of New York in respect for the genius of Robert Burns. Donated to the city in 1865 for the adornment of Central Park, the sculpture was a life-size group of Scotsmen singing "Auld Lang Syne," Burns's most famous poem. The group was carved by Robert Thompson, a Scottish carver who was one of the stonecutters in the execution of the artistic stonework of the terrace around Bethesda Fountain. Unfortunately, the stone in which the group was carved could not survive the pollutants in our atmosphere, and it disintegrated.

Henry Baerer's *Beethoven, Arion,* and *Payne*

The German-born sculptor Henry Baerer produced two monuments to Beethoven in New York City, one in Brooklyn and one in Manhattan, and a monument to John Howard Payne in Brooklyn. Baerer came to New York City as a teenager in 1854 and studied with Robert Launitz, whose style of idealized naturalism helped to shape Baerer's portrait style reflected in these busts.

Ludwig van Beethoven

To commemorate its twenty-fifth anniversary, July 22, 1884, the Beethoven Männerchor, a local German choral society, presented Baerer's monument to the city of New York, where it is erected in Central Park along the Mall. Baerer executed another bust of Beethoven ten years later for the United German Singers of the City of Brooklyn, which was erected in the Garden Terrace of Prospect Park. While the busts are similar, the earlier monument also has an under life-size bronze figure holding a lyre, a personification of the spirit of music.

Arion Hall

A substantial German population settled in the Bushwick-Ridgewood section of northern Brooklyn in the nineteenth century following the uprisings of 1848 and 1849 in their homeland. To support themselves, the immigrants established breweries, and to sustain their spirit they formed cultural groups, such as the Männerchor that once met and sang at Arion Hall.

Henry Baerer was favored by the German community that commissioned two monuments to Ludwig van Beethoven—one in Prospect Park, the other in Central Park. Both monuments feature a bust of the composer; the Central Park monument illustrated here includes a personification of the spirit of music at the base.

Brooklyn's old Arion Hall at 13 Arion Place still stands, but its bronze sculpture of the mythological figure of Arion by sculptor Alöis Loehr long ago disappeared.

Arion Hall, 13 Arion Place, between Bushwick Avenue and Broadway, 1887, originally had a figure of Arion by German sculptor Alöis Loehr. Musical symbols on the cornice of the building and the Arion Club's initials, unlike the lost statue of Arion, remain to recall those days when the Arion Männerchor met and sang at Arion Hall.

Born in Paderborn, Germany, in 1850, Loehr settled in New York in 1883. He did portrait-reliefs and busts and executed the monument to Fritz Reuter in Chicago.

POET AND PATRON

Arion as the patron for the singing group ties the German singing tradition to ancient times. More broadly, he provides a bridge between ancient and modern art. Herodotus wrote of Arion of Methymna, the world's greatest singer in the seventh century B.C., who on a voyage from Italy to Corinth was robbed by dishonest sailors and forced to jump into the sea. He sang one last song before jumping, and a dolphin, enchanted by his music, picked him up and carried him to safety. Arion made an offering in the temple of a small bronze statue of a man riding on the back of a dolphin, in commemoration of his miraculous rescue. Whether we accept Herodotus as the father of lies or the father of history—he has been called both—his themes of beauty and heroic struggle is expressed in the story of Arion and the dolphin, which has had a pervasive influence on architectural decoration from ancient times to the present. Elements of the motif are common in New York City's public buildings such as in the decorations of the New York Public Library, and in the city's open spaces, such as at Channel Gardens in Rockefeller Center.

Arion also provides the link between lyric and tragedy, the modes by which man's intense personal emotions are transformed through ritual into objects of beauty.

FROM LYRIC TO TRAGEDY

Arion was the inventor of the dithyramb, a spontaneous and impassioned hymn to Dionysus. The dithyramb was the beginning of the antiphonal choral lyric. The lyric in ancient Greece was a poem set to music or suitable to sing with the lyre; thus the name.

By the fifth century B.C., at the great Dionysian festivals the lyric form was adapted to a new dramatic form, the tragedy. The spontaneity and passion of the lyric was replaced by the struggle for survival that characterized the great tragedies, such as *Oedipus Rex* and *Medea.*

Through the ritual of the tragedy, as Aristotle has pointed out, spectators vicariously participate in the drama and thereby purge themselves of

their fears. Greek tragedy was broadened by the Romans, whose works were models for the Renaissance tragedies of Christopher Marlowe, prefiguring the tragic plays of Shakespeare in which the profound conflicts of human nature were explored in the lives of kings and conquerors. Then, in modern drama, Ibsen showed that the common man was also involved in the profound psychological struggle, and that he, too, was capable of heroic action and the search within continues among twentieth-century writers.

As long as man's response to beauty and the human struggle produces art, Arion will be a valid symbol of its ritual. Unfortunately, Loehr's bronze sculpture of Arion astride his enchanted dolphin is no longer atop Arion Hall to remind us of that timeless link between us and ancient art.

John Howard Payne

The German cultural and social societies in Brooklyn and Manhattan in the nineteenth century, were not the only ones who found that Henry Baerer expressed their sentiments. A group of New Yorkers commissioned him to produce a monument to a native son, John Howard Payne, in 1873. The bust was toppled by vandals and is in storage. Payne is best known for his ballad "Home Sweet Home," the only song he ever wrote. He composed it in collaboration with Henry Bishop, an English musician, for an operetta, *Clari,* which premiered at Covent Garden Theatre on May 8, 1823. Almost immediately everyone was singing the tune. It remains popular today, except with circuses, where it is never allowed to be played; if it is, circus people believe, an aerialist will plunge to his or her death, Douglas and Hazel Storer have noted in their study of the American dramatist.

AMERICA'S FIRST HAMLET

Ironically, Payne always wanted a home but never married and never had one. Born in New York City in 1791 at what is today 33 Pearl Street, the son of an itinerant schoolmaster, Payne was dragged from place to place in his early years, and he never outlived his restless legacy. While the family was in Boston, he was apprenticed at the age of fourteen in a countinghouse on South Street in New York City. He felt the separation from his family keenly. Soon, however, he found solace in "theatricals," which became an obsession with him and led him to found *The Thespian Mirror,* a periodical that he wrote, edited, and produced. Then he produced *Julia,* a comedy first performed on February 7, 1806, which was criticized as too risqué and

was stopped. Immediately Payne plunged totally into theatrical life. He acted, he wrote, he produced, and he toured the country from Boston to New Orleans. At eighteen he was the first American to play Hamlet, with Edgar Allan Poe's mother as Ophelia. By 1811 he was the best-known theater personality in America. Two years later he sailed for London and became an immediate success, with plays running simultaneously at Covent Garden and Drury Lane. Payne fell madly in love with Mary Shelley while he was in England, but she could not tolerate him.

YEARS OF WANDERING

Payne had no business sense, and his inability to manage his finances led to imprisonment in Fleet Street Prison. With the help of friends he escaped the prison, but never the problems that put him there. He fled to France and then returned to the United States. He sought satisfaction in the cause of the American Indians, who were being forced off their lands. Then, when John Tyler, a boyhood friend, was elected president of the United States, Payne renewed the friendship and was named American consul to Tunis, where he spent the last nine years of his life, in debt and mostly alone. When he died there on April 9, 1852, he was buried in a small graveyard near the harbor.

PAYNE HONORED

It was not until 1883, when William Corcoran, benevolent friend of artists and founder of his famous Corcoran Gallery, determined to bring Payne's body home, that anybody even thought of burying him at home. Corcoran felt it a shame that the man who gave the world the most popular song in the English language had never been properly honored.

Payne's remains were thus brought home. He lay in state for two days at City Hall in New York City, his home. Then he was taken to Oak Hill Cemetery in Washington, D.C., and given a state burial with full honors. President Chester A. Arthur, his full cabinet, and practically every dignitary in Washington attended the burial.

A stately monument over his vault bears a portrait bust by Alexander Doyle, who also did the seated portrait of Horace Greeley in New York City's Greeley Square.

Quinn's Edwin Booth

While Payne was the first American to play Hamlet, it was Edwin Booth who was immortalized in that role in sculpture by Edmond T.

Edwin Booth is commemorated in Gramercy Park with a statue of him as Hamlet by Edmond T. Quinn, erected in 1918.

Quinn, whose statue of Booth stands in Gramercy Park. America's foremost Shakespearean actor of the age stands in a relaxed contrapposto, his right hand still touching the armrest of the chair from which he has risen. His left palm presses gently against the nested "V" folds of his draped blouse, and he gazes down, his head turned slightly to the left, at the moment he is about to deliver Hamlet's most famous lines, "To be, or not to be . . ."

Older brother of John Wilkes Booth, Lincoln's assassin, Edwin is less famous, but his legacy is more influential. He was an innovator in a naturalistic and interpretive style of acting, which Quinn has captured in simple composition and reflective expression. Booth's personal life reflected the same sincerity, which helped to earn great respect for the acting profession. To give actors a better social position, Booth founded a club for them in 1888—the Players Club. His town house at 16 Gramercy Park became its headquarters.

In 1906 the Players Club decided to erect a monument in Gramercy

Park to its founder. It selected the country's leading sculptor, Augustus Saint Gaudens, but he died the following year. The highly gifted but controversial Frederick MacMonnies was the club's next choice, but his proposal was unacceptable to the Players, so a competition was held, which included entries by such well-known sculptors as J. Massey Rhind, John Flanagan, and James Earle Fraser. Ultimately Edmond T. Quinn was selected to do the monument, which was erected in 1918. Although a generation separates Quinn from Baerer, their work derives from a common source—the blend of classicism and naturalism that prevailed in America from the eighteenth to the twentieth centuries, which had its origins in European models. Baerer had come to New York as a teenager in 1854, where he studied sculpture with the Latvian-born Robert E. Launitz (1806–70). His busts reflect a tradition that combines naturalism with idealism, the hallmark of Launitz's style.

O'Connor's John Wolfe Ambrose

The portrait bust of John Wolfe Ambrose (1838–99) by Andrew O'Connor in Battery Park commemorates Ambrose's crowning achievement as a builder and developer—the construction of an entrance channel two thousand feet wide and forty feet deep, from the Narrows to the ocean, to accommodate larger vessels.

Ambrose, who came to New York as a child from Limerick, Ireland, where he was born, became one of the city's most enlightened builders and developers. At the request of the Women's Health Protective Association, for example, he proposed a bill to improve public sanitation that led to citywide improvements in street cleaning. He built the Second Avenue and the Sixth Avenue elevated roads, and he laid the first pneumatic tubes of the Western Union Telegraph Company. In the 1880s, Ambrose became involved in the development of Brooklyn's waterfront properties, and he soon recognized the limitations of New York's harbor to accommodate the larger ships of the future.

From 1881, when he began to lobby for enlarging New York's harbor, until 1899, when he finally secured the necessary appropriations, Ambrose encountered continued and obdurate resistance to his proposals. His refusal to be discouraged not only earned New York Harbor its channel, but also accounted for his successes in getting appropriations for the Bay Ridge and Red Hook channels, making them one thousand feet wide and forty feet deep. The deepened channel at Bay Ridge saved the

John Wolfe Ambrose, father of an entrance channel that would accommodate modern ships, is honored in Battery Park with a portrait by Andrew O'Connor.

waterfront there, according to authorities, which would otherwise have been useless for commerce.

The Pioneer Honored

On April 26, 1899, Ambrose was to be honored by New York's leading shipping and commercial interests at a dinner at the Waldorf-Astoria Hotel. Astutely, he declined to be the guest of honor, recalled his son-in-law, George Shrady, almost twenty years later. Instead, he said, the guest of honor should be Senator William P. Frye, chairman of the Committee on Commerce of the U.S. Senate, whose support of Ambrose's proposals was critical in its acceptance. But Ambrose received appropriate acclaim at the dinner. Theodore Roosevelt, former secretary of the navy and leader of the Rough Riders in Cuba the previous year, introduced Ambrose at the dinner as the man whose work made New York's the finest harbor in the world. Ambrose died a few weeks later and never saw his triumph realized.

A Fitting Memorial

To commemorate Ambrose, the group of businessmen who had organized the Frye banquet commissioned Andrew O'Connor, sculptor, to model his portrait bust, which they presented to his family. Then, in the session of 1901–2, Congress passed a bill naming the channel after him.

Ambrose's family then donated the bust O'Connor had executed to the city of New York, and Aymar Embury II, architect, designed the present monument incorporating O'Connor's bust in a niche with a panel beneath showing the Bay of New York and Ambrose Channel. The monument was installed in the New York Aquarium, the old Castle Clinton, overlooking the deep sea channel that bears his name. When the New York Aquarium was closed in the 1940s, the Ambrose Monument was removed to storage. During Battery Park's restoration in the 1950s, the monument was reinstalled in the new concessions building, once again facing the harbor and the Ambrose Channel.

The Sculptor

Other works by Andrew O'Connor include his relief in Siena marble of New York City's seal over the main entrance to the U.S. Custom House, facing Bowling Green, not far from the Ambrose Monument, and reliefs for St. Bartholomew's Church (chapter 18) on Park Avenue, which remain not only a treasured monument but also a masterpiece of American sculpture.

PART III

The Equestrian Monument

CHAPTER 8

Ancient and Renaissance Influences

The equestrian statue dates to antiquity. At different times in the history of art, it has served as a portrait symbol of authority and power, a funerary memorial, and a tribute to Christian virtues. As a monument portraying a great leader, the equestrian statue goes back to the Greeks and the Romans.

Marcus Aurelius—Ancient Model

The Roman leaders placed their equestrian statues on high podiums in public places to honor themselves and to serve as symbols of their authority. These statues were often gilded—that is, covered with gold leaf—so that they glistened in the sun. A figure of a bound captive was usually crouching beneath the horse's upraised front leg, symbolizing the leader's victory over his enemies and his power. In succeeding ages the crouching figure disappeared, but the horse's leg remained raised as a symbol of victory.

These equestrian monuments were common, and their images were frequently reproduced on Roman coins. As time passed, and governments and customs changed, the great equestrian monuments were melted down for their valuable bronze; consequently the statues became scarce. The only

one to survive from antiquity is the bronze statue of Marcus Aurelius of the second century A.D. in Rome. It survived because for centuries it was believed to be a statue of Constantine, the first ruler to accept Christianity, and as such was a highly revered monument.

Warrior and Philosopher

This lone survivor from ancient days has had widespread influence on the equestrian monuments of succeeding periods. Marcus Aurelius (A.D. 121–180) was a Roman emperor for the last twenty years of his life and a Stoic philosopher. Although a successful military ruler, he is best remembered for his philosophical *Meditations.* It is the combined role as ruler and philosopher some historians feel that is portrayed in the great equestrian monument that, until recently moved inside for restoration, stood in the Capitol in Rome (formerly in the Lateran but moved when Michelangelo incorporated it as the centerpiece for his innovative urban plan of the sixteenth century). That interpretation seems to be supported by the monument itself. The horse's raised front leg symbolizes power, and Marcus Aurelius' extended right arm symbolizes clemency, a humane gesture even if it is another aspect of imperial power. The portrayal of the emperor without weapons or armor and with arm extended in benevolence is seen to express the emperor's role as philosopher. Thus, imperial and humanistic notions are combined in the monument.

British and American Offspring

The *Marcus Aurelius* was the model for Joseph Wilton's monument to George III, which was toppled by the patriots from its pedestal in Bowling Green, and it was the model for Enrico Causici's lost monument to George Washington (see chapter 2), which once stood in City Hall Park. The monument to survive, however, and to pay tribute to its ancient model is the equestrian statue of George Washington in Union Square of 1856 by the American sculptor Henry Kirke Brown (1814–86).

Washington on Evacuation Day

Brown's statue shows Washington arriving in New York City in 1783, having driven the British occupying army from the city. The traditional

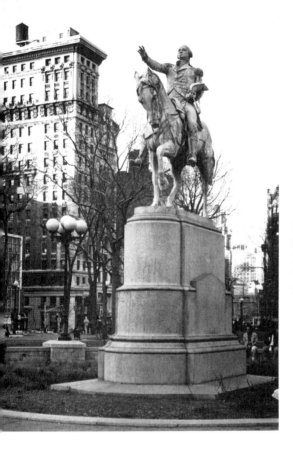

Henry Kirke Brown portrays the victorious George Washington on horseback as he returned to New York in 1783 following the defeat of the British.

symbol of victory—raised front leg of the horse—then, is appropriate, even if Brown did not fully understand the symbolism.

Unlike Marcus Aurelius, Washington wears his dress uniform, reinforcing the image of his military role and consistent with Washington's desires. For his figure of Washington, Brown retains Marcus Aurelius' gesture of the extended right arm—symbol of authority. Brown has been faithful in reproducing the ancient steed and successfully conveys its nobility to his equestrian monument. Washington reins in the animal, which expresses great power and energy by its dramatically arched neck. That action also checks the horse's gait, giving it a measured forward movement and great dignity. To preserve the clarity of this movement, Brown reversed the pose. While Marcus Aurelius has no uniform or stirrups, Washington wears a dress uniform, carries his three-cornered hat in his left hand, and sits on an elaborate saddle. The sculptor, therefore, raised the left front leg instead of the right to perhaps accommodate the abundance of detail.

The Commission

In 1851 a committee to select a sculptor for the monument invited Henry Kirke Brown and Horatio Greenough to submit models for the statue. Greenough was ill, his behavior erratic, and he alienated some of the subscribers, which left the commission to Henry Kirke Brown.

Brown was born in Leyden, Massachusetts, studied painting in Boston, and then spent four years in Italy studying sculpture. On his return to the United States, he set up a studio in Brooklyn. Brown emphasized the importance of developing indigenous themes and subject matter in order to render what has to do with one's own heritage. In addition to his *Washington,* his *Dying Tecumseh, Indian Boy, Aboriginal Hunter,* and *Indian and Panther* were popular examples of what he preached. The *Aboriginal Hunter* was produced in a series of twenty and distributed as a premium by the Art Union, one of the country's early organizations of artists, to generate membership and income.

Fine Arts Bronze

Brown was a pioneer in bronze casting in the fine arts, and he cast his early pieces himself. His Washington statue for Union Square (placed first on the triangle southeast of its present location) and his DeWitt Clinton statue for Greenwood Cemetery in Brooklyn were early forays into bronze casting in the fine arts in this country. Brown used the Ames Manufacturing Company of Chicopee, Massachusetts, a foundry that specialized in making guns and swords. Thus, casting a fourteen-foot-high equestrian statue was new for them. Brown had employed two French bronze workers whom he pressed into service, and together they produced the *George Washington* and the *DeWitt Clinton.* J.Q.A. Ward was Brown's apprentice, and Brown took him along to Chicopee for the casting. J.Q.A. Ward's name appears on the base of the bronze as Brown's assistant.

Renaissance Influence

Two famous equestrian monuments produced in bronze in the Renaissance were influenced by the *Marcus Aurelius* and in turn became major influences on later equestrian monuments, including some in New York City. The first reworking of the Roman type, which also influenced the second, is Donatello's equestrian monument of Gattamelata, 1445–50, in

the Piazza del Santo in Padua. The second is Andrea del Verrocchio's equestrian monument of Colleoni, c. 1483–88, in Campo SS. Giovanni e Paolo in Venice.

Donatello was commissioned by admirers of Gattamelata to commemorate the distinguished service of a great military leader. Donatello retained the proportions of the *Marcus Aurelius* between horse and rider and portrayed his subject erect yet relaxed in his saddle and bareheaded, so the portrait was complete. Appropriate balance between the real and the ideal is a persuasive technique in rendering believable the idea presented, the admiration here for the leader.

Verrocchio, on the other hand, was commissioned to do an equestrian monument for which the subject himself had left funds to erect. Reducing the size of the horse, Verrocchio makes Colleoni larger than life; he stands erect in the stirrups, his left shoulder thrown slightly forward, creating a torque that echoes the tension in the modeling of the horse. He gazes sternly beneath his helmet, over the projected left shoulder, into the distance.

New York Progeny

James Earle Fraser's monument to Theodore Roosevelt near Seventy-seventh Street and Central Park West in front of the American Museum of Natural History is a noteworthy blend of Donatello and Verrocchio. He borrows the posture for Roosevelt from Colleoni and from Donatello the enlarged scale of the steed and its more generalized modeling, and he introduces American subjects—the Indian and the black man. The gigantic triumphal arch of the museum's façade acts as an appropriate setting for the statue. Unfortunately, great banners now advertise the museum's exhibitions, inappropriately eclipsing the arch so that the architecture can no longer be seen. And without its proper frame, the colossal equestrian monument to Roosevelt cannot be seen properly, either. The familiar wreath adorns the granite base.

Beneath the figures of Lewis and Clark, Boone, and Audubon, standing above, Roosevelt is portrayed as hunter and explorer. Although Fraser executed this monument in 1939, Roosevelt's likeness is based upon the portrait bust Fraser had modeled in 1909–10. The statue pays fitting tribute to Roosevelt as an explorer and hunter and celebrates his greatest achievement—adding millions of acres of forests and mineral lands to the natural preserves, thereby reversing trends of disposing of public lands to private interests. Roosevelt's monument stands appropriately in front of the mu-

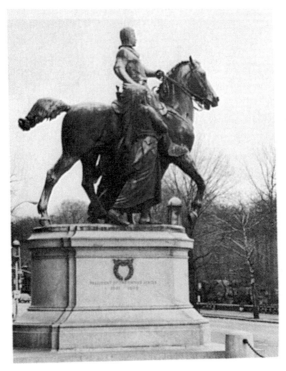

Theodore Roosevelt's lifelong interest in the wilderness and conservation of the land prompted James Earle Fraser's equestrian portrait of 1939 in front of the American Museum of Natural History.

seum of which he was so much a part and with which he is even today identified.

Hyatt's Joan of Arc

In *Joan of Arc* at Ninety-third Street and Riverside Drive, Anna Vaughn Hyatt (before she became the wife of Archer Huntington in 1923) draws on the Aurelian tradition and its reworking by Donatello and Verrocchio in the naturalism of the steed and the relationship between rider and horse. In the posture and military gesture of her subject, however, Hyatt also owes a debt to a medieval source of great fame and importance to the equestrian tradition—the equestrian monument to the Lord of Verona, *Can Grande della Scala,* erected in 1330. A friend and protector of Dante's, Can Grande wished his tomb monument, capped by this equestrian statue, to proclaim his absolute power. Unwittingly, he erected a monument whose influence extends to the twentieth century. Hyatt was also influenced by statues of the Maid of Orléans by Paul Dubois and Emmanuel Frémiet. One of Hyatt's nieces posed astride a barrel for the figure of Joan, and the Gloucester, Massachusetts, fire department (near Annisquam, where the Hyatts had a summer home) provided a horse.

Hyatt's *Joan of Arc* won international acclaim, and it was popular here

at home, too. The French government decorated Hyatt with the Purple Rosette for the statue, which was unveiled on December 6, 1915, at its present location. She had received an honorable mention for her model of the statue in the Salon of 1910 in Paris. Then, a replica of the monument was erected in Blois, France, in 1922, and she was made a Chevalier of the Legion of Honor. Architect John V. Van Pelt's pedestal with Gothic motifs provides an appropriately historical base for the sculpture.

SYMBOL OF VICTORY

Anna Hyatt's equestrian statue of Joan of Arc embodies the historical and symbolic meanings associated with Joan and her mission. The statue shows the heroine standing upright in her stirrups, clad in a man's armor and holding her sword heavenward as if entering her first battle.

In order to be historically accurate, Hyatt relied upon examples of fifteenth-century French armor in the collection of the Metropolitan Museum of Art. The weapon she places in Joan's hand represents the ancient sword the Maid of Orléans's voices guided her to retrieve behind the altar in St. Catherine's church at Fierbois. Joan's gaze is fixed on the cross of the hilt, symbol of her mission.

Joan of Arc routed the English along the Loire and at Patay, and in May 1429 she lifted the siege of Orléans, for which she was hailed the Maid of Orléans. Joan then persuaded Charles to march on Reims, where he was crowned king in Reims Cathedral with Joan standing by his side.

A MODERN RELIQUARY

To commemorate that event anew, stone from Reims Cathedral is enshrined in architect Van Pelt's pedestal. The pedestal also contains stone from the tower of Rouen, where Joan was imprisoned just before she was burned at the stake.

ICON TO VALUES

With the advent of World War I, Hyatt's *Joan of Arc* became a symbol of the close ties between France and America that had existed since the American Revolution and an icon to traditional values for which the Maid of Orléans had sacrificed her life. It is noteworthy that Joan's capture, which ended in her martyrdom, took place at Compiègne. Nearby, in the forest of Compiègne, the armistice was signed that ended World War I in 1918, just three years after Hyatt's *Joan of Arc* was unveiled on Riverside Drive. The French-German armistice was also signed there in 1940.

CHAPTER 9

The Equestrian Monument and Pan-Americanism

A group of three equestrian monuments marks the northernmost point of the Avenue of the Americas as a single tribute to Pan-Americanism. That movement toward commercial, social, economic, military, and political cooperation among the twenty-one republics of North, Central, and South America had its origins in Simón Bolívar's unsuccessful attempt to assemble a Pan-American Conference in 1826. Continued efforts throughout the nineteenth century to establish cooperation among the Americas culminated in the first of the Pan-American Conferences in 1889, held in Washington, D.C. Conferences and congresses continued into the present era and have produced notable achievements in international arbitration, codification of international law, the creation of agencies for research and practice in social welfare, and in scientific and technical fields. These achievements culminated in the establishment in 1948 of the Organization of American States (the OAS), an international body for hemispheric solidarity and economic development.

Unity of the Americas

The Avenue of the Americas, formerly Sixth Avenue, was named in 1945 and dedicated to Pan-Americanism by the late President Juan An-

tonio Ríos of Chile. The concept of the Avenue of the Americas grew out of the conviction that the unity of the Americas is essential to the welfare of this hemisphere, and the city of New York named a key thoroughfare to commemorate that principle.

To mark the thoroughfare appropriately, it was decided to place statues of the two main liberators of Hispanic America, José de San Martín and Simón Bolívar, at either end of the avenue, a southerly site for San Martín and a northerly site for Bolívar. At first San Martín was to be located at the east side of the Avenue of the Americas between Washington Place and West Fourth Street in a formal landscape setting, at the same time providing that area with a much needed neighborhood park.

Precedents and a Modern Movement

Eventually, however, it was decided that the two monuments should not be so far apart—in fact, that they should stand together. There were numerous artistic precedents for portraying the two liberators side by side. A monument to the two heroes in Guayaquil, Ecuador, perhaps the most illustrious example, shows them standing on a pedestal and a platform of four steps within an exedra decorated with bronze allegories and marble reliefs. The monument commemorates the historical meeting of the two patriots in that city on July 26, 1822. Bolívar had succeeded in liberating Venezuela, Colombia, and Ecuador from Spanish rule, and San Martín had freed Argentina, Chile, and Peru. Engravings and paintings of the period also show the two leaders together at that meeting after the two had crossed the Andes with their armies. Although details of that meeting were never revealed, from that moment Bolívar assumed command of the liberating armies of South America, and San Martín left the field to Bolívar to complete the task of achieving Hispanic America's freedom.

The Designer

Gilmore D. Clarke, engineer, landscape architect, and dean of the School of Architecture at Cornell University, was selected to design a formal terminus to the Avenue of the Americas composed of the statues of San Martín and Bolívar, each statue set in its own plaza, the two flanking the entrance to Central Park there. Clarke created plazas for the two equestrian monuments with their uniform statue bases set in granite pave-

ment of large basket-weave design and surrounded by granite benches. Between the two monuments stands a sixty-five-foot-high flagpole that arrests the view northward along the Avenue of the Americas and acts as a pivotal element around which the monuments and benches revolve, tying all the architectural and sculptural components together into an ensemble of stone, bronze, and nature. Wide granite stairways lead downward from the Plaza Bolívar to Central Park's walk system, which skirts the margin of the duck pond and leads to the Wollman Memorial Skating Rink, the zoo, and the other facilities in the park. Clarke's design provides a coherent flow of automobile and pedestrian traffic from the Avenue of the Americas and the sidewalks into and through the monumental plazas and through the park. His design makes the equestrian monuments appear as if they were planned for the site. While compatible, they were made at different times.

San Martín Replicated

The bronze equestrian statue of San Martín is a replica of a nineteenth-century statue by Louis Joseph Daunas that stands in front of the U.S. embassy and in the center of Plaza San Martín in Buenos Aires. Near that statue stands one of George Washington, a gift of the people of the United States to the people of Argentina. The placement of the two statues side by side is fitting because San Martín is known in Hispanic America as the George Washington of South America for his role in liberating his people from Spanish rule. The New York statue was given in reciprocation for the U.S. gift. An earlier replica of the Daunas *San Martín* stands in Judiciary Square in Washington, D.C., and was presented to the United States in the centennial year of San Martín's exile from his homeland. It was accepted on October 28, 1925, by President Coolidge. The Daunas bronze was always a revered image, and other replicas stand in Mendoza, Argentina, and in Santiago, Chile.

On October 19, 1949, the statue of San Martín was accepted by the city of New York from the city of Buenos Aires and placed in storage until the site at the northern terminus of the Avenue of the Americas could be prepared to receive it.

Bolívar Reinstalled

The statue of Simón Bolívar by Sally James Farnham that stood in Central Park at Eighty-third Street near Central Park West was selected to

occupy the site opposite *San Martín*. A gift of the Venezuelan government to the city of New York in 1921, the fifteen-foot-high bronze equestrian monument stood on a pink granite base high on a knoll in the park and was the third equestrian statue on that site ordered by the Venezuelan government and presented to the city. The first was removed because the Venezuelans considered it too ugly, and the second in 1897 was rejected by the National Sculpture Society. Sally Farnham's statue, completed in 1916, was the result of an international competition and was well received by the Venezuelans.

In moving Farnham's statue to its new location, Clarke landscaped the original site in Central Park, called Bolívar Hill, as a quiet and attractive sitting area for the people, mostly elderly, who enjoyed coming there to relax and enjoy the airy and picturesquely sited, secluded elevation overlooking the park. Meanwhile, the two liberators were united in a common site in the spring of 1951.

Harvey Wiley Corbett, one of the architects of Rockefeller Center, part visionary, part pragmatist, was president of the Avenue of the Americas Association on May 25, 1951, the day of the unveiling of the statue of San Martín. The ceremonies of presentation, which celebrated the relocation of the statue of Simón Bolívar, had been conducted in the facing plaza on April 19. Corbett was the featured speaker at the San Martín unveiling, and his message emphasized the freedom and unity of the Americas, which the two statues symbolized.

Fate of the Revolutionaries

José de San Martín was born February 25, 1778, at Yopeyn, educated at Madrid for a military career, and fought against Napoleon. Then, from 1817 to 1821, he raised, equipped, and led armies in Argentina, Chile, and Peru, which resulted in the emancipation of those territories. Following the meeting with Bolívar in Guayaquil, he withdrew and left the consolidation to Bolívar, San Martín's biographer, John Crane, relates. In 1824 he returned to Europe. Unable to go back to Spain because of his role in the South American liberation, San Martín lived in Belgium, then France, where he died in Boulogne on August 17, 1850. His remains were placed in a family mausoleum in France until 1880, when they were transferred to one erected to him in the cathedral of Buenos Aires. Bolívar had died in poverty and exile twenty years earlier.

Simón Bolívar was born in 1783 in Caracas, Venezuela, and was educated in Spain. He became a planter in Venezuela and was swept into

South America's battle for independence in 1811. Inspired in part by the French Revolution, he was eloquent and charismatic, and his writing helped to mobilize forces behind him. He sought to emancipate South America from Spanish rule and to weld the new continent into a single nation. Foundations for Pan-Americanism were established under Bolívar, but it was not until 1948 that the Organization of American States was formed, bringing about collaboration, territorial integrity, and independence for Hispanic America.

Brazil's Patriot Remembered

Four years after the installation of the monuments to San Martín and Bolívar at the tip of the Avenue of the Americas, a statue of José Bonifacio de Andrada e Silva was unveiled at the southeast corner of the Avenue of the Americas at Forty-second Street at the entrance to Bryant Park. Dedicated on April 22, 1955, the nine-foot-high bronze by sculptor José Ottavio Correia Lima stands on a two-thousand-square-foot plaza of fish-scale pattern in bluestone flagging and granite block. Andrada was honored as the patriarch of Brazil's independence from Portugal. He was compared to Benjamin Franklin and Patrick Henry because he, like they, fought with words. A professor of geology at the University of Coimbra and secretary of the Academy of Lisbon, Andrada was a scholar, scientist, and a statesman.

Martí of Cuba

Soon after the naming of the Avenue of the Americas, a group of Cuban citizens expressed a desire for a monument to their hero, José Martí, to be erected in Central Park. With the unveiling of the Bolívar and San Martín monuments, the desire was rekindled and gained enough support that Anna Hyatt Huntington's model of Martí, which she completed in 1958, was donated by her to the people of Cuba for presentation to the people of New York City. The Cuban government covered the cost of a granite pedestal, which was based on designs by Gilmore Clarke.

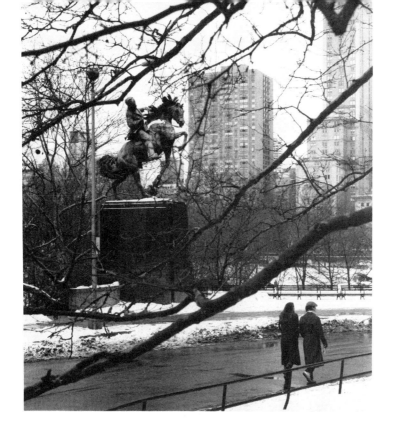

Revolutionary hero José Martí is honored at Central Park South and the Avenue of the Americas with an equestrian monument by Anna Hyatt Huntington, who portrays the "Apostle of Cuban Independence" at the Battle of Dos Rios, when he received the fatal wound.

The Patriot

José Martí was born in Havana in 1853. Exiled to Spain for his inflammatory ideas, he studied law there. Subsequently he taught at the University of Guatemala and then moved to New York as counsel for the governments of Argentina, Paraguay, and Uruguay. Although ambivalent in his feelings about the United States, his reports of the "Oklahoma Land Rush" and the "Dedication of the Statue of Liberty" reached their "highest poetic expression," according to José de Onis, linguist and reviewer of Martí's work in the United States.

As a poet Martí was considered a forerunner of the modernist movement in Spanish literature. In New York he became friendly with artists, writers, and political figures. He wrote for the *New York Sun* and South American publications, especially *La Nacion* in Buenos Aires, and was a principal spokesman for the Cuban revolution of 1895. He returned to Cuba that year and became a major general in the revolutionary army. He

was killed in action on May 19, 1895, in the Battle of Dos Rios in Oriente Province. It was in New York City that Martí participated in planning the liberation of Cuba from Spain and in organizing the Cuban Revolutionary party just three years before he returned to Cuba and was martyred. He left family in New York, and his grandson Cesar Romero became a successful actor.

The Monument

In immortalizing the "Apostle of Cuban Independence," Hyatt selects the moment Martí is shot and mortally wounded. His body recoils from the impact of the bullet, and he grasps his breast with his right hand. Martí spontaneously pulls back on the reins with his left hand, and the horse rears. The patriot's head turns. He looks down, his lips part in shock, echoed in the surprised expression in his horse's eyes. Hyatt's naturalistic modeling of each detail makes the spectator feel he or she is witnessing the actual event.

Dedication of the statue was to take place in spring of 1959, but demonstrations delayed the inauguration. Continued disturbances led to prolonged delays. Officials in Washington and New York decided to wait until the atmosphere cleared. At last the monument was dedicated on May 18, 1965, which brought a third equestrian monument dedicated to friendship among the Americas to the terminus of the Avenue of the Americas.

Unity Comes of Age

These three heroes of Hispanic-American independence have that in common. Moreover, the inclusion of Martí with the two founders of Latin-American independence was unwittingly prophetic. Born a generation or two after his predecessors had died, Martí bridged the nineteenth and twentieth centuries—not only chronologically, but also ideologically. Now, through Radio Martí, named for him and set up by the U.S. government in May 1985 to broadcast to Cuba, Martí's name is associated with the independence for which he gave his life. The principle that guided Martí's life is also the slogan of Radio Martí: "Only oppression should fear the full exercise of freedom."

CHAPTER 10

Equestrian Icons of War and Peace

Monument to Peace

In several equestrian monuments in New York City, the horse stands still or moves forward slowly, and in one striking example the horse and rider are frozen in time, like a giant icon—the *Monument to Peace,* in the gardens of the United Nations Assembly area. A gift to the United Nations from the People's Republic of Yugoslavia in 1954, it was executed by Antun Augustinčić, who was influenced by archaic Greek sculpture in this monument. The familiar raised front leg here has become part of a highly original, formalized composition and the original symbolism of victory subordinated to Augustinčić's design.

The outstretched left hand holds the olive branch, symbol of peace, and the right hand holds the globe, symbol of the world—a straightforward image to world peace. Augustinčić studied in Paris and at the Academy of Art in Zagreb. He was a student of Ivan Meštrović's, who was trained in Vienna and came to the United States in 1947, where he remained and had a profound influence on modern art in reviving the archaic tradition of ancient sculpture. His celebrated equestrians, such as the two of 1928 in Grant Park in Chicago, inspired this one at the United Nations. Augustinčić was one of the founders of Yugoslavia's pre-World War II group of naive painters called "the Earth" or "the Soil" and carried on his own

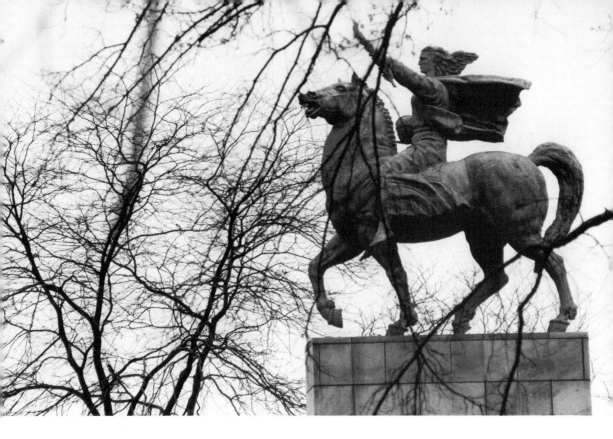

Monument to Peace by Antun Augustinčić was influenced by ancient Greek sculpture and stands in the United Nations Gardens, a 1954 gift from the people of Yugoslavia.

version of archaism embodied in this piece. *Monument to Peace* stands twenty-six feet high on its pedestal, which is faced with blocks of Yugoslavian rose-colored marble. The sculpture is cast bronze.

Augustinčić transforms the traditional equestrian pose of a horse walking forward with head up and foreleg raised into a relieflike hieratic pose. The mounted figure of Peace with cape flowing straight out behind can be read only in profile. The United Nations monument recalls the sculpture of Emile Antoine Bourdelle, student and assistant to Rodin, who sought like Maillol to revitalize the classical tradition, except that Augustinčić's work draws strongly on the archaic tradition of Greek sculpture.

Washington at Valley Forge

In Henry Merwin Shrady's 1906 *Washington at Valley Forge,* at the foot of the Williamsburg Bridge in Brooklyn, the horse is not only stand-

In *Washington at Valley Forge* at the foot of the Williamsburg Bridge in Brooklyn, sculptor Henry Merwin Shrady evokes the solemnity of the moment. A similar subject is illustrated in relief at the steps of Federal Hall on Wall and Broad streets.

ing still, but his head is bowed down and his tail falls between his hind legs. Washington is swathed in a cape whose vertical folds accent the pull of gravity. The vertical emphasis of the rider and the horizontal emphasis of the horse establish a stable composition. Set high on a pedestal, Washington looks down, contemplating his greatest moment of trial during the winter of 1777–78 at Valley Forge in Chester County, Pennsylvania, when his troops were totally bereft of hope. Through the sophisticated handling of composition, drapery, and portraiture, this self-taught artist has caught the power and simplicity of some of our strongest equestrian monuments in this sculpture.

Ulysses S. Grant

William Ordway Partridge's 1896 equestrian portrait of Ulysses S. Grant stands at rest above a high pedestal in Grant Square at Bedford

William Ordway Partridge's equestrian portrait of General Ulysses S. Grant standing in Grant Square at Bedford Avenue and Bergen Street looks across the street to Brooklyn's former Union League Headquarters, at a pair of relief portraits (*detail*) of Lincoln and Grant in the central spandrels of the facade.

Avenue and Bergen Street in Brooklyn. The horse's head is held high with nostrils flared and ears cupped forward to smell and hear. The horse's tail is extended behind. Grant's bulky figure and rumpled clothing convey a thoughtful and informal mood. Across the street is a pair of terra-cotta portraits in relief of Lincoln and Grant facing the equestrian monument, and two blocks to the north, on Bedford Avenue, J. Massey Rhind's relief of World War I doughboys with fixed bayonets charging into battle are shown in a plaque on the Twenty-third Regiment Armory, creating a commemorative corridor, recalling the sacrifices of the Civil War and World War I.

Franz Sigel Monument

Franz Sigel escaped from Germany after the unsuccessful revolution of 1848, came to the United States, and helped to rally the German popula-

tion in the north to the Union cause. He fought with distinction as a Union general in the American Civil War. After the war he published and edited German and German-English journals, and he took an active part in New York politics. Upon his death in August 1902, German-American communities in various cities throughout the country had monuments erected to him.

Sculptor Karl Bitter's reputation was at its peak at this time, and the monument committee formed to erect the Sigel Monument allowed the sculptor a free hand in selecting the site for the monument. Bitter chose to place his monument at the top of a wide flight of stairs descending from the end of West 106th Street to the sidewalk of Riverside Drive.

The Sigel Monument then arrests the view westward at 106th Street and bids us look with Sigel over the drive and park to the Hudson below.

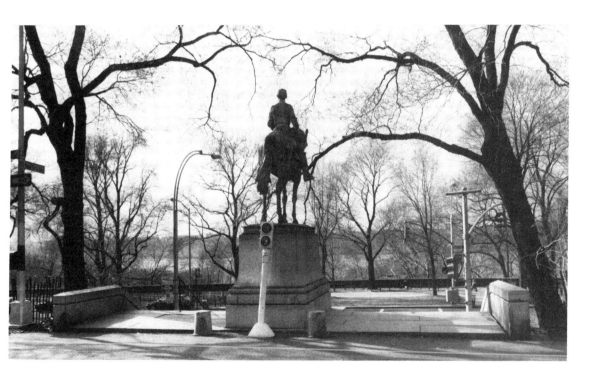

The Franz Sigel Monument at 106th Street and Riverside Drive arrests the view westward at 106th across Riverside to the Hudson River and with its placement atop the stairs down to the drive bridges the cityscape of apartments and Olmsted's ribbon of parkland.

With the other monuments along Riverside Drive, it relates the urban architecture of apartments to the landscape setting of the park across the drive. The monument is meant to be viewed from vehicles moving along Riverside Drive below and by pedestrians walking along the sidewalk or climbing the stairway. The ornate façades behind the monument create an elegant backdrop. The granite pedestal projects beyond the top step and rests on a rectangular block extended flush with the stair's riser below. So the pedestal seems to emerge from the stairs, converting the entire site into a surrounding exedra for the mounted Sigel. An accomplished horseman, Bitter was familiar with the subtle maneuvers of riding, and therefore his departure from anatomical accuracy was intentional. Sigel holds the reins of the horse correctly as the animal begins to move forward, but the horse's tail remains at rest, which is incompatible with this movement. By relaxing the horse's tail, however, there is just enough animation to complement the solid simplicity of the stairway and its grand architectural backdrop.

The "Polish King"

The great medieval knight holding crossed swords overhead while overlooking the little lake in Central Park just north of the Seventy-ninth Street transverse is popularly called the "Polish King." The statue is of Wladyslaw Jagiello, and it originally stood in front of the Polish pavilion at the 1939 world's fair in Flushing Meadow Park. After the fair it was placed in storage until 1945, when the Polish world sought a symbol.

As grand duke of Lithuania, Jagiello became Catholic to wed Jadwiga, queen of Christian Poland, and established a dynasty that reigned for almost two centuries. At Grünwald in 1410, Jagiello led the combined forces of Lithuania and Poland to victory over his longtime enemies, the Teutonic Knights of the Cross. Before the battle two messengers came to Jagiello, each bearing a sword, symbolic of Lithuania and Poland, as gifts from the grand master of the Teutonic Knights, with the grand master's taunt that Jagiello would need them. In a gesture of dramatic irony, Jagiello raised the two swords overhead and crossed them to show the union of his two forces and their protection under the Christian cross against the Teutonic Knights of the Cross. The gesture became an omen of his victory at the Battle of Grünwald, the turning point in Poland's history commemorated in this monument.

King Jagiello at the east end of Turtle Pond at Eighty-first Street in Central Park crosses two swords overhead just before the fateful Battle of Grünwald in 1410. The equestrian monument by Stanislaw Ostrowski first stood in front of the Polish pavilion at the 1939 world's fair.

A Gift to the City

In 1945, in a spirit reminiscent of that historic moment in 1410, the Polish government in exile donated this great statue to the city of New York as a memorial to Jagiello and his victory over the Teutonic aggressors. On behalf of Mayor Fiorello La Guardia, Newbold Morris, president of the city council, accepted the statue, noting that "long after Hitler's memory has been erased from the earth, the music of Chopin will be heard."

The composition, modeling, and scale of this medieval hero are suitable to the lush landscaped setting of Central Park near Belvedere Castle, the kind of terrain associated with chivalric legend. Jagiello wears a shirt of mail, a fish-scale mantle, and a long cape with the heraldic emblems of Poland (eagle) and Lithuania (horseman). Jagiello's own sword hangs at his left side, as if to underscore the symbolic meaning of the two swords he holds aloft.

Stanislaw Ostrowski

Jagiello's steed is animated. His hindquarters are lowered as if to spring forward, and his noble head is reined to the side to restrain him, as the king stands erect in his stirrups. The statue is by Polish sculptor Stanislaw Ostrowski (1879–1947), whose idea for the statue was inspired by the five hundredth anniversary of the Battle of Grünwald, according to historian Jadwiga Daniec. His portrait of the Polish king was based upon Jagiello's death mask.

Ostrowski studied at the School of Fine Arts in Krakow, then in Florence and Rome. He later lived in Paris, where Rodin's spontaneous naturalism had a formative influence on his early work. Ostrowski executed funerary monuments, medallions, and coins, but most of his work was in portraiture, both statuary and relief. His portraits continued throughout his career to reflect the broken, spontaneous modeling influenced by Rodin. Examples of his portraiture may be seen in the Kosciuszko Foundation in New York City at 15 East Sixty-fifth Street.

Animals and Fantasy

CHAPTER 11

Les Animaliers and the Romantic Bronze

Wild and domestic animals portrayed in vigorous and spontaneous action as appropriate subjects for painting and sculpture came with romanticism in the eighteenth and nineteenth centuries in England and France. Through European works of art exported to the United States and through American artists studying abroad, European ideas and techniques were incorporated into American nineteenth-century sculpture. One of the results was that a new genre became fashionable—animal bronzes. It caught on in America, where realism in sculpture was desirable. It was a happy coincidence for sculptor and patron alike that a realistic portrayal of animals, whether in their natural habitats or in zoos, was a respectable form of art.

The European Tradition

In the nineteenth century, Paris was the center of *les animaliers,* as the animal sculptors are called, and Antoine-Louis Barye (1796–1875) and Emmanuel Frémiet (1824–1910) were its most influential practitioners. The English eighteenth-century animal painter George Stubbs, with such paintings as *Lion Attacking a Horse,* the French nineteenth-century painter

Théodore Géricault, with such paintings as *Horse Frightened by Lightning,* and equally dramatic sculpture were especially formative influences on the *animaliers.*

Technical Innovations

The *animalier* modeled his animal in clay, then cast it in bronze, a process that retains the sculptor's spontaneous modeling. Revival of the lost-wax process in casting in the early nineteenth century made it possible to achieve a degree of naturalism, through accurate articulation of minute detail, unknown since the Renaissance. Another advantage in casting is that a number of reproductions can be made, called "editions." The process keeps the unit cost down, so animal sculpture became popular, and many of these bronzes found their way to America in private collections, into museums where the public became aware of them, and some were even erected in large size in public places. Auguste Cain's *The Tigress and Cubs* in front of the cafeteria in the zoo in Central Park, now in storage during the zoo's restoration, is one example. Cain was a student of Barye's and one of the most successful of *les animaliers* in France.

Erected in 1867, Cain's sculpture shows the tigress with a peacock in her mouth, about to feed her cubs and herself. The theme of survival is a common one, and the style reflects the modeling that is characteristic of these pieces. Both the sculptor's modeling and the foundry's casting are critical to success. The most successful sculptors, logically, had their own foundries. Barye had the best *cire perdue* founder of his time working for him. Then he set up his own foundry with some of the best artisans in Europe.

The Union of Art and Craft

Auguste Cain's father-in-law, Pierre Jules Mene, had a leading foundry, which produced Cain's works and which Cain took over when Mene died, as Jeremy Cooper surveyed in his *Romantic Bronzes.* This intimate connection between sculptor and founder determines the final product. The crispness of detail and the patina (the surface color) are among the essentials that depend on the foundry. Thus, the fluid surfaces and wide variations in tone that Barye produced to convey the sense of movement in his animals and that influenced his student Cain were different from the dark and pitted surfaces that a sculptor like Christophe Fratin produced in

his pieces to convey a different mood and effect. Fratin (1800/2–64) was a student of Géricault's and a contemporary of Barye's. An instructive comparison between Cain and Fratin can be made in Central Park. One of the first sculptures given to the park was Christophe Fratin's *Eagles and Prey.*

Fratin specialized in animal sculpture that portrayed predators menacing or devouring their prey. For example, in *Eagles and Prey,* erected in 1863, four years before Cain's *Tigress,* two eagles sink their talons into the flesh of a doomed mountain goat that is caught between two rocks. The appropriate mood of the sculpture, Fratin felt, was best expressed through a dark brown or black patina and a pitted texture to give his sculpture a kind of sinister strength compatible with the subject of his art. This shows how texture and color, produced in the foundry, is obviously critical in achieving the sculptor's desired effects. The manipulation of patina to create picturesque effects or to convey mood was essential to the sculpture. The success of the work depended upon the close collaboration of sculptor and foundry, a working relationship that has much in common with a growing segment of the art world today.

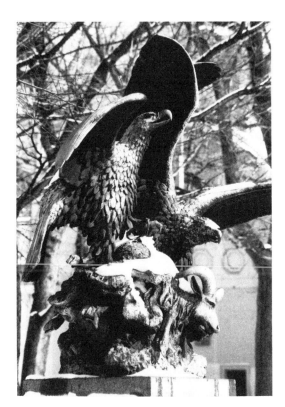

Christophe Fratin's *Eagles and Prey* portrays a theme common to romantic sculpture.

Origins of Fratin's Subject

Fratin's birds with prey are part of a very old tradition. They derive from the ancient roc, a bird of excessive size that carried its prey—an elephant—through the air. The reason the roc lifted the animal, according to Marco Polo's travel account (he claimed the bird's home was Madagascar) was to take him high enough to drop him, thereby killing the elephant, so he could then prey on his carcass. The roc and elephant came from the Indian bird garuda and the snake (the Indian word for snake is the same for elephant). Fratin's birds of prey in Central Park are about to carry the ill-fated goat aloft—once they get him free.

Truth to Nature—The American Preference

Realism was the most appealing characteristic to American sculptors and their patrons in the nineteenth century. To many American animal sculptors, realism was sought in both the setting and the accurate portrayal of naturalistic detail, which their public understood and wanted in the sculpture they bought or went to see. For that reason Frémiet's work was particularly meaningful. His influence, like that of Barye, was therefore widespread. Americans took to Frémiet's realism. His *Gorilla Dragging the Body of a Woman,* which won a medal in the Salon of 1859, is a good example. Even though he did not want to be considered only an *animalier,* it is the genre for which he is best remembered. In his meticulous attention to detail, Frémiet's equestrian groups of the 1860s and 1870s *The Gallic Horseman* in the Salon of 1863 and his *Joan of Arc,* unveiled in 1874 in the Place des Pyramides, illustrate the realism that appealed to America in the nineteenth century.

The American *Animaliers*

The successful American animal sculptors of the period combined different aspects of the French *animaliers* with their own brand of naturalism for a distinctive style. Some of the Americans were self-taught, others went to Europe to study. Selections from the work of seven animal sculptors who worked in New York in the nineteenth and twentieth centuries provide insight into the variety and nature of the *animalier* tradition in America.

Animalier *in Buckskin*

Edward Kemeys (1843–1907) was America's first great animal sculptor and perhaps the first native-born American sculptor to do exclusively animals. He added excitement to his reputation by giving lectures on his art while clad in the buckskin clothing of a frontier scout. Kemeys saw America's fauna as part of the nation's heritage that was being threatened by the advance of civilization.

IN THE NATURAL HABITAT

Kemeys went west to study American fauna in its native habitat, which gave his bronzes unprecedented credibility. He went to Paris in 1877 to study French sculpture, especially that of *les animaliers.* Although his *Bison and Wolves* was acclaimed in the Salon of 1878, the only *animalier* he liked was Barye, because for him Barye's sculpture was the most lifelike. Kemeys became convinced that the best way to work was from nature in the open spaces, not in zoos. The French *animaliers* worked from animals in zoos and from academic models. Animals in zoos were less physically fit, he observed. The flesh hung loose from the frame, and the musculature was flaccid. Besides, animals moved and reacted differently in captivity; they were sluggish. Barye alone, he felt, surmounted these limitations.

BEGINNINGS IN CENTRAL PARK

Born in Savannah, Georgia, Kemeys spent his early years in New York. He fought in the Civil War on the Union side. After the war he farmed briefly in Illinois, then back in New York he worked as a laborer felling trees in Central Park, where he spent much of his spare time studying the animals in the zoo. One day, seeing someone modeling a wolf's head, he was inspired to do the same, and he began modeling animals from life. Kemeys's aim was to catch a convincing likeness of animals as they looked and behaved in nature.

MAJOR WORKS

Kemeys's first major work won immediate acceptance. The *Hudson Bay Wolves,* two wolves fighting over the carcass of a fresh kill, of c. 1871, was purchased by the Fairmount Park Commission in Philadelphia and erected there in 1872. His output was prodigious. He claimed he made so many works that he could not count them.

Edward Kemeys's *Still Hunt,* 1883, crouches on a natural outcrop of Manhattan schist along the East Drive of Central Park.

STILL HUNT

Kemeys's *Still Hunt* of 1883 was installed by the city in Central Park at the East Drive at Seventy-sixth Street; it is one of the keenest conceptions in bronze the city possesses and one of its most effectively sited. It is a large American mountain lion crouched as if ready to spring upon its prey. The great cat is placed on a rugged outcropping of Manhattan schist above the park's East Drive. The natural setting enhances Kemeys's great cat modeled in the naturalistic style that appealed to the American public of his time and earned him success and popularity. The *Still Hunt* was exhibited in 1893 at the Columbian Exposition in Chicago, along with some of his other works, including *A Panther and Cubs,* which shows the mother cat licking and nursing her cubs, a composition resembling French sculptor Victor Peter's reclining group, *Lioness and Cubs,* at the entrance to the Prospect Park zoo (a gift of sculptor Frederick MacMonnies). The Metropolitan Museum of Art has Kemeys's *Panther and Cubs,* cast in bronze the year of his death, 1907, and the New-York Historical Society has a plaster version of *Still Hunt* in its collection.

The smoothly rubbed surfaces of Victor Peter's *Lioness and Cubs* in Prospect Park zoo shows that the sculpture has long been a favorite with children.

Edward Clark Potter (1857–1923)

The best-known jungle cats to mark a ceremonious entrance in New York are Edward Clark Potter's couchant lions, which flank the main entrance to the New York Public Library on Fifth Avenue at Forty-first Street. They are favorites of New Yorkers now, but critics attacked them for lacking in regal bearing when the lions were erected in 1911, until Daniel Chester French and Augustus Saint Gaudens came to the sculptor's defense in their praise of his sculpture. The pair of lions at the Morgan Library entrance is also by Potter. In addition to animals, Potter did ideal figures for some of New York's great public buildings—*Zoroaster* for New York's Appellate Court Building at Madison Avenue and Twenty-fifth Street, as well as personifications of Indian Philosophy and Indian Religion for the Brooklyn Institute. But Potter was best known among sculptors in his own day for his lions, horses, and oxen and for the work he did for better-known sculptors. For example, he did the horses and outriders for Daniel Chester French's great quadriga atop the grand colonnade for the Chicago Exposition, and he collaborated with French on the equestrian

One of Edward Clark Potter's couchant lions that flank the main entrance to the New York Public Library at Forty-first Street and Fifth Avenue, 1911.

statues of General Grant in Fairmount Park in Philadelphia and General Hooker for the state house grounds in Boston. Like other American sculptors, Potter studied in Paris with Mercié and with Frémiet, the foremost *animalier* there.

Eli Harvey (1860–1957)

One of the city's most impressive sculpture programs in which animal sculpture and ornamentation are blended is Eli Harvey's sculpture for the lion house in the Bronx Zoo at Pelham Parkway. Executed in 1901, the program was commissioned by the New York Zoological Society and consists of two great lions that flank the entrance, complemented by a panoply of sculptural relief and decoration. Unlike Kemeys and Potter, Harvey, who came to New York from Ohio, found his models in the zoos in New York and then in Paris, where he lived for twelve years and where he studied with Frémiet at the Jardin des Plantes (Botanical Garden). In his day he was considered after Kemeys to be America's leading *animalier,* and he won medals for his animal sculpture in the world's fairs so popular

in the early decades of this century. Harvey blended observation with the nonobjective principles of decoration, which gave him wide latitude. The great gorilla at the New York Zoological Society, inspired no doubt by Frémiet's famous gorilla, is an example of the power of his style.

F.G.R. Roth (1872–1944)

Frederick George Richard Roth also found his models in zoos. Born in Brooklyn, he studied at the fine arts academies in Vienna, Austria, and Berlin. His academic training, which emphasized a blend of observation and idealization, combined with his ability to render the observed world of animals naturalistically produced a body of work that embraces fantasy, idealization, and a faithful rendering of nature. These components are never in equal balance, therefore his work is quite varied. For example, his granite sculpture *Mother Goose* in Central Park is a blend of nature and fantasy, appropriately suited to the subject, while his bronze statue *Balto* (the Eskimo dog) is naturalistically rendered, appropriate for an actual hero.

MOTHER GOOSE

Mother Goose (1938) stands at the entrance to the Mary Harriman Rumsey Playground on the site of the old Central Park Casino near the East Drive off Seventy-second Street. Roth shows Mother Goose flying on the back of her goose, and beneath her are nursery rhyme characters in all manner of poses so that each one emerges magically as the spectator moves around the figure. Youngsters, for whom the sculpture was carved, may actually touch Little Jack Horner eating his Christmas pie, Humpty Dumpty, Old King Cole, Mother Hubbard with her hungry dog, and Little Bo Peep with her lost sheep.

BALTO

One of the city's most popular animal sculptures is *Balto,* just off the East Drive on a grassy knoll in Central Park parallel to Sixty-sixth Street. It is a monument to the courageous spirit of a great Alaskan sled dog and his crew.

In 1925 Nome, Alaska, was stricken by the "Black Death" of the northland—diphtheria—without antitoxin to combat the disease. One doctor, Curtis Welch of the U.S. Public Health Service, assisted by a few nurses, provided the total medical services available to eleven thousand people in a territory stretching one thousand miles to the east and as far north as the Arctic Ocean.

Diphtheria was sure death to the natives of the region. If it got a good

Balto by F.G.R. Roth stands just off the East Drive on a grassy knoll in Central Park near Sixty-sixth Street.

start, the entire population would be threatened. Little wonder that a prayer of thanksgiving went up from the town when on February 2, less than a week after a radio message was sent for help, a twenty-pound package of 300,000 units of antitoxin serum arrived at Nome. When the circumstances under which the serum got to Nome from the railhead at Nenana 655 miles away became known, the story added another epic to the tales of the Yukon.

The only means of transportation available to carry the serum was by dog team. These Alaskan teams were made up of huskies—that is, a mix of malamutes, Samoyeds, and other breeds—and were driven in relays by sturdy men of the woods, called "mushers," from their famous call, "Mush, you huskies, mush!" The word "mush" derives from the French *moucher,* "to fly," which became applied on the northern frontier to traveling by dogsled—no doubt, like flying compared to walking.

The mushers and huskies made history in 1925 when they received word of the emergency in Nome and made the run from Nenana in five and a half days, three and a half days less than the record. This new record was remarkable because of severe blizzard conditions encountered on the last leg of the relay—from Bluff to Nome—when eighty-mile-an-hour winds and temperatures dropping to fifty degrees below zero threatened the lives of musher Gunnar Kasson and his huskies, led by the black malamute Balto.

Messages radioed ahead to Salomon and Port Safety ordered Kasson to wait until the storm subsided, but so dense was the driven snow that Kasson did not even see the two stations and passed them by in the blizzard. Kasson, for twenty-one years a musher on the Alaskan trails, called that run from Bluff to Nome the toughest he had ever driven—and he had been mushing since 1903. He displayed a characteristic musher's respect for his

dogs when he credited Balto, his lead dog, with bringing the team through. At least one observer has noted, however, that the names of the mushers who relayed the serum from Nenana to Nome read like a roster of the gallant races who won the vast Yukon territory from the North: Leonard Sepalla, Gunnar Kasson, Titus Nicolai, "Eskimo Pete," "Musher Olsen," John Folger, Jim Kalland, Tom Green, and Bill Shannon.

The over-life-size bronze statue of Balto in Central Park shows him on the trail, panting, with brace hanging behind and looking straight ahead. A bas-relief panel installed in the natural boulder outcropping on which Balto stands shows the seven sled dogs on the historic run from Bluff to Nome. The monument was presented to the city of New York in 1925 by the Balto Memorial Commission.

OTHER WORKS

Roth was chief sculptor of the Department of Parks in New York City under the Works Progress Administration (WPA). Two other works in Central Park by Roth, which represent his body of whimsical sculpture, are *Honey Bear* and *Dancing Goat.* Many examples of his whimsy were cast by Roman Bronze Works, such as *Performing Bear, Performing Elephant, Pig Tied to a Stake,* and *Pig Scratching,* examples of which are in the Metropolitan Museum of Art. Roth came to prominence in the Pan-American Exposition of 1901 with a Roman chariot portraying four horses pulling a chariot in a spectacular *tour de force* of engineering skill in which the chariot had the appearance of flying through the air. Roth did other groups for the early-twentieth-century expositions, for which he received wide acclaim.

Alexander Phimister Proctor (1862–1950)

An encyclopedic array of animal reliefs and heads inform the visitor to the zoo in Prospect Park of the wide range of animals found in North America as well as in Rudyard Kipling's *Jungle Books,* popular in the 1930s when Aymar Embury II, architect, commissioned Alexander Phimister Proctor to do these sculptures as part of the U.S. government's WPA projects. Animal sculpture performed utilitarian roles, too. Coloristically and architecturally noteworthy is the Guastavino blue tile dome of the octagonal central pavilion, a fitting backdrop to the architecture and the sculpture.

This commission is somewhat reminiscent of Proctor's animal sculpture for the Columbian Exposition in Chicago of 1893, which launched him

Alexander Phimister Proctor's elephant head keystones survey Prospect Park zoo's walkway.

as an *animalier.* From 1891 to 1893 he produced almost forty models of animals of the American wilderness for the exposition—moose, elk, mountain lion, and polar bear.

FORMATIVE YEARS IN THE WEST

Born in Canada, Proctor grew up in Denver, Colorado, in the frontier days when Denver was occupied by Indians and mountain men—the tough, self-reliant trappers, traders, prospectors, and hunters who have been lionized by writers and artists. Proctor loved the outdoors and its wildlife. With friends, he hiked and hunted around his home and, like other artists of the period who discovered the dramatic beauty of the West, went on trips to sketch the Yosemite Valley in the Sierra Nevada in central California. The images of unsullied mountain ranges, many forms of wildlife, and the Indians and mountain men stayed with him when he went east to New York in 1888 to study at the Art Students League and the National Academy of Design. For the rest of his life he drew on the memories of those experiences for his sculpture.

STUDY IN EUROPE AND AMERICA

Proctor won a medal for his animals in the Columbian Exposition and soon after went to Paris, where he studied in the ateliers of Denys Pierre Puech and Jean Antoine Injalbert. On a second trip to Paris, he worked in the Académie Julian and the Académie Colarossi.

On his return to the United States, he assisted Augustus Saint Gaudens on the models for the horses for Saint Gaudens's Sherman Monument in Central Park and the General Logan Monument in Grant Park in Chicago. James Earle Fraser also assisted on the Sherman Monument.

POPULARITY AND SUCCESS

Proctor's animal sculpture and his wild West themes grew in popularity both in the United States and in Europe, and many were cast in Paris and New York. Through their common interest in the American wilderness, Proctor and Theodore Roosevelt became good friends, and Proctor's *Charging Panther* was what the president's cabinet gave him in farewell on leaving office. A drawing of the sculpture was later used as the frontispiece for one of Roosevelt's books, and years later Proctor made an equestrian statue of Roosevelt as a Rough Rider for the city of Portland, Oregon. Proctor is represented in the Metropolitan Museum of Art's collection with a fawn, buffaloes, Morgan stallion, and one of his most popular pieces, *The Buckaroo,* a cowboy on a bucking pony, cast by the Roman Bronze Works in New York City in 1915.

PROSPECT PARK'S PUMAS

Proctor's two colossal bronze pumas flank the Third Street entrance into Prospect Park. They compose toward the center—that is, their postures are mirror images creating a symmetry suitable for framing an entranceway. Heads held high, tails gracefully arched, their proud stance lends authority and grandeur to the entrance. Architect Stanford White's high granite pedestal of broad, plain panels framed by simple torus molding enhances the elegance of these regal felines.

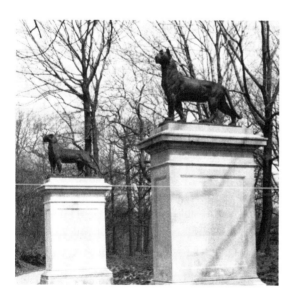

Proctor's bronze pumas flank Prospect Park's Third Street entrance.

Carl Akeley's Art, Science, and Invention

One of America's most accomplished animal sculptors, Carl Akeley (1864–1926) was first an explorer, conservationist, inventor, and the father of modern taxidermy. Three of Akeley's numerous inventions were a panoramic camera called the "Akeley" (negatives still exist in the archives of the American Museum of Natural History), a camera fitted with a telescopic lens that he called the "Gorilla," and a motion-picture camera.

AKELEY'S DISSATISFACTION

It was, in fact, his dedication to science that led Akeley to become a sculptor. Working at the Field Museum in Chicago, Akeley was dissatisfied with the exhibitions of the animal groups because they were not at all convincing. They did not look lifelike, he felt. Until Akeley came to taxidermy, it was nothing more than an upholsterers' craft, as Dorothy Greene has related in her review of Akeley's methods. A poorly tanned skin was stuffed with rags, straw, or sawdust and propped up with uncertain supports.

THE AKELEY METHOD

Akeley believed that through an accurate anatomical construction, along with realistic gestures, composition, scale, and textures, the visual as well as the psychological aspects of the animals within their native habitats could be replicated. To build realistically convincing museum groups, Akeley learned how to make a bronze sculpture, then adapted the method to his needs. It is now called the Akeley method:

1. He modeled the animal in clay, using the animal's skeleton as a sculptor would use an armature in making a statue.

2. From this clay model he made a plaster mold. (The plaster mold is cut open in the illustration to show each step of Akeley's process.)

3. He covered the inside surface of the mold with water-soluble glue and a layer of muslin.

4. Papier-mâché and a kind of wire cloth were worked into the mold, up to approximately an eighth of an inch thick.

5. The plaster mold was immersed in water, allowing the glue to dissolve, thereby freeing the papier-mâché sections; these sections were then assembled like a mannequin.

6. The carefully tanned skin of the animal fit over the modeled flesh and muscles (the mannequin) as perfectly as it fit over them in the flesh.

7. The finished work was then placed into the habitat, a permanent piece as well as one that was scientifically accurate and startlingly lifelike.

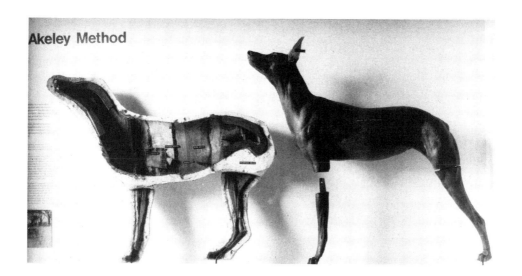

Akeley Method

The Akeley method.

Detail.

TAXIDERMY AND ART

Even though Akeley had created works of art through his system, he realized that if taxidermy were to be recognized as an art, the taxidermist would first have to be recognized as an artist. He therefore modeled his first bronze sculpture, *The Wounded Comrade,* and exhibited it in the winter exhibition of the National Academy of Design in 1913. The sculpture today is in the executive offices of the American Museum of Natural History, where Akeley did so much of his work. The composition shows three

elephants, the most respected animals of the jungle and at that time Akeley's favorite of all jungle beasts. Two of the elephants are helping their wounded comrade with broken tusk to safety. Akeley used the same device in the sculpture that he used in his groups, except that the group is cast in bronze. He humanized the elephants by attributing to the great beasts the emotion of sympathy, a device for which the French *animaliers* Barye and Frémiet were noted. James Earle Fraser, a famous sculptor of the time, made that observation years later when he noted how like those of Barye and Frémiet were Akeley's works.

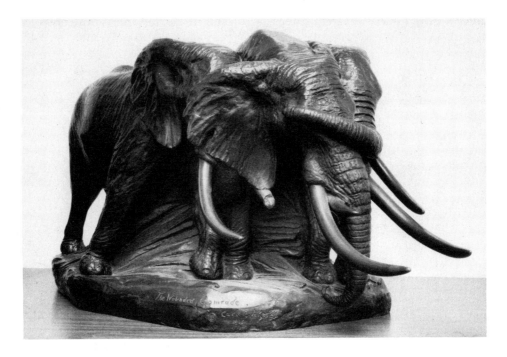

Carl Akeley's *The Wounded Comrade* is a symbol of the union of art, craft, and science.

AKELEY ACCEPTED AS AN ARTIST

The public saw *The Wounded Comrade* as a work of art because it was made in bronze. Now they could see his mounted animals in the museum as art, too. As a result of this success with *The Wounded Comrade,* Akeley was made a member of the National Sculpture Society. Then, in 1916, he was made

a member of the National Institute of Social Sciences for "making taxidermy one of the arts," thereby achieving his aim.

TRUTH TO NATURE

Akeley made death masks in the field, took measurements of animals, preserved models of animals, and photographed and sketched animals in the field to make his groups as accurate as possible.

AKELEY'S AFFECTION FOR THE GORILLA

One of these death masks, although Akeley's original plaster is lost, is a faithful replica, and it is preserved in the American Museum of Natural History. Akeley's mold was the basis for his portrait bust of his first gorilla. Called *The Old Man of Mikeno* after the volcano in the Belgian Congo and on permanent exhibition in the museum, he was named for the gorillas that populated the Mount Mikeno area. Akeley was responsible for having the

A replica of Akeley's plaster cast of the model for *The Old Man of Mikeno.*

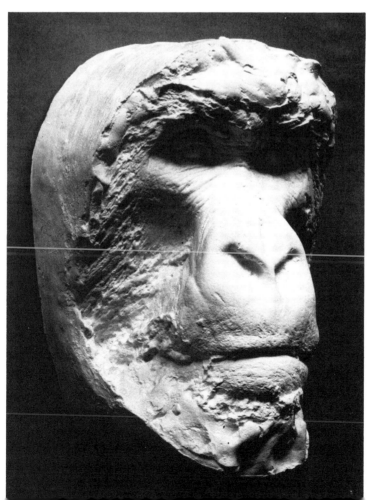

area converted into a sanctuary—named Parc National Albert for the land's sovereign, King Albert of Belgium—to protect these animals he grew to love. It is ironic that Akeley died on the slopes of Mount Mikeno on the verge of realizing a lifelong dream. He was embarked on a journey he had planned for many years—to follow the river Congo to the sea, as Henry Stanley had done nearly fifty years before; but he contracted dysentery in the gorilla sanctuary he had established and was buried there according to his wishes. A monument erected to him there has been destroyed, so the exact site is no longer marked.

THE AFRICAN GROUPS

Akeley's life-size lion-spearing groups in the great Roosevelt Hall portray one of the most dramatic rituals in African life and express Akeley's admiration for the beauty and courage of the Nandi spearmen and the lions they hunt. The first two groups enact the attack of the native hunters, whose spears and swords are gracefully poised, and the answering charge of the doomed lion and lioness. In the third group the lion lies dead as the natives, holding shields aloft, chant their requiem. The power of these groups is in their immediacy. All figures are life-size, and the groups are only slightly elevated so that close examination by the spectator is possible. A shiny spear point and lion's paw attest to the many hands that touch the surfaces of these sculptures every day. The immediacy of the groups is enhanced by the great open space of the Roosevelt Hall and the abundance of sunlight that pours in through the skylight, suggesting the expansive African plain on which this ritual is played out.

AKELEY AND THE DIORAMA

Akeley was instrumental in a remarkable revolution in exhibition techniques during his own time. The diorama was at the center of the revolution. Staff artists went on the expeditions with the scientists and painted the habitats and landscapes en plein air, as landscape painters had done for many years. So in addition to the sculptors and taxidermists, and along with the lighting specialists, the painter of the backgrounds of the dioramas was a key figure. Unlike landscape paintings in museums, backgrounds of dioramas are curved, and the viewer must be able to read the scene from any point of view standing in front of the diorama. This requires a system of perspective that employs intricate curved grids, a system entirely different from the traditional single-point perspective employed for painting naturalistic spaces on a flat surface. No art schools teach these things; artists learn them at such institutions as the American Museum of Natural History. In Akeley's time the artists on the staff of that great museum had an annual

exhibition of their paintings and sculpture. Some of the artists were well known, and their works are still exhibited. For example, William Leigh's paintings of the Grand Canyon were part of the museum's exhibition of landscape paintings in the fall of 1985.

A SCULPTOR'S TRIBUTE

Sculptor James Earle Fraser, who executed the equestrian monument to Theodore Roosevelt that stands in front of the Museum of Natural History, liked Akeley's *The Wounded Comrade* the best of all his works and called the animals "alert, fearful, disturbing." Fraser felt that the lion group in the Roosevelt Hall was "a powerful piece of action." He felt that Akeley had created a "colossal feeling" in his works. Fraser lamented that "Ake," as his friends called him, had never completed his monument to Theodore Roosevelt. The centerpiece was to be a forty-foot-long lion that Fraser said would have assured Akeley a high place in American sculpture.

Anna Vaughan Hyatt Huntington (1876–1973)

Anna Vaughan Hyatt Huntington was one of America's most successful animal sculptors, and a long life enabled her also to be one of the country's most prolific. Even though she did not limit herself to animal sculpture alone, it was in that genre that she is best remembered. She was born in Camden, Massachusetts, where her father was a professor of paleontology at Harvard University, a subject that fascinated her and influenced her art from early childhood, resulting in a host of animal sculptures of all sizes. Following early training with the Boston sculptor Henry Hudson Kitson, Anna Hyatt moved to New York and studied at the Art Students League with Hermon MacNeil, whose statue of George Washington on the Washington Arch in Washington Square Park in Greenwich Village is one of his better-known pieces. She also studied with Gutzon Borglum there, whose knowledge of equestrian sculpture was a formative influence. Both men had studied in France, where they had mastered contemporary styles and techniques. Anna Hyatt's *Winter Noon* (or *Winter Grou,* as it was also called), made in 1902, reflects the style of *les animaliers.* Consisting of two dray horses resting from their labor in wintertime, it brought her immediate recognition when it was exhibited at the Society of American Artists in New York in 1903 and in St. Louis the following year at the Louisiana Purchase Exposition and in 1904 in Philadelphia at the Pennsylvania Academy of Fine Arts. The sculpture is in the Metropolitan Museum of Art along with several other animal sculp-

tures by her, including *Goats Fighting* (1905) and two companion pieces—*Reaching Jaguar* and *Jaguar*—both modeled in 1906 and inspired by her fascination with Señor Lopez, a prize jaguar in the Bronx Zoo. Large versions of these two works in stone are in the New York City Zoological Park.

Chroniclers of the Wild West

America's sculptors who chronicled the West included Frederic Remington, Cyrus E. Dallin, and Gutzon and Solon Borglum. Their works included mountain men, roughriders, Indians, broncos, and cattle, and their works are in most of the major museums in the United States and in many European collections, both public and private. Of this group, Gutzon Borglum made the greatest mark on New York City with his works. Yet they are not animal sculpture. His Henry Ward Beecher statue and Abraham Lincoln relief are at Plymouth Church in Brooklyn Heights, and his General Daniel Butterfield is at 122nd Street and Claremont Avenue. He also did pieces for the Cathedral Church of St. John the Divine on Amsterdam Avenue. His younger brother, Solon, executed a pair of Indians that stand in front of St. Mark's in the Bowery, unfortunately ravaged by atmospheric pollution.

A Glance Ahead

Although the nineteenth century *animalier* tradition continued into the twentieth century, it came to an end with the work of Anna Hyatt Huntington, who lived until 1973. The genre was transformed, however, in the twentieth century by the mastery of such sculptors as Paul Manship, Gaston Lachaise, Robert Laurent, Albert Laessle, William Zorach, and John B. Flannagan. That transformation is illustrated by comparing John Quincy Adams Ward's *Indian Hunter* in Central Park and Paul Manship's bronze gates at the Bronx Zoo.

Ward's piece represents the best work of America's dean of nineteenth-century realism and Manship's gates one of the finest pieces of an avant-garde artist who treated sculpture as form occupying space before it represented a group of animals in the jungle.

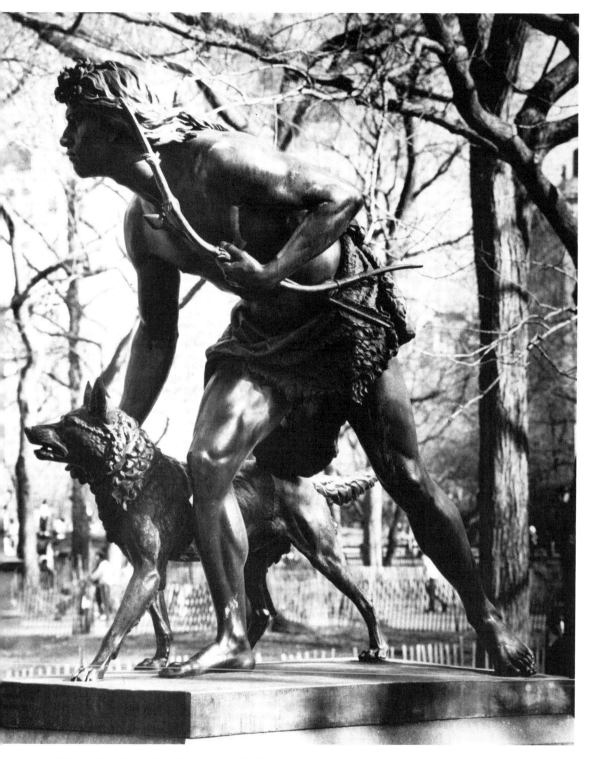

J.Q.A. Ward's *Indian Hunter* was the first sculpture in Central Park by an American sculptor (1869).

INDIAN HUNTER

Across the drive from *Balto,* J.Q.A. Ward's *Indian Hunter* restrains his anxious hunting dog as he tracks his prey. Ward's statue was erected in 1869, the first sculpture in Central Park by an American sculptor. To make it true to life, Ward traveled to the West, where he studied the American Indian in his habitat. That he selected a cast of the *Indian Hunter* for his grave in Urbana, Ohio, reflects his affection and respect for the piece, Lewis Sharp has shown.

BRONX ZOO GATES

Paul Manship's bronze gates to the Bronx Zoo combine the jungle's inhabitants, a contemporary artist's interpretation of their habitat, and a captivating whimsy that thrills children and adults alike. They also continue to inspire artists and to provide an appropriate gateway from one reality to another.

DELIGHTFUL DIVERSION BY DISTINGUISHED SCULPTORS

Some animal sculpture provides delightful diversion in public spaces. The eight-foot-high bronze *Bear and Fawn Fountain* in Morningside Park at 114th Street off Manhattan Avenue, for example, is a much-loved if little-known work. It was given to the children of New York City in 1914 by Alfred Lincoln Seligman, who was a New York banker and vice president of the National Highways Protective Association.

The creation of sculptor Edgar Walter, it depicts a fawn hiding under a rock, above which a bear is crouched in wait. From a hollow in the rock, running water supplies a drinking fountain for children at the base of the sculpture. Even though the fountain no longer functions, the smoothly worn surfaces of the sculpture show how appealing the bronze group is to young sliders and climbers. Walter's *Primitive Man* in bronze is in the collection of the Metropolitan Museum of Art. Born in San Francisco, he studied in Paris with Jacques Perrin. Walter exhibited at the Salon, where he received an honorable mention, and in 1915 he served on the jury of the Panama-Pacific Exposition.

An animal relief tucked away in Murray Hill on East Thirty-fifth Street affords pleasure for those who stop to look. For her studio at the end of the converted nineteenth-century stables called Sniffen Court, after John Sniffen, who built them, sculptor Malvina Hoffman (1887–1966) reproduced part of the equestrian frieze from the Parthenon. Nothing could be more logical—horses for converted stables and one of the most revered friezes in classical art for a sculptor's studio. Even though Hoffman died in

1966, and her studio is no longer a sculptor's studio, the relief is still intact, a delightful reminder of an outstanding artist and a novel twist to the *animalier* tradition in New York.

CHAPTER 12

The Symbolism of Monsters, Hybrids, and Fauna

Early Symbols

An ancient traveler and geographer Pausanias wrote a description of Greek monuments and legends in the second century A.D. in which he told how the mask of a powerful demon was set in the wall of a house to protect the people within. Many of the symbols carved on New York City's buildings derive from such ancient or medieval apotropaic symbols, that is, forms that serve to guard or protect by frightening away an enemy.

As the ages passed the original protective meaning of the image was forgotten and the image alone remained. It was adapted to new uses or designs, or the image remained simply as decoration. Thus, gargoyles are found not only on churches but they also decorate homes and skyscrapers, such as the Woolworth Building, and they are given new symbolism in the buildings of City College. When gargoyles are used on a neo-Gothic church of the twentieth century, they may no longer have their original use as apotropaic water spouts but will become fascinating foils and complements to the architecture and the statuary. Although we do not believe the sculptured lion will protect us, we still use the animal as a decorative figure. Among the best examples in New York City are the couchant lions in front of the New York Public Library and at the entrance to the Morgan Library.

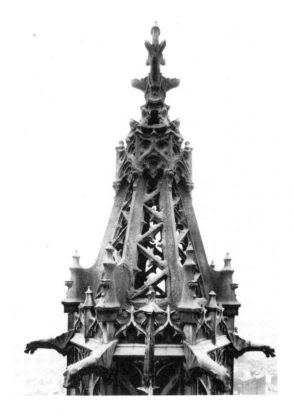

Surrounding the tourelles of the Woolworth Building, dogs are "gargoyled."

The Lion Mask

The most common ancient motif to survive into the twentieth century is the lion head with a ring in its nose. Art historian Otto Kurz has traced its origin to a Greek artist twenty-five hundred years ago who first combined the symbol with utility: the protecting lion mask equipped with a ring in its nose as a knocker or handle. Even though lion masks are common on nineteenth- and early twentieth-century buildings in New York City, the image is often elegant. The lion mask with ring that appears on the keystones of the New York Public Library's first floor windows, for example, were modeled by one of America's leading animal sculptors, Alexander Phimister Proctor, as Henry Hope Reed has shown.

Migration and Meaning

Historians have long sought to know how monsters and hybrid motifs originated and how they migrated from place to place. Art historian Rudolf Wittkower, for example, pursued the subject for thirty-five years, and his

lectures are still being published almost two decades after his death. Witt-kower's essays on the migration of symbols are landmarks in this pursuit of the origins and meanings of monsters, hybrids, and what art historian Henri Frankfort has called "fantastic fauna."

Wittkower has shown in his study with Margot Wittkower, *Born Under Saturn,* as well as in his essays and lectures that the ancient Greeks sub-limated the irrational elements of the unconscious in their mythological monsters as well as in the fantastic animals and races of man they believed lived in India. And two learned Greeks in the early fourth century B.C., Ktesias and Megasthenes, wrote accounts of what these monsters and races were like. The Greeks had earlier travelers' accounts from the sixth century B.C., as J. W. McCrindle has shown at the beginning of this century. But Ktesias was a physician to an Indian court, Megasthenes an ambassador to India, and their pseudo-scientific descriptions of monsters, combined with history and information about the social institutions and geography of the country, gave their accounts a new credibility that fueled the imagination of their contemporaries and subsequent writers and artists.

Ktesias told of pygmies and giants, dog-headed races and people with no heads at all whose faces were on their chests. Megasthenes reported there were enormous winged serpents and scorpions, he revived some of the monsters Herodotus had written about, and both of these learned Greeks perpetuated the myth of the unicorn as the Indian rhinoceros.

These monsters from the East became increasingly more believable as their appearance accompanied the scientific advances in geography. Theologians and religious writers by the Middle Ages had accepted these fabulous races as descending from Adam and therefore part of the mystical body deserving of eternal salvation.

Links to the Inscrutable

Thus, the fantastic imagery from the East transmitted through travel-ers' accounts, ancient mosaics and manuscripts, cylinder seals and reliefs, found its way into the illuminated manuscripts, tapestries, stained glass, enamel work, and stone carving of the medieval artist. Romanesque and Gothic tympanums, reliefs in cloisters, and historiated capitals gave birth to a panoply of fantastic hybrids that spread throughout Europe. Some of these hybrids have been more popular than others in the architectural decoration of New York City in the nineteenth and early twentieth centu-ries.

Griffins, grotesques, and gargoyles hold interest today partly because

they touch upon the unconscious, partly for their narrative fascination, and partly for their decorative qualities. They also fascinate twentieth-century man because they are still to a significant extent cloaked in mystery.

Griffins

Perhaps the most popular hybrid and the one used most widely as a decorative motif is the griffin, a fabulous animal with forepart, head, and wings resembling an eagle and body, hind legs, and tail like those of a lion. The limitless variations on these combinations demonstrate the range of invention possible in combining the eagle and the lion. The motif's popularity in New York City architectural decoration is evident not only in the ubiquity of the motif, but also in the fact that a building at Thirty-ninth Street and Park Avenue is even named for it.

Grotesques

Animal forms of all kinds as sculptural decoration were discovered in ancient Roman houses. The most famous of those houses was the Golden House of Nero. Because the animal hybrid forms were discovered in grottoes, the term *grotteschi,* or "grotesque," is used to describe ancient decoration that consists of sphinxes, foliage, and the like. These forms became popular especially in the Renaissance and have remained so ever since. Psychologists and psychiatrists such as Ernst Kris hold that grotesques are both comic and frightening and that they express inner urges, which are transformed into acceptable forms through a psychological mechanism similar to dreams.

Symbols and the Unconscious

Besides its attraction as pleasing or striking design, then, much decorative sculpture has an enduring fascination probably because its psychological or cosmic significance is recognized at the unconscious level.

Atop the south tower of the Cathedral Church of St. John the Divine, for example, a Saturnian figure devours a naked human being. The crisp lines of the carving and the light color of the stone reveal that the corbel has been recently carved, part of the building campaign of the great cathe-

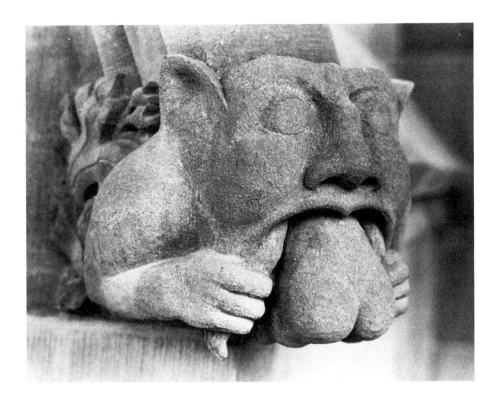

Saturnian figure atop the south tower of the Cathedral Church of St. John the Divine.

dral. That image, however, was carved first in ancient times. It portrays Saturn devouring his children to prevent the prediction from coming true that one of his offspring would overthrow him.

In the seventeenth century, Peter Paul Rubens painted Saturn devouring his children to show one aspect of ancient civilization's transition from chaos to order, whereas Goya's treatment of the subject in the early 1820s is charged with madness and ferocity—perhaps to express the artist's estrangement from modern society, art historian Fred Licht has suggested.

In a fifteenth-century manuscript showing a wide range of aberrations, learned Thomas of Cantimpré portrays an anthropophagus, a cannibalistic creature, eating a naked human being. In 1819 Théodore Géricault dealt with the subject of cannibalism less directly than Cantimpré but more dramatically in his *Raft of the Medusa,* which portrays a shipwreck whose survivors perform acts of cannibalism to stay alive.

Fantasies of cannibalism, psychologists tell us, are common in infancy to compensate for the loss, or temporary absence, of a loved one. The only experience an infant has of how to retain the desired object is through ingestion, an awareness reinforced by the act of nursing. Certain primitive

peoples practice cannibalism to gain the desirable qualities of the object eaten, others practice it as a respect for the deceased. Respect for and identification with the consumed object are spiritualized in Holy Communion, one of the sacraments of the religion whose ritual takes place beneath the Saturnian corbel and within the Cathedral Church of St. John the Divine.

A complex and frightening concept, the notion of cannibalism is as unpalatable to contemplate today as it has been for centuries. The subject is therefore relegated to cartoons of missionaries being boiled by cannibals or to the topmost perch of a neo-Gothic cathedral, where only binoculars reveal the carved image. Nonetheless, the fantasy still lurks in the shadows, side by side with images that instruct and entertain.

Whimsy and Instruction

Near the Saturnian figure on the top of St. John the Divine, today's carver makes a comment on the traffic congestion and high noise level along Amsterdam Avenue, which the figure faces with his fingers in his ears, a familiar gesture in New York City today. Multiheaded creatures that date back to medieval carvings are also found on St. John the Divine, symbolizing vigilance and also recalling the different moods of man. It is difficult to be surprised if a face covers three views. The different expressions incorporated in this corbel suggest the temperaments of man as well.

La Gargouille

The central image in this aspect of symbolism is the gargoyle, as critics G. L. Hunter and Charles deKay analyzed earlier in the century. According to one legend, the word "gargoyle" comes from the ancient monster La Gargouille, who in the seventh century preyed on the shepherds, flocks, and herds of Rouen, France, with his fatal fiery breath. The demon was satisfied only by a diet of human flesh consisting principally of convicted criminals.

The people of Rouen lived in constant fear until one day Saint Romanus arrived at Rouen and offered to capture La Gargouille if the village would accept Christianity. As soon as the people agreed, Saint Romanus took a convicted criminal to the place of sacrifice, but instead of leaving the victim, as was customary, the saint waited for La Gargouille. With bell and candle, he exorcised the demon and led him back to Rouen, where La

Above: A gargoyle atop the south tower of St. John the Divine protects itself from the noise of Amsterdam Avenue. *Below:* Another south-tower gargoyle symbolizes vigilance.

Gargouille was burned at the stake on the same square, tradition holds, in which centuries later Joan of Arc, ironically, was burned as a witch.

Origins of the Gargoyle

Even though La Gargouille was burned at the stake, his head and scaly neck refused to burn, which inspired artisans to carve the water spouts of their churches into the "gargoyles" to perpetually quench his fiery breath that fatally seared the people of Rouen. The gargoyles took on many forms. A log was bored or channeled lengthwise to form a water pipe, and a spout was finished at the end in some eccentric shape: a gargoyle, a chimera, a harpy, a nondescript beast. These gargoyles, as they came to be known, were talismans to protect people from many ills. Eventually any such form was called a gargoyle, and they were fashioned in stone and terra-cotta as well. The word even came to be used as a verb—so dogs, owls, cats, pumas, pelicans, and owls were "gargoyled." The most vividly romanticized gargoyles were seen through the eyes of Victor Hugo's benevolent monster, Quasimodo, atop Notre Dame, where the gargoyles "barked," salamanders "puffed at fire," and tarasques "sneezed in smoke."

Changing Attitudes

As for putting gargoyles on churches in the twentieth century, many Christians have thought they are sacrilegious. Even on the Union Theological Seminary in New York City, architect Charles Collens dared not employ the real thing. He stated: "The religious character of the building does not allow such freedom." The ornament is very restrained, and the grotesques are confined to the library and tower, depicting the various symbols of knowledge, with the owl, the sphinx, and busts of monks typifying pedagogy, thought, research, and preaching. The chapel, while having various ornamental billet courses well adapted to grotesques, has been treated only with angels, cherubs, and evangelists. The ornament of the other buildings consists in armorial bearings of foliation. "The day of the grotesques in church decoration," added Collens, "has gone by."

City College and Post's Fantasies

In secular architecture, more ambitious attempts have been made to

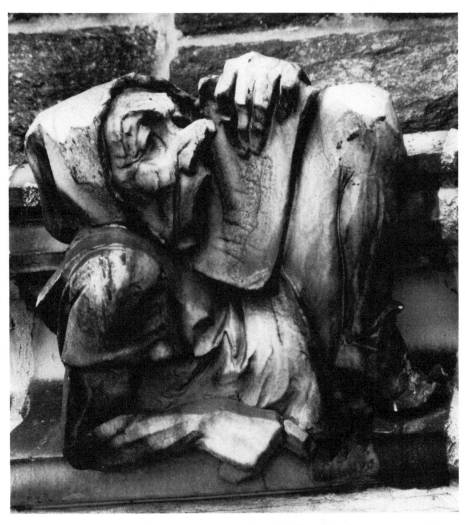

A monklike figure does his sums.

Another cowled instructor lifts
a skeleton with his calipers.

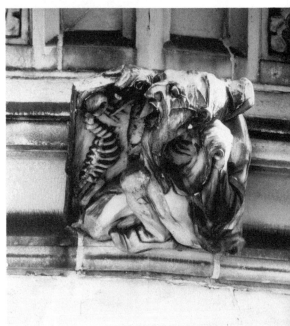

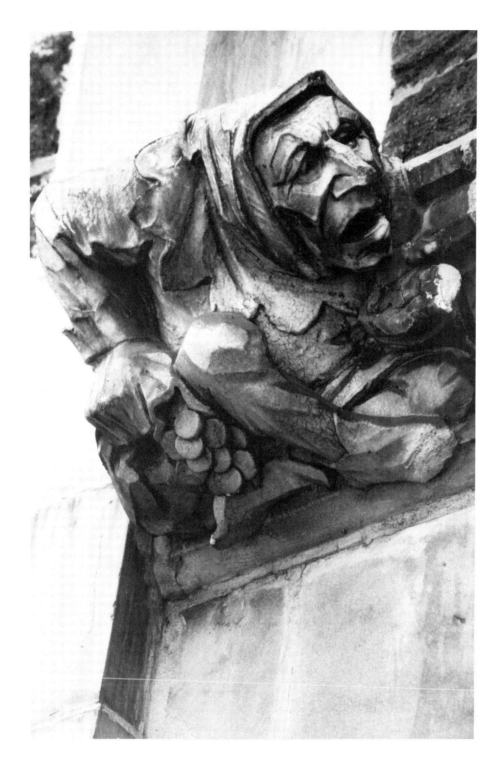

City College's curricula is "gargoyled" at its campus on Convent Avenue. Economics is portrayed spilling coins.

A professor of biology is "gargoyled."

revive the glories of the past. The best modern example of the free use of gargoyles and grotesques is the College of the City of New York, whose buildings architect George B. Post has enriched with more than six hundred figures, all different—on the gymnasiums, athletic contortions; on the chemistry building, mysterious experiments; on the mechanical arts building, goblin mechanics; on the subfreshman building, the beginning of education; on the main building, the higher studies. They help vastly to relieve the deadly monotony of geometrical shapes and forms. One wonders if CCNY graduates had any influence on the figures holding rackets over the entrance to the Shelton Tower on Lexington Avenue. The loftiest gargoyles are on the Woolworth Building. Among the animals "gargoyled" are the bat, pelican, puma, frog, owl, and dog.

Neo-Gothic Gargoyles

There are buildings that are exceptions to the out-of-vogue treatments of gargoyles on churches in the early twentieth century–the Chapel of Our Lady Queen of All Saints, for example, at the corner of Lafayette and Vanderbilt in Brooklyn. Built in 1914, the architects were Robert J. Reiley and Gustave Steinback. Gargoyles were carved to add interest and relief to the architecture and as foils to the symbolic figures of the evangelists that top four of the pinnacles. The interior of the church, a replica of Ste. Chapelle in Paris, is a jewel box of color and light.

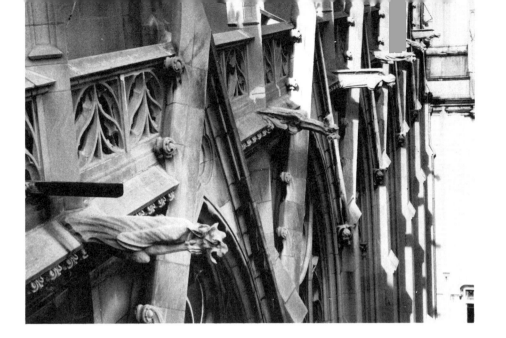

Gargoyles peer from the Chapel of the Our Lady Queen of All Saints in Brooklyn.

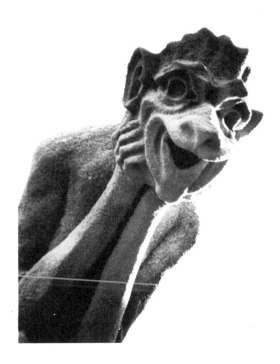

Gargoyle from the roof of Brooklyn's Chapel of
Our Lady Queen of All Saints.

A pair of gargoyles along Park Avenue parody A.W.N. Pugin's famous nineteenth-century book, *Contrasts,* which juxtaposed Gothic revival with classical revival buildings to show the superiority of Gothic over classical architecture for churches.

The Eagle's Ubiquitous Pedigree

The marvelous monsters and fabulous races of the East provided the architects, sculptors, and designers of the nineteenth and early twentieth centuries with a remarkable variety of hybrids to emulate and from which to draw inspiration. It is the eagle, however, that has emerged as the single most pervasive visual and symbolic link between the East and the West.

Everywhere in New York City, or anywhere in the world, for that matter, are painted, modeled, carved, and woven eagles. Eagles support flagstaffs in front of municipal buildings and in parks, hold up tables in the New York Public Library and in banks, guard the entrance to Grant's Tomb, watch over the U.S. mail, and even reign over New York City's seal and the seal of the New York Public Library. People collect eagles. Playwright Herb Gardner's protagonist in *A Thousand Clowns* opined that a fellow can never have too many eagles, in spite of the clutter of his New York City brownstone apartment.

The wingspread of the ubiquitous eagle extends from ancient to modern times and spans the arc from East to West. The eagle is one of the world's oldest symbols. Its image is known on the pottery of early civilizations in Babylonia and the Indus Valley (today's Pakistan), for example. Large statues of eagles have been found that date from 2500 B.C. A seven-foot-high stone eagle in present-day Turkey dates from the Hittite empire of Asia Minor, 1400 B.C.

The eagle in the World War II memorial in Battery Park symbolizes resurrection.

In ancient and modern times the eagle has power. It appeared on Roman triumphal arches, symbolizing victory. In that spirit, eagles surmounted the great triumphal arches in New York City that celebrated the return of Admiral Dewey in 1899 and the U.S. Armed Forces under General Pershing in 1919. Those arches were temporary. McKim, Mead, and White's Washington Arch of marble at the foot of Fifth Avenue proudly carries an eagle atop the arch designed by Philip Martiny and carved by the Piccirilli brothers.

Heroes are transported on the mighty wings of eagles in Babylonian cylinder seals. Because of the strength of his wings, ancient people believed, the eagle flew the highest of any bird—right into the sun. The heavenly sphere, then, was accessible to it alone, so in ancient Greece and Rome the eagle came to represent Helios, or Sol, the sun. On Roman coins the eagle symbolized imperial power. From the third century B.C. in Syria the eagle was the bird of resurrection, a notion that was adopted by imperial Rome. As Jupiter was carried aloft by his favorite bird, the eagle, so the soul of the deified emperor was carried by him to heaven, an image that became widespread and appears on Roman tombstones. In Indian literature it was the eaglelike bird Garuda, carrier of the sun god, who stole the drink of immortality.

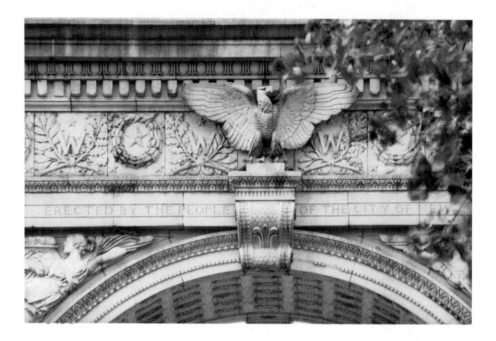

The eagle atop the Washington Arch at the foot of Fifth Avenue was designed by Philip Martiny.

Symbol of Liberation and Deliverance

The eagle became a symbol of salvation and resurrection in the Judeo-Christian tradition as expressed in Psalm 103, verse 5: " thy soul is renewed like the eagle's." The Jews of the Diaspora represented their god as an eagle that carried the deceased up to the sun. Later, Christ was shown supported by the eagle and became identified with the sun. The seated figure of Christ supported by the eagle is well exemplified in one of New York's unique treasures, the Antioch Chalice on display at the Cloisters in Fort Tryon Park, Metropolitan Museum of Art.

The eagle became the symbol for Saint John the Evangelist. As the eagle could look straight into the sun and not be blinded, so John in writing the Apocalypse was permitted to look directly into the face of God in all his glory, the beatific vision, without being blinded. In the central portal of Saint John the Divine at 112th Street and Amsterdam Avenue, that drama is enacted in heroic scale as Saint John stands in front of the *trumeau* looking up into the tympanum to Christ as King of Heaven in all his glory. For Saint Jerome, the eagle was the symbol of the Ascension of Christ and of prayer. Dante called the eagle the bird of God.

A collection of animal tales as Christian allegories, from the second

century A.D. in Greece, contains stories of the eagle's flight toward the sun, his fall, and his rebirth, showing the eagle as the bird of resurrection. The eagle in the World War II memorial in Battery Park is the centerpiece of the monument both formally and symbolically. Formally the eagle is the focal point of the monument. Symbolically it stands for the immortality of the fallen heroes and the principles for which they died.

A Symbol of Our Time

When the eagle, the most powerful bird, is portrayed defeating the snake, the most dangerous reptile, the image symbolizes victory and triumph. The Romans used it to signify military victory, and it is found in ancient myths and religions, where it stands for the triumph of good over evil.

In the nineteenth century Percy Bysshe Shelley used the motif as a symbol of the French Revolution, and in the *Marriage of Heaven and Hell,* William Blake's eagle of genius and imagination raises the serpent up. The eagle and serpent as a symbol of enlightenment is a fitting motif then for the city's cultural institutions, especially the New York Public Library where it appears in various locations.

Motif as Tribute

The eagle and serpent motif as a symbol of enlightenment pays fitting tribute to the studies of Rudolf Wittkower, Otto Kurz, J. W. McCrindle, Henri Frankfort, and the growing contingent of scholars who are exploring the origins and migrations of ancient forms. They continue to provide valuable insights into the richness and significance of the sculpture decoration of the historical revival styles of the nineteenth and early twentieth centuries.

PART V

The War Memorial

CHAPTER 13

Materials and Symbols

A discussion of representative examples of New York City's war memorials reflects the richness and variety of its commemorative and funerary monuments and masterpieces.

War memorials in the city embody many styles and many meanings. Monumental memorials honor our heroes. Plaques and tree markers, too, pay tribute to the service and sacrifice of individuals and of groups. And commemorative plaques throughout the city identify and explain key places that gained historical significance during the American Revolution, reminders that America's first war was fought in New York.

War memorials are not monuments to wars. They are monuments to the people who fought them and to the principles and human values those people served and for which they even sacrificed their lives. To express those timeless principles and human values embodied in our war memorials, their creators have gone to nature for their materials and symbols, as people have done since ancient times.

Trees, stone, and bronze, which symbolize eternal forces in nature, are the essential materials that usually compose our war memorials. And the human figure, symbolic of people's yearning for immortality, is the dominant theme that recurs in the sculpture programs of the city's war memorials.

The Tree as Symbol

From ancient times the tree has been emblematic of inexhaustible life: a symbol of immortality, a testament to life after death. The tree's roots reaching downward for moisture and its leaves reaching upward for sunlight, its consistence, growth, and proliferation, its generative and regenerative process, have made the tree a popular symbol of immortality uniting heaven and earth.

Trees have therefore been planted to honor fallen heroes and to commemorate their courage and devotion in the service of their country. The practice was especially widespread following World War I, and a small bronze plaque mounted on a granite plinth was usually installed next to the tree identifying the honored hero with his name, rank, and dates of his birth and death. Sometimes an image accompanies the words. Bronze is used because it is the ideal metal for casting, since when melted it flows into the crevices of a mold faithfully reproducing every detail, and once it is hardened it is easily worked with a tool. And it will withstand the outdoors. That bronze has been used for casting since 3500 B.C. imparts to the material timeless associations compatible with notions of eternity.

Groups also commemorate their comrades in this way, well exemplified in the trees and markers in Madison Square Park. And a tree and its plaque west of the band shell in the mall in Central Park, for example, honor the marines of the Fourth Brigade who died in the war. The bronze plaque may be in a boulder as in Monsignor McGoldrick Park, Nassau to Driggs, Russell to Monitor streets, in Brooklyn. The tree was planted on Armistice Day, November 11, 1919, by Greenpoint Post 241, American Legion, and dedicated to the memory of those of Greenpoint who gave their lives.

For security, the granite block is buried three feet in the ground with only a few inches visible above ground, and the bronze plaque is set into the granite and secured with screws or pins. Nonetheless, many plaques have been stolen for the value of the metal. Yet several hundred of these markers in the five boroughs are still intact.

The Commemorative Grove

A variation on this category of memorial is the grove of trees marked by a bronze plaque. Flora thrives and grows freely in the grove. Its foliage obscures the light of the sun and creates an intimate and protected enclo-

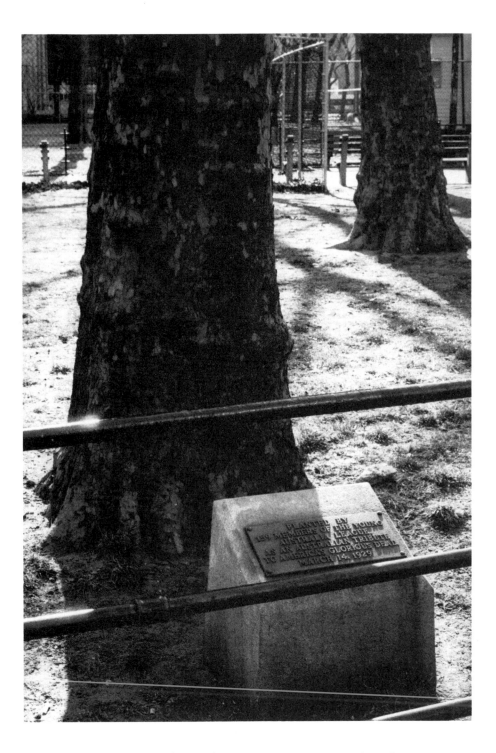

Tree markers are common forms of commemoration—a tree planted to commemorate an individual or a group, identified by a bronze plaque bearing the dedication.

There are groves of tree mark-
ers, such as the memorial grove
south of the band shell in Cen-
tral Park.

The plaques from the memo-
rial grove in Hero Park have
vanished, but the great boulder
that once bore identifying
plaques still stands.

sure, conducive to contemplation. The grove of trees is both symbolic of the Garden of Eden and expressive of the richness and variety of the living landscape.

East of the Mall and south of the band shell in Central Park, for example, is a memorial grove marked by a large natural boulder and bronze plaque with its honor roll of 560 war dead of the 307th Infantry Regiment. Throughout the grove, randomly arranged, are eighteen limestone markers with bronze plaques commemorating the various companies of the regiment. Today, some of the trees are gone, and a number of the plaques have been stolen.

The Hero Park Memorial Grove on Staten Island, created in 1920, commemorates the war dead of World War I from Staten Island. It is located at Victory Boulevard, Lewis Street, and Howard Avenue. Memorial plaques were arranged randomly throughout the grove, and bronze reliefs by sculptor Francis Muller, 1921, honored Dr. Louis and Berta E. Dreyfus, who gave them and the park to perpetuate the memory of the heroes of Staten Island, those who gave their lives in World War I. None of the memorial plaques remain, and the reliefs on the boulder have also disappeared. At the entrances to the park, however, plaques do remain that remind the visitor, "This park is a public sanctuary entrusted to the guardianship of the people."

Independence Flagstaff

Many flagpoles and their bases in New York City commemorate the wars, their veterans and martyrs, and America's independence. They are sometimes synonymous with freedom poles and are symbolic extensions of the tree of liberty. But one whose site uniquely celebrates the country's independence, past and present, warrants review.

LIBERTY COMMEMORATED

The Charles F. Murphy Monument in the center of Union Square at Fourteenth Street is named in honor of one of the powerful bosses of the Tammany Society. However, it is popularly known as the Independence Flagstaff, because it was erected in 1926 on the 150th anniversary of the Declaration of Independence and it symbolizes the liberty poles of revolutionary times, which British colonists erected to protest colonial policies.

Atop the liberty poles in revolutionary times, a liberty cap was placed to symbolize freedom and later independence. That is why atop the flag-

The Declaration of Independence is reproduced in its entirety at the base of the Independence Flagstaff in Union Square. With reliefs by sculptor Anthony De Francisci, it was dedicated in 1926.

pole in Union Square is a gilded weather vane in the shape of the revolutionary liberty cap.

In the 1760s Paul Revere introduced the liberty cap into the American rebellion with his engravings, as art historian Yvonne Korshak has noted in her study of the liberty cap as a revolutionary symbol. Then, when artists in the United States and abroad depicted the American flag, they usually put the liberty cap atop the pole.

The liberty cap has its origins in the *pileus* cap of ancient Rome and the Phrygian cap of ancient Greece. While the *pileus* cap was originally identified with freedom from bondage, the Phrygian cap signified a stranger or foreigner. In the course of the eighteenth and nineteenth centuries, however, the two caps came to be used interchangeably as symbols of freedom, independence, and political rebellion. Statesman and orator Edward Everett discussed the meaning of the cap with Hiram Powers, when the American sculptor was modeling his Statue of Liberty (America) in Florence.

As part of the ancient Roman ritual of manumission, the slave was "called to cap," that is, he was given the cap of the Roman working man, the *pileus,* to demonstrate his freedom. It has been observed that the conically shaped *pileus* cap served to conceal the shaved head of the slave. A

shaved head made detection easy and escape difficult. Ancient reliefs and coins portray the manumission ritual and the cap in various forms.

The close-fitting, soft cap with floppy peak worn by the people of Phrygia appeared in ancient Greek art and came to represent all people from distant lands—foreigners. The Phrygian cap then became identified with foreign captives and finally with enslavement.

France picked up the liberty cap from America for its own revolution and retained the Phrygian cap into the twentieth century. Even today the Phrygian cap appears on French stamps and coins as the symbol of the French Republic.

In the United States, the liberty cap fell into eclipse after the American Revolution. A symbol of liberty based upon freedom from bondage could only divide a nation in which the institution of slavery was practiced.

TRIBUTE AND REMINDER

The presence of the liberty cap, then, atop the flagpole in Union Square is a tribute not only to the independence the United States won in the revolutionary war, but also to the freedom from slavery the country achieved through the Civil War. The cap is a constant reminder that economic freedom in the United States is still to be achieved.

The Independence Flagstaff is set in a two-tiered circular base of pink granite thirty-six feet in diameter and nine feet high, designed by architect Perry Coke Smith. The drumlike base is faced with bronze reliefs by sculptor Anthony De Francisci, a pupil of James Earle Fraser's. He also worked with Weinman and MacNeil. The frieze celebrates the nation's independence through symbol and narrative. The complete text of the Declaration of Independence on the south face of the relief is flanked by the sword and torch, symbols of freedom and the might to preserve it. Opposite, on the north face of the base, is the Tree of Liberty. The circular reliefs on the east and the west of the base represent the evolution of freedom under democratic rule contrasted with the denial of freedom under tyranny, and they read from south to north. The ensemble appears as a great bronze bracelet, hinged with the Tree of Liberty and clasped with the Declaration of Independence. On the east, allegorical figures, whose features resemble those of Francisci's wife, who was often his model, represent law, wisdom, strength, industry, agriculture, and the fine arts, while on the west a figure representing tyranny holds an outstretched sword, symbolizing the rule of force, over a row of downtrodden figures representing life under dictatorial rule. Above the reliefs of freedom are bronze plaques bearing the coats of arms of the thirteen original colonies.

It is proper that the Independence Flagstaff stands at the center of

The statue of Mohandas Gandhi by Kantilel B. Patel, 1986, celebrates the cause of nonviolence and the sources of Gandhi's teachings, which includes the writings of Thomas Jefferson, Abraham Lincoln, and George Washington, who are also honored with monuments in the park.

The Phrygian cap in the pediment of the old Tammany meeting place across the street from Union Square celebrates personal liberty, for which the park is symbolic.

Union Square, a park that has meant independence and freedom of speech for generations. There, especially during the 1930s, people came to speak their minds without fear of assault or arrest. Appropriately, the statues of Washington, Lincoln, Lafayette, and most recently Gandhi, share axes with the Independence Flagstaff. And it is fitting, as one stands to read the flagstaff's historic friezes with their idealized, almost life-size figures of Indians, pioneer families, horses, and buffaloes, portraying the American struggle for independence, that another liberty cap—across the street in the pediment of the old Tammany meeting place at 100 East Seventeenth Street—is eminently visible as it oversees the park and the Charles F. Murphy Monument.

Stone as Symbol

Plaques set into great boulders and outcroppings of Manhattan schist, the stone that is millions of years old upon which Manhattan is built, have a special character because of the meaning of stone. The solidity, integrity, and permanence of stone have been recognized from early times as the antithesis of biological things, which are subject to laws of change, decay, and death. Ancient cultures worshiped stones as possessing magic powers and as dwelling places of the gods. They treated certain stones with special respect. In the book of Genesis, the stone Jacob took from a sacred shrine and used as a pillow when he dreamed of the prophetic stairway between God and man, he interpreted as the abode of God and set up as a memorial stone. Alchemists thought the philosopher's stone contained the power to transform baser metals into gold.

Megaliths

Monumental stones were used by ancient cultures to mark sacred places and burial sites. Historians call these massive markers megaliths, which means "great stones," and they date from as early as 3000 B.C. If they are dressed—that is, cut and prepared—they are called monoliths. Great boulders in their primitive and natural state, then, are associated with people's earliest attempts to deal with notions of death. These associations continue even into modern times. Following World War II, for example, rough-hewn natural boulders had widespread appeal as commemorative markers, and they are found throughout the city in all boroughs bearing

memorial plaques. The people of Norway brought a great stone from their coast—"where forces of nature have worn and shaped them for thousands of years," the inscription reads—for a monument in Battery Park.

In funerary monuments the permanence of stone is symbolic of immortality. Thus, when the likeness of Father Edward J. Giorgio in bronze relief is set into a stone stele, the notions of immortality and commemoration are united in a single funerary hieroglyph. Erected by the Catholic War Veterans on June 13, 1954, the five-and-a-half-foot-high polished black granite stele bears sculptor A. A. Cianfarani's bronze portrait of the beloved priest of Our Lady of Mount Carmel Church in Brooklyn, who served as an army chaplain during the war. The monument stands in Father Giorgio Square at Lorimer and Jackson streets and Meeker Avenue, near the Brooklyn-Queens Expressway. Sergeant Edward R. Miller is commemorated by the square named for him at Cooper Avenue and Seventy-third Place in Glendale, Queens, and a simple granite stele with bronze plaque bears the dedication to Sergeant Miller, "killed in action/Huertgen Forest, Germany, November 22, 1944. . . ."

A great stone from Norway symbolizes the desire for a permanent bond between two countries and their people.

Obelisks, Columns, and Stele and Exedra

The column and the obelisk unite the forms of tree and stone with other forms in nature to enrich their funerary symbolism. The obelisk has since ancient times been identified with the rays of the sun; thus as a funerary symbol it is a conduit of eternal life. The column is an abstraction of the tree and the phallus, thus symbolic of life and creation.

OBELISKS

From ancient Egypt to twentieth-century America, obelisks have been a favorite form to mark burial sites and to commemorate the deeds of fallen heroes. New York's tallest obelisk, seventy-five feet high, is one of three identical monuments, each fashioned of 1,400 tons of granite. Designed by Sir Astor Webb, P.R.A., in 1931, they were erected in New York; Dover, England; and Cap Blac, in the northeast of France, with funds raised by the British in commemoration of the Dover Patrol as a tribute to the comradeship and service of the American and British naval forces in Europe during World War I. New York's obelisk is located in Fort Hamilton Park at Fort Hamilton Parkway and Shore Road in Brooklyn.

Architect William Welles Knowles designed the Bayside Memorial for the north side of the station in Bayside, Queens, at Forty-first Avenue and 213th Street. It is a third of the height of Webb's great needle in Brooklyn, and Knowles placed his obelisk atop a slender shaft and set the whole within an esplanade. This marble-and-granite monument of 1925 reflects the architect's tasteful use of an ancient form, a sense of style evident also in his Georgian U.S. Post Office building of 1932 at the northeast corner of Main Street and Sanford Avenue, not far away. In the 1940s, 1950s, and 1980s, the inscription on the Bayside Memorial was modified to include tributes to those who served in World War II, the Korean conflict, and Vietnam. The monument was then moved to Clearview Expressway and Northern Boulevard.

The architects of the Soldiers' and Sailors' Memorial on Riverside Drive, Stoughton and Stoughton, designed the twenty-foot-high octagonal obelisk at Bronx Boulevard and 219th Street in 1923, commissioned by the Seventh Draft Board in the Bronx to honor those killed in action from that district, whose names are inscribed on the monument.

In Queens the World War I Memorial, on Rockaway Boulevard and 106th Street and 109th Avenue, dedicated in 1929, consists of a seven-and-one-half-foot-high granite obelisk set on a base and plinth with bronze nameplates of the honored war dead from the area.

COLUMNS

Two war memorials in the Bronx attain grandeur through height in the use of the classical column. A Doric column supporting an American eagle above a granite pedestal soars thirty-two feet in the air, honoring the war dead of Local Board 2 in the Bronx; Howard Bowdin, architect; Menconi Brothers, sculptors. Located at Third Avenue, 139th Street, and Lincoln Avenue, the monument was dedicated on Armistice Day, 1921.

The Bronx County War Memorial was dedicated to the country's sons who died in the war. It consists of a Corinthian column seventy-five feet high supporting a bronze Winged Victory eighteen feet tall by Belle Kinney. The column and figure rests on an eighteen-foot-high pedestal of Vermont marble. The monument, designed by architect John J. Sheridan and erected in 1925, stands in Pelham Bay Park off the Bruckner Expressway. Several hundred trees were planted row on row to approximate traditional headstones erected in military cemeteries, so that the grove of tall trees echoes the lofty splendor of the stone column. The permanence of the slender column and the resilience and cadence of the grove compose an anthem to the commitment and dedication of the martyrs honored there.

Sheridan's Corinthian column seems to echo the classical forms that architects Herts and Robertson orchestrated in Rice Memorial Stadium of 1916 nearby. Rice's one-hundred-foot-high white marble Doric column towers over the small Greek temple atop bleachers that frame Louis St. Lannes's heroic statue *American Boy*. Charles Rumsey's colorful frieze of Olympic athletes beneath the roof cornice is well preserved compared to the deteriorated condition of the structure and the statue.

Shafts and eagles are combined in the Bushwick War Memorial by the Piccirilli brothers at Bushwick, Metropolitan, and Maspeth avenues, and Humboldt Street and in the Liberty Avenue World War II Memorial (its eagle missing) in Brooklyn at Eldert Lane and Liberty Avenue. In the Piccirilli brothers' monument the eagle stands on a great ball, a motif also used in the Woodlawn Heights War Memorial in the Bronx at East 238th Street, Oneida Avenue, and Van Cortlandt Park East.

STELE AND EXEDRA

The stele and the exedra are forms from the ancient world of Greece and Rome that have been incorporated into monuments and memorials in the modern world.

The stele is a stone shaft, usually rectangular in shape, that may be from three to twenty feet in height. The Greek *stele* means "to set up" or "mark," as for a commemorative site. The stele, a popular form for war

Bronze relief honors British journalist and humanitarian William Thomas Stead, last seen helping women and children into lifeboats as the *Titanic* sank.

memorials, provides surfaces on which to either inscribe appropriate text or to place a bronze plaque with the desired names and words. The eleven-foot-high stele by sculptor James Novelli, for example, for the Clasons Point War Memorial at Soundview and Patterson avenues in the Bronx carries a seven-foot-high bronze plaque with quotations by Presidents Washington, Lincoln, McKinley, and Wilson. And Charles Keck's granite stele, the same height, unveiled on November 11, 1922, at Ocean Parkway and Fort Hamilton, also carries a bronze plaque, and it bears the names of the forty-seven men from the Sixty-first District Draft Board in Brooklyn who died in action in World War I.

Exedra describes an open space in the ancient world set aside for conversation and furnished with a nearly semicircular bench or seat with a solid back. In the United States, the exedra gained monumental importance in 1881, when architect Stanford White and sculptor Augustus Saint Gaudens erected the Farragut Monument in Madison Square Park in Manhattan. Their design was a masterpiece that was the first to combine the ancient exedra with the modern historic bronze portrait, and it created a new type of public monument that influenced an era. A generation later, Karl Bitter's monument to Carl Schurz at 116th Street and Morningside Drive of 1913 illustrates the influence of their design on major sculptors of the age.

A block west of the Schurz Monument on Columbia University's campus the exedra of 1911 adjacent to McKim, Mead, and White's Low Library and on axis with the entrance to St. Paul's Chapel demonstrates the adoption of the ancient form to an existing complex at the turn of the century. And it became a popular form to commemorate the veterans and martyrs of the country's wars.

The exedra sometimes incorporates the stele and bronze plaque as a modest alternative to the historic bronze portrait statue rising above it. An example is the Astoria Park World War I Memorial of 1926 by sculptor Gaetano Cecere in collaboration with architects Ruehl and Warren at the East River in Astoria Park, Queens, at Nineteenth Street and Twenty-fifth Avenue. It consists of a modified granite exedra and stele with the names of the war dead.

The Votive and the Utilitarian

As memorials, monuments may be divided broadly into utilitarian and votive. The utilitarian memorial subordinates commemorative ideas to

less-exalted ends and addresses sociological issues rather than the ideas of the dead. The votive memorial, on the other hand, is directed at evocations. If it is successful, its expression is direct, its language simple. In the examples selected for review here, one combines the votive and utilitarian aspects of the memorial, the others deal with evocation.

A Votive in Bronze, Stone, and Space

The East Coast Memorial stands in Battery Park and commemorates the soldiers, sailors, marines, coast guardsmen, and airmen who met their deaths in the western waters of the Atlantic during World War II. Its counterpart stands in California facing it from across the continent and honors those brave servicemen and women who died in the Pacific during the war.

WREATH AND TALONS

The East Coast Memorial consists of four pairs of gray granite steles, eighteen feet high, flanking a wide plaza. This composition of steles may have its origins in the arrangement of menhirs in ancient Brittany—great single stones set vertically upright and arranged in parallel rows oriented to the sun and honoring the dead. The plaza of the East Coast Memorial is commanded by a great bronze eagle at the highest point of the plaza. The eagle, sign of resurrection, alights on a rectangular base, its talons clutching a funerary wreath, the symbol of victory over death, its proud head and feathered tail pointing across the Upper Bay to the Statue of Liberty, toward which the entire monument is oriented. From the eagle, the focal point of the memorial space, the plaza slopes gently toward the promenade along the bay and more steeply to the path into the park, emphasizing the rise of the earth, symbolic of the grave, from which the eagle surveys the memorial site.

GRANITE MONOLITHS

The name, rank, organization, and state of each of the 4,596 Americans who died in the Atlantic during the war are inscribed on the faces of the granite monoliths. Viewed from the promenade along the bay, the skyscrapers of the financial district are a backdrop whose shapes echo the great granite steles that carry the names of the martyrs memorialized here.

The East Coast Memorial combines a symbolic setting with a record of the 4,596 Americans who died in the Atlantic during World War II.

GEHRON, SELTZER, AND MANCA

The memorial, by architects William Gehron and Gilbert Seltzer and sculptor Albino Manca, was completed in 1963. Manca, who studied art in Rome, where he also taught, came to New York in 1938 to exhibit his sculpture and stayed on. He excelled as an *animalier,* and from 1939, when he exhibited his *Gazelle and Cactus* at the World's Fair in New York City, until well into the 1970s, young and old alike were thrilled by his gazelles, deer, wolves, and tigers. His bronze gates to the zoo in Corona Park in Flushing from 1964 are a masterful composition embodying the animal kingdom in everyday life. Through the sensitive interrelationship of site, symbols, and materials, the architects and the sculptor have produced a monument that evokes contemplation of those who are commemorated here.

The Coast Guard Memorial

Across the lawn to the southeast, the Coast Guard Memorial, also facing the Statue of Liberty, honors the men and women of the U.S. Coast

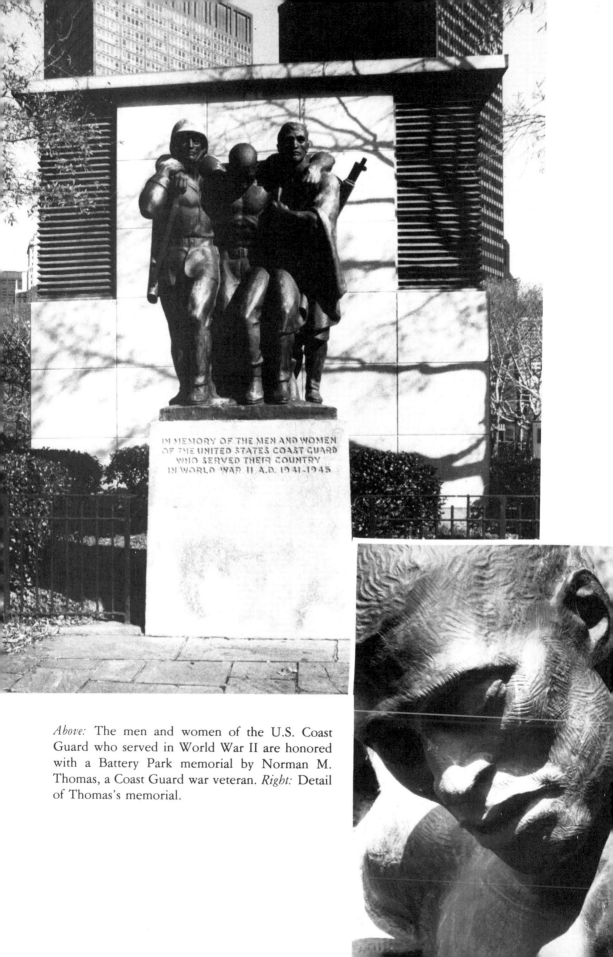

Above: The men and women of the U.S. Coast Guard who served in World War II are honored with a Battery Park memorial by Norman M. Thomas, a Coast Guard war veteran. *Right:* Detail of Thomas's memorial.

Guard who served in World War II. The eight-foot-high bronze group of two servicemen helping a wounded comrade to safety was modeled by Norman M. Thomas, a veteran of the Coast Guard in World War II. Thomas studied at the American Academy in Rome and with Paul Manship at the National Academy of Design in New York City and distinguished himself as an etcher and painter as well as a modeler.

Evocation and Assembly: The Brooklyn Memorial

On June 11, 1944, a contest was announced for designs for a war memorial to commemorate properly the three hundred thousand men and women of Brooklyn who served in the armed forces of the United States in World War II. This boroughwide project was the result of Robert Moses's policy to prevent the practice common after World War I of putting up what he considered too many small and inadequate war memorials.

The winning design by Stuart Constable, chief designer of the Department of Parks, and sculptor Elisabeth Gordon, in May 1945, called for a group of three buildings within a parklike setting, bounded by Tillary, Washington, and Fulton streets and the approach to the Brooklyn Bridge. An auditorium seating two thousand people would provide a space for veterans' organizations to assemble, an administrative building would have facilities for committee and executive functions, and a memorial room would house memorabilia and relics such as battle flags and documents.

The World War II memorial in Cadman Plaza, Brooklyn, was adopted from a design by Stuart Constable and sculptor Elisabeth Gordon, with colossal figures by sculptor Charles Keck.

The names of all the men and women involved in the war were to be recorded in the memorial room. These three buildings were to surround a memorial court with a personification of Victory as its centerpiece.

COMPROMISE RETAINS BALANCE BETWEEN VOTIVE AND UTILITARIAN

Inadequate funds made the winning project impossible to execute. A less costly one was, therefore, selected by designers Stuart Constable, Gilmore D. Clarke, and W. Earle Andrews, working with architects Eggers and Higgins—a single building with auditorium and meeting-room accommodations and an honor roll of Brooklyn's war dead inscribed in the walnut-paneled hall. The Department of Parks developed the landscape around the memorial, and the exterior wall facing a long greensward was selected as a memorial panel for an inscription honoring Brooklyn's veterans flanked by two great figural reliefs by the well-known sculptor Charles Keck, whose civic sculptures include the bronze statue of Father Duffy in Duffy Square and the great pylon figures celebrating Wisdom and Science flanking the entrance to Columbia University at 116th Street and Broadway. Keck's figures for the Brooklyn War Memorial, twenty-four feet high, are the largest relief figures in the city of New York. They consist of a male warrior with a sheathed sword, symbolizing victory and peace, and a woman and child, symbolizing the lasting virtues of human love and family life, values the war was fought to preserve. They flank the inscription "This memorial is dedicated to the heroic men and women of the Borough of Brooklyn who fought for liberty in the Second World War, 1941–1945, and especially to those who suffered and died. May their sacrifice inspire future generations and lead to universal peace."

The memorial panel is of granite, one hundred feet wide and twenty-five feet high, looking out over a long greensward toward Borough Hall. The building is sixty feet deep, and the other three sides of it are faced with limestone.

The memorial is actually a two-story building with ample basement. The upper floor of the building was designed as a memorial hall, seating six hundred people with a speaker's platform and space for memorial flags and mementos of war. Intended for a meeting place for veterans' groups and community gatherings, it is now used primarily for recreational functions. An art gallery is also housed on the main floor. The rooms below are used for games, administration, and parks personnel.

The Brooklyn War Memorial was restored in 1976–77 with funds raised by the Italian Historical Society of America and the Better Brooklyn Committee.

In spite of Robert Moses's efforts to discourage the small memorial,

there are many throughout the city. For example, on Claremont Parkway at Clay Avenue in the Bronx, a bronze plaque set in a granite base commemorates twenty-year-old Sergeant Alvin Shleman, who was killed over Salzburg, Austria, on November 22, 1944. Private Moses Miller, who died at sea on January 26, 1944, is remembered with a bronze plaque on a granite base at Livingston Place between Fifteenth and Sixteenth streets in Manhattan.

The Doughboy

World War I memorials take numerous forms. One type honors the war's hero, the doughboy, easily recognized in uniform moving forward on the battlefield with fixed bayonet, wearing a metal helmet and puttees and carrying a pack on his back. Or he may be ministering to a fallen buddy, mourning a lost comrade, or simply reflecting over the grave of another doughboy. The doughboy got his nickname from the gold-colored buttons on his uniform, which looked very much like the cakes or dumplings the British called "doughboys." The doughboy as an icon of American sculpture came out of the lone Civil War sentries of Martin Milmore and J.Q.A. Ward.

The Doughboy as Hero

America did not require divine descent in its hero of the Great War. It endowed him, however, with strength and courage sufficient to safeguard its values. And the country immortalized the doughboy in bronze statues and reliefs for his heroic virtue of self-sacrifice and for expressing and preserving the human values the nation cherished. Physically attractive, he sometimes looked like a matinee idol, combining contemporary fashion with timeless values. The Richmond Hill Doughboy of 1926, for example, near the entrance to Forest Park at Myrtle Avenue, in Queens, stands bareheaded at the grave of his fallen comrade, expressing the tenderness felt for a lost loved one and one's devotion to another in the contemplation of death and of man's hope for eternal renewal. The bronze figure by sculptor Joseph Pollia is high-waisted, has straight shoulders, quite different from other doughboys, and along with his distinctive hair trim recalls the famous actor Francis X. Bushman, who may have been the model.

William Van Alen, best remembered for his Chrysler Building at

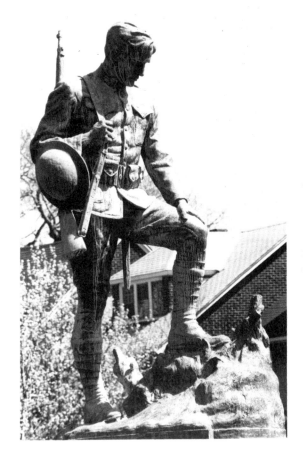

The bareheaded mourning doughboy in the Richmond Hill Doughboy in Forest Park bears a close resemblance to a famous actor of the time, Francis X. Bushman.

Forty-second Street and Lexington Avenue in Manhattan, designed the base of the Richmond Hill War Memorial, which carries an honor roll of seventy-one names, identifying the men from Richmond Hill who served and died and for whom the memorial was erected as "an expression of everlasting gratitude and love."

Abingdon Square Doughboy

Our sculptors, whose training included drawing and modeling not only from the live model, but also from plaster casts and prints of such famous ancient sculpture as the *Laocoön,* the *Dying Gaul,* and the *Borghese Warrior,* as well as of Renaissance and Baroque creations of Michelangelo and Bernini, transformed those models into the doughboy—just as our expatriates had transformed Venus into the *Greek Slave,* an image not only for its age but also of timeless beauty.

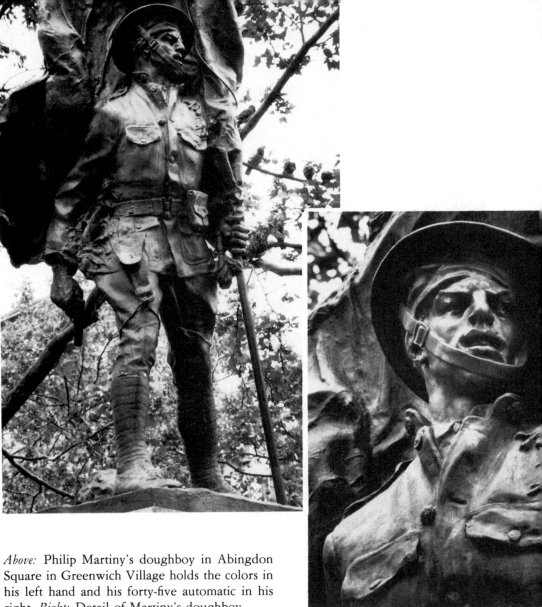

Above: Philip Martiny's doughboy in Abingdon Square in Greenwich Village holds the colors in his left hand and his forty-five automatic in his right. *Right:* Detail of Martiny's doughboy.

In the hands of a Beaux-Arts master of bronze, like Philip Martiny, the doughboy results in a major masterpiece of the genre, such as his 1921 doughboy in Abingdon Square in Greenwich Village. Inspired partly by Michelangelo's *Slaves* in the Louvre, Martiny deftly combines in his doughboy the Renaissance master's rugged athletic quality and his remarkable sensuality. In the viselike grip on his forty-five, the sinews of the doughboy's hand and wrist stand out like piano wires. The way his arm hangs, the torque of his body, and the turn of his head are reworkings from the *Slaves.* The doughboy's furrowed brow and thick sensuous lips, his muscular neck, and smooth chin strap provide Michelangelesque contrasts of

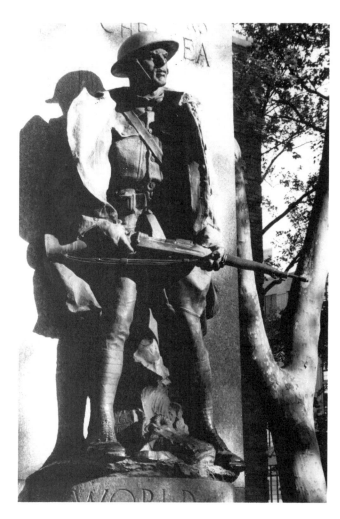

Michelangelo's seminal influence is less pronounced in Martiny's doughboy in Chelsea Park.

animated and calm passages that dramatize the figure's pulsating flesh created by the spontaneously modeled bronze surfaces.

Martiny's doughboy with full lips in Chelsea Park of six years later, although more restrained, continues the notion of the self-involved image that had by then become almost commonplace, and the sculptor uses the same model.

Park Slope Doughboy

Sculptor Anton Schaaf's bronze doughboy (bayonet missing) is drawn from the figures of ancient warriors. It stands on a six-foot-high granite base designed by Helmle and Corbett, architects, in front of the Fourteenth

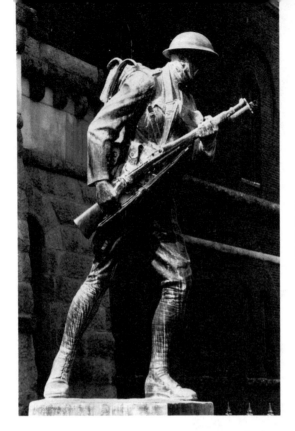

Sculptor Anton Schaaf's doughboy in front of the Fourteenth Regiment Armory in Brooklyn.

Regiment Armory at 1402 Eighth Avenue between Fourteenth and Fifteenth streets in the Park Slope section of Brooklyn. Inscriptions on all four sides of the base commemorate the heroic service and devotion of the men of the Fourteenth Infantry Regiment. The monument is picturesquely and symbolically sited in front of William A. Mundell's heroic red brick Armory Building of 1895, and Schaaf's bronze statue charging forward is a type that was highly popular in the 1920s. The doughboy has lost parts of his weapon to vandals, not uncommon for statues standing in public places. In reliefs, the components remain intact, as in J. Massey Rhind's doughboy relief affixed to the façade of the Twenty-third Regiment Armory at 1322 Bedford Avenue two blocks from William Ordway Partridge's statue of Ulysses S. Grant in Crown Heights.

The Woodside Memorial

Inscribed "Lest We Forget," the Woodside Memorial in Queens at Woodside Avenue at Fifty-sixth Street by sculptor Burt W. Johnson features a bronze seven-foot-tall doughboy on a granite pedestal designed by architect C. N. Kent. Originally called the *Returning Soldier,* this monument was dedicated in 1923.

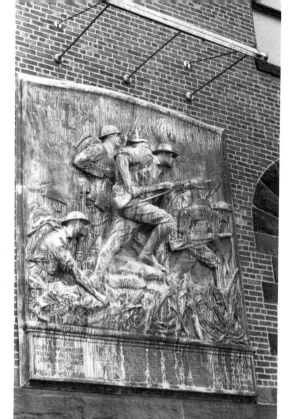

Two blocks from William Ordway Partridge's equestrian monument to Ulysses S. Grant and the Union League Club of Brooklyn, J. Massey Rhind's doughboy is portrayed in relief on the armory façade, charging uphill with fixed bayonet.

DeWitt Clinton Park Doughboy

Six years later Johnson collaborated with Harvey Wiley Corbett, one of the architects of Rockefeller Center, on the "Flanders Fields" World War I memorial in Manhattan's DeWitt Clinton Park, Eleventh Avenue and Fifty-third Street. Dedicated on November 11, 1929, by the people of the Clinton neighborhood as a memorial to the youths who died in World War I, it bears the lines from John McCrae's poem "If ye break faith with those who died / We shall not sleep / Though poppies grow in Flanders Field." Poppies lie at the doughboy's right foot as he stands in reflective contrapposto and with his right hand proffers a small bouquet of poppies to passersby.

The Hiker

One of the best-known monuments of this category of war memorials because of its location a short distance from the ferry landing on Staten Island is the *Hiker* in Tompkinsville Park. By sculptor Allen G. Newman, 1916, it was a very popular type. Many "hikers" are found throughout the country, although slightly different from the Staten Island *Hiker.* It was

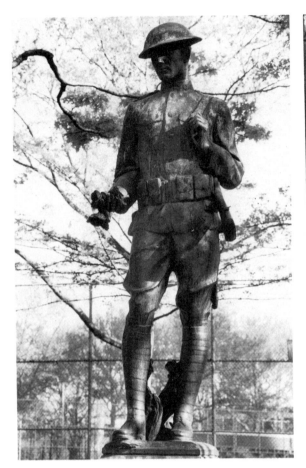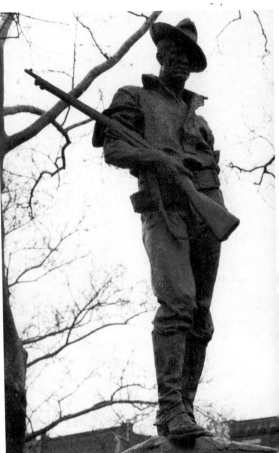

Left: Sculptor Burt Johnson's thin-lipped doughboy in DeWitt Clinton Park holds out a handful of poppies, recalling John McCrae's poem "In Flanders Fields." *Right:* The *Hiker* is dedicated to the veterans of all wars. He stands in Staten Island's Tompkinsville Park near the ferry landing.

dedicated to the veterans of all the wars and was erected through public subscription. The *Hiker*'s rugged naturalism reflects the influence of Newman's teacher, J.Q.A. Ward.

Staten Island's doughboy by George T. Brewster, which stood on its granite pedestal at Pleasant Plains Avenue and Amboy and Bloomingdale roads, was cast by the famous Gorham Foundry. The Pleasant Plains Memorial was dedicated in 1923 to the thirteen soldiers and sailors of the Fifth Ward who died in action, and it carried their names. Now, alas, destroyed.

Victories and Other Doughboys

A bronze doughboy by Augustus Lukeman stands in the Red Hook section of Brooklyn on Van Brunt Street between King and Sullivan streets (1921). Architect Arthur D. Pickering designed the granite base. Lukeman was one of the contingent of academic sculptors who worked in the Beaux-Arts tradition in the 1893 Chicago world's fair. He also carved the figures of Robert E. Lee and Stonewall Jackson on the face of Stone Mountain near Atlanta, Georgia (1926), and he collaborated with F.G.R. Roth on the Kit Carson Monument in Trinidad, Colorado, 1910.

Hermon MacNeil's winged victory at Northern Boulevard near Leavitt Street, 1925, is carved in marble and dedicated to the seventy-seven men of Flushing who gave their lives. MacNeil's victory has an idealized naturalism that prevailed in the great world's fairs—a style that is well represented in his Washington figure on Washington Arch.

Sculptor Max Hausle's missing doughboy of the Highbridge War Memorial at University and Ogden avenues of 1923 honored the veterans of Highbridge with special recognition of the twenty-one men from the community killed in action, whose names were inscribed on bronze plaques also missing.

Two bronze figures were erected in the Bushwick-Ridgewood section of Brooklyn in the same year, 1921, by sculptor Pietro Montana. A doughboy honors the 157 men from the community who served in World War I. Located in Heisser Square Park, where Knickerbocker and Myrtle avenues meet, it is called the Bushwick-Ridgewood Memorial. The base was designed by architect Giles Greene Pollard. The other, the Freedom Square Memorial, a winged victory, is at Bushwick and Myrtle avenues and was erected in memory of the ninety-three men from the Nineteenth Assembly District who died in the war. Their names are inscribed on the granite base, designed by architect William C. Deacy. Four years later Montana's idealized doughboy on its granite pedestal was dedicated to commemorate the 144 men who served from Highland Park in Brooklyn. Called the *Dawn of Glory,* the monument stands at Jamaica Avenue and Cleveland Street.

In 1923, in Monsignor McGolrick Park, at Nassau to Driggs avenues, and Russell to Monitor streets, the Greenpoint Memorial Association dedicated their winged victory by sculptor C. A. Heber to the living and dead heroes of Greenpoint who fought in World War I. And in 1926 James Novelli, sculptor of the victory relief for the Saratoga Park Memorial in Brooklyn at Halsey and Macon streets completed his freestanding victory

for the Winfield Memorial in Queens at Laurel Hill Boulevard and Sixty-fifth Place, dedicated to those from Winfield who died in battle and those who served and returned.

Doughboy Groups

A monument by Karl Illava to the 107th U.S. Infantry stands at Sixty-seventh Street and Fifth Avenue. A gift of the regiment, it portrays seven doughboys, some bareheaded, four with bayoneted rifles, in the act of charging the enemy. The group is a composite of actions all pressed together and interwoven like a colossal tableau vivant. Placed eight feet above the ground, the heroic-scale figures give the impression of charging right over the spectator's head. Adding to the fantasy, the figures do not all share a common ground, and the gestures of the seven soldiers—the way they stand, lean, and move—are lessons that the sculptor learned from his teacher, Gutzon Borglum, whose hallmark was the imaginative composition of many figures, often in complex relationships. The realism of Illava's modeling and composition makes each individual soldier appear to be alive and totally involved in his press forward into battle. He wanted to show the "hell of war," he told his daughter. That Illava was a sergeant in World War I and saw active duty in France no doubt accounts for his convincing realism, which is made even more believable by his use of actual portraits of friends and his self-portrait in hands. For example, the bareheaded doughboy in the center is Paul Cornell, successful New York advertising executive, and all the hands in the group are modeled from the sculptor's own hands.

Born Karl Illava Morningstar, son of a successful starch manufacturer in New York City, he chose to become a sculptor rather than go into the family business, Morningstar-Paisley, Inc. To help maintain his independence, the sculptor retained the old family name Illava and dropped his last name. One of Illava's principal mentors was his uncle George Peixotto, the painter.

Following World War II, when the transverse road through Central Park at Sixty-fifth Street was widened, the monument was moved from Sixty-sixth Street, where it was originally installed, to Sixty-seventh Street and Fifth Avenue, its present location. As the spectator looks west down Sixty-seventh Street from Madison toward Fifth Avenue, Illava's monument becomes a picturesque terminus that arrests the spectator's view with the landscape of Central Park as its backdrop. Fourteen feet six inches wide,

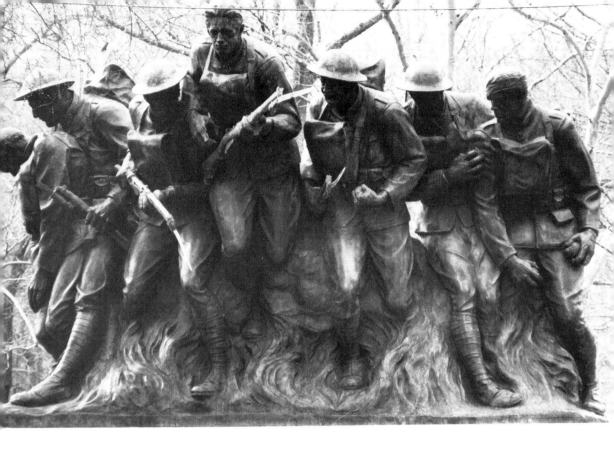

Above: The monument to the 107th U.S. Infantry by sculptor Karl Illava, on the park side of Fifth Avenue at Sixty-seventh Street, shows seven infantrymen on the battlefield in the midst of combat. *Left and below:* Detail of Illava's memorial including self-portrait of Illava's hands.

five feet three inches deep, and nine feet six inches high, the bronze group stands on a granite pedestal twenty-five feet wide, nine feet deep, and four feet five inches high, designed by architects Robert and Hennessey approached by five steps. Inscribed at the base are the words "Seventh Regiment, New York, One Hundred and Seventh United States Infantry, 1917. In Memoriam 1918," and flanking the pedestal are two pylons decorated with carved oak leaves and regimental insignias.

A less tortured and more academic sculpture group on Mosholu Parkway by Irish-American sculptor Jerome Conner and architect Arthur George Waldreaon portrays a bareheaded doughboy with rifle and fixed bayonet standing over a wounded comrade. The American eagle is perched at the base to one side. Opposite the eagle is the wounded doughboy, whose posture is borrowed from the famous ancient sculpture in Rome the *Dying Gaul,* and the central figure standing forms the apex of a pyramid. Combining academic poses into a stable pyramid is a characteristic of the Beaux-Arts style.

In some of the city's monuments the doughboy is part of a commemorative ensemble. A doughboy and a winged angel of death in bronze, for example, seven feet six inches tall, are the centerpiece of the Prospect Park Memorial. The group personifies the Seventy-ninth Infantry Division's motto, "Until Death," and faces a classical altar, two feet nine inches high, symbolic of sacrifice.

Sculptor Augustus Lukeman and architect Arthur D. Pickering, who had collaborated on the doughboy in the Red Hook Memorial in Brooklyn, designed the monument, located south of the flower garden in the park.

A classical exedra flanks the doughboy, angel, and altar and carries six (one missing) bronze plaques six feet five inches wide and four feet high, which bear the 2,800 names of Brooklyn's honored dead. The monument is set in a yellow brick terrace and is approached by a low granite stair of three steps. Steps are one of the oldest and most notable architectural forms and are traditionally connected with ancestral rites. Symbolically, they open the way from one world to another, establishing a relationship between the two realities.

In Queens a circular temple, a tholos in granite, was commissioned by the Gold Star Mothers of the borough to honor the war dead of Ridgewood. The little Greek temple, located at Myrtle and Cypress avenues, incorporates the doughboy and was designed by Helmle and Corbett, architects of the Bush Terminal Building in Manhattan. These two, individually and in partnership with other architects, designed many commercial, religious, and cultural buildings in various boroughs. The memorial con-

On Mosholu Parkway in the Bronx, a doughboy stands guard over his wounded comrade, a figure borrowed from the ancient *Dying Gaul.*

tains three bronze reliefs by sculptor Anton Schaaf, honoring the army, navy, and air force of World War I. A woman with a torch accompanies a doughboy in the army relief, Neptune is shown with a sailor for the navy, and an aviator is portrayed with a female allegory of the skies.

Gertrude Vanderbuilt Whitney's Washington Heights and Inwood Memorial at Mitchel Square, bounded by Broadway and St. Nicholas near 167th Street, portrays three doughboys on the battlefield trying to help each other in the pitch of battle. Two are wounded, one wears his trench helmet, and two are bareheaded. The heroic figures are modeled naturalistically in a large pyramidlike composition that unites them in their battle for survival and gives the composition stability.

The strained muscles, torn clothing, and battle-worn equipment the doughboys carry that Whitney's naturalistic style describes in detail is set within a restrained and monumental design that enhances the scale and gestures of the sculpture's group.

The monument was unveiled in 1922, and an inscription around the base explains that it was erected by the people of Washington Heights and Inwood in commemoration of the men who gave their lives in World War I. The names of the war dead are cast in twenty bronze tablets around the base. Between the name plaques are smaller bronze reliefs of inverted torches. Traditionally the symbol of life, the torch when inverted symbolizes death. The design of the elegant base and the sensitive siting of the monument are the work of architects Delano and Aldrich. Their distinguished list of buildings in New York City includes the Colony, Union, and Knickerbocker clubs, the Sloane, Straight, and Pratt houses, St. Bernard's School, and the Third Church of Christ, Scientist. The memorial flagstaff near Whitney's sculpture groups was erected in 1941 to the memory of John Purroy Mitchel, after whom the square is named.

"Greater Love"

The sacrifice of one's life for another, whether in war or peace, has inspired a variety of monuments in New York City that express distinct aspects of the human spirit. A common bond of human love and commitment that unites a group of chaplains, a litany of wireless operators, a married couple, and an internationally known journalist produced four quite different monuments—a tree marker, a stele, a fountain, and a bronze relief.

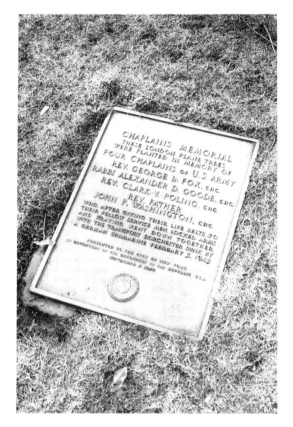

A bronze plaque across the street from the entrance to Riverside Church pays tribute to the sacrifice of four army chaplains who gave their lives for their men.

Chaplains

At 121st Street and Riverside Drive, opposite Riverside Church in Manhattan, is a bronze plaque set in a block of granite, called the Chaplains Memorial. It identifies a grove of London plane trees planted in memory of four U.S. Army chaplains: the Reverend George L. Fox, Rabbi Alexander D. Goode, the Reverend Clark V. Poling, and the Reverend Father John P. Washington, "who after giving their life belts to their fellow servicemen, locked arms and praying went down together with the transport *Dorchester* sunk by a German submarine February 3, 1943."

Wireless Operators

The Wireless Operators Memorial in Battery Park in Manhattan consists of a fountain and cenotaph in yellow granite. A gift of the wireless operators in 1915, it is eight feet ten inches high and designed by architects Hewitt and Bottomley. The monument was erected in memory of wireless

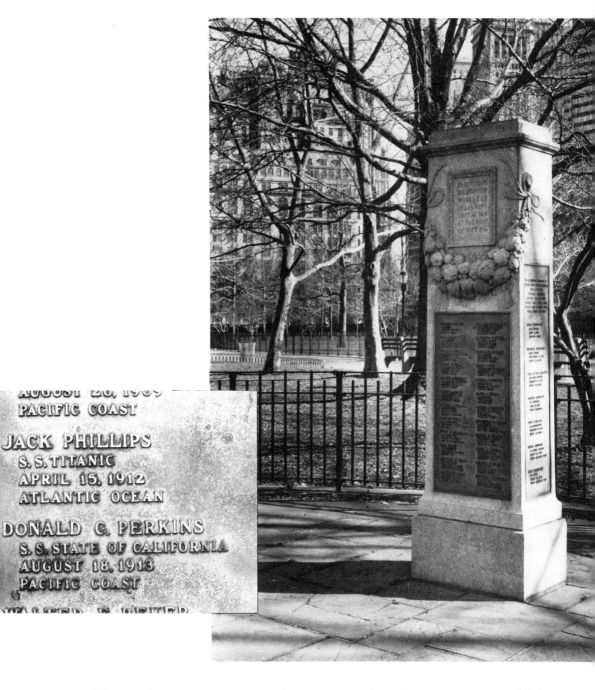

The Wireless Operators Memorial in Battery Park is a living monument, added to each time an operator goes down with a ship. The most recent martyr commemorated was Danilo Stajaragan, who was lost at sea on February 25, 1987, when his ship, the SS *Balsa,* sank in the Atlantic. A ceremony is held each year by the members of the Wireless Operators Fraternity at the monument. *Left:* Detail of the Wireless Operators Memorial.

operators lost at sea who refused to leave their post. Whenever an operator is lost at sea "at the post of duty," a bronze plaque with his name is added to the cenotaph. The most recent martyr to be honored is Danilo Stajaragan, who went down with the SS *Balsa,* which sank February 25, 1987, in the Atlantic. The list of names includes Jack Phillips, who on April 15, 1912, aboard the sinking *Titanic,* made the tragic signal SOS famous.

A Married Couple

A memorial to Isidor and Ida Straus, by sculptor Augustus Lukeman, at 106th Street and Broadway honors a couple who refused to be separated in death when the *Titanic* sank. A bronze life-size personification of Memory reclines along the top of a granite fountain, looking down toward the water as if in contemplation of the past. Ida Straus could have joined the other women in the lifeboats but instead chose to remain with her husband, and they went down together with the ship.

A Journalist

Famed British journalist and humanitarian William Thomas Stead, who also died on the *Titanic,* was last seen helping women and children into lifeboats and is honored with a memorial on Fifth Avenue at East Ninety-first Street. The freestanding statuettes of the personifications of Fortitude and Sympathy that flank the relief portrait of Stead pay fitting tribute to the principal message of his career—peace through arbitration. Stead was on his way to a peace conference, when he was drowned. The bronze memorial, installed in 1920 on the wall enclosing Central Park facing East Ninety-first Street is by the most prominent British sculptor of his time, Sir George James Frampton, R.A., who, besides his many achievements in bronze, terra-cotta, and marble, also served as president of the Royal Society of British Sculptors.

CHAPTER 14

U. S. Grant: His Tomb, His Life, and His Generals

One of the most famous memorials to a president is Grant's Tomb at West 122nd Street and Riverside Drive in Manhattan. It is also perhaps the least appreciated national monument in the country. It is picturesquely sited on a rise along the Hudson River. A grove of Japanese cherry trees; an intimate garden across the street, Sakura Park; Riverside Church, the grand neo-Gothic mass of limestone hovering protectively nearby; a child's grave; several portraits; a statue; and a flagstaff memorial are held together by a common bond of commemoration for a leader who touched the soul of a nation.

Grant was loved and respected by Northerners and Southerners alike, so when he died of the devilish cancer that first attacked his throat, the ground swell of public sentiment produced a drive to erect an appropriate monument to the man the public credited with saving the Union. The Grant's Tomb National Monument Act of 1995 (H.R. 1774), which provides for the completion and perpetual care of the monument, remains in the House of Representatives without being considered.

Duncan's Monumental Design

An open competition was held in 1888 for designs for a tomb. When none was acceptable, a second competition was held in 1890, which included equestrian memorials, temples, and a giant shaft supporting an allegorical figure. New York architect John H. Duncan, whose Soldiers'

Grant's Tomb at West 122nd Street and Riverside Drive, inspired by the ancient tomb of King Mausolus, is the repository of the remains of Ulysses S. Grant and his wife, Julia.

and Sailors' Memorial Arch at the entrance to Prospect Park in Brooklyn had distinguished him, won the commission. Duncan believed that the tomb should convey a sense of monumentality and be rooted in the most substantial tradition of funerary memorials. He therefore drew inspiration from the tomb of King Mausolus at Halicarnassus in Asia Minor, the only fourth century B.C. monument that corresponds in architectural importance to the Parthenon of the previous century. The monument had long since

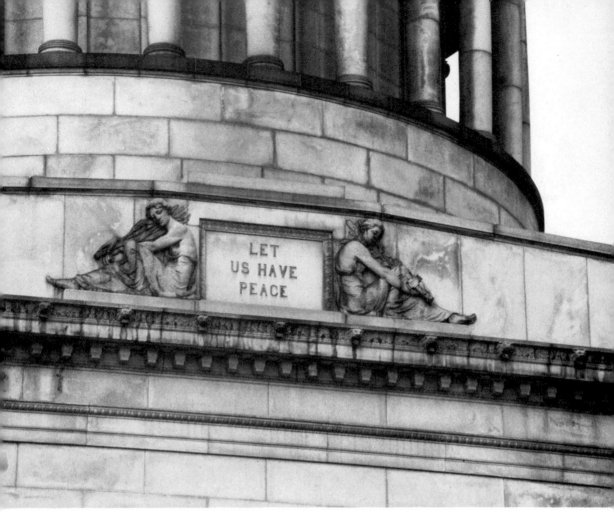

The only sculpture on the building, by J. Massey Rhind, consists of a plaque bearing the words "Let Us Have Peace," flanked by two guardian figures, Victory and Peace.

been destroyed, but excavations of the site, which were a source of excitement into the nineteenth century, uncovered fragments of the structure and much of the sculpture. These discoveries along with ancient descriptions of the structure enabled archaeologists and historians to reconstruct what the structure looked like. The tomb of Mausolus was so large that its name became transformed into "mausoleum," the word used for a category of huge funerary monuments.

Mausolus's tomb was composed of three main parts: a tall, rectangular base, supporting a colonnade of Ionic columns forty feet tall, which in turn supported a pyramid capped by a chariot with statues including that of the deceased. The building was about 160 feet high. An elaborate sculpture program included allegorical and mythological figures and reliefs combined with animals and portraits of the deceased and his ancestors.

Design Changes

Grant's Tomb, completed in 1897, is 150 feet high, made of gray granite, a repository of the remains of Ulysses S. Grant and his wife, Julia. Like Mausolus's tomb, Grant's consists of three levels, a high rectangular base from which rises a cylindrical core surrounded by colossal Ionic columns, which support a conical roof. Although Duncan's original design called for a giant quadriga on top, great eagles at the corners of the base, an allegorical sculpture group in the center atop the rectangular base, and equestrian statues of Grant and his generals, funds were insufficient, so the only exterior figural sculpture retained from the original design is the pair of reclining figures, Victory and Peace, flanking a plaque on which is carved the words "Let Us Have Peace." The figures placed over the main entrance are by J. Massey Rhind, whose others works in New York City include the allegorical figures on the façade of the American Surety Building on Broadway facing Trinity Church at Wall Street, for which he also executed a set of bronze doors, a bronze bust of Dr. J. C. Skene in Grand Army Plaza, Brooklyn, and a standing portrait of Alexander Stewart Webb at the entrance to City College at 138th Street (1917).

To raise funds for the monument, former president Chester A. Arthur and financier J. P. Morgan helped establish the Grant Monument Association. General Horace Porter, Grant's aide-de-camp, became president of the organization in 1892, and Richard T. Greener, one of America's great black leaders, supervised the fund-raising campaign as secretary of the organization.

Greener was the first black man to graduate from Harvard. He then taught at the University of South Carolina at Columbia. Later he became dean of Harvard University Law School and served as American consul to Vladivostok under President William McKinley.

Five Portraits

Even though the scope of the original sculpture program was reduced and Grant's generals were not memorialized astride their steeds above the ceremonious façade of the tomb, the busts of five of his generals were added by the Works Progress Administration in 1938. Sculptor A. W. Mues modeled the busts of Sherman and Sheridan and sculptor J. Juszko the busts of Thomas, McPherson, and Ord. Each of these generals had distinguished himself under fire.

General Edward O. C. Ord came to public attention early in the war,

apprehending General Earl Van Dorn's troops near the Hatchie River in Tennessee, and Grant chose Ord to replace General John McClernaud as head of the Thirteenth Army Corps during the Vicksburg campaign in June 1863. General Ord and General James Longstreet were involved in the early peace negotiations between Grant and Lee.

General James B. McPherson took a leading role in the most severe battle of the Vicksburg campaign—that of Champion Hill, where the Union suffered 2,441 casualties and the South 3,851. McPherson's Army of Tennessee was part of Sherman's machine at the Atlanta campaign in May 1864 to break up the South's vital supply, manufacturing, and communications center of Atlanta. In a daring refusal to surrender, McPherson was shot from his horse by Confederate skirmishers and died instantly on July 22, 1864.

George Henry Thomas was known as "the Rock of Chickamauga" for holding the line there against General Braxton Bragg in September 1863. When Grant told Thomas to hold on, Thomas replied, "We will hold the town till we starve." When he was urged to run for president in 1868, he refused to challenge his comrade and superior, General Grant.

Philip Henry Sheridan, suspended for assaulting a classmate at West Point, was also threatened with court-martial early in his career. But when the war broke out and he was given a command, Sheridan was transformed in a short time into a brilliant tactician, and he became a respected commander. Sheridan's aggressive leadership and tenacity in the face of great odds won him respect in the army and even inspired poets to sing his bravery. At Cedar Creek, for example, when Sheridan's troops were caught off guard, he made his famous charge to rally his troops and lead them to victory, immortalized in Thomas Buchanan Read's poem "Sheridan's Ride." Even Sheridan's courageous steed Rienzi was later stuffed and placed in the Smithsonian Institution. Sheridan pressed on relentlessly in the closing months of the war, defeating General Pickett at Five Forks and cutting off Lee's way out of Appomattox, thus forcing his surrender there.

Sheridan is also honored at Sheridan Square in Christopher Park at Christopher, Grove, and West Fourth streets in Greenwich Village with a bronze portrait statue on a pedestal of Conway green granite by Joseph P. Pollia. The statue was dedicated in 1935.

William Tecumseh Sherman, born in Ohio and educated at West Point, had given up a life as a banker and lawyer he found tiresome and headed up a military school in Louisiana before the war broke out. Reverses marred his early leadership. His engagements, for example, in the first Bull Run campaign, July 1861, were a major defeat for federal forces. He then became embroiled in quarrels with his superiors in Washington and with the press. His fortunes changed in the fierce fighting at Shiloh in

April 1862, where Sherman was wounded and had three horses shot from under him. Both Grant and Halleck commended him for his bold actions. Then followed the long engagements leading to the decisive Union victory at Vicksburg, and finally his famous march to the sea, leaving scorched zones of destruction from Atlanta to the Atlantic, which was designed to cut off the supply lines of the Confederacy. In his commitment to total victory, Sherman is recognized as a pioneer in the notion of total war.

Sherman is the subject of the finest equestrian monument erected by an American sculptor. It is Augustus Saint Gaudens's Sherman Monument at Fifty-ninth Street and Fifth Avenue in Grand Army Plaza dedicated in 1903, discussed in chapter 5. The monument is appropriately placed in the plaza named in honor of and to perpetuate the deeds of the Grand Army of the Republic and the Union forces that brought about the rebirth of the nation conceived in liberty. The Grand Army medal and the shield of the city of New York are placed at the lower corner of the bronze plaque placed there in 1925 in front of the Sherman Monument.

Porter was a logical selection to head up the fund-raising effort. He received the Congressional Medal of Honor for his courage at Chickamauga in September 1863, and he was with Grant at Appomattox where Grant's words set the tone of the surrender: "The war is over, the Rebels are our countrymen again. . . ."

Partridge's *Grant*

Grant was honored with an equestrian monument in Grant Square at Bedford Avenue and Bergen Street in Brooklyn. The bronze statue on a granite base was executed in 1895 by William Ordway Partridge, and the sculpture was dedicated in 1896, a gift to the city by the Union League Club of Brooklyn, whose building across the street bears portrait reliefs of Lincoln and Grant. Partridge infused the sculpture with a kind of pensive vitality that draws the spectator into the general's thoughts. Grant is also shown on his horse in high relief in the Soldiers' and Sailors' Memorial Arch in Grand Army Plaza. Dedicated in 1896, the bronze relief is by William Rudolf O'Donovan and Thomas Eakins.

Mistaken Identity

Hiram Ulysses Grant is known to us as Ulysses S. Grant because his name appeared incorrectly on his class roster at West Point, and instead of changing it, he let it stand. A similar situation dealing with his identity

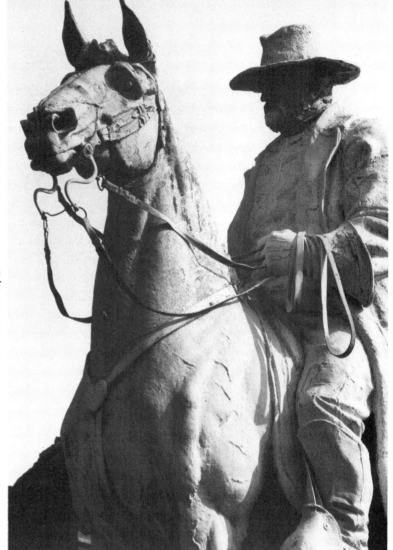

William Ordway Partridge's 1896 equestrian statue of Grant at Bedford Avenue and Bergen Street in Brooklyn captures the rumpled look and contemplative posture characteristic of Grant.

occurred during the Civil War in connection with his picture published in the newspapers.

Until 1863 the only available portrait of Grant was a photograph made at Cairo, Illinois, early in the war, when Grant temporarily wore his beard longer than his usual short clip. By the time he first attracted national attention, his wife, Julia, had him clip his beard, but publishers were unaware of this, and they continued to print portraits of a long-bearded Grant. To confuse matters even more, a beef contractor named William Grant, who looked like the general, had also had his photograph taken at Cairo, and this one was mistakenly submitted to the illustrated weeklies as a second portrait of General U. S. Grant. For two years *Leslie's Illustrated Newspaper* and the *Illustrated News* used both portraits interchangeably, while *Harper's Weekly* relied entirely upon the portrait of the beef contrac-

tor. Those who knew Grant thought it was a great joke. The printmakers were dependent upon the photographers and illustrated newspapers for their likenesses of Grant, and in perfect innocence they perpetuated the inaccuracies. Even as late as 1863 Grant's true appearance was so little known within the army that a photographer in Chattanooga, Tennessee, was selling portraits of U.S. Grant that were not actually of the general. It was not until Mathew Brady made his portrait of Grant, and photographs of Grant were taken in the field, that the general's true appearance emerged.

The Civil War photographs of Robert E. Lee also misrepresented the Southern leader. The photograph with which the public was familiar during the first years of the war, for example, had been taken nine years before the war. So even his uniform was incorrect.

Grant's Early Years

From his youth Grant was an excellent horseman, and he had a gift for mathematics, but at West Point he was not an outstanding student. Following West Point, Grant served in the South until the war with Mexico broke out. He fought in most of the major battles of the Mexican War, and he learned lessons in leadership from Zachary Taylor and Winfield Scott that served him well in the Civil War. Taylor's informal manner and practical approach to warfare taught Grant how to deal with his troops and his officers. Scott was a legend in his own time. His decisive manner and unconventional methods—how he would cut loose from his supply base, for example, if the situation warranted such unusual tactics—were models for many of Grant's unorthodox battlefield decisions. Grant earned Scott's respect, and following the Civil War, Scott presented Grant with a gift inscribed "from the oldest to the greatest general."

Grant's Formula for Success

Following the war with Mexico, uninteresting assignments and a reprimand for drinking led to Grant's resignation in 1854. He failed at a succession of jobs during the next six years—farming, real estate, custom-house clerk. Finally he got a job as a clerk in his brother's leather store in Galena, Illinois, until the firing on Fort Sumter, and he joined up as colonel of a regiment of Illinois volunteers. It was in his assault on Fort Donelson in western Tennessee that Grant issued the famous ultimatum that also

presaged his tenacity throughout the war: "No terms except an unconditional and immediate surrender can be accepted." That ultimatum set the tone of Grant's determined approach to the war, which frequently drew criticism. But Lincoln supported him: "I can't spare this man—he fights."

Grant proved himself in the Civil War as a strategist and tactician. He developed a coordinated plan for the entire military effort. And at the end of the war his dogged determination and the Union's superiority of supplies turned the tide at Petersburg from June 1864 to April 1865: "I propose to fight it out on this line if it takes all summer."

In the final analysis, Grant was the general who succeeded where others had failed at leading the North to victory in the most significant conflict this country ever experienced, a conflict that threatened the foundations upon which the nation had been built—union and freedom. These were issues, distinguished historian Henry Steele Commager has pointed out repeatedly, not only of national significance, but of global importance. That the American Civil War settled the issue of slavery, at least legally, and the question of union partly explains the nation's persistent interest in that war and why the monuments to Civil War heroes continues to hold a profound fascination for us. Not many wars have had such noble goals and consequently such persuasive justification.

The Compassionate Victor

Grant was sensitive and generous to the defeated enemy, and he returned home as the nation's number-one hero and became the leading contender for the presidency, which he won in 1863. His eight years in the White House were marred by corruption of his administration, even though it did not touch him personally. The retirement that followed was first highlighted by world travel and public honors. Then, ill-advised investments and his alcoholism led to financial failure, reminiscent of his years before the Civil War. As Grant was dying, he was even exploited by developers who secured a house for him to live in, to enable him to finish writing his memoirs. If he died there, they reasoned, the house would attract business. The Grant house is a national landmark.

When Grant died, a great outpouring of sentiment flooded the city of New York and produced one of the most spectacular processions ever staged in America. An estimated 1 million people turned out for the funeral procession down Broadway, hanging from windows, standing on rooftops, climbing trees, and crowding sidewalks for a glimpse of the cortege and the catafalque. The procession of sixty thousand marchers stretched seven

miles and took five hours to pass. President Grover Cleveland, his cabinet, the justices of the Supreme Court, and most of the Congress of the United States were in the parade.

Irony in Death

Symbolic of the preservation of the Union, and as if to underscore that the Civil War was indeed over, two Confederate generals, Simon Buckner and Joseph Johnston, were pallbearers at Grant's funeral. Buckner had been Grant's classmate at West Point and was the officer left at Fort Donelson to surrender to Grant early in the Civil War. After the war he went on to become governor of his home state, Kentucky. Johnston, Virginia born, also graduated from West Point and had fought in the Mexican War. In the Civil War he was unsuccessful in stopping Sherman's march to Atlanta, thereby losing his command to General Hood. Ironically, Johnston died from pneumonia contracted from standing hatless in the rain at the funeral of General Sherman.

Fond Remembrance

On completion of the monument in 1897, Chinese Secretary of State, Li Hung-Chang donated a ginkgo tree marked by a memorial tablet of bronze set in a granite plinth at Riverside Drive, north of Grant's tomb. An inscription in both English and Chinese explains that the ginkgo tree commemorates Grant's greatness, and that it is planted by Li Hung-Chang as "Guardian of the Prince, Grand Secretary of State, Earl of the First Order Yang Yu, Envoy Extraordinary and Minister Plenipotentiary of China, and Vice-President of the Board of Censors Kwang Hsu 23rd year, fourth moon, May 1897." The ginkgo tree is native to eastern China and has apparently been preserved from ancient times in China as a temple tree.

A flagstaff pedestal with bronze plaque set in a granite base on Grant's Tomb terrace at Riverside Drive at 122nd Street erected in 1939 honors Brigadier General Horace Porter, Grant's aide-de-camp and military secretary, who later served as U.S. ambassador to France. The memorial to Porter is appropriately placed near Grant's Tomb because as president of the Grant Monument Association in 1892, he was a key figure in raising funds for erecting the tomb. But his book, *Campaigning with Grant,* published the same year Grant's Tomb was completed, is his finest memorial and provides an indispensable view of the way Grant conducted the war.

CHAPTER 15

Four Generals and Their Sculptors

The General and the Opportunistic Sculptor

Winfield Scott Hancock was one of the most skillful Union generals in the Civil War. He was conspicuous as the leader of the Second Corp at Gettysburg and foremost in repulsing Confederate attacks—notably Pickett's charge on July 3, 1863, which helped turn the impending defeat at Gettysburg into victory. A democratic presidential candidate in 1880, he ran unsuccessfully against James A. Garfield.

The bronze bust of Hancock in Hancock Square at Manhattan Avenue and 123rd Street is by James Wilson Alexander MacDonald, who also did the seated portrait of Fitz-Greene Halleck at the southern end of the Mall in Central Park and a colossal bust of Washington Irving in Prospect Park in Brooklyn. Born in Ohio, MacDonald grew up in St. Louis in the first half of the nineteenth century and studied sculpture and anatomy there. He never left the United States, and he settled in New York City, where he developed a prolific business in sculptural replicas of famous people. MacDonald claimed to own Jean-Antoine Houdon's original model for the bust of George Washington, which greatly enhanced his replica business.

MacDonald's financial success in portraiture was due in part to his selection of well-known and popular figures of the 1860s, 1870s, and 1880s. The bust of Hancock, for example, was probably cast from a model he made when Hancock was the Democratic presidential candidate in

1880. Although Hancock lost to James A. Garfield, it was a close election, and Hancock was a popular candidate, the kind of subject that enhanced MacDonald's already lucrative business.

Henry Baerer's Two Generals

General Kemble Warren

Another key figure at Gettysburg, Gouverneur Kemble Warren, is honored with a statue in Grand Army Plaza in Brooklyn, executed by German-born sculptor Henry Baerer in 1896.

After victory at Chancellorsville, Robert E. Lee embarked on the second invasion of the North by way of the Shenandoah Valley in southern Pennsylvania. The two armies met just west of Gettysburg. On July 2, 1863 the Confederates' assault on Round Top, Little Round Top, and Cemetery Hill failed. On July 3 Lee sent G. E. Pickett's division against the Union's center, but it was beaten back. These defeats, and Lee's withdrawal on July 4, marked the turning point of the war.

An army engineer by training, Warren's principal achievements before the Civil War were explorations he conducted west of the Mississippi

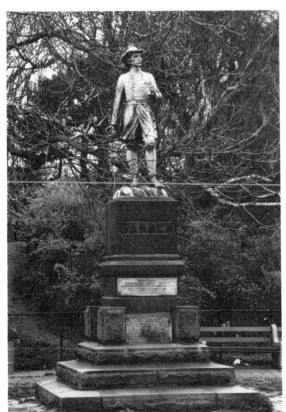

Sculptor Henry Baerer's 1896 bronze statue of Gouverneur Kemble Warren, portraying one of Grant's heroes at the Battle of Gettysburg, stands in Grand Army Plaza in Brooklyn.

Warren's pedestal contains stone from the battlefield of Gettysburg, where Warren fought and Lincoln delivered his brief but memorable address.

between 1855 and 1858. As a general during the Civil War, however, he distinguished himself in the prolonged fighting near Richmond, Virginia, June 26 to July 2, 1862, and he has been credited with saving Round Top and Little Round Top at Gettysburg. It is appropriate, therefore, that the pedestal for Baerer's statue of Warren includes stone quarried from Little Round Top. This is not an uncommon practice with memorials. It makes the monument a kind of reliquary and imparts to the base a sacrosanct value and unique significance.

General Edward Fowler

A second Civil War monument by Baerer, dedicated in 1902, honors Brigadier General Edward Fowler from Brooklyn. Fowler joined the Regular Army as a youth, fought in the Mexican War, then returned to civilian life but remained active in the state militia, heading up the Fourteenth Regiment. When the Civil War broke out, Fowler distinguished himself as a fearless soldier and astute tactician, and led his "Red-Legged Devils" through twenty-two major battles to honor and national fame. Deriving its name from the red puttees its members wore, Fowler's regiment was known for its courage and daring. Reported killed at the Battle of Bull Run, Fowler often recalled the feeling of profound relief he had on reading his own obituary.

Following the Civil War, Fowler retained command of his regiment as the Fourteenth National Guard. He entered public life and served as a customs official and representative of the Eleventh Ward to the Kings County Board of Supervisors, and as president of Brooklyn's War Veterans Association.

Fowler was popular with the public and respected by civilian and military officials. When he died in 1896 the citizens of Brooklyn established a memorial committee to erect a monument to honor his bravery and

Baerer's bronze statue of Brigadier General Edward Fowler, dedicated in 1902, stands at the junction of Fulton and Lafayette streets and South Elliott Place.

courage. Baerer was commissioned to make a standing portrait of Fowler in his Civil War uniform. The bronze figure stands seven feet eleven inches high; the granite pedestal is nine feet eleven inches and bears the names of all the battles in which Fowler fought. The monument was erected in 1902 in Fort Greene Park below the Prison Ship Martyrs' Monument on the slope leading toward DeKalb Avenue. By the mid-1960s the statue was extensively vandalized and even toppled from its circular granite base.

A group of citizens generated enough interest and funds to have the monument restored and erected in 1975 in its present location in Lafayette Square at Fulton and Lafayette streets and South Elliott Place. The location is especially appropriate because Fowler lived in that Brooklyn neighborhood for more than sixty years.

The Academic Sculptor and the Veteran College President

The General

The influence of J.Q.A. Ward's restrained naturalism on J. Massey Rhind (1860–1936) is evident in Rhind's portrait statue of Alexander Stewart Webb, major general and commander of the Philadelphia Brigade at Chancellorsville and Gettysburg. He was president of City College from 1869 to 1902. When he died in 1911 the alumni raised funds to erect a monument to him in 1917.

Located at Convent Avenue near the entrance to City College at 138th Street, the eight-foot-tall statue is appropriately sited, and its base reflects Rhind's expert sense of architectural decoration in the elegantly modeled terra-cotta base and pedestal. The general stands akimbo, the breeze having gently lifted the end of his coat from his right leg, placed forward on the plinth. Unfortunately, all that is left of Webb's scabbard is a remnant upon which his left hand rests, and the sword once held in his right hand disappeared long ago.

The Sculptor

Having been trained as a decorative sculptor in his native Edinburgh, Scotland, Rhind then studied with Jules Dalou in London and worked with him in Paris in the 1880s. He came to the United States in 1889. He distinguished himself in his first major commission, architectural decoration

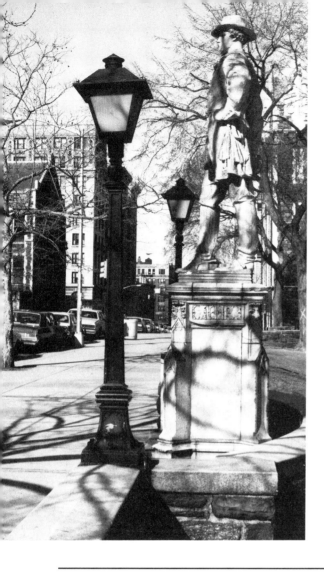

Rhind's vandalized standing portrait of Civil War general Alexander Stewart Webb watches alertly at 138th Street near Convent Avenue on the campus of City College, where Webb served as president.

for the General Theological Seminary on West Twenty-first Street in New York City and the bronze doors for the chapel. Then, as one of the three winners for the three sets of bronze doors for Trinity Church in New York City, Rhind was brought to the attention not only of the public, but—more important for his career—of architects and patrons who were commissioning art. He excelled in architectural decoration and monumental sculpture. His figures for the American Surety Building of 1895, robed female personifications of Peace, Truth, Honesty, Fortitude, Self-Denial, and Fidelity, across the street from Trinity Church, are reminiscent of the caryatids on the porch of the Erechtheum on the Acropolis in Athens. Other caryatids include those at the fourth floor of the Park Row Building at 15 Park Row between Ann and Beeckman streets, 1899, R. H. Robertson, architect.

CHAPTER 16

Vigils to the Victors

A Union Tholos

The Soldiers' and Sailors' Monument in stone at Eighty-ninth Street and Riverside Drive provides a permanent vigil to those patriots who died in the service of the Union during the Civil War. The design by brother architects Charles W. and Anthony A. Stoughton, won in a competition of 1897, was for a monument to be erected at Fifty-ninth Street and Fifth Avenue. By the time construction started in 1900, however, the site was changed to its present location.

Heroes Honored

It was formally dedicated on Memorial Day, 1902. The grand eagles, sculptural relief, and ornamental carving were executed by sculptor Paul Duboy. Around the top of the structure is inscribed in bold letters, "To the Memory of the Brave Soldiers and Sailors Who Saved the Union." A bronze plaque set into the front steps commemorates the valor of those remembered there, and the New York volunteer groups are listed. Around the monument the names of heroes and battles include Farragut at New Orleans, Fair Oaks, and Malvern Hill; Sherman at Gettysburg, Chick-

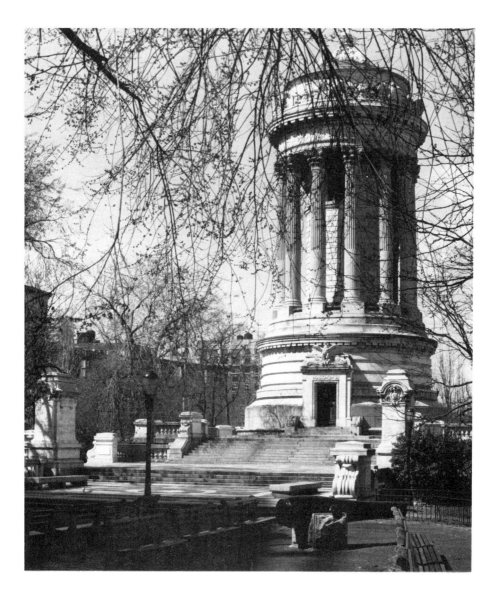

The Soldiers' and Sailors' Monument at West Eighty-ninth Street and Riverside Drive, by Stoughton and Stoughton, architects, honors the Union martyrs.

amauga, and Cold Harbor; Porter at Five Oaks, Petersburg, and Appomattox; and Worden, Cushing, and Taylor.

The Form

Constructed of white marble, the form of the monument is a tholos— that is, a circular Greek temple. The tholos became popular in America in

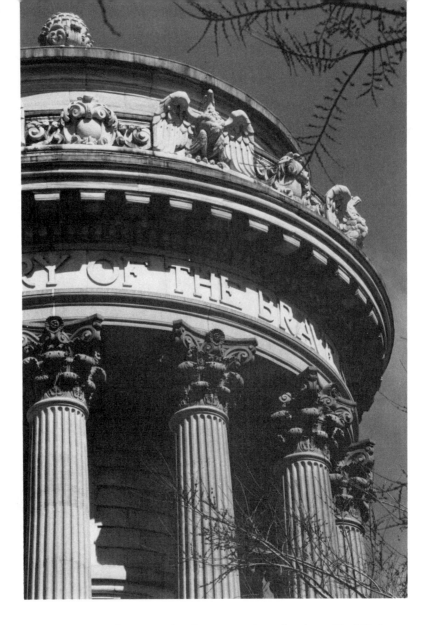

The monument, featuring the elegant carving of sculptor Paul Duboy, was restored in the early 1960s.

part because of Thomas Jefferson, who drew inspiration for the Hall of Representatives in the U.S. Capitol from a most famous tholos in Athens—the Choragic Monument of Lysicrates (fourth century B.C.), which subsequently influenced the work of many other architects and builders in the United States. Its circular form made the tholos uniquely suitable for housing the bells on top of churches and for concealing the barrellike water tanks on top of apartment houses and office buildings, and the tholos's classical columns provided a structure that was attractive.

A colonnade of twelve Corinthian columns surrounds the central compartment of the Soldiers' and Sailors' Monument. The diameter at the base is fifty feet, and the surrounding esplanade is one hundred feet in diameter. The monument is one hundred feet high. The interior chamber is of polished marble. It is ornamented with rich carving and contains five niches originally intended for bronze statues, which were never executed.

Steel Shaft Rejected in Favor of Restoration

By the 1950s, a half century of polluted atmosphere, seacoast winters, and natural weathering had produced progressive deterioration of the marble, which threatened the entire structure. When pieces of marble began to fall from the columns and the architraves, it was apparent that immediate action was imperative to save the monument and to protect the public. In August of 1960 the Parks Department undertook a full-scale restoration.

Carvers and restorers shaved down the deteriorated surfaces of the marble walls to provide the structure with an entirely new façade. The marble capitals and architraves, said to be too extensively deteriorated to be recarved, were replicated in Vermont granite.

A year before the restoration began, an alternative plan was presented to Mayor Robert F. Wagner to replace the Soldiers' and Sailors' Monument with a twelve-story illuminated steel shaft set in a memorial plaza. In declining the offer, the city emphasized its commitment to restoring the Soldiers' and Sailors' Monument as well as other historically and architecturally important structures.

The Soldiers' and Sailors' Monument in Queens

Located at Hillside Avenue at 173rd Street, the monument was designed in 1896 by Frederic W. Ruckstull, one of America's leading sculptors at the turn of the century.

In 1895, while he was working in New Rochelle at the farm of a friend on an equestrian statue of General John F. Hartranft for Harrisburg, Pennsylvania, Ruckstull worked out the design for the Queens monument. It consists of a bronze angel ten feet tall standing on a granite pedestal ten feet high. The angel is a personification of Peace. She holds a laurel wreath in her left hand, the traditional symbol of victory, and a palm bough in her

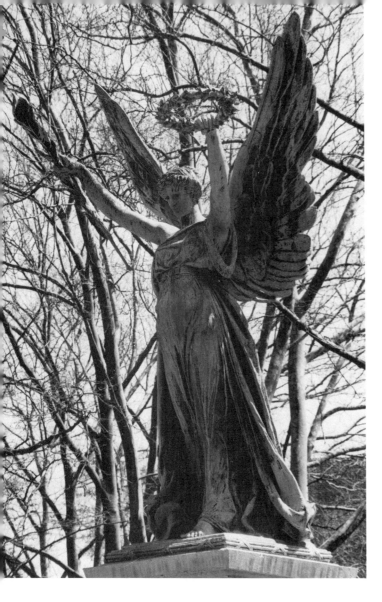

At Hillside Avenue and 173rd Street the *Angel of Peace* by sculptor Frederic W. Ruckstull, 1896, commemorates the Union's soldiers and sailors of Queens who died in the Civil War.

right hand, symbol of strength. The monument was originally located at the intersection of Merrick Boulevard and Hillside Avenue, but because of increased traffic at the junction, it was moved in 1958 to where it now stands, two blocks west of its original site.

Ruckstull's Angel

It is noteworthy that the angel for the Queens Soldiers' and Sailors' Monument was one of the sources for Ruckstull's monument to the South Carolina Women of the Confederacy fifteen years later in 1911, which stands on the grounds of the State House at Columbia, South Carolina.

Even though the later work has several figures, the stance and the wreath, wings, and drapery of the angel emphasize its derivation from the Queens monument.

The Sculptor

Ruckstull's parents immigrated to the United States from France when he was two years old and settled in St. Louis, Missouri, where he grew up. Classes at Washington University and membership in the St. Louis Sketch Club inspired him to study at the Académie Julian in Paris, where the academic style attracted him and the art of the avant-garde sculptors and painters repelled him. He returned to America and settled in New York City, where he became a founding member of the National Sculpture Society, which controlled the major sculpture commissions in the country for decades. He won a medal in the Columbian Exposition in 1893. An outspoken critic of Rodin, Matisse, Brancusi, Picasso, Cézanne, and Archipenko, he lectured and wrote in defense of academic art, and he was an editor of *The Art World,* founded in 1916. He was a moving force behind the grand sculpture projects of the period. He was, for example, in charge of the sculpture program for the Dewey Arch, director of sculpture for the Louisiana Purchase Exposition in St. Louis, and was chosen to do the quadriga atop the U.S. Government Building, "Welcoming the Pan-American Nations," for the Pan-American Exposition, and he organized and directed the Appellate Court Building sculpture program at Madison Avenue and Twenty-fifth Street. His figures in that program, personifications of Wisdom and Force, reflect the influence of Michelangelo's *Moses* in Rome and the Medici Tomb portraits in Florence. His more restrained *Phoenicia* for the Custom House across from Bowling Green was done while he was in Paris. Ruckstull did a number of Civil War monuments for the North and the South.

CHAPTER 17

Icons of the Civil War

The Gettysburg Address

The Union's victory at Gettysburg was a turning point in the Civil War. Important enough was the place that on November 19, 1863, four and a half months after the battle, a Civil War Cemetery was dedicated there. Many distinguished guests attended the ceremony. One of the nation's leading orators, Edward Everett, statesman, scholar, and university president, spoke for almost two hours.

No one today remembers Everett's speech, but everyone remembers the Gettysburg Address delivered by Abraham Lincoln. Ironically, most people at the time thought his address was dull and commonplace, except for three people—Everett, who acknowledged Lincoln's eloquence and insight in a brief note to the president the next day, a Chicago newspaper reporter, who prophesied correctly that Lincoln's remarks would live forever, and J. G. Batterson, who published the address as a literary master-piece long before it was considered one. Lincoln's grief for the fallen soldiers and his recognition of the principles for which they died were embodied in memorable phrases that are among the most quoted speeches in any language. Lincoln's simple and direct words carried his conviction that the sacrifices of the war would assure "that government of the people, by the people, for the people, shall not perish from the earth."

The Gettysburg Address is inscribed on numerous public buildings. At

the northeast corner of Borough Hall in Brooklyn at Fulton and Court streets, a bronze tablet is affixed to the wall of the building. Dedicated in 1909, it carries the Gettysburg Address with a bas-relief portrait of Abraham Lincoln.

The Gettysburg Address is also found in many of the city's schools. At P.S. 17 in Brooklyn, located at Driggs Avenue and North Fifth Street, for example, and at Newton High School on Gerry Street in Queens, bronze tablets with the address were installed.

In Brooklyn, for example, on the wall of the Fourteenth Regiment Armory, Eighth Avenue between Fourteenth and Fifteenth streets, a few paces from Schaef's doughboy, a memorial tablet of granite incorporates a stone from the battlefield at Gettysburg as a kind of reliquary. The inscription reads: "Gettysburg/All of which I saw part of which I was/This stone/From the battlefield of Gettysburg/Presented by/The Fourteenth Regiment War Veterans/1894."

Echoes of Gettysburg and Antietam

A Civil War memorial in Calvary Cemetery at Laurel Hill Boulevard and Borden Avenue in Queens, erected by monument maker John G. Draddy, looks as if it belongs in a public park. Its presence here reminds the visitor that cemeteries in the nineteenth century were our first public parks and sculpture gardens, where families came regularly for recreation and to commune with deceased members of the family. Draddy's bust of Irish poet and satirist Thomas Moore stands in Prospect Park. The bust of Moore was erected by the St. Patrick Society of Brooklyn to mark the centenary of the birth of the Irishman who was "the poet of all circles and the idol of his own," who gave us "Believe Me If All Those Endearing Young Charms."

Draddy's Civil War monument was erected in 1866 by the city of New York. It consists of a forty-foot-high granite obelisk supporting a bronze symbol of peace. Bronze ornaments originally applied to the base and at the four corners of the base have been vandalized or stolen. Standing on individual bases are four life-size bronze statues in the different uniforms of the Union. Four cannon once marked the corners of the monument. Surrounding the memorial is an iron fence in need of repair enclosing the plot, thirty-six feet square. Bronze eagles with widespread wings once stood at the corners of the plot on granite pedestals. The design of the monument is in part indebted to J. G. Batterson, whose obelisk to General

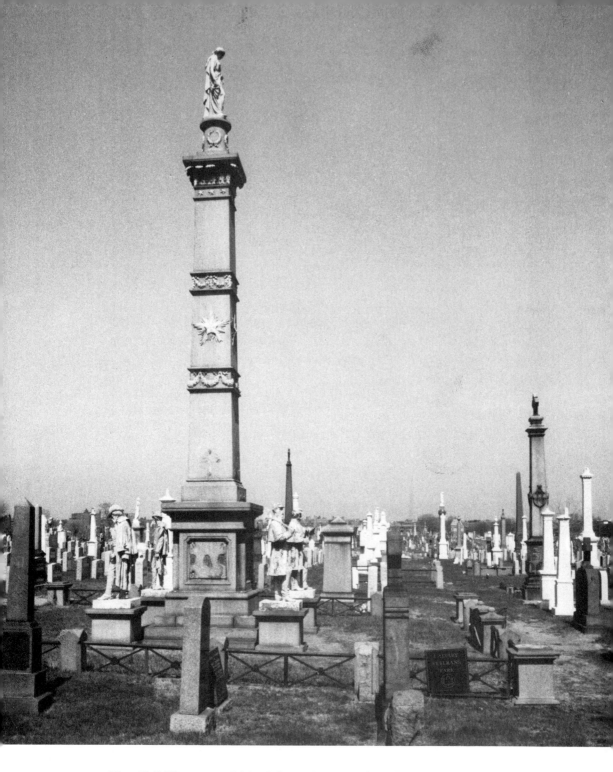

The Civil War memorial in Calvary Cemetery by John G. Draddy was conceived as an environment—an enclosure with life-size sculpture and military trophies surrounding an obelisk with allegorical figure.

Bronze figures of Civil War soldiers survey the headstones at Calvary Cemetery.

Worth was erected in 1857 and whose monuments at Gettysburg and Antietam were famous.

A Schoolhouse Between Two Trees

A shaped boulder at Forty-eighth Avenue and 216th Street in Queens commemorates Captain William Dermody, the first Union soldier from Bayside to lose his life in the Civil War. Dermody, who served with the Sixty-seventh Regiment, New York Volunteers, was killed in action at Spotsylvania, Virginia, during the wilderness campaign. At the close of the war, his sister and brother-in-law, Mr. and Mrs. James O'Donnell, set aside

a plot of ground from the O'Donnell farm as a memorial to Dermody. A one-room schoolhouse stood on the site, the first public school in that part of the North Shore. When peace was declared, citizens of Bayside held ceremonies at the school and planted a tree on either side of the schoolhouse, a maple for the North and a sycamore, "cotton boll," for the South. The schoolchildren were an integral part of the tree-planting ceremonies. In their wisdom, the Bayside citizens saw in the children the hope of a better Union through education, symbolized by the schoolhouse between the two trees.

Seventy years later the trees were dying, and the little schoolhouse had long since disappeared, when Public Works Commissioner John J. Halleran unearthed the history of the park and generated renewed interest in perpetuating what had been begun at the close of the Civil War.

In a rededication on Memorial Day, 1935, two new trees were planted amidst a costume pageant replicating the original tree-planting ceremony. Many members of that 1935 cast were descendants of the grown-ups and children who planned and carried out the first tree planting. The focus of the ceremony was a great boulder placed to mark the site of the schoolhouse. Bearing the simple line "For a better Union 1861–1865," the boulder was unveiled by veteran representatives of the Union and the

A shaped boulder in Bayside, Queens, commemorates that community's first Union casualty and marks the site of its first public school.

Confederacy as the children from P.S. 31 sang appropriate songs, closing with "The Star-Spangled Banner."

By the 1970s the memorial had been neglected and all but forgotten. Then Bayside residents and descendants of Captain Darmody rekindled interest in the memorial once again and on Memorial Day, 1973, rededicated Darmody Square.

The *Lone Sentry*—Icon and Model

The *Lone Sentry* by John Quincy Adams Ward, which stands on the West Drive opposite Sixty-seventh Street in Central Park, and a similar figure by Martin Milmore in Forest Hill Cemetery in Boston became the models for countless Civil War monuments throughout the country.

Ward's monument was commissioned by the Seventh Regiment National Guard to commemorate the fifty-eight men from the New York Regiment who died in the Civil War. A lone soldier of the Seventh Regiment on guard duty rests the butt of his rifle on the ground. Ward's design was to convey the vigilance and virtue for which the regiment was proudly known.

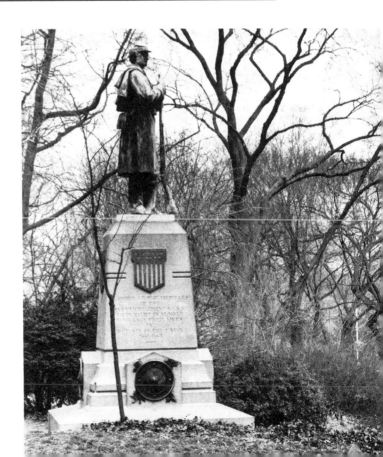

J.Q.A. Ward's sentry of 1869 in Central Park was the model for many other Civil War memorials throughout the country and a source of the doughboy of World War I.

Steele MacKaye, a well-known actor, playwright, theatrical designer, and inventor, a friend of Ward's, was the model for the figure. He was also the model for the *Shakespeare* in Central Park. Ward's statue was finished in 1869, but it was not unveiled until June 22, 1874, because of the many revisions in the design of the pedestal by architect Richard Morris Hunt. Hunt's original design created an environment of which Ward's statue was a part. A plaza, elegant stairs and balustrades, and sculpture groups surrounded the sentry. The ensemble was gradually simplified to the final version that now stands in the park. A granite base and tapered pedestal are faced with cast-bronze plaques and carved inscriptions. Bronze roundels with fasces and laurel, symbols of war and victory, bear the motto of the regiment—"Pro Patria et Gloria"—on all four sides, which also bear shields with stars and stripes. The dedication "In Honor of the Members of the 7th Regiment . . ." is inscribed in the granite.

The model for Ward's sentry was actor Steele MacKaye, who also modeled for Ward's Shakespeare statue in Central Park. A copy of *Shakespeare* was made in 1986 for the Carolyn Blount Shakespeare Theater in Montgomery, Alabama.

Henry Ward Beecher—Living Icon

The standing bronze statue of Henry Ward Beecher in Plymouth Church in Brooklyn is by Gutzon Borglum. The statue stands on a granite base with two seated slave children. One of the children is no doubt Rose Ward. During his sermon on February 5, 1860, Beecher auctioned off a ten-year-old black slave girl from Washington, D.C., to his congregation for $1,000 so that she would not have to go back to her owner. In the collection box was a ring given by a woman by the name of Rose Terry. Beecher placed the ring on the child's finger, calling it her freedom ring, and christened the former slave Rose Ward, after Rose Terry and himself. The Plymouth Society then sent Rose Ward to Howard University, where she completed her studies. In 1928 Rose Ward returned to Plymouth Church to tell the story of her emancipation there sixty-eight years before.

Three weeks after Rose Ward was freed, Abraham Lincoln delivered his historic speech at Cooper Union in Manhattan at the invitation of Plymouth Church. Lincoln attended service at Plymouth Church the day before to acknowledge his invitation. The pew is marked by a silver plaque, and his likeness is placed on the wall in the garden outside.

In 1914, the year after the addition of the present church house and gymnasium and the connecting arcade were completed, a bronze statue of Henry Ward Beecher and a bronze relief of Abraham Lincoln as he sat in pew 89 on February 21, 1860, were considered appropriate additions to the garden facing Orange Street. The ten-foot-high standing portrait statue was set within a classical aedicule of stone against the red brick of the arcade wall and the Lincoln relief portrait was set within the relieved arch to the left of the statue.

The monument was unveiled on October 19, 1914, by two of Beecher's great-granddaughters. Behind Beecher's monument within the passageway of the arcade are notable memorabilia: portraits of the ministers who followed Beecher, a piece of Plymouth Rock, a painting portraying Rose Ward being auctioned off by Beecher, and, almost unnoticed at the end of the hallway, the most sensitive portrait bust yet rendered of Henry Ward Beecher. Less than a foot high, it was modeled by sculptor R. J. Morris on the tenth anniversary of the end of the Civil War and executed in Parian ware by W. T. Copeland and Sons in Stoke Upon Trent in 1875, for Ovington Brothers in Brooklyn.

J.Q.A. Ward's Beecher

J.Q.A. Ward's monument to Beecher stands eight feet high on a black granite pedestal designed by Richard Morris Hunt. The three youths, two whites and one black, flanking the base and rendered life-size attract the spectator to participate in paying tribute to the "Great Apostle of the Brotherhood of Man," as inscribed on the base. The black girl stands alone and lays a palm of gratitude near where Beecher stands, the platform no doubt where he auctioned off Rose Ward, possibly symbolized by this figure.

The ample macfarlane with its full folds draped easily about the preacher's bulk is an effective surrogate for the body of the animated preacher who commanded an auditorium with twenty-five thousand people. The full head of hair slightly tousled and concealing his neck frames a likeness known only in death. Ward modeled the portrait from a death mask and photographs and set it within a noble composition. The sculptor's monument is a reminder of Henry Ward Beecher and the principles for which he stood that would ennoble the lives of multitudes for generations to come.

The monument was unveiled on June 24, 1891, to a throng of more than fifteen thousand spectators, in the park in front of Borough Hall. In 1959 it was relocated to its present site in Cadman Plaza.

The Beechers

Henry Ward Beecher, son of Lyman Beecher, Protestant minister and founder of the American Bible Society, was the most charismatic preacher in America, as well as a mighty abolitionist and force for temperance and women's suffrage. He embraced Darwin's and Spencer's theories of evolution, and a charge of adultery never proved was unable to stop him. His sister Harriet Beecher Stowe was equally dedicated to social reform, and her novel *Uncle Tom's Cabin, or Life Among the Lowly* (1851–55) fanned abolitionist sympathy. Catherine Beecher, another sister, contributed to a transformation in domestic architecture in America. Her designs, published in 1869, providing a place and space for everything, began a tradition in the American home that Frank Lloyd Wright, born that year, would in the next century raise to a fine art in his so-called prairie house.

Already known through his preaching and writing, Henry Ward Beecher was called as minister to Plymouth Church in 1847. In less than two years the church burned, and a larger one was completed in 1850 by

J.Q.A. Ward's Beecher monument of 1891 portrays the "Great Apostle of the Brotherhood of Man."

English architect John C. Wells, architect also of First Presbyterian Church in Manhattan at Fifth Avenue and Twelfth Street, finished in 1846. The new building had an auditorium designed especially for Beecher's preaching—without a traditional pulpit. Beecher was a corpulent man and an animated orator who used no notes. He therefore needed no support for lecture notes, but he did need room to move. The present pulpit is a later addition. The new, enlarged church would accommodate 2,500 people, and Beecher filled the auditorium every time he spoke, from 1847 until he died forty years later.

Beecher's ministry made Plymouth Church a center of antislavery sentiment. The fiery preacher even sent rifles to an antislavery group in Kansas to help them in the fight to keep Kansas a free state. The shipment was disguised in boxes marked "Bibles," the origin of the term "Beecher's Bibles," meaning rifles supplied to free-soil settlers. His lasting influence, however, came through peaceful measures.

PART VI

Some Notable Masterpieces in Stone and Bronze

CHAPTER 18

The Church of St. Bartholomew

Traveling through southern France in the summer of 1878, Stanford White discovered the church of St. Gilles-du-Gard, and in a letter home he called its "triple marble porch . . . the best piece of architecture in France." The abbé of St. Gilles was apparently delighted with White's intelligence and wit, and White was pleased to find the abbé interested in the architecture of his church: ". . . his sole objective in life being the restoration of his church. It was destroyed by the Huguenots and all the noses knocked off the saints; and I hope they have been well boiled for it." White was impressed with the classical features of the portal: columns, molding, acanthus decoration, and naturalistic sculpture.

Many years later the "triple marble porch" was the model for McKim, Mead, and White's portal for the Church of St. Bartholomew on Madison Avenue and Forty-fourth Street. The Romanesque-style portal was commissioned by the Vanderbilt family in memory of Cornelius Vanderbilt, who died in 1899. Redolent with sculpture in stone and bronze, the portal was designed in 1909 by McKim, Mead, and White for St. Bartholomew's, which had been built in 1872 by James Renwick, Jr., architect of Grace Church on Eleventh Street and Broadway and St. Patrick's Cathedral at Fifth Avenue and Fiftieth Street.

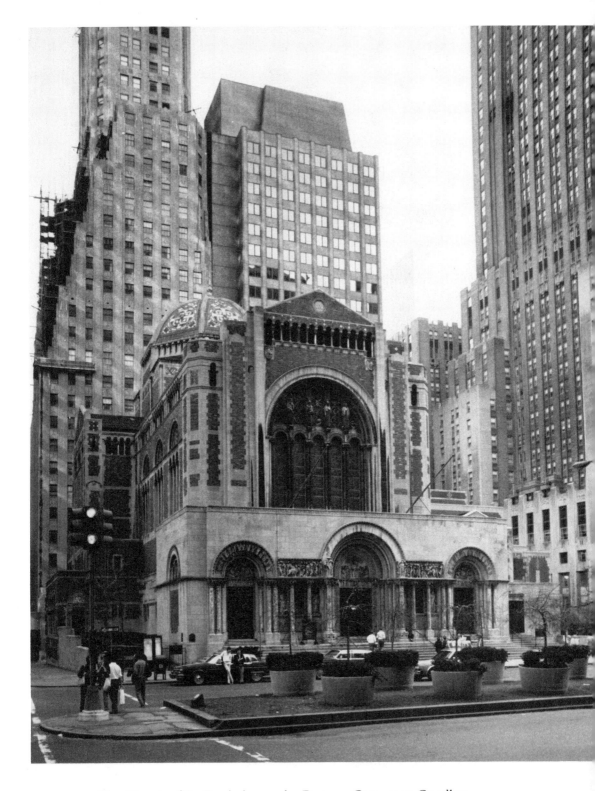

The Church of St. Bartholomew by Bertram Grosvenor Goodhue.

The Vanderbilt Portal—Relic and Centerpiece

Forty-five years after the Madison Avenue church opened, structural problems developed that were impossible to correct, so the congregation commissioned architect Bertram Grosvenor Goodhue to design a new building for them on the present site, Park Avenue between Fiftieth and Fifty-first streets. The Vanderbilt portal was incorporated into the new building, setting the tone and establishing the style to be followed in the new building—the Romanesque of northern Italy and southern France. McKim, Mead, and White's design was modeled on the triple portal of St. Gilles-du-Gard on the edge of Provence in southern France. The superstructure of the façade and the nave of the Provençal church was destroyed during the religious wars of the sixteenth century, leaving the Romanesque portal somewhat truncated. The portal's isolated appearance was no doubt what gave Goodhue the idea to incorporate the Vanderbilt portal as a ruin into his design. In McKim, Mead, and White's design the portal was correctly integrated into the building, supporting the façade and a corner tower.

By placing the portal prominently in front of the church proper, Goodhue at once showed appropriate respect for the portal's architectural distinction and for its importance as a memorial, Richard Oliver has ex-

The Vanderbilt portal, designed by Stanford White.

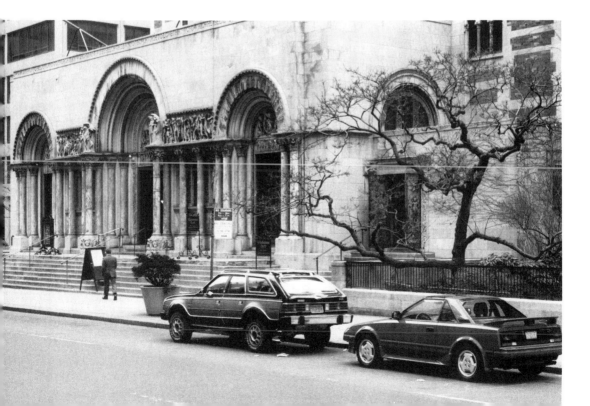

plained in his discussion of Goodhue's design. And he allowed himself the desired latitude for his own design for the new church, a blend of Romanesque and Byzantine styles. Royal Cortissoz, a noted art critic of the time, called the portal one of the noblest works of its kind. Even though it has been sadly neglected and is sorely in need of restoration and care, the portal remains a rare architectural and sculptural treasure.

The Sculpture Program

While the Vanderbilt portal is inspired by St. Gilles, one of the greatest existing assemblages of Romanesque sculpture, McKim, Mead, and White's sculpture program is singularly distinguished in its design and its interpretation of the Judeo-Christian tradition.

The three round-arched portals are unified architecturally and symbolically. They are united architecturally by a screen of columns and a sculptural frieze, and they are unified symbolically by a program of relief sculpture that portrays mankind's redemption through the Incarnation of Christ. The carved reliefs surrounding the center door illustrate the essentials of the Incarnation, the central theme of Christian belief. The reliefs framing the north and south doors portray scenes from the Old and New Testaments, showing prophecy and fulfillment in the Scripture's story of the Incarnation.

CENTRAL THEME

Christ's Coronation, the pivotal symbolic event in his ministry, is portrayed in the tympanum of the central portal. Flanked by angels who place a crown on his head, Christ's grand figure and frontal posture dominate the space. In the frieze below the tympanum, Isaiah's prophecies extend from left to right in a continuing narrative. The theme is Christ's Crucifixion, the act that brought about his Coronation pictured above. Carved in high relief, a procession of Old and New Testament figures illustrates the prophecies and their fulfillment in the Crucifixion. The prophecies are inscribed above and below the dramatic procession.

JOY AND SORROW

Similarly, in the tympanum of the north portal the large frontal figures of the Madonna and Child, flanked by heavenly angels, produce an imposing icon. Architecture critic Russell Sturgis hailed this tympanum by Herbert Adams as recalling the work of Renaissance sculptor Luca della Robbia. In the frieze below, events of the Crucifixion are depicted. Placing these

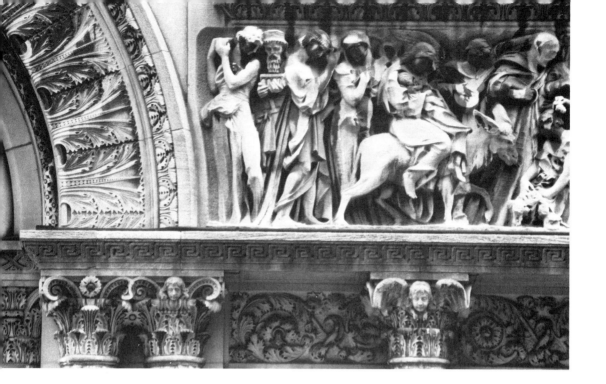

Scenes from the New Testament form a connecting frieze between the doors of the façade.

seemingly unrelated scenes together has a long tradition. Since the Middle Ages, Mary's foreknowledge of and participation in her son's Passion and death had been depicted in Annunciation, Nativity, and Holy Family scenes. Artists through the ages have portrayed events combining similar biblical events of joy and suffering, such as the Presentation in the Temple. Simeon, after prophesying the Messiah's triumphant and tragic future, turned to Mary and announced her own pain with the words "Yea, a sword shall pierce thine own soul. . . ." The story of Simeon's prophecy is prominently portrayed in one of the clerestory windows inside St. Bartholomew's. It was designed by Hildreth Meière and assisted by artist-designer Linn Fausett and his younger brother, muralist Dean Fausett, and Simeon's prophetic words are inscribed in the glass below the scene.

COUSINS

The south portal addresses the relationship of Christ and John the Baptist. In the tympanum, John and Jesus are portrayed as boyhood cousins playing together. In the lintel below, Christ carries the cross to Calvary. Sturgis praised Philip Martiny's frieze, comparing it to Saint Gaudens's Shaw Memorial, high praise at that or any time. He did not like Martiny's tympanum above, however.

The dramatic events between these two periods in the lives of Christ and John are portrayed in sculpture, mosaic, and stained glass throughout the church. And John's role as the precursor of Christ is poignantly told. John and Christ appear together in the baptistery, for example, where John holds the cross and a banner inscribed "Ecce Agnus Dei"—"Behold the Lamb of God"—and Christ is clad in ecclesiastical robes as shepherd of souls. It was when John baptized Christ that he helped to launch his cousin as the Messiah on his earthly career, which ended in crucifixion. John appears on the pulpit, carved in wood, wearing his traditional animal skin and holding the cross and banner.

SYMBIOSIS OF THEMES AND COVENANTS

Two scriptural friezes connect the north and south portals, visually and symbolically, to the center portal. Scenes from the New Testament (the Magi, the flight into Egypt, and Judas's betrayal) connect the north door to the central door, and scenes from the Old Testament (Adam and Eve, their expulsion from the Garden of Eden, the murder of Abel, the Israelites freed by Moses) connect the south door to the central door. Each of these sculptural friezes is physically supported by two Old Testament figures framed by Egyptian porphyry panels and Cippilino (so called because they look like sliced onions) marble columns. And these Old Testament figures symbolically support the scenes depicted in the frieze above because the

The Expulsion of Adam and Eve from the Garden of Eden, near the south door.

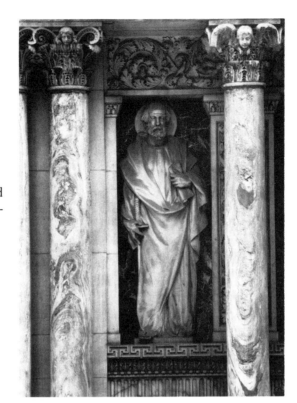

The prophet Isaiah is portrayed with sword and book—identifying attributes.

figures below are the historical basis of the scenes above. For example, the messianic prophecies of Isaiah, standing with sword and book, which identify him, and Elijah shown with his chariot are fulfilled in the New Testament scenes in the frieze above. Jeremiah, the prophet of doom, with his staff, and Moses, the lawgiver, with his tablets of stone, are both portrayed beneath scenes related to their lives and prophecies.

This symbiosis of the Old Testament and the New is a recurring theme throughout the decoration of St. Bartholomew's. In the pulpit inside the church, for example, Isaiah is portrayed beneath the lily, nails, and thorns, referring to his prophecies concerning the Virgin and Christ. The lily is symbolic of Mary's purity, and the nails and thorns are symbolic of Christ's Passion.

The Bronze Doors

The three pairs of bronze doors in the Vanderbilt portal, as in medieval churches, are not only entrances to the church, they are also symbolic gateways. Russell Sturgis called the bronze doors "one of the most remark-

The bronze doors connect the Old and the New Testaments through narrative and sy̶bolic elements.

able sculptures of modern times." Their reliefs provide narrative and symbolic interconnections between the Old and New Testaments. They outline the story of the Incarnation and summarize the tale of fulfillment and conversion related in the Scriptures.

In six panels, the center door's sculpture presents the New Testament's central theme—the Incarnation. The Annunciation and the Adoration of the Magi are portrayed in the two upper panels, and two scenes from the Crucifixion, the way of the cross and the descent from the cross, occupy the lower pair. The two central panels portray Matthew, Mark, Luke, and John, the chroniclers of the New Testament, who proclaimed the message of redemption through the Incarnation in their four gospels. Inscribed below is Jeremiah's admonition to "hear the word of the Lord daily, ye that enter at these gates." (7:2). The evangelists, portrayed with their symbols (Luke, winged ox; Mark, winged lion; John, eagle; Matthew, winged man),

The center door's primary theme is the Incarnation.

are called the tetramorph and appear frequently in sculpture, stained glass, and manuscript illumination.

The north doors illustrate salvation through conversion with specific examples: the Transfiguration—a feast extended to the whole church in the fifteenth century—is also represented in the apse mosaic over the main altar, St. Paul's conversion on the road to Damascus, and his conversion of Lydia at Philippi. The psalmist's conditions for conversion are inscribed below: "Enter into his gates with thanksgiving and into his courts with praise. Psalm CIV."

The south doors celebrate the completion of the Incarnation, the core of Christian belief. Through his Resurrection, Christ demonstrated his victory over death and thereby gave to mankind divine life. In the Ascension (right panel), as head of the church, he opened his Father's kingdom to humankind. At Pentecost (left panel), he completed the work begun in his earthly life by sending his Holy Spirit to dwell with the church and to guide it. The so-called descent of the Holy Spirit upon the Apostles at Pentecost, therefore, is the traditional birthday of the Christian church.

Tradition and Art

Symbolic connections are carefully woven throughout the church, and Goodhue incorporates elements of the earlier church with his designs. A stained-glass window from the crypt, for example, which portrays the Resurrection, was brought from the Madison Avenue church. The peacock, symbol of immortality, and the phoenix, symbol of resurrection, which flank the doors to the crypt, are also found on the center doors of the main portal. The decoration program over the main portal unites Goodhue's design with the earlier church and its later portal. The arched windows above, for example, repeat the triumphal arches of the portal and contain stained-glass memorial windows of the evangelists from the earlier church on Madison Avenue.

Saints and Symbols Old and New

Three knives carved in medallions in the gable high above the main entrance and the figure of Saint Bartholomew carved in the arch over the doorway show that the church is dedicated to him. The three knives are the traditional symbols of the saint, who was martyred by being flayed alive and then beheaded. The number three symbolizes the Trinity. They also decorate the lintel of the doorway of the community house facing the terrace.

Bartholomew is frequently portrayed with Philip. That is because it was Philip who told Bartholomew about Christ. The event is portrayed in one of the panels at the crossing inside the church, and statues of the two apostles flank the great south transept window on the south façade. Bartholomew was singled out by Christ for his innocence and simplicity of heart, virtues that made him receptive to Christ's message. His calling

Three knives symbolize Saint Bartholomew's martyrdom and identify the church as his.

is portrayed in another of the panels at the crossing inside the church.

Goodhue's statues between the windows above the Vanderbilt portal link the founders of Christianity and medieval asceticism with the origins of European Protestantism, and they pay tribute to a key figure in the Protestant church in America, who had a direct influence on the Church of St. Bartholomew.

Two of the statues represent saints of the early church: Saint Paul, Apostle to the Gentiles, and Saint Francis of Assisi, founder of the Franciscans. The other two were Protestant leaders: Martin Luther, German leader of the Protestant Reformation, and Phillips Brooks, bishop of Massachusetts and influential American Episcopalian clergyman and preacher, who wrote "O Little Town of Bethlehem." Brooks had a formative influence on the Reverend Leighton Parks, who was rector of St. Bartholomew's when Goodhue built the new church. Brooks was a leading figure in the church in Boston when Parks was rector of Emmanuel Church there, and they continued to be friends. Brooks was recognized as a distinguished preacher, and his image is found in other churches in New York City. His carved portrait statue appears on the pulpit of St. Thomas's church at Fifty-third Street and Fifth Avenue alongside other churchmen known for their eloquence. He is also portrayed in the reredos of the same church as

Figures of key church leaders unite the present with tradition.

bishop of Massachusetts, and in New York's preeminent Trinity Church at Broadway and Wall Street.

Union of Style, Theme, and Material

As the sculpture on the great portal of St. Gilles was the work of six or eight pairs of hands, so the Vanderbilt portal of St. Bartholomew's is the product of several artists: Daniel Chester French and Andrew O'Connor, the central portal; Herbert Adams, the north portal; and Philip Martiny, the south portal.

The sculptors' individual styles are different but compatible, reflecting a successful balance between naturalism and idealism in the portrayal of anatomy, gesture, and expression, which gives the sculpture a timeless quality with universal appeal.

The sculpture of the Vanderbilt portal is the key to the decoration of the entire church. The story of the Incarnation expressed in the stone, metal, mosaics, glass, and wood throughout the church is tied to the portal sculpture in both meaning and style. The themes expressed in the portal, therefore, are woven into the decorations in all parts of the church. And the portal's medieval design, elegant limestone carving, variegated marble columns, warm panels of Egyptian porphyry, and rich bronze doors are uniquely complemented in texture and tone inside by the Byzantine flavor of the resplendent mosaics and stained glass, subtly veined marbles of warm tones, and colorful panels of inlaid geometric patterns, all set within the

framework of light limestone piers and trim and cocoa-colored Akoustilith tile. In a nostalgic but appropriate departure, Goodhue used the marble shafts from the Madison Avenue church for the columns in the south chapel.

COLOR, LIGHT, AND SHADE

Russell Sturgis praised the high quality of John Buehler's designs for the flat leafage of the archivolts, the leaf composition of the capitals, elaborate spirals of the moldings around the doorways and tympanums, and the complex carving of the hood moldings. The unknown stone-carvers work-

Critics have praised the decorative detail of the building.

ing for B. A. and G. N. Williams who did the actual carving of these details are unsung heroes.

The architect's selection of materials was influenced by the light that would illuminate the church's surfaces both within and without. The gray Indiana limestone for the lower walls and the salmon-colored brick above make a fitting enclosure for the body of the church behind the Vanderbilt portal and a grand base for the splendid octagonal dome above surfaced with marble mosaic.

St. Bartholomew's interior glows by turns with the resplendence of a faceted stone and the warmth of a medieval cabochon whose roundness and color contain the reflective light like a low-burning flame. Figures and patterns animate its many surfaces. Musicians, for example, are carved into the capitals of the columns that support the organ casing along the west wall. The Piccirilli brothers carved the capitals of the double columns along the north aisle with Old Testament scenes and those along the south aisle with New Testament scenes. This placement follows medieval tradition. Churches from the eleventh to the sixteenth centuries usually were oriented—that is, the apse of the church was placed in the east. The north side of the church, then, was on the left, and the left was identified with darkness, while the right side was equated with light. Reading from left to right symbolized going from prophecy to fulfillment. In the narthex, heads of well-known humanitarians are carved in the capitals. These include Louis Pasteur, chemist; Florence Nightingale, English nurse; and George Williams, founder of the YMCA.

The sanctuary walls are paneled with Italian marble inlaid with geometric patterns and the vine and wheat symbols of the Holy Communion. The wood choir stalls, carved with delicate inlay, were brought from the Madison Avenue church. In the baptistery, the altar and its reredos, the chandelier, and the white marble life-size angel holding the baptismal font (a shell), long thought to be carved by Bertel Thorvaldsen, Europe's leading neoclassical sculptor of the mid-nineteenth century, all came from the Madison Avenue church. And the painting by Francis Lathrop, *The Light of the World,* which hangs in the north transept, originally hung above the reredos of the Madison Avenue church.

A MODERN RELIQUARY

In its inventory of 1956, St. Bartholomew's listed a marble tablet in the southeast corner of the church that contains a stone from the great Roman wall of the second century A.D. Tradition holds that the stone was carved by a Saxon stone-carver in A.D. 675 for the east end of All Hallows Church

and that it was a gift of that church to the people of St. Barthlomew's. A connection with tradition through such enshrined relics is not an uncommon practice. In St. Thomas Church at Fifty-third Street and Fifth Avenue, for example, following World War I, stones were brought from the cathedrals of Rheims, Amiens, Aubert, and Peronne, churches damaged in the bombings of World War I, and those stones were incorporated into a World War I memorial in the parapet between the nave and the chancel.

KEY ELEMENTS OF DECORATION

The mosaics and stained glass of St. Bartholomew's are significant to the decorative program of the church. They are distinguished works of art, and their reflective and translucent properties are as integral a part of the decorative program as are the images they bear and illuminate. Light has long had symbolic meaning, and stained glass even came to be identified analogously with the virgin birth. As the glass remains intact when the light passes through it, so Mary remained a virgin when she conceived through the Holy Spirit.

The mosaics of the five-domed narthex tell the story of the Creation from the Book of Genesis. Hildreth Meière, the designer, received the Gold Medal of the New York Architectural League for these mosaics. A broad variety of reflective tones expresses all aspects of the Creation from the brilliance of day to the darkness of night and from the blue and white of ocean and sky to the greens of trees, plants, and grass. Meière also designed the apse mosaic of the Transfiguration and some of the clerestory windows.

In keeping with Byzantine and Romanesque stonework, Meière has made each window a combination of geometric and organic shapes. Through dynamic patterns, and a crystalline clarity she has achieved in the glass, her windows richly illuminate the images of the biblical stories they carry and transform the natural light that passes through them into a truly transcendent experience. The *Magnificat* window in the south clerestory of the church is especially remarkable in the richness and variety of color and for the dynamic and human qualities with which the artist has managed to charge the figures in the familiar scenes of the Annunciation and Visitation, and the hieratic quality of the central figure of the Virgin as the icon of the Incarnation. Meière's versatility is evident in these windows. It is instructive to remember that in addition to her decorations here and such other projects as the decorations for Temple Emanu-El, Meière also designed monumental reliefs for Radio City Music Hall and other public spaces in a variety of styles.

The Light That Is Threatened

The great rose window that dominates the façade of St. Bartholomew's south transept celebrates the eternal light of heaven and the temporal light that animates these windows, their stories, and their symbolism. The archangel Uriel, "the light of God," holds the sun, emblem of that which enlightens all creation. Golden rays of light, symbolizing almighty God, radiate from the center of the window, uniting in ever-widening circles the hosts of heaven: archangels, angels, saints (Saint Bartholomew is top center), priests, and even those yet to be born.

It is fitting that so central a form as the great rose window in the south transept looking out into the garden terrace should carry the theme of light, both eternal and temporal, because the color, shading, and life of the surfaces in the church depend upon the transformation of natural light through the stained glass combining the man-made light within. The natural light pours through these windows, animating their scenes and transforming the interiors of the church anew each moment. For as the light outside changes constantly through the movement of the sun across the sky, so also does the light within. These subtle and ever-changing properties of light depend for their existence on the open space around the church, which is now being threatened by a proposal to build a skyscraper on the site. Besides being architecturally inappropriate for the site, the tower would place St. Bartholomew's in total eclipse and would thereby destroy the interior design of the church, which relies on the natural light coming through the stained glass for its life.

The garden terrace at the south of the church set back from Park Avenue creates an oasis of light and space unique in that highly congested area. The terrace garden is not only an integral part of the superb siting of the building, it also provides the light that is essential to the design of the south windows and the life of the interior of the church. Because the great rose window is central to the design of the south façade, its symbolism is especially noteworthy now in the face of the current threat to it.

THE WHEEL OF FORTUNE

The rose window derives ultimately from the wheel of fortune in ancient times. In the Middle Ages, the wheel of fortune became a popular symbol of the instability and transience of power, riches, and glory. It was illustrated as a spoked wheel with human figures attached to the spokes, showing how the figures rise and fall with the rotation of the wheel, thereby symbolizing the changing fortunes of man in this world. The form evolved into some of the great rose windows in Europe during the Middle Ages,

The garden terrace provides space outside and illumination inside the church.

Detail of St. Bartholomew's rose window.

which in turn influenced such distinguished windows as those in St. Bartholomew's.

The Chapel

The chapel south of the main portal is set back and designed in different scale and style, so as not to appear to be part of the Vanderbilt portal. Although separate from the main portal, it is not divorced from it, a connection that is subtly achieved by an asymmetrical treatment of the chapel door. At the north end of the entablature, a carved angel curves over the corner where the chapel entrance is set back from the main façade, making an easy transition from one plane to another. The angel once held a lantern (alas, it has disappeared) that hung unimpeded, lighting the entrance and further enhancing the division between the two portals and compensating the side portal for its secondary position.

The chapel was designed for the youth of the parish. The decoration, therefore, appropriately carries youthful themes. The bronze doors, modeled by Albert D. Stewart, bear images of Saint John the Baptist and Jesus as children, echoing their portrayal in the nearby tympanum in the main portal. The traditional symbols of the four evangelists (the tetramorph) are above and below them. The tetramorph is also carved at the ends of the cross on the north façade, on the pulpit, and on the lectern, in the apse over the main altar, and in the capitals near the prophets on the Vanderbilt portal. The eagle appears twice in the lectern, once as the symbol of Saint John, again as the support for the gospel book, and it has special symbolism. As the eagle's wings carry the bird to all parts of the world, so will the gospel be known all over the world. The triumph of the gospel throughout the world is symbolized by the triumphal cross standing on the globe atop St. Bartholomew's mosaic dome.

An appropriate inscription from Isaiah 54:12 celebrates the education of youth, and the limestone jambs are carved with the Holy Innocents and the figures of children's favorite saints: Christopher, Cyril, Nicholas, Pancreas, and Simon. The jamb figures are held in position by intertwining vines, recalling the Tree of Jesse so often represented (as on the chancel screen inside the church).

Joy and Life

Bertram Goodhue puts materials together in his design for St. Bartholomew's that produce an exhilarating visual experience and complement the way the components of the Judeo-Christian message are put together in the church's decorative program. While the agony of the quest involved in the Incarnation is related in a traditional way in St. Bartholomew's decoration, what Joseph Campbell calls the rapture of revelation, an integral part of all the great myths of history, is what is emphasized in the church's decorative program. The message that emerges, then, is one in which sadness gives way to joy and death to resurrection and eternal life.

CHAPTER 19

Gateways in Bronze

The three sets of great bronze doors at the Broadway entrance to Trinity Church at Broadway and Wall Street were given by William Waldorf Astor as a memorial to his father, John Jacob Astor III, grandson of John Jacob Astor, founder of the American Fur Company. John Jacob III had been a longtime vestryman of Trinity when he died in 1890. Architect Richard Morris Hunt was commissioned in 1891 to do the doors, and they were completed in 1894 and cast at the foundry of the Henry-Bonnard Bronze Company, New York City.

Sculptors were selected in open competition, following a Renaissance tradition. Each participant modeled a relief panel of a scene for the doors. For the competition panel, Hunt chose the Expulsion of Adam and Eve from the Garden of Eden (Gen. 3:23–24). The first-place winner would execute these doors, and the two runners-up would do the doors for the north and south entrances.

Karl Bitter

Twenty-four-year-old Karl Bitter won first place. Born and reared in Austria and trained at the Academy of Fine Arts in Vienna, Bitter had been in the United States only sixteen months at the time of the competition for

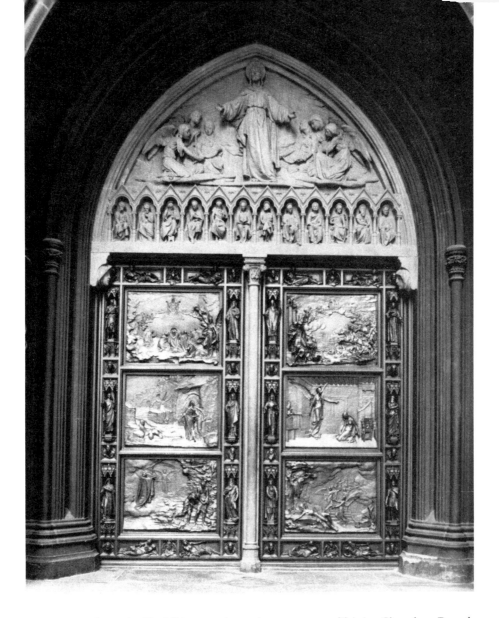

The bronze doors by Karl Bitter at the main entrance to Trinity Church at Broadway and Wall Street. The Expulsion of Adam and Eve from the Garden of Eden at lower left was his entry in the competition for the commission.

the bronze doors to Trinity Church. In that time he had already established a studio and executed some commissions for Richard Morris Hunt, architect for the Trinity doors, who discovered Bitter a few weeks after the sculptor arrived in New York in November 1889. A particularly important commission further connects sculptor, architect, and client at that time. Hunt designed Mrs. William Astor's mansion at Sixty-fifth Street and Fifth Avenue, for which Bitter executed sculptural decoration.

The Trinity competition was reminiscent of the fifteenth-century com-

petition for the doors for the Baptistry in Florence, which was won in open competition by Lorenzo Ghiberti. In fact, Ghiberti's doors influenced Bitter's design, as James Dennis has explained in his study of Karl Bitter's work. Bitter acknowledged his debt to the great Renaissance sculptor by naming a dish "à la Ghiberti" for a dinner celebrating the completion of the Trinity doors. Even though Bitter's modeling style has little in common with Ghiberti's, the panel arrangement of biblical scenes within a framework of symbolic and portrait figures is inspired by the Renaissance sculptor's famous doors.

A Style for Its Time

Bitter's style is characteristic of much late-nineteenth-century Beaux-Arts sculpture. It is a blend of naturalism and idealism derived from Renaissance and baroque sculpture and painting. His panels for the Trinity doors reflect compositional principles of baroque landscape paintings. Each scene is composed of a large mass at one side, counterbalanced by a smaller mass at the opposite side. These frames for the scenes are called "coulisses," derived from theater nomenclature. The term was used to describe stage sets. Bitter used this framing device to stabilize his composition, Dennis noted, by placing the large masses nearest the *trumeau,* the central vertical support between the two doors. In the bottom pair of panels, for example, Adam and Eve are portrayed against a rocky background in the left panel, and Jacob against a landscape in the right panel, which make up the largest masses in their respective panels and are, therefore, placed nearest the *trumeau.* Another characteristic of baroque landscape in these panels is the use of atmospheric effects in the backgrounds, which Bitter achieves by very low relief and soft lines. A convincing sense of deep and realistic space is thereby realized, which is reinforced by the naturalistically modeled rock formations and figures that project outward into the spectator's space and overlap the frame. The most dramatic example of using projected forms is in the top left panel, where the angel's wing actually casts a shadow over the frame surrounding the panel.

A Central Theme

The six panels are set within an architectural latticework of biblical and symbolic figures and portrait busts in niches and rectilinear frames. The overall effect is that the spectator is a witness to the actual biblical events

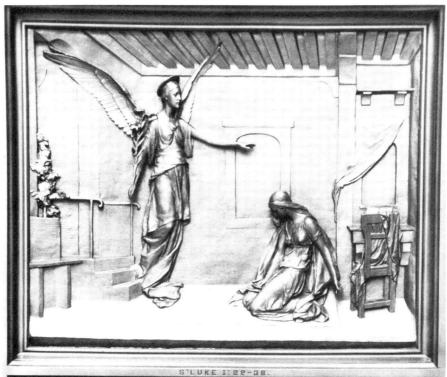

S¹ LUKE I: 22-38.

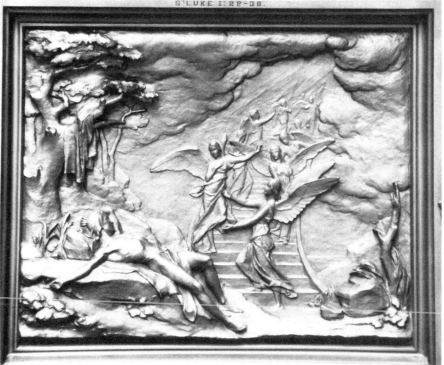

Bitter composed the panels to provide the spectator with a sense of "being there."

being enacted simultaneously. The spectator beholds the scenes through six separate windowlike openings, akin to the experience of looking at six TV monitors on a wall, each with a different but related event frozen in time.

The doors carry the theme from the "Te Deum": "Thou didst open the Kingdom of Heaven to all believers" (the first two words of the hymn in Latin are "Te Deum"), and the three pairs of panels portray the development of the theme through six biblical events, beginning with the pair at the bottom—the Expulsion from the Garden of Eden (left) and Jacob's Dream (right). In medieval stained-glass art, the story also begins at the bottom and reads upward.

The Expulsion of Adam and Eve from the Garden of Eden portrays the Fall of Man, and Jacob's Dream portrays the message of hope in God's promise to bless his descendants. The central pair of panels, the Annunciation and the Empty Sepulchre, portray man's redemption, and in the uppermost pair of panels eternal reward and divine justice are illustrated. In the Worship of the Church in Glory (left), the twenty-four elders (representing the twelve Apostles and twelve tribes of Israel), fall down and worship God, and in the Triumph of Divine Justice (right), judgment is portrayed as the sinners hide from the face of God.

In the lintel above, extending across both doors, the twelve Apostles are seated like a gallery of kings on the façade of a great Gothic cathedral, and in the tympanum above them the figure of Christ in Majesty is shown. Flanked by angels, he extends his arms in welcome, the culmination of the "Te Deum" theme begun below.

Influences of Tradition

The Old Testament figures that surround the panels are related through their prophecies and the saints through their preaching and writing. The tetramorph (the symbols of the four evangelists), located at the top and bottom of the doors, are flanked by pairs of reclining figures. At the bottom of the left door Mortality and Sin flank the winged lion (Saint Mark), and at the right Time and Tradition flank the winged man (Saint Matthew). The two figures top left representing Eternity flank the eagle (Saint John), and those on the right representing Divine Justice flank the winged ox (St. Luke).

It is not coincidental that the reclining figures resemble Michelangelo's figures of Night and Day and Dawn and Dusk on the Medici tombs in Florence. As a student Bitter was especially drawn to Michelangelo's sculpture, and he copied the great artist's work, as did the other academy

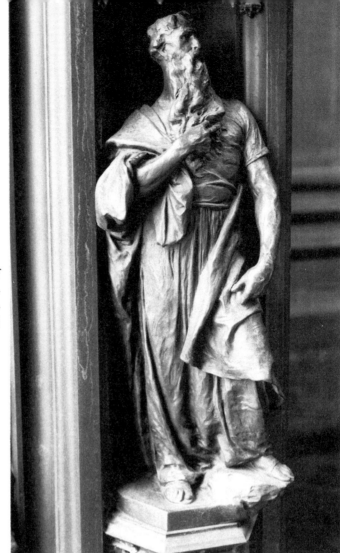

The small bronze figure of Moses was inspired by two statues in Italy by leading Renaissance sculptors Donatello and Michelangelo.

students as well, and the twisting and turning of Michelangelo's figures, the *figura serpentinata,* is evident in Bitter's figures. Other influences may be noted, and Bitter's remarkable ability to combine them is evident. The freestanding figure of Moses, for example, is derived from two Renaissance sources. The upper part of Moses' torso and head, with the prophet's fingers entwined in his beard, is borrowed from Michelangelo's seated statue of Moses in Pope Julius's monument in the Church of St. Peter in Chains in Rome (Freud wrote an essay on this figure, probing its psychological content), while the distinctive contrapposto of the figure derives from Donatello's statue of Saint Mark on the façade of Or San Michele in Florence, which may have had something to do with the arrangement of the tetramorph, placing Mark at the bottom of this door nearest Moses.

An identical pair of bearded busts are the doorknobs, and portrait

In the tradition of the Italian Renaissance, Bitter included in the doors a self-portrait and the likeness of the architect, Richard Morris Hunt.

Daniel Chester French's 1901 portrait of Hunt in the Hunt Memorial on Fifth Avenue at Seventieth Street provides an instructive comparison for the likeness.

busts alternate with the statuettes that frame the panels. The portrait of Richard Morris Hunt is at the lower right corner of the Annunciation scene on the right portal. And as Ghiberti had done centuries before, Bitter included his self-portrait. He portrays himself in his beret respectfully below Hunt at the lower right corner of the door. The portraits are vital, and a comparison between Bitter's bust of Hunt and the portrait of Hunt by Daniel Chester French in the memorial at the edge of Central Park at Seventieth Street and Fifth Avenue, facing the Frick mansion, shows that Bitter has caught the architect's likeness. That Bitter's portrait is more animated may be due not only to the Austrian's freer and livelier style, but also to the fact that it was no doubt modeled from life, whereas French probably relied largely on photographs.

Charles Henry Niehaus and J. Massey Rhind

Charles Henry Niehaus (1855–1935) and J. Massey Rhind (1860–1936) were the runners-up in the Trinity doors competition and were, therefore, commissioned to do the north and south doors. Their names would appear together again in 1914, both competing for the Francis Scott Key Monument in Baltimore, celebrating the centennial of "The Star-Spangled Banner," a commission Niehaus won.

The South Doors

The selection of Niehaus to do the south doors, which portray principal people in the history of Manhattan and Trinity Church, was no doubt a result of his success as a portrait sculptor. He had distinguished himself with portraits of celebrated Ohioans, President James Garfield and William Allen, for Statuary Hall in Washington, D.C., the old Hall of Representatives, which was converted after the Civil War into a national repository for statues of leading Americans.

Niehaus was born in southern Ohio and studied art in Cincinnati at the McMicken School of Design and later at the Royal Academy in Munich, Germany. He was born to German immigrants, and his family ties influenced his selection of Munich instead of Paris for European study.

MANHATTAN ISLAND AND TRINITY CHURCH

As with the main doors, the narrative begins with the panel at the lower left, Henry Hudson in his ship the *Halfe Moon,* and reads upward chronologically. The inscription below the first panel, "Hendrick Hudson off Manhattan, September 11, 1609," identifies the explorer at the time he claimed the great natural harbor for the Dutch. From the deck of his ship Hudson looks toward shore, as his crew make preparations to land. Hudson's posture and dress, and his dominant position near the *trumeau* and apart from the small group of his crew, reflect the same principles of baroque composition employed in Bitter's panels.

Even though the other portraits in this panel have not been identified, it is tempting to see the officer in the center of the crew, whose left arm extends in a commanding gesture, as Robert Juett, who wrote the first documented description of the area. After laying claim to the land, Hudson proceeded on September 12 up the river to what are today Albany and Troy, and then to the mouth of the Mohawk River. And although he found that he had discovered no passage to the Orient, Hudson did find that a fur trade with the Indians could be developed, which prompted the Dutch to send a ship the following year (1610) to pursue this avenue of trade. It was with the American Fur Company, chartered in 1808, that J. J. Astor long maintained a monopoly in the fur trade, which helped him to become the richest man in the United States.

It is singularly fitting that an Astor Memorial begin with this landmark in the history of the fur trade in New York.

To the right of the Hudson panel, Trinity Church's second rector, native-born Henry Barclay, is portrayed at the age of twenty-seven beginning his mission to the Mohawks in 1738. Fluent in the Mohawk language (and Dutch as well), he remained their pastor for eight years while he was rector of St. Peter's Church in Albany, until in 1746 he was made rector of Trinity Church, as Clifford P. Morehouse has noted in his informed history of Trinity parish. A graduate of Yale College, he continued his interest in the Indians throughout his ministry, and in 1762, two years before he died at the age of fifty-three, he supervised the publication of the Book of Common Prayer in the Mohawk language.

THE WASHINGTON PANEL

The third panel shows George Washington entering St. Paul's Chapel for a Thanksgiving service following his inauguration a few blocks south at Federal Hall, April 30, 1789. Members of the cabinet, Washington's loyal followers through the American Revolution, and vestrymen from Trinity

who had been supporters of the American cause, were present at the service. After the inauguration, Bishop Provoost, Chancellor Robert Livingston, and Mayor James Duane walked with Washington and members of his cabinet up Broadway to St. Paul's Chapel.

Trinity Church had been ruined by fire shortly after the outbreak of the Revolution and was being rebuilt when Washington was inaugurated. Because Trinity was unfinished, the service was held in St. Paul's Chapel. Bishop Samuel Provoost is shown at the main door, which faces the churchyard, so Trinity's steeple may be seen in the center background. What has become the main entrance facing Broadway was a later addition to the chapel.

Samuel Provoost came to Trinity in 1766 as an assistant but because of his outspoken Whig sympathies had to resign in 1771. After the war he returned to New York from Albany, where he had served, and was elected Trinity's fifth rector by a reorganized vestry of all Whigs that included Duane, Livingston, and Marinus Willett. He was consecrated first bishop of the Episcopal Diocese of New York in 1787, just two years before Washington's inauguration, and he was the U.S. Senate's first chaplain. When the second Trinity was completed in 1790, Washington would be present at Bishop Provoost's consecration of the new church.

Robert Livingston, chancellor of the state of New York and vestryman of Trinity, administered the oath of office to Washington. He had been a justice of the Supreme Court and a member of the Second Continental Congress, which issued the Declaration of Independence and appointed General Washington commander in chief of the American armed forces. He had also been a vestryman at Trinity during the divisive years of the Revolution when the church was split between Whigs and Tories.

Mayor James Duane, also a member of the Second Continental Congress and Trinity vestryman, had been a potent voice for the Revolution and had helped to draft the Articles of Confederation. Marinus Willett, one of Washington's generals and a vestryman, led the welcoming committee to Federal Hall for the inauguration. Willett was also a member of the Committee of Resistance, a group formed soon after the outbreak of the Revolution, and he was responsible for a skirmish on Broad Street in which his group of soldiers seized the supplies and ammunition of the British. The event is memorialized in a bronze plaque mounted on the face of Olympia and York's Building on Broad Street illustrating the event. It is interesting also because it shows a view of Broad Street then and a portrait bust of Willett.

A painting of Washington's inauguration hangs in today's Federal Hall on the site of the original building where Washington actually took the oath

Detail of bronze plaque dedicated to Marinus Willett. Willett's troops seize ammunition and rifles from British on Broad Street. Note the anachronism in Federal Hall in left background: When the skirmish took place, the building had not yet been converted.

of office. Among those in the picture are Chancellor Livingston, who holds the Bible as he administers the oath of office. John Jay, one of Trinity's wardens and acting secretary of state, holds the cushion upon which the Bible is placed. He had been born a few blocks east at Pearl Street and Coenties Slip, in the house his grandfather Frederick Phillipse built in 1699 on the site of New York's first official landfill under the British.

TRINITY'S MISSION

In panel four the consecration of four bishops on October 31, 1832, celebrates Trinity's coming of age and its increasingly important missionary role in the Episcopal church. The four bishops are John Henry Hopkins, who became bishop of Vermont, Benjamin Bosworth Smith of Kentucky, Charles Pettit McIlvaine of Ohio, and George Washington Doane of New Jersey. Pictured also is the presiding bishop, the Right Reverend William White, bishop of Pennsylvania, and Bishop Provoost at the left.

The main figure in the scene, Bishop John Henry Hobart, is absent, because he had died two years before. But his ministry is what established

the church's missionary role that this panel celebrates. Fittingly, the two senior bishops portrayed in the panel symbolize Bishop Hobart's profoundly influential contribution to the church's growth in the New World. Bishop White baptized and confirmed Hobart, and Provoost ordained him.

Hobart applied enormous zeal and energy to the missionary role of the church, and he advanced rapidly to positions of influence. Thirteen years after ordination he was rector of Trinity, and three years later he was bishop of New York and rector of Trinity Church at the same time. Having both jobs had advantages. Trinity's wealth helped the diocese, and diocesan innovations could be implemented first at Trinity without resistance. He infused new life into traditional devotion by enlarging the congregation's role inworship and enhancing the quality of the liturgy with better music and more sophisticated teaching and preaching. His own writings and sermons not only inspired personal piety, but helped to raise standards of instruction among the clergy.

Hobart traveled extensively, establishing new churches in the diocese, he was innovative in training young clergy, he organized publications to improve religious education, and he promoted in-home instruction for children while encouraging family prayer. Hobart did not escape criticism, however, and his "high church" type of ministry, too Catholic for some, rancored members of the clergy and parishioners alike.

The consecration panel is symbolic of the end of an era of "uncertainty and hesitation," noted the Reverend Morgan S. Dix, parish historian and himself rector of Trinity from 1862 to 1908, and the beginning of a new era of "earnest missionary work." Moreover, the new direction was seen by the church hierarchy and parishioners to be a direct outcome of the work of Bishop John Henry Hobart. Following Hobart's death, the Episcopal church continued the expansion he had begun throughout the country and increased its international activity through such avenues as the Democratic and Foreign Missionary Society.

TRINITY'S THIRD CHURCH

The fifth panel commemorates the consecration of the third Trinity Church on this site on Ascension Day, May 21, 1846. The first church, opened on March 13, 1698, and enlarged in 1735, was destroyed by fire in 1776 at the beginning of the revolutionary war. The second church was completed in 1790, but by the late 1830s it was discovered that the church was about to collapse. English-born architect Richard Upjohn, then practicing in Boston, was commissioned to design the third Trinity Church, the one that stands today overlooking Wall Street.

The only participant in the ceremony to be identified in the panel is

the Right Reverend Samuel A. McCoskry, bishop of Michigan, shown about to enter the church. Bishop McCoskry was chosen to officiate in place of Bishop Benjamin T. Onderdonk, who was under suspension. Bishop Onderdonk had replaced Bishop Hobart as bishop of New York. Bishop Onderdonk, like Bishop Hobart, favored a "high church" approach to ritual as advocated in the *Tracts for the Times,* a series of pamphlets by J. H. Newman, John Keble, and E. B. Pusey and seen by some as coming close to the emotional appeal identified with the Roman Catholic church. The issue was controversial, and Bishop Onderdonk became unpopular with influential churchmen and parishioners because of his stand on these issues. Onderdonk, also a professor at the General Theological Seminary, further antagonized his adversaries when he overruled them to ordain seminarian Arthur Carey, whose theological views were considered to be an impediment to his ordination. In ill health for some time, Arthur Carey died soon after he was ordained. Nonetheless, Onderdonk's action fired his enemies with new zeal. They finally succeeded in having him suspended from the ministry on moral grounds.

THE ASTOR REREDOS

The last panel commemorates the dedication of the Astor reredos on June 29, 1877. The panel shows a remarkably accurate rendering of the reredos, which may be compared with the actual memorial by simply looking toward the altar where it stands. The only identifiable person is the Right Reverend Horatio Potter, bishop of New York, who dedicated the memorial. Potter was founder of the Cathedral Church of St. John the Divine, and his likeness appears also in St. Thomas Church at Fifty-third Street and Fifth Avenue.

The Astor memorial marble altar and reredos were commissioned by the sons of William B. Astor, son of the family's scion. John Jacob Astor and his brother William Astor commissioned architect Frederick Clarke Withers to design an appropriate memorial to their father. Withers is best known for the Jefferson Market Courthouse, 425 Avenue of the Americas, southwest corner of West Tenth Street, a landmark that today functions as a branch of the New York Public Library in Greenwich Village. Its exterior was restored and its interior remodeled by Giorgio Cavaglieri in 1967.

Withers employs English Gothic forms in creating an appropriate memorial compatible with Upjohn's English Gothic revival building. The sculpture and decoration carry the theme of man's redemption. The Last Supper is set within a rectangular format just above the altar table, illustrating the institution of the Eucharist and establishing a base for the depiction of the Crucifixion directly above. Both scenes are framed by a pointed arch

whose shape echoes the great chancel window (and unfortunately eclipses too much of it), designed by Upjohn and executed by Abner Stephenson with stained glass imported from Germany. In the spandrels to the left and right above the Crucifixion, two trefoils portray the Resurrection (left) and the Ascension (right), completing the paschal cycle. In the gable above, Christ in Majesty is set within an elaborately carved mandorla (almond-shaped halo), flanked by angels in prayer and adoration and surmounted by the cross. Four piers frame this central triumvirate and flanking panels that carry reliefs of the twelve Apostles and related scenes. Atop each pier a fluttering angel plays a musical instrument celebrating the Redemption.

The altar and reredos are carved in white Caen stone. The figures are by Robert Smith and the inlaid mosaics by Daniel Ball, both artists from England. Above the twelve Apostles is the inscription "To the Glory of God, in Memory of William B. Astor, this reredos is erected, AD 1877."

Placement of the dedication panel for the Astor reredos directly above the consecration panel in the south doors recalls the enduring influence of Bishop Hobart. In his interest in ritual he was ahead of his time and anticipated the Tractarian movement of the 1830s and 1840s (later called the Oxford movement because it started at Oxford), which revived ceremonial customs, brought back the use of colorful vestments, and emphasized beautifying churches. It is unlikely that the elegant Astor reredos would have been permitted if there had been no Oxford movement.

In the tympanum at the top of the door, the seals of the Venerable Society of the Propagation of the Gospel, which helped support the colonial church, and the Corporation of Trinity Church are supported by an angel. A dedication is inscribed below, "To the Glory of God, In Memory of John Jacob Astor," with the date 1890.

The North Doors

The north doors were executed by J. Massey Rhind, immigrant sculptor from Edinburgh, Scotland, and third-place winner of the portal competition. He had studied and worked with the noted French sculptor Jules Dalou in England and Paris and had worked as a decorative sculptor with his father and brothers in Scotland before he came to America in 1889. Rhind's first important commission in New York was for the chapel decorations of the General Theological Seminary on West Twenty-first Street. He went on to produce a large amount of work over the next four decades, largely in public monuments, portraiture, and architectural decoration. His nineteenth-century academic style, blending naturalism and idealism, was

especially suited to the Trinity commission for the north doors. They carry the biblical theme of deliverance from tribulation.

Rhind illustrates this notion of passage from one state to another with different kinds of thresholds, a play on the work of art itself—doors. His figures are large in scale and occupy shallow spaces against architectural backgrounds in which prominently placed doors or gates carry narrative or symbolic meaning. The theme for the ensembles is expressed in the tympanum above by the portrayal of the Good Shepherd with his sheep and the inscription "I am the door of the sheep." As with the other doors, the narrative begins with bottom panels and reads upward, and the scenes compose toward the trumeau.

DELIVERANCE THROUGH LOVE

The first pair of panels shows scenes from the Pentateuch, the first five books of the Bible, which the Jews call Torah, or Law. They also referr to it as "the five-fifths of the law," whence comes *Pentateuch,* from the Greek name for it. These first two scenes, from Exodus and Deuteronomy, portray deliverance through God's love for his people and their love for each other. In the first panel, the Passover in Egypt, from the Book of Exodus (12:23), God miraculously delivers the Israelites from the Egyptians. The Israelites were instructed by Moses to sprinkle the blood of a lamb on their doorposts and lintels. At night the destroying angel passed over the houses so marked but slew the Egyptians in the unmarked houses, thereby freeing the Israelites.

The second panel shows the Flight to a City of Refuge from Deuteronomy (19:1–6), which means "second law." Although not actually another law, Deuteronomy contains further explanations of the law proclaimed on Mount Sinai, and they are set forth as discourses to the Israelites by Moses on the eve of his death. In this scene Moses admonishes the Israelites to set up places of refuge where the innocent may have deliverance from injustice.

THE BEAUTIFUL GATE AND PRISON DOORS

The central pair of panels continues the theme of deliverance into the New Testament as illustrated in scenes from the Acts of the Apostles. This volume, written by Luke, supplements his Gospel and relates the spread of Christianity first to the Judeo-Christian community, then to the Gentiles. Luke attributes this spread of Christianity (the Christian community) to the action of the Holy Spirit emphasizing the roles of Peter and Paul. It is fitting, then, that events from the ministries of Peter, recognized head of

the Judeo-Christian communities, and Saint Paul, Apostle to the Gentiles, are selected for these panels, which illustrate the theme of miraculous deliverance.

Once, when Peter and John went to the temple to pray, a lame man brought each day to beg at the temple gate, called the Beautiful Gate, asked them for an alms (right panel, Acts 3:1–2). Peter told him they had no money but would give him what they had. He ordered the lame man to get up and walk, which he promptly did. To the stupefied crowd that assembled around Peter and John, Peter explained that the God of Abraham through Jesus Christ, whom they had rejected, had granted this man deliverance from his lameness.

Having been thrown into jail in Philippi for disturbing the peace, Paul and Silas were miraculously delivered from prison by an earthquake that caused all the prison doors to open (left panel, Acts 16:25–28). Aware that this was no ordinary earthquake, the guard and his family were converted to the new faith, which they then proclaimed to others.

DELIVERANCE AND REWARD

The upper pair of panels illustrates the ultimate deliverance for each individual, eternal salvation. The right panel shows the entrance into Heaven with Saint Peter bearing the Keys as described by the Book of Revelation (22:14), so called because Christians believe it to be the Revelation of Jesus Christ to his faithful of the things that will come to pass.

Written in the face of Roman persecution under Domitian at the end of the first century A.D., it is composed in the form of a circular letter to the Christian churches, admonishing them to stand firm in their faith and to avoid compromise with paganism even if it demands martyrdom. The author, who calls himself John and may be the author of the Gospels, has been exiled to the island of Patmos because of his Christian faith.

Although much of the symbolism of the book is obscure, the message of deliverance, and its alternative, are clear in the description of the judgment of the good and the wicked and the vision of the heavenly Jerusalem. The scene in the panel, portrayed toward the end of the book, shows the blessed being welcomed by Saint Peter at the gate of Heaven (Rev. 22:14). In the panel at the left, another message of the Book of Revelation, deliverance through martyrdom, is enacted in the panel to the left, "Domine Quo Vadis": "Lord, Where Are You Going?" These are Peter's words to Christ, whom the Apostle sees in a vision while fleeing from Rome. Having carried on the ministry for some twenty-five years, Peter was accused of casting a spell on one of the imperial favorites, and his followers urged him

to leave Rome. When he met Christ, the Savior told Peter that he was going to Rome to be crucified again, to which Peter responded by returning to Rome, where he ultimately gained eternal salvation through martyrdom.

FICTION AND TRUTH

This last panel is the only one that is not a biblical scene. It is part of a rich tradition of apocrypha, a kind of "fictional history." "Fictional history," however, is an inadequate description for this body of work, because even though apocryphal stories did not actually take place, they provide useful insight into the truth and significance of beliefs, doctrines, and traditions, and they impart a sense of reality to biblical events that appeals to the reader's and spectator's reason and imagination.

Civic Temples of Commerce and Culture

The Sculptural Legacy of the Great Fairs

American sculpture was given its most dramatic impetus from 1876 to 1915 by the great world's fairs that celebrated the country's achievements in the arts, industry, technology, and agriculture. The writings of Wayne Craven and William Gerdts provide useful insights into this period of American sculpture.

Although best remembered for its industrial exhibits, the Centennial Exposition of 1876, held in Philadelphia to celebrate the founding of our country, provided the first grand retrospective of American art—sculpture, painting, and photography drawn largely from the three main art centers at that time: New York, Boston, and Philadelphia. Side by side with the neoclassical art that prevailed during the first half of the nineteenth century was the art of the new generation of sculptors working in bronze. Their realistic portraiture and idealized monumental works celebrated America's achievements and aspirations.

The Columbian Exposition held in Chicago in 1893 established a scale and opulence in architecture and design that would dominate public art for a generation. Sculptor Augustus Saint Gaudens envisioned the beginning of an American Renaissance. Short of that, certainly a new level of collaboration in the arts was established there that prevailed until World War I.

Daniel Chester French's sixty-five-foot-high statue of the Republic was

the focal point of the White City, as the fair was called because of the abundance of stone and staff (an impermanent material to make into sculpture and architectural forms consisting of plaster reinforced with such materials as hemp fiber, straw, and horsehair over a wood-and-metal armature). She reigned over a grand lagoon surrounded by twelve palaces, a triumphal arch, and a barge of state drawn by giant dolphins and tritons (the *Republic* later became the model for *Alma Mater* in front of McKim, Mead, and White's Low Library at Columbia University). Frederick Mac-Monnies's Columbian Fountain and Karl Bitter's twenty-two groups of sculpture for Richard Morris Hunt's Administrative Building were the crowning glories of this grand revival of Renaissance, baroque, and classical forms.

A direct result of the Columbian Exposition was a new and exalted role in public art for American sculpture, which led to the formation of the National Sculpture Society, founded in May 1893. Its first major project in New York City, the sculpture program of the Appellate Court House at Madison Avenue and Twenty-fifth Street in Manhattan, which combines colossal personifications of the law from ancient times and distant lands and symbolic groups and figures of Justice and Time, still stands today as a landmark to the age of rich sculpture programs at the turn of the century. The National Sculpture Society grew, its members prospered, and the nation developed a great need to decorate its parks, plazas, and public buildings along the lines of the great monuments of Europe.

Although the world's fairs continued, they gradually became more focused on the individual and his or her place in America. The Pan-American Exposition in Buffalo, 1901, for example, ushered in the new century, and it had one theme—nature and people's conquest of it for their own development physically, culturally, and spiritually. The sculpture programs were thematically focused and coordinated with buildings to ethnology and government arranged along a mall, a causeway, and a Court of Fountains.

The sculpture theme of the Louisiana Purchase Exposition of 1904 in St. Louis was the country's settling of the West and revolved around the U.S. purchase of the Louisiana Territory from the French. Sculpture portrayed the life of the Indian before the arrival of the white man, and the pioneer settlement of the area. The focus of the sculpture program was a great shaft dedicated to the United States's peaceful annexation of the Louisiana Territory.

The theme of the Far West in the Panama-Pacific Exposition of 1915 in San Francisco was epitomized in two equestrian statues: Solon Borglum's *The Pioneer* and James Earle Fraser's *The End of the Trail.* Borglum's alert

frontiersman is armed with his rifle, symbolic of survival and conquest. Fraser's Indian brave, ravaged by the frontier winds and astride his cowering animal, can barely hold onto his long spear, symbolic of defeat and despair.

The mixture of symbolism and realism in these themes of pioneers and Indians is far removed from the neobaroque style and content of the Columbian Exposition of 1893. It is just as far removed, however, from the new art that had arrived from Europe around 1910 and was exhibited in the Armory Show in 1913. With cubism and abstraction came a preference for simplified form, which coincided with the advent of direct carving in sculpture.

The personal and subjective art that came with the one-to-one relationship between the sculptor and his material to a large extent replaced the workshop and apprenticeship tradition as it was practiced by the Beaux-Arts artists. So the Panama-Pacific Exposition of 1915 was the last of the great fairs with grand sculpture programs. With the modern movements in art and the shock of World War I, American sculpture underwent a profound change.

Temples in the City

New York City's permanent record of the Beaux-Arts tradition, which produced grand collaborative programs of sculpture, architecture, and decoration, includes a rich array of temples of public administration and the law, banking, communications, and maritime commerce. The discussions that follow illustrate various aspects of that tradition and how the collaborative program of symbolism and decoration continued on into later twentieth-century styles.

CHAPTER 20

Temples of Public Administration and the Law

The Municipal Building

For its time, the Municipal Building, by McKim, Mead, and White (1914), was described as a modified Italian Renaissance-style building, and it was called a modern "Colossus of Rhodes" because its triumphal arch straddled Chambers Street with its grand colonnaded façade facing west enclosing a U-shaped courtyard behind. Pilasters continue around the building, and above the columns and pilasters are sculptures in relief by Adolph Alexander Weinman carved in granite from the quarries of North Carolina that typify the spirit of the Municipal Building. They consist of spandrels, medallions, and friezes that survey the progress of municipal government from colonial times to the twentieth-century.

Sculpture Program

Crowning the four columns of the arch are the shields of the city of New York and the county of New York and the coat of arms of Great Britain surmounted by the royal coronet, a reminder of the days when New York was an English colony and the colors of King George III fluttered in the breeze over the island of Manhattan. Within the architrave and between the massive columns, cherubs support garlands and a tablet bearing the

Called a modern "Colossus of Rhodes" because it straddled Chambers Street, the Municipal Building is decorated with reliefs that illuminate its role in city government.

inscription in large bold incised letters: MANHATTAN. The left spandrel of the great central arch reveals the figure of Guidance, supporting a rudder and tablet of the law, while the spandrel at the right represents Executive Power, holding the fasces, symbol of authority.

Over the north arch is the figure of Progress in bas-relief, holding as its symbols a torch and winged bull, while the relief figure above the south arch represents Prudence holding a mirror in her outstretched hand, symbol of reflection and wisdom.

The frieze above the south arch celebrates Civic Pride and shows the standing figure of the city receiving the tribute of her people. The companion frieze to the north typifies Civic Duty, with another figure of the city partly resting upon volumes of the law and accompanied by a cherub carrying the municipal coat of arms. In her right hand, before the group of citizens, she holds a scroll, symbolic of the laws she expects them to obey.

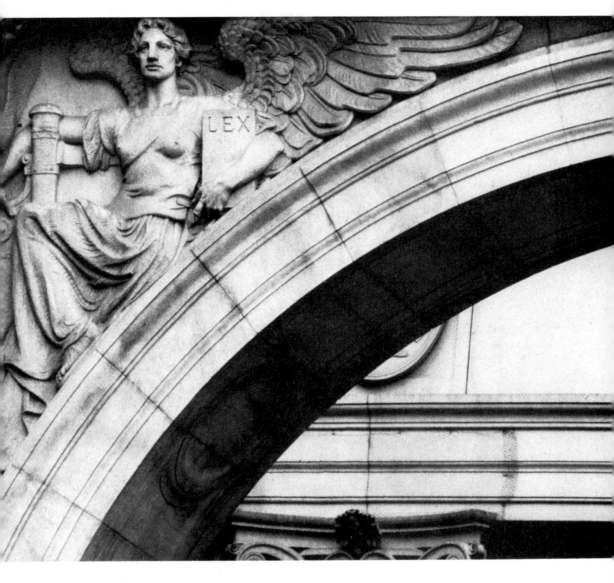

Guidance is personified in the rudder and tablet of the law. Executive Power *(not pictured)* holds the fasces, symbol of authority.

Prudence holds a mirror, symbolizing the wisdom that comes from reflection.

Civic Pride is portrayed as the city receiving her people's tribute.

City Offices

Classic figures beside the windows of the second story portray branches of municipal government located within the building when it opened. Left to right on the south pavilion, they are comptroller, water supply, elections, licenses, civil service, sheriff. Left to right on the side of the south pavilion are records, accounts, correction, building inspection, public service commission, board of estimate. Right to left on the north pavilion are board of estimate and apportionment, public service commission, building inspection, correction, accounts, records. Right to left on the side of the north pavillion are sheriff, civil service, water supply, elections, licenses, comptroller.

Civic Fame

Atop the tower rising above the court stands Civic Fame facing the Hudson River, where ocean liners came and went. Twenty-seven feet tall, she is made of hammered copper and stands on a copper globe. In her left hand she holds a crown composed of five parapets symbolic of the five boroughs of the city and surrounded at the base by a band of festive dolphins symbolizing a seaport town. Her right arm supports a shield carved with the seal of the city, and in her hand appears a spray of laurel. Her laurel wreath is the symbol of fame. From this altitude, Civic Fame proclaims the prestige, preeminence, and development of New York City, destined perhaps someday, they prophesied, to be the metropolis of the world. The model for the figure of the sculpture was the New York woman who posed for Saint Gauden's Victory in *Sherman's March to the Sea* in Grand Army Plaza, Julia Baird, nicknamed "Dudie."*

A. A. Weinman was a pupil of Augustus Saint Gaudens's, and he worked in the studios of Olin Levi Warner, Daniel Chester French, and Charles Henry Niehaus, whose portrait is in the collection of the Metropolitan Museum of Art. Other works by Weinman in Manhattan include two friezes for the façade of the Morgan Library at Thirty-seventh Street and Madison Avenue, which symbolize Music inspiring the allied arts, and

*"Dudie" Baird was known for her lithe Pre-Raphaelite proportions. She was five feet six inches tall, had an elegant bearing, and modeled for most of the best artists of the day, including Edwin A. Abbey, Kenyon Cox, Thomas W. Dewing, Edwin H. Blashfield, Robert Reid, and Edward Simmons. To capture her proportions accurately, Saint Gaudens made plaster casts of her body from which to design his *Diana*.

Truth Enlightening the Sciences. Accompanying Music are graceful figures of Architecture, Sculpture, Painting, and Textiles, with symbols of each art, while in the panel of Truth and the Sciences appear Literature, Philosophy, History, Oratory, and Astronomy with their attributes. The great monumental clock of the old Pennsylvania Railroad Station by McKim, Mead, and White was by Weinman, and the robust figures over the entrance of that building were also by him. The figure of Day appeared with a cluster of sunflowers in homage to the orb of day, and Night, robed in flowing mantle, clasped poppies gathered from some faraway field beneath the stars. Those figures were installed over the entrance and were amidst decorative panels over the winged wheel of Speed, Progress, and Commerce, typifying industry and an ornamental eagle, surrounded by a large wreath and deeply undercut details.

Weinman executed several medals of note for various societies devoted to the arts and literature: the gold medal of honor for the American Institute of Architects, one for the National Institute of Arts and Letters, and an award medal for the St. Louis International Exposition. In collaboration with Augustus Saint Gaudens, he designed the inaugural medal of former president Theodore Roosevelt in 1905. The obverse of the medal shows the head of Roosevelt and bears the motto "Aequum Quique" ("A Square Deal"), and the reverse side bears the American eagle.

Another bronze medal by the sculptor was designed for the U.S. government as an award for conspicuous heroism in saving life on American railroads. Symbolic of courage, it shows the stalwart figure of a hero bearing the flaming torch of safety, a beacon light to the traveler.

The Appellate Court House

In 1894 the Appellate Division of the New York Supreme Court was established, and designs by James Brown Lord for the Appellate Court House at Madison Avenue and Twenty-fifth Street were approved two years later.

The building is in the Beaux-Arts tradition with columned porches, a prominent cornice, and an attic story on its two façades—Madison Avenue and Twenty-fifth Street. The sculpture program was conceived by the architect and executed by leading members of the National Sculpture Society, destined to become the most influential sculptural organization in the country until the Second World War. This was the first collaboration of New York sculptors to promote the new organization. Sculpture programs of

The Appellate Court House sculpture program was the first collaboration by members of the newly formed National Sculpture Society, whose present-day offices overlook the park.

this sort, which consisted of allegories and personifications of moral subjects carved or cast in a classical-baroque style, came out of the Columbian Exposition of 1893. Ironically, the offices of the National Sculpture Society today are across the street on Twenty-sixth Street, facing Madison Square Park as the courthouse does.

The Sculpture Program

The aim of the sculpture program was to represent the universal acceptance of law and its benefits to mankind. The program consisted of imaginary portraits of Eastern and Western lawmakers accompanied by symbolic groups of the principles they represent: Justice and Peace.

On the Madison Avenue façade standing at the left is Confucius, or Chinese Law, and it was executed by Philip Martiny. Moses by William Couper is on the right and represents Hebraic Law. The crowning central group of Peace is by Karl Bitter. The personification of Peace, standing in classical contrapposto, is flanked by a seated female figure leaning on a cornucopia and holding a sphere emblematic of wisdom and wealth. The

Left: Chinese Law is represented by Confucius. *Right:* Moses represents Hebraic Law.

male figure, on the right, leans on the fasces, symbolizing strength. At the attic story are four caryatids by Thomas Shields Clarke, representing the seasons of the year and signifying the perpetuity of the principles personified in the figures above being supported by the caryatids.

The portraits above the balustrade continue along the Twenty-fifth Street side. Zoroaster, by E. C. Potter; Alfred the Great, by J. S. Hartley; Lycurgus, the Spartan lawgiver, by G. E. Bissell (his standing portrait of Chester A. Arthur is across the street in Madison Square Park); Solon, the Athenian lawgiver, by Herbert Adams (he was involved in the replication of the base of the Farragut Monument across the street in the park in the 1930s); Louis IX by John Donoghue; and Manu, the Indian lawgiver, by Augustus Lukeman; Justinian by Henry Kirke Bush-Brown; and Mohammed (now in storage) by C. A. Lopez. Charles Niehaus did the five figures in the pediment representing the triumph of law. Crowning the entire group is Daniel Chester French's justice group. The personification of Justice is reminiscent of his figure for the Republic of the Chicago

Caryatids, representing the seasons of the year, stand for the timeless principles of Justice and the Law personified in the sculpture program.

Exposition and looks ahead to *Alma Mater* at Columbia University. She is flanked by Study and Power. Reclining on the two pediments over the two windows on either side of the entrance doors are figures of the four hours of the day by M. M. Schwartzott.

On either side of the stairway to the main entrance are Wisdom and Force by Frederic Ruckstull. Wisdom, left, reads from the book of the law and is clad in robes of the philosopher. Force at the right, on the other hand, wears military gear and holds a sword in his lap. The postures of both figures bear resemblance to Michelangelo's figures in the Medici Chapel in Florence and his *Moses* in the Church of St. Peter in Chains in Rome.

The Surrogate's Court

Nowhere in the city have architecture and decoration been more splendidly combined than in the Surrogate's Court and Hall of Records at 31 Chambers Street by John R. Thomas of 1899–1907. Inspired by Charles Garnier's famous Paris Opera House, this building is not only the self-acknowledged crowning achievement of the architect's oeuvre, but also the corona of the Beaux-Arts style in New York City, and fortunately the architecture and decoration are intact.

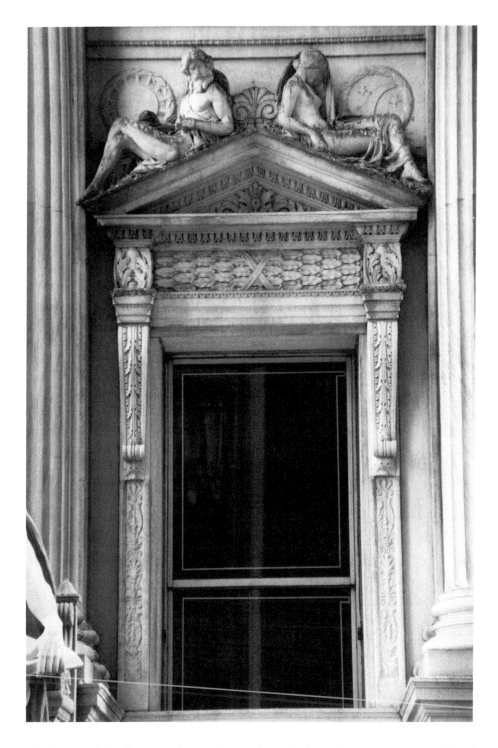

The hours of the day carved over the windows flanking the entrance are indebted to the personifications of Michelangelo's Dawn and Dusk and Night and Day in Florence's Medici Chapel.

Wisdom and Force, which flank the entrance, are reminiscent of Michelangelo's portraits of Lorenzo and Giuliano de Medici for their tombs in Florence.

John R. Thomas's Surrogate's Court.

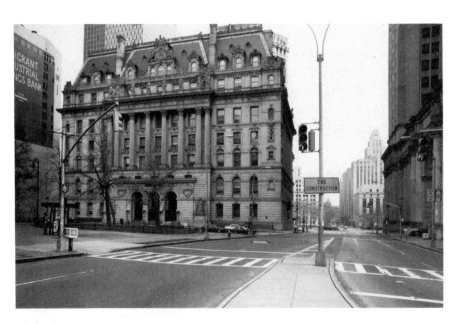

Peter Stuyvesant, identified by his finely turned peg leg, stands atop the Surrogate's Court beneath a motherly figure nurturing a child—a reminder that the Surrogate's Court was established in 1656 during Stuyvesant's rule.

Philip Martiny's sculpture on the exterior of the building celebrates New York's birth and development, and it honors outstanding New Yorkers whose roles were significant in that birth and development. Two sculpture groups, New York in Its Infancy, to the right, and New York in Revolutionary Times, to the left, flank the main entrance.

In the foyer, mosaics by William L. Dodge (1867–1935) illustrate in a naturalistic style the two arms of municipal government housed within the building—Hall of Records and Surrogate's Court. In the lunettes atop the end walls, scenes depict "Searching the Records" and "Widows and Orphans Pleading Before the Judge of the Surrogate Court."

The Surrogate's Court was established under the Dutch in 1656 for the administration of the property of "orphans and minor children" who were residents within the jurisdiction of the city government. By the nineteenth century the repository of municipal records finally warranted its own space, and the first Hall of Records was established (1831) in the old jail northeast of City Hall, across the street from its present location. The Surrogate's Court was accommodated in the same building until the court had to make way for the increasing city records and move into the New

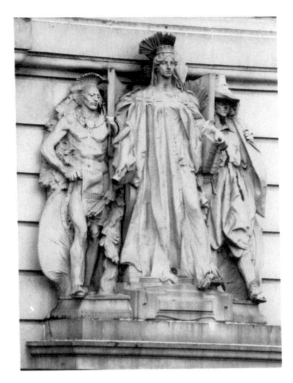

Two sculpture groups flank the main entrance and represent, on the right, New York in Its Infancy *(portrayed here)* and, on the left, New York in Revolutionary Times.

York County Court House, better known as the Tweed Court House, behind City Hall.

Guardian Twins Reunited

John R. Thomas's plans for the new Hall of Records once again accommodated the Hall of Records and the Surrogate's Court in one building. Although the name of the Hall of Records was changed to the Surrogate's Court in 1963, because of the increased use of the building by that court, the mural decorations in the lobby reflect a repository of municipal records when it was built some sixty years earlier. It is noteworthy that the pendulum is once again swinging back and a sophisticated repository of city archives is housed in the basement of the building.

Two sculpture groups in the lobby in white marble by Albert Weinert, who was born in Leipzig, Germany, and trained in Brussels, Belgium, and Paris, introduce the visitor to the theme of the Hall of Records. Over the west doorway, "Recording the Purchase of Manhattan Island" is portrayed by a male nude youth handing a bag of gold to a seated female at his right who holds a tablet and stylus while an Indian brave looks on. Over the east doorway, "The Consolation of Greater New York" is portrayed by a youth flanked by two female figures. One offers him the key to the city, the other leans on a model of City Hall.

History, Decoration, Symbolism

The historical highlights narrated by these mosaics and sculptures, extending from the founding of New Amsterdam to the modern era, summarize the events recorded in the archives housed here. These narratives are portrayed beneath a vaulted mosaic, designed by Dodge, like a great firmament whose signs of the zodiac and images of ancient deities of Justice, Retribution, Sorrow, and Labor place the functions of the recorder and the surrogate in New York within the broader scope of world history.

The tiny and irregular ceramic tesserae in varying tones of red, green, and blue that make up Dodge's palette of mosaics, and the variety of cool and warm-toned marbles of the sculpture and fixtures enhance the grand scale of the soaring space of the two-story lobby and enrich the treatment of its civic symbolism.

Through the foyer the lobby rises two stories, covered with a skylight set within a bronze dome resting on a vaulted gallery whose arcade faces out, overlooking the lobby.

Bronze chandeliers, wall sconces, and convector covers crowned with the American eagle with outstretched wings perched on globes are set within the pink, blue, and yellow Siena, Verona, Belgian, and Tennessee marbles that sheathe the walls, piers, and main stairway. Hand-carved keystones, swags, capitals, and baroque ornament at once enhance the lobby and provide a rich setting for a colossal cartouche that bears the seal of the city of New York supported by winged putti.

The Courtrooms

The north and south courtrooms on the fifth floor were designed as a pair and carry the themes of Wisdom, Law, and Justice. The south courtroom is finished in warm Santo Domingo mahogany. Above the entrance doors the city seal is supported by female figures, and above the judge's bench a carved figure of Justice holds a book on her lap inscribed "SAP," the Latin abbreviation for "wisdom."

The north courtroom is paneled in tawny English oak, and "LEX," accompanying a relief of the scales of Justice, is inscribed on the door panels. The Latin word for "law" also accompanies the lamp of truth, the two flanking the figure of Justice above the judge's bench. Reliefs of the scales of Justice, staffs of Mercury, military standard, and ancient weapons embellish the walls and frame portraits of outstanding surrogates and allegorical reliefs of Wisdom, Truth, and Civilization.

CHAPTER 21

Temple of Culture: The New York Public Library

The sculpture program of architects Carrère and Hastings for the New York Public Library draws from ancient tradition, both sacred and profane, to integrate the architecture, decoration, and symbolism of one of the great classical revival buildings in New York City.

Paul Bartlett did the six attic figures for the New York Public Library, each about eleven feet high, ornamenting the entablature above the main entrance. Coming late to the commission, Bartlett inherited a space that limited him: the shelf on which the figures were permitted to stand was only one foot deep, which posed a problem in creating enough of a relief. The placement of the figures was determined by the arrangement of the columns below. The figures act as terminal elements or finials to the upward thrust of the columns. The four central figures are therefore grouped in pairs; the two end ones stand alone. The character of the sculpture and the details are dictated by these realities.

Subject and Symbol

The subject matter deals with various phases of literature; since the purpose of the building is to house books, this was deemed appropriate. From left to right, the figures represent Philosophy, Romance, Religion,

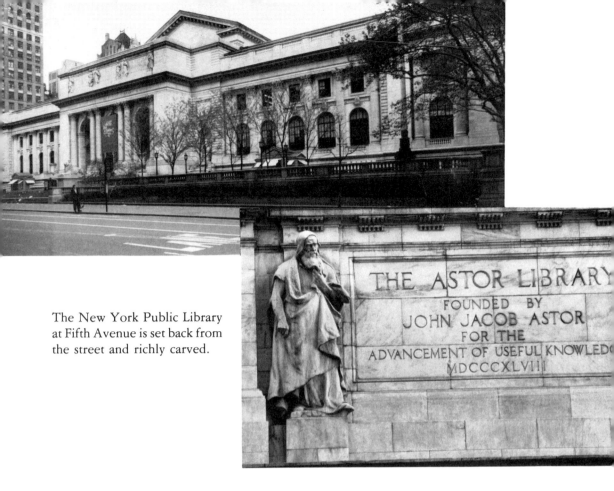

The New York Public Library at Fifth Avenue is set back from the street and richly carved.

Poetry, Drama, and History. Conceptually they read as Philosophy and History embracing Romance and Religion, Poetry and Drama. Bartlett needed to use every bit of the space he had at his disposal. He therefore decided to rely little on accessory symbols but to give each figure the character appropriate to its subject.

Philosophy, with his hand in his beard, reminiscent of the way Michelangelo carved the gesture in his *Moses* in the Church of St. Peter in Chains in Rome, wears the philosopher's cap. Romance has a flower in his left hand and a volume of poetry in his right hand, which rests on his hip. Religion gazes heavenward with a look of piety. Poetry wears a laurel crown and places his left foot on a book of verse. Drama traditionally carries two masks, symbolic of comedy and tragedy, which are in each hand. History is bearded and holds a scroll of parchment.

Beneath Bartlett's attic figures, and set within classical niches, personifications of Beauty and Truth reign over the two fountains flanking the main entrance to the library and epitomize the building that ritualizes the essence of the collections that lie within.

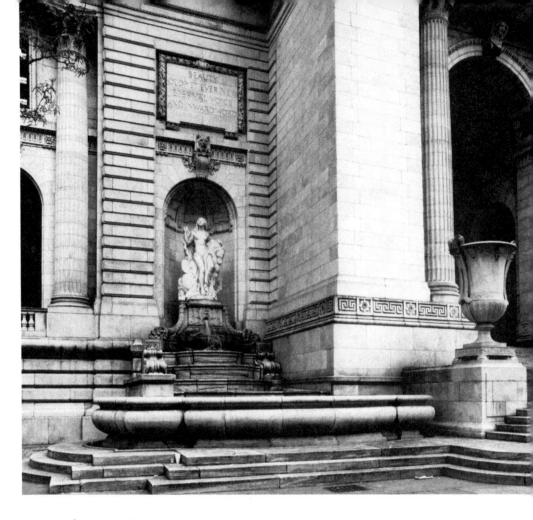

Personifications of Beauty and Truth by Frederick MacMonnies that flank the main entrance signal the insights to be gained from the sacred and profane traditions whose writings are collected within.

Myths, Symbols, and the Written Word

In the fountain to the left of the entrance, Minerva is portrayed as Beauty. She sits on the back of Pegasus, the winged horse she caught and tamed and presented to the Muses in their home on Mount Helicon. Once peaceful and verdant, with celebrated fountains, their mount was now parched and dry since Phaeton, son of Apollo, trying to prove himself, unsuccessfully attempted to drive the chariot of day and unwittingly set the world afire, leaving it scorched and devoid of life. With a powerful kick of his foot, Pegasus miraculously opened a fountain, thereafter called Hippocrene (the combination of two Greek words—*hippo,* "horse," and *crene,* "fountain"), and restored Mount Helicon to its original beauty.

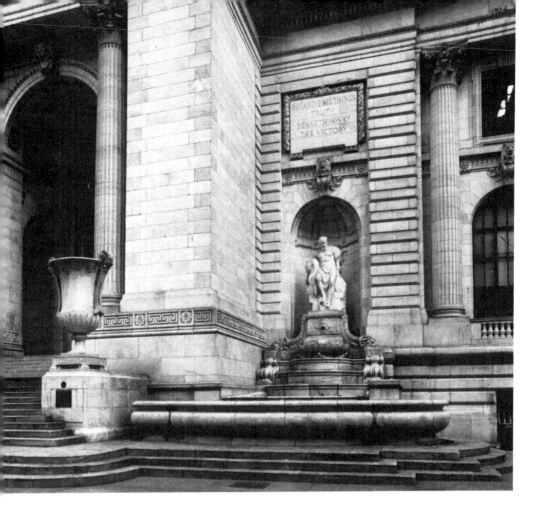

Fountain of Beauty

Frederick MacMonnies shows Beauty perusing the elegant space in front of the library as Minerva perused the wonders wrought by the kick of the horse's hoof—the ancient groves of the forest renewed, the slopes grassy again, and the caves redolent with colorful flowers. As the waters flowing from the Hippocrene were the source of poetic inspiration in ancient times, so MacMonnies's fountain on Fifth Avenue symbolizes the sources of inspiration within this remarkable institution.

The timelessness of beauty and inspiration are expressed in the words of John Greenleaf Whittier inscribed above: "Beauty old yet ever new eternal voice and inward word." Beauty looks up and draws our gaze to Paul Bartlett's statues at the attic level.

Fountain of Truth

To the right of the entrance, a bearded man seated upon a sphinx personifies Truth. The old man is Esdras, the Old Testament prophet to whom it was revealed in an apocalyptic vision, "Above all things, Truth beareth away the victory." The sphinx recalls the Monster of Thebes that killed all travelers who failed to answer the riddle "What animal goes on four feet in the morning, on two feet at noon, and three feet in the evening?" Oedipus' correct answer to the riddle—man, who crawls on all fours as a baby, walks upright as an adult, and walks with a cane in old age—killed the monster. Oedipus, then, in ignorance, killed his father, married his mother, and lived out his days in blindness and torture.

The Old Testament reference to Esdras emphasizes the omnipotence of truth, and the sphinx's reference to the Oedipus myth demonstrates the tragedy of ignorance. Therefore, the wisdom embodied in the ancient myths and in the Bible underscores the insights to be gained from both pagan and religious traditions, whose writings make up the repository of the library.

Submerged Symbols Link Past and Present

Carrère and Hastings use other symbols to tie the twentieth-century building and its decoration to ancient traditions. Mercury and Minerva make up the keystones over the main entrance. And Mercury's caduceus, his identifying emblem, is prominently displayed at the east entrance of the library, curiously isolated. Carried by Mercury, the caduceus was a symbol of fertility, wisdom, and healing, an appropriate image for a cultural repository. It is noteworthy, however, that the caduceus was adopted by the medical branch of the U.S. Army as its official insignia in 1902, the year the library's cornerstone was laid.

The caduceus, therefore, all by itself and prominent, is a way the architects used to date the building with a symbol that ties it to the classical tradition in the modern world. Its appearance here is as a symbol submerged.

Another submerged symbol is the bee that is carved so clearly on the capitals atop the columns in Astor Hall, at the entrance to the building. It relates the library's magnificent interior to the architecture and the values of the ancient world.

Universally emblematic of industry and creative energy, the bee is found in the imagery of such traditions as the Romanesque, early Christian,

Mercury and the god's caduceus
that dates the building.

Indo-Aryan, Moslem, and Judeo-Christian. Its presence here, however, refers to the magnificence of Astor Hall as one of the few rooms in New York City ever built entirely of marble.

According to an ancient Greek tradition, the most beautiful marble temple in Delphi had been miraculously erected entirely by bees. The bee, then, became not only the Greek's favorite emblem of work and obedience in the ancient world, but it also became Carrère and Hasting's symbol in the twentieth century of the most beautiful marble room in New York City.

The design of the candelabra in Astor Hall, as Henry Hope Reed has noted in his detailed account of the architecture of the building published in 1986 as part of the celebration of its recently completed restoration, was inspired by ancient Roman models in the Vatican, and by the busts of Titus, Sophocles, Terence, Julius Caesar, and Brutus, carved by Leone Clerici and located in the exhibition hall next to Astor Hall.

The bees in Astor Hall symbolize industry and recall the building of one of the temples of Delphi.

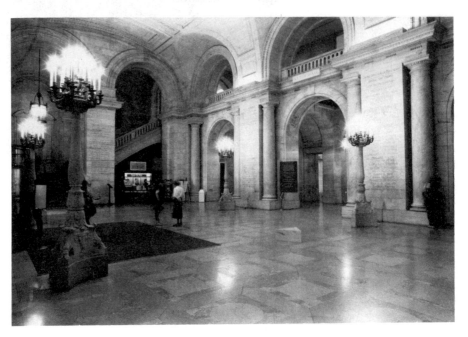

Astor Hall, like the great temple of Delphi, is carved of marble but not by bees.

Portraits Paired

Two modern portraits in marble, reflecting the various stylistic possibilities within the classical tradition, are set in niches along the stairwalls of Astor Hall. The portrait of Thomas Hastings, architect of the library, is by Frederick MacMonnies, and Herbert Adams did the bust of John Stewart Kennedy, library trustee.

Kennedy was a Scot who came to New York to represent an English iron company. By 1868 Kennedy was an independent banker and was active in local philanthropies. He financed the United Charities Building on Park Avenue South and Twenty-second Street, designed in 1891 by R. H. Robertson and Rowe and Baker, architects, and it was Kennedy who donated Emanuel Leutze's colossal painting *Washington Crossing the Delaware* to the Metropolitan Museum of Art.

The niche for the Kennedy bust by Adams is a rich assemblage of classical decorative elements. MacMonnies's bust of Hastings, on the other hand, is set in a simpler arrangement of classical architectural forms. While Kennedy's portrait is framed within an elaborate aedicule within the wall, Hastings's portrait depends upon the flat wall for its effect. A simply relieved Roman arch without keystone springs from a pair of engaged Doric columns to frame MacMonnies's bust of Hastings, which stands on a simple pedestal of one-to-one proportions in front of the arch. The ashlar is cut in ample blocks whose joints contribute to framing the bust as if it is in front of a grand window. The apparent opening up of the great marble wall by this device is effective in giving a lightness to the already animated treatment of the portrait. The jointing of the ashlar makes the entire ensemble appear to be composed simply of several stones, enhancing its grandness.

MacMonnies was obviously aware of J. J. Winckelmann's (principal theoretician of neoclassicism) admonition to give meaning to decorative design and to his conviction that architecture is "grand when the articulation of the principal members of the orders consists of few parts and when these receive a bold and powerful mass and curvature."

The portrait bust of Thomas Hastings by MacMonnies and the bust of John Stewart Kennedy by Herbert Adams are carved along the south stairwall off Astor Hall.

Highlights of Excellence

The fireplace in the Trustees Room in the New York Public Library is a remarkable ensemble of decorative detail and figural carving, by François Michel Louis Tonetti (1863–1920), who was born in Paris and studied there under Falguière. Later, when he moved to America, he assisted Frederick MacMonnies with the Ship of State at the Columbian Exposition of 1893.

Resting on the mantel above Minerva and Hercules over the hearth, a dedication panel is flanked by two maidens similar in composition to Flora in the ceiling above them. One carries calipers, the other an hourglass, elegant reminders that the library was created by man in time. And though this "gilded monument" may not last forever, while it does, those values for which it stands "shall shine more bright in these contents" (Shakespeare, Sonnet 55). Elegant references to the arts are also found in the ceiling of the second-floor stairway.

Edward Laning's murals in the third-floor landing hall of the library (1938–42), a WPA project, relate the history of the inscribed word, analogous to Prometheus bringing to humankind fire and knowledge stolen from the gods. Appropriately, that ancient Greek myth is portrayed in the vault above the hall, and set within blind arches are Laning's four sixteen-foot-high murals painted in oil on canvas. The murals were financed by Isaac Newton Phelps Stokes, who amassed a prodigious collection of historic prints of New York, which formed the basis of his *Iconography of Manhattan Island* and are cared for by the prints division of the library; the collection is still available to scholars.

Scenes of four high points in the history of the inscribed word, which Laning selected, are Moses coming down from Mount Sinai with the Ten Commandments; a medieval monk transcribing an illuminated manuscript; Johann Gutenberg discussing his Bible with Adolph of Nassau, elector of Mainz, where the book was printed, pioneering movable type; and Ottmar Mergenthaler, inventor of the Linotype machine, shows Whitelaw Reid of the *New York Tribune* a page printed by the first mechanical typesetter.

The pedestals that support the bench seats in front of the murals subtly tie together the idea of the building as classical revival architecture and the repository of one of the world's great libraries. Echoing the design of the volute supports of the bench seats are paired dolphins, reminiscent of the ancient symbol of Arion, to whom can be traced the origins of lyrical and tragic literature.

CHAPTER 22

Temple of Finance: The Bowery Savings Bank

The Bowery Savings Bank, part of New York City's urban landscape since 1834, has stressed the skillful blending of sculpture and architecture in all its branches. That combination of art and technology is especially noteworthy in their branch at 130 Bowery, designed by Stanford White in 1893–95 and designated a New York City landmark in 1968, and the Bowery Savings Bank at 110 East Forty-second Street designed by York and Sawyer in 1923.

Stanford White's façade on the Bowery recalls a Greek temple. In the pediment, two figures, male and female, flank a colossal clock, a group created by famed sculptor Frederick MacMonnies, whose other sculpture in New York City includes *Nathan Hale* in City Hall Park, *Civic Virtue* in Queens, originally in City Hall Park, the fountain figures at the entrance to the New York Public Library, the sculpture groups on the arch in Prospect Park, and the angels at the main altar of the Paulist Church near Lincoln Center.

The Bowery's square banking room is distinguished by its fifty-foot-high coffered ceiling with gilded rosettes and glazed skylight resting on colossal wood marbleized Corinthian columns with gilded acanthus leaf capitals. The room is further enhanced by rich floor mosaics, elaborate moldings, and marble wainscoting.

The banking room at 110 East Forty-second Street is equally remarkable for its conflation of architecture and sculpture. Designed in the Ro-

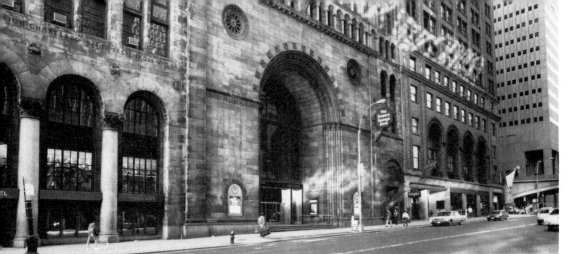

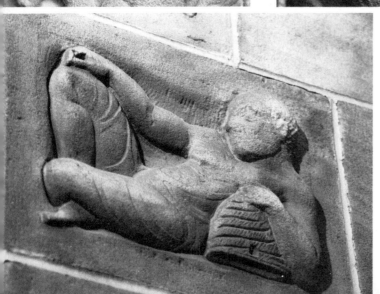

The decorations of the Bowery Savings Bank on Forty-second Street facing Grand Central Terminal blend Aesop's fables with the imagery of thrift.

manesque revival style, the building is eighteen stories high and clad in Ohio sandstone. The grand scale of the room is enhanced by different-colored and -textured marbles from six countries and the United States and with a lively panoply of figural decoration reminiscent of the Romanesque churches of medieval Europe.

Decoration with Tradition

The banking room is 160 feet long, 80 feet wide, and 65 feet high. Its end walls are of limestone and sandstone. Six engaged columns on either side of the hall with variegated marble shafts and leafy capitals support grand relieved arches and flank broad marble panels above darker marble wainscoting and a carved grille in Missouri marble at the center of each panel. The walls and floors are ablaze with Cosmati work, by DePaoli, and the ceiling decorations were designed by Angelo Magnanti and painted by Barnet Philips.

"Cosmati work" is a generic term for fine stonework and takes its name from a group of marble workers in the vicinity of Rome from the twelfth to the fourteenth centuries, many of whom were of a family named Cosmos or Cosimo. Their superior decorative work in marble with inlays of colored stone, mosaic, glass, and gilding greatly enriched Italian Romanesque architecture.

Symbols and Fables

A highlight of York and Sawyer's decorative program is the character and variety of stone and bronze figures that populate the doorways, corbels, mailboxes, cabinets, tables, and walls. Ghouls and gremlins lurk beneath the lintels. A sphinx stares out from beneath a writing table. A pair of dancing cupids decorates mailboxes. Squirrels stash away nuts at the door of the banking floor, as well as on the façade. Sea horses crown a teller's cage. Owls are at your elbow. Beehives permeate the decoration. And monkeys climb the fire-hose cabinet. On the east and west walls of the banking room hang the original massive bronze doors that served the public for forty years, prior to the entrance's being remodeled in 1963.

The collaboration between architects and sculptors of this period has produced in the Bowery's decorations a remarkable record of a tradition that has died out. The designs were executed by the studio of Ulysses Ricci and Angelo Zari under the direction of the architects with the approval of the bank.

The Diligent Saver is carved into a surround on the Forty-second Street façade.

Even Aesop's fables were pressed into service. In the fable "The Diligent Saver," whose toe is bitten by the "Rat of Bad Influence," the sculptor has carved on the Forty-second Street façade the entire narrative, ending with the rodent's being hung from the topmost branch of a vine.

Both people and animals carry the message of thrift through saving. A man holds keys symbolic of the bank's guardianship, an ox head symbolizes strength through saving, a lion power gained from saving, an owl the wisdom of saving, a dog the importance of fidelity to saving, a squirrel the advantages of thrift, a rooster the necessity of punctuality in making payments, and the American eagle suggests that it is even patriotic to save. A male figure holding coins represents Finance, a classical female figure with strings of pearls personifies Luxury, a farmer embodies Work and Industry, the bull and bear of Wall Street stand for Wise Investment, and a chicken-and-egg capital in the lobby whimsically celebrates the advantages of having a nest egg.

Corbels of crouching figures at the ceiling of the lobby oversee the vestibule decorations, which include the original bronze elevator doors,

A capital in the lobby near the subway entrance celebrates the advantage of a nest egg.

still intact, emblazoned with portraits of professionals and their employees who pass through the doors each day on their way to the offices of the building—a bemonocled architect at his drafting table and a telephone operator curled up with a book while waiting for a call are among these bronze reliefs.

Other lobbies nearby echo the rich decoration of the Bowery Savings Bank. The Pershing Square Building of 1923 at 100 East Forty-second Street by York and Sawyer with John Sloan has elaborate mailboxes with powerful eagles and bronze doors with virtues illustrated that are associated with good business, integrity, industry, and sincerity. A marble plaque tells the story of Pershing Square. The Lincoln Building at 60 East Forty-second Street, 1929, by J.E.R. Carpenter has quotations from Lincoln's second inaugural address and the Gettysburg Address, and a miniature sculpture of Daniel Chester French's seated figure of Lincoln in the Lincoln Memorial in Washington, D.C., is displayed in the lobby.

Figural and decorative ornament were an integral part of architecture well into the twentieth century, in spite of the advent of the international

In the modern world of business, trains run on time—a twentieth-century pictogram of hourglass, train, and wheel of commerce. Trains that run on time support modern-day commerce.

style. Although it was considered *retardataire* by some observers and practitioners of the period, there is now a growing appreciation of the collaboration between sculptor and architect that was its hallmark and that produced the decoration of the Bowery Savings Bank.

CHAPTER 23

Temples of Communications: Two Telephone Company Buildings

The first Bell Telephone Company building in the Art Deco style, Barclay and Vesey streets, was known as "the House of a Million Voices" because it was also the first to house both the equipment and the executive offices. So not only were the executives and records assembled there, but all the telephone calls in New York came through that building.

Communications Linked Through Excavation

Ten panels on the ceiling of the lobby painted in fresco by R. B. Newman (who also restored the murals in the 1950s) survey the history of communication from ancient times to the twentieth century and illustrate in each roundel one aspect of that history. In the first use of light to send messages, ancient Greek warriors are shown using the polished surfaces of their metal shields to reflect the sun's light to flash messages over long distances. The early use of fire as a means of communication is illustrated by the Roman system of blazing beacons. The roundel shows a signal being sent along an old Roman wall from beacon tower to beacon tower. In another medallion the American Indian relays his messages by smoke signals. In the early days of wooden ships, signaling by firing cannon was a

Murals in the lobby of "the House of a Million Voices" tell the story of communication.

common method of communication. The ships illustrated here are reminiscent of the eighteenth-century merchant sailing ships that frequented New York's harbor. Ironically, an entire ship of that kind was found below this lobby—so below this medallion—when the landfill upon which the building stands was being excavated to lay the foundation.

In the Middle Ages signal flags were used to relay messages from one army to another, shown in Newman's mural, a mode of communication that was passed down to modern times and is still in use in the military and such organizations as the Boy Scouts. The signal flag was adopted to the Morse and semaphore codes.

The Aztec runner depicted on the ceiling here portrays that phase in communication when messages were carried by courier; modern couriers no longer travel on foot. Chinese merchants for thousands of years sent carrier pigeons on errands over great distances, and that celestial method portrayed here has been used more recently by modern princes of finance. Sound has been used by primitive as well as sophisticated civilizations. Legends of how ancient Egyptians used the megaphone with such sensitivity that spoken words could be transmitted several miles inspired one of these mural medallions. And for centuries African tribes have used drums to transmit signals from one village to another over many miles, shown here.

Muralist R. B. Newman portrays the medieval method of relaying messages by signal flags.

At the center of the group of panels, the telephone, telegraph, and radio illustrate modern communication by which it is possible to contact anyone, anywhere, anytime. Telephone research and technology have made it possible for people to eradicate the barriers of time and space, the central theme of the frescoes.

History, Symbol, and Art

Besides using ornamentation narratively to portray the history of communication in the lobby, the architect uses it symbolically and decoratively as well. The pelicans in the ironwork outside, for example, symbolize service in self-sacrifice and nod to the Woolworth Building nearby, whose architect Cass Gilbert employed that image over the main entrance on Broadway. The pelican is shown in both buildings piercing

her own heart to feed her young rather than allowing them to starve.

Sunken, low, and high relief designs of flowers, plants, and game in the limestone trim along the south walkway directed to the passersby related that part of the building to the market stalls of the Washington Market, which once occupied the site of the World Trade Center across the street.

Influence of Decoration on Design

To prevent the different parts of the building from looking like packing boxes or children's blocks randomly stacked up, Ralph Walker, the architect, eliminated the traditional projecting cornice and used instead a simple cresting or ornamental relief at the summit of each blocklike segment. He further unified the composition by emphasizing the vertical lines of the piers and windows with foliated relief so that the boxlike forms appear to merge.

The wall itself was an important design feature for Walker, not only structurally but also visually. The exterior walls enclose banks of offices around a central core that houses the elevators, toilets, and service units. An equal balance between wall and window provided its occupants with ample natural light combined with a sense of solidity. From the outside, the continuous brick cladding and limestone trim around the windows express their interior spaces.

Walker exhibited the same sensitivity in relating building to site in two other Art Deco telephone company buildings in New York. In the Long Island headquarters, 101 Willoughby Street at Bridge Street in Brooklyn, in 1931, the building is related to its site through the decorative grillwork at the ground level repeated at the subway entrance. The willow leaf motif in the ornament on the telephone company building at 425–437 West Fiftieth Street, between Tenth and Eleventh avenues, in Manhattan of 1930 relates that building to its residential neighborhood site, and the high level of craftsmanship and distinguished silhouette of the building convey an image of permanence and high purpose for which the Bell Telephone Company wanted to be known.

The respect some avant-garde architects had for the building is reflected in its appearance as the frontispiece to Le Corbusier's *Towards a New Architecture.*

195 Broadway

Ralph Walker believed that it is impossible to take provincial European forms and enlarge them to gargantuan proportions and successfully express modern skyscraper technology. William Welles Bosworth, on the other hand, blended old and new on a colossal scale in another Bell Telephone Company Building nearby at 195 Broadway, the offices of AT&T and Western Union. The building is now in private hands. Bosworth also designed the base for Karl Bitter's equestrian monument of Franz Sigel at 106th Street and Riverside Drive, remodeled the Morton F. Plant residence into Cartier's in 1907 at Fifth Avenue and Fifty-second Street, and designed the fashionable Beaux-Arts town house at 12 East Sixty-ninth Street in 1914.

The Modern-Day Cella

Guided by the ground plan of an ancient Doric temple, Bosworth made a modern skyscraper. The Doric temple was composed of a central room, the *cella,* surrounded by a band of open space screened by columns on all four sides. In place of the *cella,* Bosworth installed the elevators, toilets, and closets. In place of the walkway around the *cella,* he placed the hallway and the telephone company offices, and in place of the temple's freestanding columns, Bosworth erected a wall of engaged Greek columns with large windows in between. His design was both historical in its reliance on ancient Greek forms and modern in allowing the columns and the architrave to reflect the steel skeleton behind. This space upon which Bosworth built his building was the site of George B. Post's Western Union Building, which, along with the Tribune Building, was America's first skyscraper.

Classical columns are the central motif of the building, both structurally and ornamentally. The exterior is composed of eight tiers of Ionic columns, and the lobby is a forest of columns that provide corridors like promenades to and from the elevators and entrances.

Ancient Motifs Subsumed

Bosworth borrowed from the Septizodium in Rome, one of the seven wonders of the ancient world, no longer extant but known from ancient records and a favorite ruin in later paintings. George B. Post's St. Paul

Building across the street was also indebted to the Septizodium and established the eight-story tier that Bosworth repeated in his building. Built by Septimus Severus on the exposed southeast flank of the Palatine Hill, the highest of Rome's seven great hills, it was a seven-story-high, freestanding screen of columns facing the Appian Way, an imperial monument that welcomed visitors from the south.

Bosworth's Doric columns are copies of those of the Parthenon, and his Ionic columns that surround the upper stories are based on columns from the temple of Artemis, c. 356–334 B.C. Excavation of that temple had begun in 1869 and after an interruption had resumed in 1904–5. The great truncated column in the Metropolitan Museum of Art that New Yorkers know so well and that now stands at the entrance to the cafeteria there came from that excavation. Bosworth, then, drew on three revered ancient monuments for his models for the AT&T decorative or architectural elements.

Screens of columns were common in ancient Rome, in baths and amphitheaters, for example, and New Yorkers were familiar with their adaptation during the Greek revival of the 1830s, for example, in Colonnade Row on Lafayette Street. The device continued in favor well into the twentieth century, to which the colossal screen of columns on the façade of Butler Library at Columbia University by James Gamble Rogers, 1934, attests.

Even objects that served the practical day-to-day functions of the building were conceived as an integral part of the decoration. Classical motifs continue the antique themes in the decorations throughout the building. The directory board in the lobby, for example, is framed with Ionic columns of the fifth century B.C. and a cornice of Greek fretwork. The lobby's cast-iron chandeliers carry hand-carved alabaster fixtures derived from Greek oil lamps. The bronze decoration of the elevator cars, the grilles throughout the building, the push buttons, and the doorknobs are classical in design and decoration. Even the door keys were designed in the form of Greek shields.

The mailbox in the lobby is special, too. Hand-carved in white marble with guardian eagles at the corners, the receptacle required special permission from the U.S. Post Office because it differed from the standard mailbox.

The warm tones of Istrian and Botticini marbles in the lobby combine with the giant white Vermont marble columns to convey a sense of solidity and permanence in keeping with AT&T's image of public service.

Contemporary Tributes

Two heroic-size wall reliefs celebrated communication and service. A bronze relief of Alexander Graham Bell pays tribute to the accepted inventor of the telephone. By the noted sculptor Paul Manship, best known for

Replicas of panels designed by Paul Manship above the four Broadway entrances to 195 Broadway represent the four elements of earth, water, air, and fire—symbols of regeneration.

his *Prometheus* in Rockefeller Center, the relief style ties in appropriately with Manship's reliefs over the entrances to the building. The panels above the four Broadway entrances represent the four elements, earth, water, air, and fire, symbols of regeneration. Matter, in its three states of water, earth, and air, is transformed by fire into spiritual energy. These panels were inspired in style by the panels on the Temple of the Winds at Athens. These panels are replicas of the originals, which are in storage.

A bronze-and-marble allegory of AT&T's service to the nation in peace and war was executed by sculptor Chester Beach, who is known for his portrait bust of Theodore Low De Vinne, which still stands in Low Library, Columbia University. Beach's sculpture features an over-life-size bronze personification of Telecommunications wearing headphones and carrying telephone cable. The figure is partially swathed in the American flag. Above the standing figure personifications of War and Peace appropriately fly in opposite directions and support a map of the United States on which principal communications centers are linked by the telephone cable. Peace is a lightly draped female figure carrying a sheaf of grain, and War is a male figure holding a sword.

At the main entrance, south door, a great bronze roundel was set in the floor showing Mercury as the symbol of rapid communications carrying messages to the gods. The relief has since been removed, as was the clock at the opposite end of the lobby to the north, when AT&T moved uptown.

Longman's Golden Boy

Atop the building, Apollo-like, soared the spirit of Communication, above a stepped temple reminiscent of the famous tomb of Mausolus at Halicarnassus. The sculpture is a heroic figure standing on a golden globe, symbol of the earth, his left arm pointed toward the sky, from which he has snatched the thunderbolts grasped tightly in his hands. His right arm supports coils of a telephone cable, one end of which he holds while longer loops sweep gracefully around his body. The great male figure personifies AT&T's transformation of nature's resources into its network of worldwide communication. Tiptoeing 434 feet above the street, the *Genius of Electricity,* as the sculpture is also known, stood nineteen feet high with a wingspan of twelve feet. It weighs sixteen tons and faced north when it crowned the AT&T Building.

Placed atop the building in 1916, the sculpture was executed by Evelyn Beatrice Longman, the first woman to be admitted to the National Academy of Design. The judges were Theodore Vail, president of AT&T

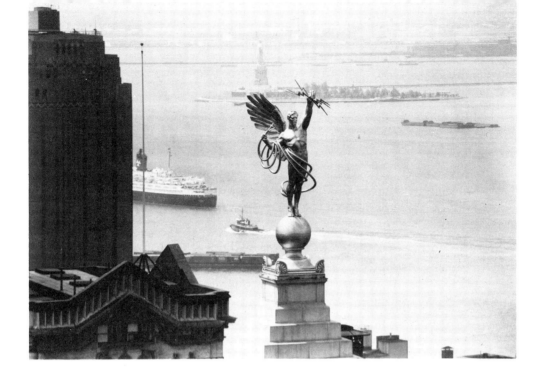

Evelyn Beatrice Longman's *Golden Boy* in its original location atop 195 Broadway, before it was removed in 1980 to be placed in the lobby of 550 Madison Avenue, AT&T's new headquarters.

and Western Union, W. W. Bosworth, the architect, and Daniel Chester French, a foremost sculptor of the day, who was also Longman's teacher.

Removed in 1980 to be placed in the public lobby of AT&T's new building at 550 Madison Avenue by Philip Johnson and John Burgee, the figure is cast bronze with a sophisticated internal steel frame for support and wind bracing. The statue is covered with twenty-one-karat gold leaf, the reason it is more familiar to New Yorkers as *Golden Boy,* which was restored every seven years when it stood atop the 195 Broadway site. Now that the figure is inside, protected from the environment and acid rain, the gold leaf should last much longer.

The building was designed to be an efficiently functioning space and a work of art to express the ideals of the telephone company. Theodore Vail, its president then, enumerated these as permanence, stability, and excellence, achieved through dedicated public service. *Golden Boy* is a development of a *Victory* that Evelyn Longman created for the world's fair in St. Louis in 1904. *Victory* was chosen for its excellence to crown the Festival Hall, the principal building of the exposition, and it won a silver medal for the sculptor.

Temple of Commerce: The U.S. Custom House

A History in Stone

When architect Cass Gilbert was commissioned to design a new custom house for the U.S. government in 1903, the country had become a world power, and revenue from the New York port was a major source of the government's income. The new building, therefore, should look the part. It did. *The New York Times* called it "a great Temple of Commerce" and praised the building's sculpture program, especially the way the statues above the cornice at the top of the building (the attic story) portrayed the history of maritime commerce and power from ancient times to the present. Moreover, critics praised the tasteful way the architect also used the statues to unite the upper and lower parts of the façade.

These attic figures suggest the columns beneath them with their fluted shafts and richly carved capitals. Gilbert required the sculptors to give the lower part of the figures a vertical movement either by the pose of the limbs, the drapery, or an object such as a staff or sword to continue the vertical lines of the columns below. The upper parts of the statues were to be rich in detail, culminating in an appropriate resolution of the upward movement. This treatment focuses attention visually on the figures, which then tell the story of maritime commerce through the ages from ancient times to the present. The narrative reads from left to right beginning with Greece and Rome and ending with France and England.

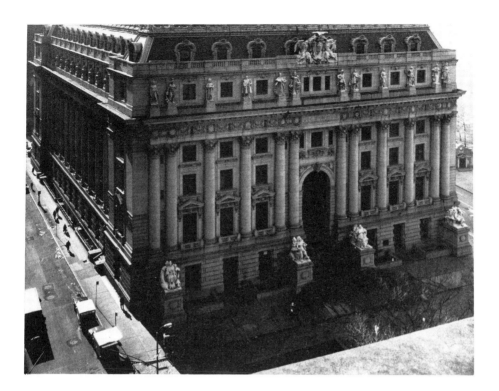

View of U.S Custom House, Bowling Green, by Cass Gilbert, 1907.

Greece and Rome

Gilbert commissioned Frank Edwin Elwell to do Greece and Rome. Curator of modern and ancient sculpture at the Metropolitan Museum of Art at the time, Elwell had studied at the Ecole des Beaux-Arts in Paris and had executed works for the great Columbian Exposition at Chicago in 1893. Elwell made Greece a beautiful female and Rome a strong male, because, as he wrote to Gilbert, "Rome conquered the world; Greece made the world worth conquering." (All the figures compose toward the center—that is, the lines lead toward the center of the building.)

Greece is represented by Pallas Athena, patron of Athens, goddess of wisdom, who came forth from the head of Zeus fully formed and armed with the traditional crested helmet and cuirass, carrying a shield and the sacred olive plant, symbols of the arts of peace and war. Rome is represented by a soldier who carries a scepter, symbol of power, and on his breastplate are the figures of Romulus and Remus, the wolf, and sunburst. Romulus, legendary founder of Rome, and his twin, Remus, sons of Mars, were abandoned in the Tiber but found and suckled by a wolf, then reared by a shepherd to manhood, when they restored the throne usurped by

Amulius to Numitor. His right hand presses against the head of a slave.

Elwell had recommended to Gilbert that he give commissions to Enid Yandell and Janet Scudder. Although Gilbert rejected Elwell's suggestion, the statue of Rome, on which he was assisted by August Zeller of the Carnegie Institute (Zeller's name appears next to Elwell's on the base), bears the influence of Enid Yandell in the crouching figure behind. Yandell admired Michelangelo and studied with Martiny in New York and Rodin in Paris; the figure resembles Rodin's *Thinker* and Michelangelo's *Slaves* in posture and expressive surfaces.

Phoenicia

Phoenicia is represented by Astarte, the Phoenician goddess who corresponds to Venus or Aphrodite in Roman and Greek mythology.

Detail of Rome atop the U.S. Custom House.

Identified by the sun and crescent on her drapery, she holds a ship in front of her, and the Phoenician characters carved on the stole that hangs almost the length of the figure salute her as "mistress of the sea." The columns represent the Pillars of Hercules—promontories at Gibraltar in Europe and at Ceuta in Africa, at the east end of the Strait of Gibraltar. Augustus Saint Gaudens portrayed the pillars on the obverse of the Chicago world's fair medal, and Ruckstull had one of the medals.

Frederic Ruckstull (see chapter 17) fashioned the statue after the so-called Elch Phoenician bust in the Louvre (so called because it was discovered at Elch, Spain) and statues of Minerva he had seen in Athens and Berlin, as well as illustrations in books on antique art. Ruckstull was a founding member of the National Sculpture Society; other members who also worked on the U.S. Custom House included Daniel Chester French, Karl Bitter, and Augustus Lukeman.

Genoa

Lukeman represented Genoa as Christopher Columbus with clean-shaven face, high forehead, and long, thin hair, holding the plumed helmet and long sword that identify him as duke of Veragua and admiral of the ocean.

Born in Richmond, Virginia, Augustus Lukeman grew up in New York and studied at the National Academy of Design and Cooper Union before he went to Paris to study at the Ecole des Beaux-Arts. On his return he became Daniel Chester French's assistant and did a number of ideal statues as well as portrait figures, including the inspired lawgiver of India, Manu, on the Appellate Court Building, and the equestrian statue of Kit Carson for Trinidad, Colorado.

Venice and Spain

The two most elaborately carved figures are Venice and Spain, by François Michel Louis Tonetti, who was known by his fellow artists as the "half Italian and half French faun." The reference was to a character in Hawthorne's popular novel *The Marble Faun,* which chronicled artist life in nineteenth-century Florence. Spain is represented as Queen Isabella, whose hand rests on the globe and points precisely to the new continent. Her drapery and shield bear the arms of Castile and Leon, and beneath her left hand is Columbus's flagship, the caravel *Santa Maria,*

which is a recurring motif in the ironwork in the lobby of the building.

Venice is represented by a doge, traditional religious, civil, and military head of the country. With the lion, symbol of Saint Mark, patron of Venice, to his left, he rests his right hand on the *delfino* (literally "dolphin," but it refers to the prow, which has six "teeth" to symbolize the districts that make up Venice) of a gondola. The ring he holds in his right hand he will cast into the Adriatic to celebrate the symbolic marriage of Venice with the sea. This ritual, conducted on Ascension Day each year, was instituted to commemorate the conquest of Dalmatia by Doge Pietro Orseole II in the year 1000.

Tonetti came to America from Paris in 1899, when he was thirty-six years old, after studying with Frederick MacMonnies, and he earned recognition in 1904 for his personification of Dance and a portrait of Charles Goodyear for the St. Louis Exposition. He married Mary Lawrence, one of Augustus Saint Gaudens's most promising students. Saint Gaudens called her a "picnic girl" (an endearing term) until she gave up sculpture when she married and devoted her life to Tonetti and their home, a converted church on Fortieth Street.

Holland and Portugal

Louis Saint Gaudens, brother of the better-known Augustus, was commissioned to do Holland and Portugal, which, along with Tonetti's pair, flank the great triumphal archway below. To typify Holland, Saint Gaudens at first chose to represent Admiral Maarten Harpertszoon Tromp with his legendary broom, which he reportedly fastened to his masthead upon entering the Thames after defeating Admiral Robert Blake off Dungenesse in 1652, in the first of the Dutch wars. The reference to his "clean sweep" of the British fleet in Holland's "Golden Century" was a bit too controversial, Gilbert thought, so the broom was replaced with the baton (symbol of authority) "Jan Maat" now holds in his right hand. Wearing a sword on his hip, he rests his left hand on nautical rigging.

Prince Henry the Navigator, whose discovery and colonization of the Azores in the fifteenth century and whose navigational studies stimulated maritime explorations of more than half the globe over the following century, represents Portugal. The absence of Prince Henry's orb, which he traditionally holds, may be explained by the fact that at first Portugal was to be represented by Vasco da Gama, and the change to Henry was made after the statue was well along. Prince Henry is dressed in armor and

wears a richly embellished cape, and his hands rest on a sturdy sword.

Saint Gaudens studied in Paris and was an assistant to his brother, Augustus, for many years. He won a medal at the Pan-American Exposition of 1901 in Buffalo and executed a relief for the Church of the Ascension on Fifth Avenue at Tenth Street.

The irregular treatment of the headdresses of the four figures that flank the archway posed a problem at first for Gilbert. All the statues were supposed to be eight feet high, but if some were to have high head coverings, the figures would be out of scale. Augustus Saint Gaudens solved the problem with his suggestion that Gilbert employ the principle used in the Renaissance—that is, keep all the eyes on the same level, and everything else will fall into proper scale.

Denmark

Denmark (Scandinavia) was made by a Danish sculptor, Johannes Sophus Gelert, who studied at the Royal Academy of Fine Arts in Copenhagen before immigrating to the United States in 1887 when he was thirty-five years old. A member of the National Sculpture Society, the Architectural League, and the American Federation of the Arts, he received awards for his work in the Nashville Exposition of 1897, the Paris Exposition of 1900, and the Pan-American Exposition. His works include the Hans Christian Andersen and Beethoven monuments in Chicago and *Roman Civilization* for the Brooklyn Institute of Arts and Sciences.

The Viking figure is emblematic of the maritime power of the Norsemen, whose migrations from the eighth to the eleventh centuries are legendary and extended southward to the British Isles, the Frankish empire, and the Mediterranean, eastward to the Baltic, Russia, and Byzantium, and westward to Iceland, Greenland, and America.

Gilbert had originally planned to represent Denmark and Norway individually, but when Germany was added he referred to the single figure then as Denmark-Norway or Scandinavia, because during the Viking age when these people were the best sailors and shipbuilders in the world, Gilbert reasoned, they were united. Because of his origins, however, Gelert always referred to the figure as Denmark, and that is the designation the statue has kept. Gelert made a small version in stone for Cass Gilbert, which the architect kept in his office but which, alas, is now lost. This statue was Gilbert's favorite.

Left: Sculptor Johannes Gelert chose a Viking to represent Denmark. *Right:* Germany as it appeared atop the U.S. Custom House in 1907.

Germany

Because of Germany's historical as well as contemporary maritime importance, Gilbert decided to include it, and Albert Jaegers, originally commissioned to do Norway, was assigned this figure instead. That was agreeable to him since he had been born in Germany and had come to the United States in 1882 when he was fourteen years old. He was working for Gilbert on the St. Louis Exposition and later achieved recognition for his Von Steuben Memorial in Washington, D.C., and the Pioneer Monument for Germantown, Pennsylvania.

Germany was a powerful, full-breasted androgyne leaning on a shield inscribed in low relief with the words "Kiel" and "Wm. II" and decorated with a dolphin. The figure wore an elaborately plumed helmet, a German eagle embellished the cuirass, and Teutonic ornament enriched the girdle. Kiel held special meaning for William II. It was the major Baltic seaport, seat of the dukes of Holstein from the Middle Ages, and in modern times the home of the chief German naval station. Under William II, the Kiel Canal (also called the Kaiser Wilhelm Canal) to the North Sea was opened in 1895, and he gave the port major significance as a modern center for yachting. But he also caused unrest in New York.

At the outbreak of World War I, over a third of the United States was either immigrant or children of immigrants. Kaiser William II's talk of a colonial expansion and militarism antagonized this sector, and Germany's assault across Belgium, whose neutrality it had promised to respect, generated especially strong anti-German sentiments in New York. To prevent public riot at the U.S. Custom House and Jaegers's statue from being pulled

Albert Jaegers's figure of Germany after it had been altered and as it appears today.

down, as the colonists had pulled down the equestrian statue of George III at Bowling Green in 1776, Cass Gilbert had Germany changed to Belgium.

The alteration was accomplished cosmetically, but effectively, by removing the Teutonic ornament and imperial eagle from the helmet and the cuirass and "Kiel," "Wm. II," and the dolphin from the shield (all in low relief, therefore easily ground off). Then "Belgium" was incised on the shield, and there was enough stone in Jaegers's elaborate helmet to give the figure a simpler Belgian World War I helmet. Jaegers was incensed at the use of "a little camouflage with a relabel" to turn his statue into Belgium and argued it was "a somewhat dubious honor for plucky little Belgium." Jaegers had been decorated by the German government and refused to perform the alterations when Cass Gilbert asked him. Instead, Jaegers suggested replacing Germany with a personification of Japan, which Gilbert fortuitously rejected. The transformation of the statue from Germany to Belgium was accomplished by the Piccirillis on May 3, 1919, and there was no further public outcry.

France and England

The last pair of figures, France and England, was executed by Philadelphia sculptor Charles Grafly, who had studied in Paris as well as with the American realist painter and sculptor Thomas Eakins at the Pennsylvania Academy in Philadelphia. The eleventh figure was originally to have been America. Nationalistic feeling ran high at that time, and sculptors found such commissions very appealing; therefore, Grafly was irate at first when Gilbert, realizing a major power had been left out, changed the figure to France.

France's left hand rests on the tiller of a ship, symbolic of her maritime pursuits, and standing to France's right is "Le Coq de France," emblem of its long tradition as a great European power. Although the emblem's origins in antiquity are obscure, the Gauls wore helmets with a cock on the crest, and in 1214 an order of knights formed itself as the Order of the Cock, under the emblem of a white cock. In 1792 the First Republic adopted the cock to replace the Bourbon lilies of the fallen dynasty.

In her right hand France holds a small bronze personification of the Fine Arts, symbol of the long tradition of the French Academy. Many of the world's leading architects were educated at the Ecole des Beaux-Arts in Paris, and many American architects followed the Beaux-Arts tradition well into the twentieth century, as Cass Gilbert has done in his design for the U.S. Custom House. The figure France holds, then, appropriately

salutes the artistic tradition upon which the building and its decoration was founded.

England wears a cuirass and crown, symbols of military regal power, while her left hand rests upon the wheel of a ship, symbolizing the union of maritime commerce and power. She holds the caduceus in her right hand, which rests on a shield bearing the image of England's patron, Saint George of Cappadocia, slaying the dragon that had tyrannized the town of Selena in Asia Minor and saving Cleodolinda, the king's daughter. These symbols underscore that England had grown great from its sea power and that American naval experts had admonished the United States to learn from its example in developing overseas bases, naval strength, and maritime commerce. The caduceus, called also the wand of Hermes because he carried it, is a symbol of fertility, wisdom, and healing, and in 1902, the year before Grafly received his commission, became the official insignia of the medical branch of the U.S. Army.

If Grafly could not have the commission to do a national figure for the building, then he would incorporate a national symbol into one of his figures. Grafly's use of the caduceus as a submerged symbol recalls Carrère and Hastings's use of it as a submerged symbol to date their New York Public Library building.

PART VIII

Grand Images of Triumph and Honor

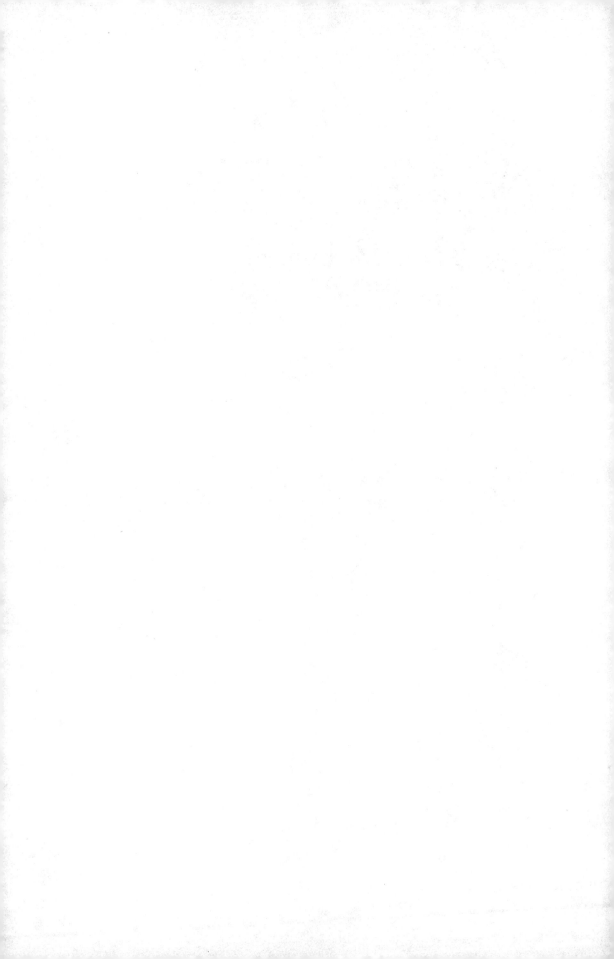

CHAPTER 25

Honorific Columns and Triumphal Arches

In ancient times, Rome's military leaders raised great columns on which to hang their trophies of battle and to honor their military and civic achievements. At first makeshift and simple, they later became architectural and sculptural triumphs of design. Statues (often gilded) of leaders were placed atop the columns, and wreaths and other symbols of victory were placed at the bases below.

Trophaic and honorific columns and wreaths and symbols of victory have continued to be a part of the history of public monuments down to the present day.

New York City has two great columns that are of particular interest in the way they combine the honorific and trophaic elements of the ancient tradition—the Christopher Columbus Monument at Columbus Circle in Manhattan and the Henry Hudson Memorial in the Bronx at 227th Street and Independence Avenue.

Column to Columbus

The Columbus Monument was executed by the Italian sculptor Gaetano Russo in 1892, and it was one of the many works of art executed for the four hundredth anniversary of Columbus's discovery of America.

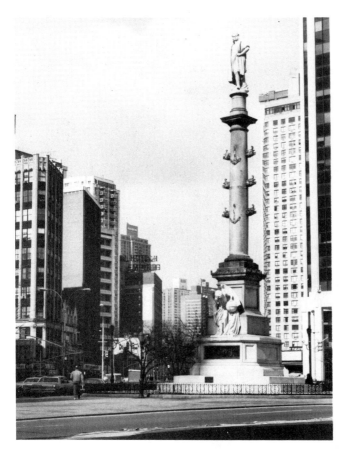

The Christopher Columbus Monument at Columbus Circle by Gaetano Russo celebrates the four hundredth anniversary of Columbus's discovery of America.

In the spirit of its ancestral prototypes, the honorific columns of ancient Rome, the Columbus Monument bears narrative reliefs at the base, a statue of Columbus at the top, and the explorer's trophies affixed to the shaft of the column.

On the north and south faces of the base, bronze plaques modeled in low relief and signed by Russo illustrate Columbus's ship leaving Spain (north face) and Columbus landing in the New World (south face). A winged youth carved in stone and appropriately placed directly above the south relief, rests his left hand on a globe of the world, while he bends over it to examine the place where Columbus actually landed. Unfortunately, little remains of the youth's left hand, and his face is badly deteriorated.

Above the base rises a seventy-seven-foot-high classical column bearing Columbus's name and bronze prows and anchors projecting from the smooth shaft of the column. Russo's prows and anchors, which symbolize Columbus's conquest of the New World, were directly inspired by the famous lost column of Emperor Augustus on which the emperor hung prows of the ships he had captured in the battle of Actium.

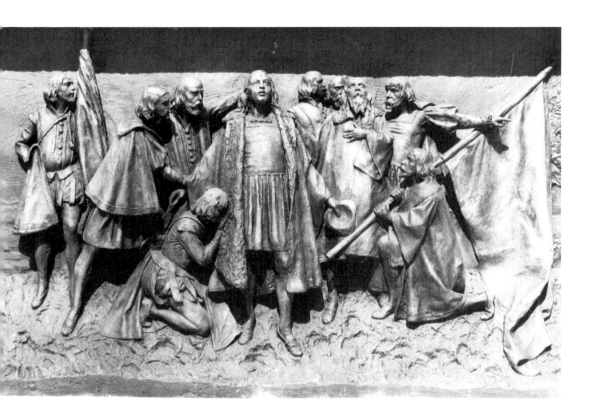

The bronze relief on the south face of the monument's base shows Columbus landing on the shores of the New World.

Atop the column Columbus stands akimbo with nautical rigging, symbolizing his role as master of the sea, placed behind his left foot, which extends slightly but dramatically over the edge of the circular base upon which he stands.

Column to Hudson

New York City's Henry Hudson Memorial column is picturesquely sited along the Hudson and grand in scale. While it contains no trophies of the explorer, its colossal portrait statue of Hudson atop the classical column and the narrative reliefs at the base, place it squarely in the tradition of the ancient honorific column.

Karl Bitter was the sculptor commissioned for the project, but he lost interest in it, and it was completed by others. Bitter was especially annoyed with the period portrait of Hudson, and he confided his lack of interest in a letter of January 2, 1910, to his friend and biographer, Viennese architect Hans Kestranek.

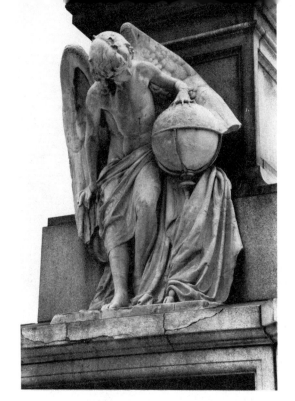

A winged youth surveys the globe at the base of the Columbus Monument.

Although we may never know the real reason for his disinterest, Bitter did execute a model for the Hudson standing portrait with which he was probably never happy, but he never completed the commission. His assistant Karl Gruppe finally finished it in the 1930s using Bitter's model as a guide.

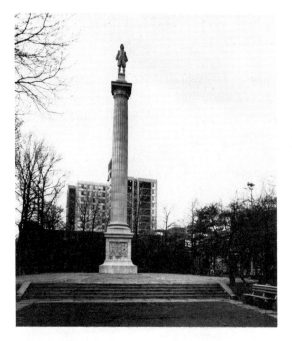

Karl Bitter was the sculptor for the Henry Hudson Memorial.

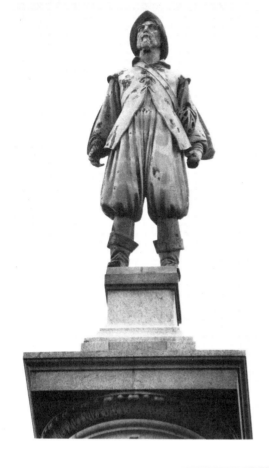

Karl Gruppe executed Bitter's design for Hudson's portrait statue.

Atop the tall Doric column, the sixteen-foot statue of Hudson gazes out over his river. The monument was erected in 1939 (begun 1909) to commemorate the three hundredth anniversary of the voyage of the *Halfe Moon*. The bronze relief on the column base includes figures of Hudson and his son. After mutineers took over his ship on his fourth voyage, in the bay in Canada that was to be named after him, they put him, his son, and seven others adrift in the subzero weather to starve or freeze. They were never heard from again and were presumed to have perished in 1611. The Milford granite column (seventy-seven feet high) was executed by Walter Cook, and the pedestal (twenty feet high) was done by Karl Gruppe. This site was once occupied by the Weckqueskeek tribe of Indians. Hudson's *Halfe Moon* lay at anchor nearby.

Triumphal Arch and Quadriga

Like the first honorific columns of ancient Rome, the first triumphal arches in the ancient world were connected with victory celebrations and were not permanent.

Over time the Romans found that the architectural form of the city gate when isolated from its ancient wall provided a suitable structure for ceremonial passage and an ideal armature of surfaces and platforms for monumental sculpture. The form likewise offered a variety of possible configurations. Some triumphal arches, such as the Arch of Trajan, have one passage, while others, the Arch of Constantine, for instance, have three, and still others, such as the Janus Arch in Rome, have four façades to accommodate passage at intersections.

Bronze sculpture groups were placed atop the triumphal arches. The sculpture was gilded so that the reflected sunlight made them visible from great distances. The groups were composed of personifications of Victory with attendants driving a chariot pulled by four horses (one was even drawn by elephants), and they are therefore referred to as quadrigas (those pulled by only two horses are called bigas).

The practice of erecting temporary triumphal arches continued down to the twentieth century. What some famous ones looked like is known because they were the subjects of prints or appear in contemporary paintings. For example, a seventeenth-century print shows the triumphal arch erected in Amsterdam in 1638 for the visit of Maria de Medici. Some art historians believe that structure was the model for the arch in Rembrandt's famous 1642 *The Night Watch*.

The Dewey Arch

The triumphal arch with quadriga became popular in the United States with the Columbian Exposition in Chicago of 1892–93. In New York it is well represented atop the triumphal arch at Grand Army Plaza entering Prospect Park in Brooklyn. The quadriga without the arch is the crowning motif of the *Maine* Monument at the southwest corner entrance to Central Park. These monuments were influenced in part by John Quincy Adams Ward's quadriga symbolizing Naval Victory, which surmounted the Dewey Arch in 1899 and crowned a complex sculpture program of war imagery made up of seven groups of monumental figures by leading sculptors of the National Sculpture Society. That arch was erected just south of Madison Square Park to honor the return of Admiral Dewey from his victory in the Philippines, which brought the Spanish-American War to an end. Made of impermanent material called staff, the arch was dismantled soon after the admiral and his entourage passed beneath it.

In spite of efforts to raise funds enough to rebuild the arch permanently, in stone, interest in Admiral Dewey waned and along with it the

desire to produce his arch in permanent material. The monument remains, then, only in photographs and accounts published in the newspapers and periodicals of the time.

The National Maine *Monument*

The spark that ignited the Spanish-American conflagration also kindled a fire in the hearts of the people that produced one of New York City's great monuments—the National *Maine* Monument. The *Maine* Monument was conceived not to honor one great military leader, but to commemorate 258 enlisted men who gave their lives when the *Maine* was sunk in Havana Harbor on February 15, 1898. The *Maine* was present in the port to look after U.S. interests in Cuba. A tense atmosphere between the United States and Spain had grown out of the U.S. support of the Cubans' fight for independence from Spain. When the *Maine* was sunk, under conditions that are still unclear, the United States was outraged and demanded that Spain withdraw from Cuba. Spain's declaration of war on April 24 was the answer. America's victory in the so-called Spanish-American War produced the Treaty of Paris, signed December 10, 1898, which freed Cuba, ceded Puerto Rico and Guam to the United States, and surrendered the Philippines to the United States. The U.S. course in international affairs was consequently extended to Latin America and the Far East.

In a larger context, then, the *Maine* Monument commemorates the U.S. emergence as a world power, but it also commemorates the dedication of a group of brave Americans, all of which prevails in this monument and touches the emotions of people of all ages.

The monument was erected "to the valiant seamen who perished on the *Maine* by fate unwarned, in death unafraid." The fund-raising was conducted by William Randolph Hearst, and a national competition was conducted for the design. The winners were sculptor Attilio Piccirilli and architect H. Van Buren Magonigle. After Piccirilli and Magonigle had won the competition and their plan had been approved by the Art Commission in 1902, political wrongdoing and loss of the originally approved site delayed the project until 1908, when discussions were begun anew that led to approval in 1910 of a new site in Central Park. The monument was originally intended for a site in Times Square at Broadway and Seventh Avenue at Forty-fifth Street. Due to what has been called a clerical oversight, an explanation without credibility in view of the city agencies and the influential people involved, a comfort station was built there, so that when

The *Maine* Monument was unveiled in 1913 and restored in 1980–81. *Detail:* Columbia Triumphant surveys the circle below.

the architect went to inspect the site, he found it no longer available. It was then that Central Park was selected.

DESIGN CHANGES

Although the design was approved in 1902, the monument was not erected until 1913. In the interim, tastes had changed. When Piccirilli's design had been exhibited in the Pan-American Exposition of 1901, it had been widely acclaimed for its artistic merits and innovative design. These were the very things the public found wanting in 1913. However, the *Maine* Monument has regained its favor with the public, undergone several restorations, and it is now recognized as one of New York City's most distinguished monuments. The sculpture program—that is, the symbolism of the sculpture and how it was fashioned—carries contemporary meaning clothed in historical imagery.

Columbia Triumphant is an allegorical group symbolic of victory and consists of a female figure standing in a seashell chariot drawn by three plunging sea horses (hippocampi), the front part made up of horses, the rear part by dolphinlike anatomy. The bronze group stands fifteen feet high. Columbia holds in her left hand the laurel branch, symbol of victory or triumph, and in her right the fasces, Roman symbol of power and authority. The shield behind Columbia was probably an afterthought to help the composition, giving the figure some mass, otherwise it would be overwhelmed by the hippocampi. That may also be the reason Piccirilli used three sea horses instead of four, as in the ancient quadriga, which inspired Piccirilli's group. The shield could also serve the iconography of the monument, underscoring Columbia's military role. And the shield gave the group additional structural support. The group is secured to the metal, stone, and brick superstructure with clamps, a highly successful engineering feat on such a large scale. The group is cast from the guns recovered from the battleship *Maine,* so the sculptural group becomes a giant reliquary of the bronze that was a part of the daily lives of the *Maine*'s 258 martyrs, who were caught unaware and without warning.

Although the group was originally covered with gold leaf, this eventually wore away and the surface became green from the action of the atmosphere. In the restoration of 1980–81, the surface was painted in an attempt to make it look like gold leaf.

PEACE, COURAGE, AND FORTITUDE

The ten carved marble allegorical figures below symbolically support Columbia Triumphant just as the great pylon supports it structurally. On the side facing Columbus Circle, Peace reigns over Courage and Fortitude,

virtues necessary for peace. Peace, a standing and robed female figure, extends her arms over the personifications of Courage and Fortitude, a gesture that at once unifies them in the composition and establishes her relationship to them. Courage is a seated male with legs crossed, a posture that combines elements from Michelangelo's personifications of the times of day for the Medici tombs in Florence.

The group is set within a configuration of a ship, and Peace looks forward to the prow, where a youth stands with his arms extended. The laurel wreath and the olive branch that he once held have been destroyed by vandals. Symbols of victory and death, they emphasized the price paid for Cuba's independence. The boy is the symbol of Cuba ushering in the new era through the Spanish-American War. Former president Taft, the principal speaker at the unveiling ceremony in 1913, said that the monument bore threefold witness: to the sacrifice of the *Maine* martyrs, the birth of a new nation, and the expansion of the United States into a new role of international trade, politics, and military power. "Cuba is our foster child," he declared, as he stressed the U.S. responsibility to Puerto Rico and the Philippines in helping them achieve self-government, notions that are timely in the 1980s.

JUSTICE, WAR, AND HISTORY

On the side of the monument facing the park, Justice reigns over the Genius of War and History, two aspects of Justice. War, personified by a muscular male nude, twists and turns energetically upward to return Justice's sword, as History, personified by a partially draped female figure, thoughtfully records the deeds of Justice. The implication is that Justice was served and its deeds recorded in the Spanish-American War. This group's story is unclear to the spectator today because the sword originally held by the figure of War was vandalized before the 1930s restoration, and it was never replaced. The city judged it too vulnerable to vandalism and theft.

The inscription over the Justice group reads: "To the freemen who died in the War with Spain that others might be free."

A UNIVERSAL ROLE

The names of the *Maine* martyrs are inscribed on the north and south faces of the pylon. Beneath these names are personifications of the Atlantic Ocean, a youth, and the Pacific Ocean, an old man with flowing beard. The figures derive from ancient sculptures of river gods as well as from Renaissance and baroque models. The two oceans symbolize the universality of the U.S. role in the world community, and the union of youth and old age symbolizes the permanence of that role.

Piccirilli's personification of the Pacific Ocean is a blend of Renaissance and baroque models.

Decorative molding incorporating waves and dolphins surround the base of the monument relating it to the sea, which recalls the deathbed of the martyrs, the new U.S. role, which crosses the ocean, and the island of Cuba surrounded by water.

SUBMERGED SYMBOLISM

Piccirilli and Magonigle also used decoration as metaphor in the *Firefighter's Memorial* at Riverside Drive and West One Hundredth Street, which was erected the same year as the *Maine* Monument. Flame and water motifs surround that monument, and water is shown quenching fire. Piccirilli's lamps for the monument, no longer extant, carried a decorative flame at the very top of its multiple globe luminaire.

Other sculptural aspects of the two monuments unite them to each other and to the Piccirilli family, revealing a personal statement of the sculptor.

The figure of Fortitude in the *Maine* Monument is personified by a mother comforting her child at the loss of its father in the *Maine's* explosion. The figures of the mother and the child closely resemble the allegorical figures on the *Firefighter's Memorial*. In that memorial, the personifications consist of a widow with her dead husband on the north side of the monument, and on the south side, she is shown with her young son, holding her dead husband's fireman's helmet on her lap.

The mother and child composition for Fortitude in the *Maine* Monument had special meaning for Piccirilli. When his mother died in 1910, he

had a bronze cast made of that group as the marker for his mother's grave in Woodlawn Cemetery in New York. The monument still stands there, although it is greatly eroded by time and the atmosphere. Piccirilli's mother and one of the Piccirilli children were probably models for the group, which may explain why he selected it as a personal memorial.

The resemblance of the child in the Fortitude group on the *Maine* monument to the child in the Firemen's Memorial, therefore, is not coincidental, nor is their resemblance to the child as the New Era on the prow of the ship of the *Maine* Monument.

The Piccirillis were a large family, and the models used for both monuments were doubtless Piccirilli children. There are carvers and artists still living who remember the large Piccirilli studio, which was also where the family lived. They recall how much art and life were a part of each other for America's first family of carver-sculptors.

There is evidence of Attilio Piccirilli's special affection for the figure of the New Era. In 1934, when the monument was being restored as a WPA project, Piccirilli wanted to remove the figure and replace it with a bronze copy because the marble figure was in such poor condition from vandalism and the action of the atmosphere. It would have been too costly to do the work properly, the city judged. That solution was used, however, in the *Firefighter's Memorial* in the 1930s when that monument was restored. The low relief in Tennessee marble, the central panel of the monument, had suffered extensive deterioration, and it was obvious that there was no way to reverse the steady disintegration of the surface. A mold of the relief was therefore made from which a bronze replica was cast, which replaced the weathered one. That bronze relief is still intact.

The *Maine* Monument was unveiled on Friday, May 30, 1913, Memorial Day. Even though President Woodrow Wilson could not attend, his greeting was read and former president Taft gave the principal talk. William Randolph Hearst had raised the money to build the monument, so it seemed only fitting that his young son George should pull the silken cord and release the large American flag that covered the top part of the monument.

A FORMAL ENTRANCE

The monument was originally designed to be approximately sixty feet tall. When its site was moved to Central Park, the height of the pylon was reduced so as not to compete with the Columbus Monument in Columbus Circle, and it was flanked by two roadways into Central Park to effect a transition from the thoroughfare into the park. To further enhance that transition, garden house-like structures were added to define the roadways. Those pavilionlike features were reminiscent of such structures in Euro-

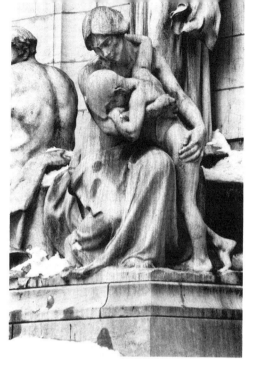

Piccirilli's figures on the *Maine* Monument and his figures in the *Firefighter's Memorial* on Riverside Drive share a common origin.

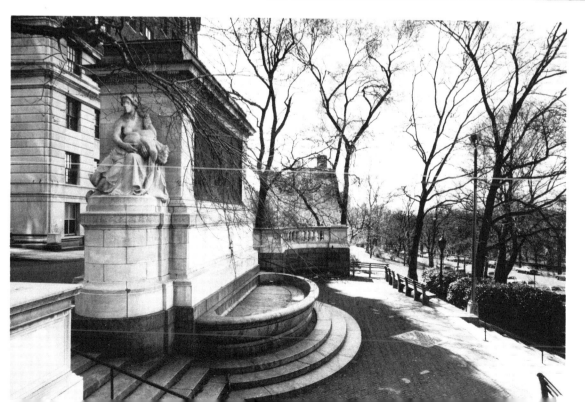

pean parks. When the structures were inspected in the restoration of 1934, the Parks Department considered using the five-by-eight-foot space for storage, for use by the Rangers, or for information centers.

Soldiers' and Sailors' Memorial Arch

The Soldiers' and Sailors' Memorial arch was erected to the defenders of the Union in the American Civil War. The cornerstone was laid in October 1889, and the monument was dedicated in October 1892. The granite arch was designed by John Duncan, who was also the architect for Grant's Tomb.

The Soldiers' and Sailors' Memorial arch is set within a giant oval. The elliptic plaza, incorporated into Calvert Vaux's design, is defined by four giant columns topped with bald eagles by Frederick MacMonnies. The circular street pattern of the plaza moves traffic around, past, and into Prospect Park so that the sculptural power and harmonic proportions of the architecture are experienced from all sides. The arch's relationships of height, width, and depth impart calm grandeur and monumentality to the site and afford a suitable gateway to Prospect Park.

The monument is a gigantic cube eighty feet high and eighty feet wide. The arch peaks at fifty feet and has a graceful span of thirty-five feet. The piers are a massive fifty feet thick at the base. Against these piers MacMonnies's groups of army and navy are placed. Above the attic story is a giant quadriga. Between the columns of the pedestals medallions in low relief honor Brooklyn's army and navy corps. On the south façade the spandrels contain figures of civic and military character, designed by Philip Martiny, whose sculpture decorates the Surrogate's Court Building across from the Tweed Court House, the Washington Arch in Greenwich Village, and St. Bartholomew's Church on Park Avenue. On the north façade the spandrels carry the seals of New York State and Brooklyn.

MACMONNIES'S SCULPTURE PROGRAM

Atop the attic story stands the animated quadriga composed of a bronze victory chariot with its team of four horses and heralds, completed by MacMonnies between 1896 and 1898. This group of four bronze horses is reminiscent of the four bronze horses over the porch of St. Mark's in Venice and of Johann Gottfried Schadow's quadriga on Carl Gotthard Langhans's Brandenburg Gate in Berlin of 1788–91. The St. Mark's horses are Hellenistic (or Roman) works brought from Constantinople in 1204. The overall design is derived largely from the Arc de Triomphe in Paris, a favorite monument of MacMonnies.

MacMonnies's group represents the triumphal force of Columbia, who has just achieved peace amidst bloody conflict. She stands majestically in her chariot of victory led by the herald of Peace. The press hailed the spirited action of the horses. The high relief groups on the piers represent the army and navy and were added to the south faces of the piers fronting Prospect Park in 1901. Also by MacMonnies, the navy is preparing to sink with its doomed ship. The army rushing to battle was inspired by François Rude's "Marseillaise" of 1833–36 for the Arc de Triomphe in Paris. The swaggering swordsman holding the bridle of the horse may be a self-portrait. The plaza contains four giant bald eagles also designed by Mac-Monnies. The only inscription on the memorial is over the arch: "To the defenders of the Union 1861–65."

LINCOLN AND GRANT

The equestrian sculptures in high relief on the inside of the arch show Lincoln and Grant. The sculptures are by Thomas Eakins, recognized as America's leading realist painter of the late nineteenth century, and William O'Donovan, who came to New York from Virginia and specialized in portrait busts and reliefs. There is a sculptural quality to Eakins's painting not unlike this relief. These two equestrian reliefs act as foils to the sculpture groups on the great piers and the quadriga above, which are active in movement and complex in composition. Lincoln and Grant are simply composed and quiet in movement, like bronze icons grandly framed by classical molding. Moreover, Lincoln holds his stovepipe hat in his right hand down and slightly extended as if in quiet greeting to his general on the opposite panel. Grant looks straight ahead, sitting erect in his saddle, his horse's right foreleg slightly raised in a slow, forward walk.

TROPHY ROOM

Inside the monument, iron stairs with stone treads carry military motifs—for example, the balustrades are Roman battle-axes and spiral up to the trophy room, an open space behind the attic of the monument. This room is over twenty-five feet high and was conceived to house trophies of war. Unused for many years, it now houses exhibitions in spring and fall prepared by the Parks Department. Skylights in the roof of the monument provide the space with natural light.

Rooms in the piers on either side of the arch at the ground level are used for storage and to house electrical equipment for floodlighting the monument and for the plumbing equipment for the Bailey Fountain nearby.

CHAPTER 26

The Washington Arch

The Washington Arch in Washington Square Park not only is one of New York's most distinguished monuments, it also contains one of the city's—if not the country's—most important sculptural heritages, both historically and aesthetically. Designed by famous architect Stanford White to commemorate the one hundredth anniversary of the inauguration of the nation's first president, the arch is constructed of cream-colored marble carved with inscriptions, reliefs, and figures in light marble that pay tribute to George Washington, the city and state of New York, and the people who conceived and built the monument. White's design for the arch originally included a large sculpture group surmounting the monument reminiscent of the quadrigas that crowned the great triumphal arches in ancient Rome and similar to the group atop the *Maine* Monument at the southwest entrance to Central Park. The group was eliminated as too expensive.

Plaster and Horsehair

When the arch was first constructed it was built of staff, an impermanent material made of a mixture of plaster and horsehair (or other fibrous materials to hold the plaster together) covering a wooden frame, and it

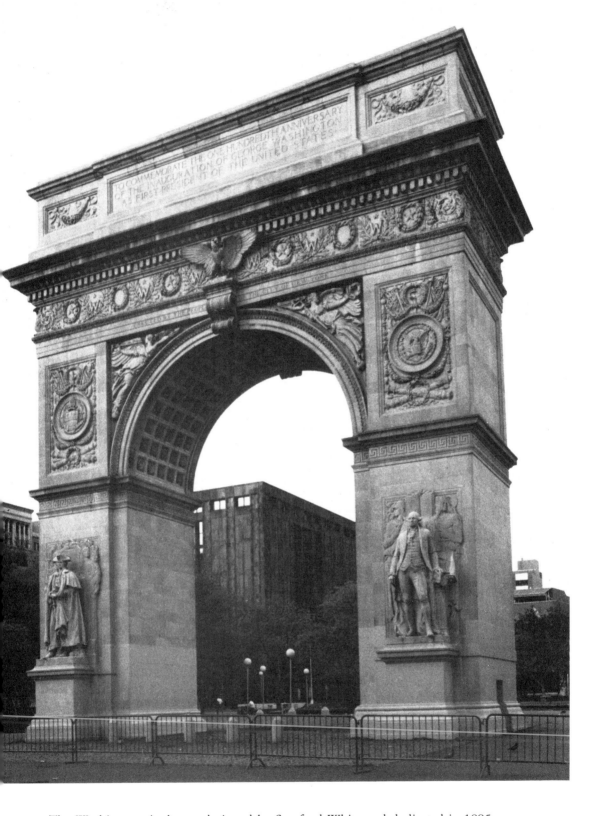

The Washington Arch was designed by Stanford White and dedicated in 1895.

straddled Fifth Avenue, across the street from its present location. The white plaster gleamed brilliantly in the sun as parades passed beneath it during the anniversary festivities.

Atop White's triumphal arch of staff stood a nine-foot-high wooden statue of George Washington, which had been brought from Bowling Green, where it had replaced a statue of King George III during the American Revolution. After the wooden arch was dismantled, following the anniversary celebration, the statue found its way into the hands of a speculator and wound up in front of a cigar store. In 1912 it was rescued by T. Coleman DuPont, U.S. senator from Delaware, who sent it along to Wilmington, Delaware, and it is now in the Delaware Historical Society.

So popular was the temporary arch that a group of New Yorkers decided to erect the arch in permanent materials at the north end of Washington Square Park, where it stands today. A committee headed by New Yorker and philanthropist William Rhinelander Stewart was therefore formed to raise the funds to rebuild the arch in Washington Square Park, and Stanford White was asked to be the architect. White received no pay for his work, and Stewart almost single-handedly raised the funds to rebuild it. It was begun in 1892, dedicated on April 30, 1895, and illuminated by the Edison Company two years later, but the last sculpture was not set in place until 1918.

Triumphal arches made of temporary materials to celebrate great events have a long history that begins in Europe, and they have influenced other arts such as painting, even the works of the greatest artists. For example, the town gate in Rembrandt's famous painting of 1642 *The Night Watch* was probably inspired by the triumphal arch (or an engraving of it) erected for Marie de Medici's grand visit to Amsterdam in 1638.

In New York one of the most celebrated of these temporary arches, and one of the most elaborately decorated, was the Dewey Arch of 1899, which also appears in photographs and engravings of the period.

Limestone Model

Charles Dunn, one of the stone-carvers on the arch, carved a scale model in limestone. It stood for many years in Avery Library, the architectural library at Columbia University. By 1930 the carver was once again in possession of his model and sought to find a permanent home for it, as in the Museum of the City of New York. Stanford White tried to arrange to have it exhibited in the National Sculpture Society and in the Columbian

Exposition in Chicago. The model did not include the two sculptural groups on the east and west pedestals of the north façade, because those statues and their reliefs were later additions. It was hoped that the sculptors would contribute scale models of their work in plaster or wax for Dunn's model. White's son also offered to the Museum of the City of New York his father's original scale model for the earlier wooden arch that straddled Fifth Avenue. Both of these models are lost.

The Sculpture Program

Numerous interruptions delayed completion of the sculpture program for the arch. Key members of Stewart's committee died, for example, and a major setback to the program was the murder of Stanford White by Harry Thaw in 1906, which stalled plans for the sculpture for almost six years. Then, in 1912, Stewart formed a new committee, and with William M. Kendall and Rutherford Mead, of McKim, Mead, and White, he worked to complete the arch.

Inscriptions and reliefs displayed over the surface of the monument identify it as a tribute by the city and state of New York to the nation's first president and a salute to the creators of the monument. The heroic statues of Washington with appropriate allegorical reliefs symbolize his leadership of the new nation in war and peace. Washington's inaugural quotation is inscribed on the south façade: "Let us raise a standard to which the wise and the honest can repair. The event is in the hands of God." "To Commemorate the 100th Anniversary of the Inauguration of George Washington as First President of US" is inscribed atop the corona of the north façade, and just below are the words "Erected by the People of the City of New York," flanked by the dates of his inauguration and its centennial, 1789 and 1889.

The two female figures in relief on the north spandrels are portraits of Stewart's and White's wives carved from photographs. The likeness of Stewart's wife is on the west looking west toward their house on the square; that of White's wife is on the east. These portrait reliefs serve as signatures of the artist and the patron.

The decorations for the arch are by some of America's leading sculptors of the period: Hermon MacNeil, A. Stirling Calder, Frederick Mac-Monnies, and Philip Martiny, and the sculptural carving was executed mostly by the Piccirilli brothers.

Left: Washington as general by Hermon MacNeil occupies the east pier. *Right:* Washington as statesman by A. Stirling Calder occupies the west pier. *Bottom:* Detail of Calder's Washington shows deterioration of the sculpture caused by atmospheric pollution and sandblasting.

The Piccirilli Legacy

Perhaps the most prolific studio executing public sculpture in New York City was the studio of Giuseppe Piccirilli, who came from Massa, Italy, in 1888 to New York City, where he established his studio in the Bronx. The Piccirillis became more than carvers of others' works; they

became recognized sculptors in their own right. Attilio Piccirilli, one of Giuseppe's seven sons, for example, who had studied at the Accademia di San Luca in Rome, exhibited three original pieces at the Pan-American Exposition of 1901. (This was the exposition at which Daniel Chester French exhibited plaster models of Painting, Sculpture, and Architecture from the Hunt Memorial.) Two of Piccirilli's were fauns, the third was the model for the *Maine* Monument, which stands at the entrance to Central Park at the southwest corner. At the Louisiana Purchase Exposition, he exhibited three marble busts and a marble faun. In New York, the Piccirillis enlarged and carved in marble many pieces, including the pedimental figures that Paul Bartlett had modeled from J.Q.A. Ward's designs for the New York Stock Exchange building and most of the statues for Cass Gilbert's U.S. Custom House.

The spandrel figures are portraits from life.

Among Attilio's architectural works are the figures of Indian Litera-
ture and the Indian Lawgiver for the Brooklyn Museum and the lunettes
for the Frick mansion on Fifth Avenue. In 1935 he experimented with new
material for sculpture in the glass reliefs he produced for the Palazzo
d'Italia in Rockefeller Plaza, cleaned and repointed in 1986 to return the
reliefs to their original brilliance.

Martiny's Eagle

Philip Martiny (1858–1927) designed the American eagle on the
north front. So popular was it that Tiffany and Gorham Manufacturing
Company were given permission to replicate it for their exhibition at the
Columbian Exposition in 1893. Noted *animalier* Edward Kemeys had ap-
parently also submitted designs of an eagle for this location. Martiny came
to New York from Strasbourg, France, while he was still in his twenties and
worked as an assistant to Augustus Saint Gaudens. The sculptural decora-
tions Martiny designed for McKim, Mead, and White's Agriculture Build-
ing at the Columbian Exposition of 1893 gained him national recognition.
He is perhaps the most consistently Beaux-Arts sculptor of the period, and
his numerous pieces in New York City are worthy testimonies to his
virtuosity within that style: Confucius for the Appellate Court Building at
Twenty-fifth Street and Madison Avenue, the two seated granite figures of
Justice and Authority flanking the entrance to the New York County Court
House at Foley Square, the bronze south doors of St. Bartholomew's
Church at Park Avenue and Fiftieth Street with limestone frieze "Road to
Calvary" and marble tympanum, and the remarkable figures and decora-
tion on the Hall of Records north of City Hall. There, he did eight cornice
figures of famous New Yorkers, sixteen symbolic figures, and two groups
representing New York in Infancy and New York in Revolutionary Times.
The attic figures were placed amid Martiny's richly carved swags, car-
touches, and capitals. In 1919, for New York City's welcome home to the
World War I troops, Martiny did a large group, "Our Allies," made of staff
and placed atop the Flatiron Building (now known only in photographs).
Between 1917 and 1927 he worked on two World War I memorials still
standing: a monument to the soldiers and sailors of Chelsea is at Twenty-
eighth Street and Ninth Avenue, and at the triangle bounded by West
Twelfth Street, Eighth Avenue, and Hudson Street, Abingdon Square, a
monument is dedicated to the soldiers and sailors of Greenwich Village
who died in battle. A bronze doughboy is the main feature of each monu-
ment. The doughboy in Abingdon Square holds a pistol and defends the

flag whose furls partly surround his figure, and the interplay of its animated billows with the vigorous stride of the doughboy create a composition that holds one's attention from any point of view.

MacMonnies's Authorship

Stanford White commissioned the then famous Frederick MacMonnies to do the sculpture symbolizing War and Peace for the north side of the Washington Arch and the two portrait spandrels there. MacMonnies's first major work in this country was for White in St. Paul's Church on West Fifty-eighth Street. He did two angels for the main altar that still stand there looking at White's altar. MacMonnies had studied with Saint Gaudens in New York when Martiny was there. Then MacMonnies went to Paris and studied with Falguière. At the time the arch commission was given, MacMonnies was gaining in popularity with a very animated and decorative style of modeling and composition quite unlike his angels in St. Paul's. Such pieces as his sensuous *Bacchante,* which was almost a portrait of a well-known French model named Eugenia, were popular, and his remarkably agile and animated figures for the Barge of State for the Columbian Exposition in Chicago received wide critical and public acclaim.

For the Washington Arch, MacMonnies proposed two statues of Washington, one for each pedestal, backed by allegorical figures in high relief: Washington as commander in chief, in military uniform, backed by allegories of Valor and Fame; and Washington as president, in civilian dress, backed by allegories of Wisdom and Justice. White found MacMonnies's sketches too animated and the compositions too complex for the clear, classical lines and the simplified forms of the arch. MacMonnies's preference for baroque forms and compositions would find expression in his army and navy groups for the Soldiers' and Sailors' Monument at the entrance to Prospect Park in Brooklyn in 1901. That style, however, was not what Stewart and White wanted for the Washington Arch. MacMonnies was able to modify the spandrel portraits to White's satisfaction (White even brought in Saint Gaudens to approve them), but the problems they had with the Washington groups were never resolved. The fact that Mac-Monnies decided to stay in France made communication difficult, and negotiations between White and the sculptor came to a standstill. Then, with the murder of Stanford White and the deaths of other key members of the committee, it seemed that the sculpture for the arch would never be completed. But in 1912 Stewart decided to move the project forward to completion. Macmonnies was still in France. Only photographs of his mod-

els existed, which were more in the character of the Prospect Park arch, a style still not acceptable to Stewart, probably the reason the committee approached Hermon MacNeil and A. Stirling Calder to do the work. They were two distinguished sculptors who worked in a more restrained style the committee felt would be more compatible with the architecture of the monument.

MacMonnies's ideas of the two groups, Washington as commander in chief flanked by allegorical figures representing Valor and Fame and Washington as president flanked by Wisdom and Justice, were modified so that Washington would be portrayed as a single standing figure on each pedestal. The allegories would be carved in low relief behind, as opposed to MacMonnies's high relief, thereby simplifying the composition. MacNeil would do Washington as general of the armies, about forty years of age, and Calder would do Washington as president and statesman, about sixty years of age. When MacMonnies heard that his ideas for the two pedestals were to be used, he was furious, and he wrote to Stewart expressing amazement that his designs were being used without communicating with him. He also communicated with the artists, complaining that he did not want the commission, but neither did he want his ideas appropriated. Stewart responded that ideas could not be legally protected and that the groups of MacNeil and Calder were not at all like MacMonnies's earlier groups. The artists assured MacMonnies that they knew nothing of his models.

Realization of the Program

MacNeil and Calder were logical choices. MacNeil had studied in Rome and Paris and had distinguished himself as a figural sculptor working with architects on large-scale projects. His President McKinley Memorial in Columbus, Ohio, and his grand figures for such world's fairs as the Louisiana Purchase Exposition in St. Louis, 1904, and the Pan-American Exposition in Buffalo, 1901, were highly acclaimed by critics and public alike. Artistically, then, he was more than capable, and temperamentally he was suited to working with architects and committees. MacNeil completed his figure and relief by 1916.

A. Stirling Calder, whose sculpture was installed in 1918, had similar qualifications. When he was commissioned to do Washington as Peace for the Washington Arch, he was acting head of the sculpture program for the Pan-Pacific Exposition in San Francisco to be held in 1915, having been appointed to that post at the untimely death of Karl Bitter. Calder came

from a prominent family of sculptors known for great public works. The sculptures of his father, Alexander Milne Calder, for Philadelphia City Hall were famous, and young Stirling grew up in his father's studio while they were being done. Stirling had studied with Thomas Eakins at the Pennsylvania Academy, then with Chapu and Falguière in Paris. His sculpture for the St. Louis world's fair brought him national recognition.

Calder completed his piece in time for its dedication on February 22, 1918, Washington's Birthday. There had been difficulties with Calder's interpretation of the statue, however. For example, Stewart inspected Calder's quarter-size model and complained to Kendall that Calder showed Washington delivering an oration, and that Washington's mouth was open. Portraying Washington with his mouth open worried Stewart because when the statue was carved in its full size, fifteen feet five inches high, the open mouth would probably become a pigeon roost.

Photographic Innovation

Innovative use of photography was critical to the sculpture program of MacNeil and Calder. These two sculptors worked with photographic blowups of their models to determine the correct size of their sculpture. Blowups of projected sizes were made and actually affixed to the piers until the appropriate size could be determined. Ironmaster Samuel Yellin in Philadelphia was doing the same thing with his designs at this time. The Washington Arch may be the first use of this device in New York City. This use of photography was probably invented by the sculptors, craftsmen, and architects designing for the great world's fairs.

Jefferson's Vision Recalled

It is ironic that Calder's Washington for the monument is prophetically fulfilling. His statue is based on the life-size statue by Houdon for the Virginia State Capitol in Richmond, which Calder may have known in the original but must have known in the bronze replica owned by the city of New York, now standing in the lobby of City Hall (see chapter 3). Thomas Jefferson, who commissioned Houdon to do the standing portrait of Washington, meant for that statue to be an accurate record of Washington and to be the prototype for all subsequent standing portraits of Washington, both in the United States and abroad. Jefferson's prophetic vision is characteristically expressed in this historic portrait of George Washington.

A Replica for the French

In 1881 representatives of the French government visited the United States to participate in the celebration of the centennial anniversary of the British surrender at Yorktown. Seeing their countryman's statue of Washington in Richmond, they wanted a reproduction of it to place next to Houdon's *Diana* in the Louvre. It was not until August 18, 1910, that the Frenchmen had their wish fulfilled when the state of Virginia presented the French government with a bronze reproduction of Houdon's statue of George Washington.

Notable Achievements in Terra-Cotta and Iron

CHAPTER 27

Terra-Cotta for a Cultural Capital of the World

Herbert Croly, philosopher and author of *The Promise of American Life* (1909) who wrote architectural criticism for the *Architectural Record* early in the century, felt New York City should take its place with London and Paris as a cultural center. Part of being a city of intellectual significance was looking like one. And Croly was convinced that the surfaces of New York City's buildings could "transform the city's spaces into a wonderland of elaborate, fanciful and vivid masses and patterns," fitting for a cultural and intellectual capital of the world. He believed in the magic of terra-cotta to help bring that about.

Terra-Cotta's Limitless Possibilities

Terra-cotta provides the architect with an almost unlimited range of color and ornament. It can be given a ceramic finish as bright as the intense blue and green of the Art Moderne apartment house at 210 East Sixty-eighth Street or at 28 East Sixty-third Street, or it can be made into the simple and direct lines of Art Deco as in the apartment house at 235 East Twenty-second Street. No wonder it has been used for so many apartment houses, Croly observed, terra-cotta offers a perfect mix of lightness and dignity. Subtly colored glazed terra-cotta, for example, sprouts from the brickwork of Schwartz and Gross's Art Deco structure in the 241 Central Park West apartments at the northwest corner of West Eighty-fourth Street.

Louis Sullivan's landmark skyscraper, the Bayard-Condict Building at 65–69 Bleecker Street, opposite Crosby Street, has a façade clad in decorative terra-cotta, and the frieze beneath the cornice carries decorative motifs and six tall angels with outstretched arms in a guardian pose. Terra-cotta can also be formed into patterns of remarkable delicacy, as in Alwyn Court, at West Fifty-eighth Street and Seventh Avenue, which looks like carved limestone.

It is noteworthy that the first building with a steel skeleton to be fireproofed with terra-cotta still stands as a testament to Croly's conviction: the Potter Building at 38 Park Row near City Hall, built in 1883 by N. G. Starkweather. Combinations of cast and pressed terra-cotta and cast iron clad the steel skeleton, elegant in any age.

Origins of Terra-Cotta

Terra-cotta, Italian for "baked earth," has been used in the decorative arts since ancient times. Used first in vases, figurines, and tiles in predynastic Egypt, ancient Assyria, Persia, China, and pre-Columbian Central America, it first became important as an architectural material in Greece, where from the seventh century B.C. it was used for roof tiles and ornamental detailing. It was widely used during the Renaissance, especially in Italy and Germany. It became extensively used in sculpture in Italy, and the polychrome enameled terra-cotta, or faience, of the della Robbia family of Florence beginning in the fifteenth century established a wide range of new possibilities for its artistic use.

Luca della Robbia founded the workshop in Florence in the early fifteenth century. His famous *Madonna and Child* in the blue-and-white relief, characteristic of the style, is in the Metropolitan Museum of Art in New York City. Terra-cotta work in building and decoration spread from Italy via migrant artisans throughout the world.

When terra-cotta is glazed with an enamellike surface it is called faience, a French translation of Faenza, a town in Italy where it was made.

Early Uses in the United States

Chicago's famous fire of 1871 occasioned the use of terra-cotta in rebuilding the city, the first American city to trust the material on a large scale. The cost of stone, the rusting of iron, and the flammability of wooden structures led Chicago builders to accept a material that would combine texture and color with the brick-making industry to give them a decorative and useful building material that was also fireproof.

Terra-Cotta in New York City

Some New York City architects and builders doubted terra-cotta's structural durability, and they disparaged its aesthetics. They claimed terra-cotta could not withstand the rigors of New York's climate and called it "a clay imitation of an iron imitation of stone." Their criticism of terra-cotta, however, unwittingly identified the adaptability and flexibility of the material. Since terra-cotta could be both modeled and carved, and since it could be manufactured in any color, it could be produced to match or replicate any shape and any material. It was good for the Victorian, Gothic, classical, and Romanesque decorations popular at the time.

Although James Renwick, Jr., best remembered as the architect of Grace Church at Broadway and Eleventh Street in Greenwich Village and of St. Patrick's Cathedral at Fifth Avenue and Fiftieth Street, may have been the first architect to use terra-cotta in New York City, it took others to develop it, especially as ornament. Renwick started using terra-cotta for sewer pipes in 1853. Then he used it as ornament on three houses on West Ninth Street between Fifth and Sixth Avenues, probably numbers 29, 31, and 33 of 1854, whose original moldings have either been shorn or stuccoed over in twentieth-century restorations. Terra-cotta cornices and coursings on other buildings Renwick designed have long since disappeared, so there is no extant record in terra-cotta of his ideas. But how he probably combined his favorite Gothic style with terra-cotta may be expressed in his successor firm Renwick, Aspinwall, and Russell's warehouse adjoining Grace Church's parsonage opposite East Eleventh Street of 1888. In the Church of All Saints at the northeast corner of Madison Avenue and East 129th Street of 1894 in Harlem, traceried rose and mullioned windows, pinnacles, and gables were made of gray terra-cotta, reflecting a change from the red of the 1880s, placing the firm in the forefront of stylistic trends.

George B. Post

Because terra-cotta was inexpensive to manufacture, quickly replaceable, easy to maintain, fireproof, and lightweight, it caught on during New York's building boom of the 1870s, in spite of the gainsayers. George B. Post probably built what has been called the first terra-cotta building in New York City. In 1877, on the north side of Thirty-sixth Street near Madison Avenue, Post built a building for James B. Smith that was constructed substantially of terra-cotta; otherwise, little is known about it, and it no longer stands.

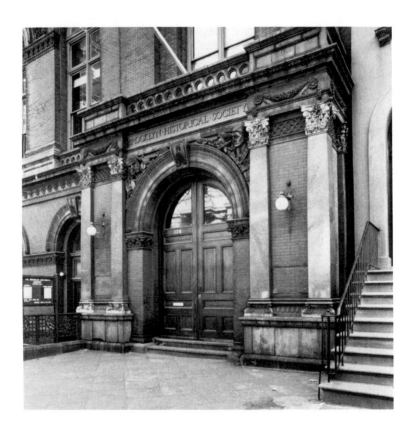

The entrance to George B. Post's Long Island Historical Society Building, an innovation in the use of terra-cotta in New York.

Post's Long Island Historical Society Building, however, at 128 Pierrepont Street in Brooklyn, begun the following year (1878), marks the first serious use of architectural terra-cotta for the decoration of an important structure in New York City. Post introduced with that building the use of bright red terra-cotta in elaborate decoration, influenced by the rich polychromy of England's leading Gothic Revival architects A.W.N. Pugin and William Butterfield. The extensive use of the vivid red is offset by the wide range of details—pilasters, arches, medallions, and cornices.

Heroic figures, a Viking and an Indian by sculptor Olin Levi Warner flanking the entrance to the building, are symbolic custodians of the wealth of New York's historical material that lies within, and they are grand sculptural foils to the animated terra-cotta decoration, which underscores the sisterhood of the arts. The idea that painting, sculpture, and the decorative arts formed a sisterhood with architecture was demonstrated by the Columbian Exposition of 1893 in Chicago, better than anything since ancient times, in the minds of the New York architects who participated in the fair. After all, they reasoned, architecture could never reach its full potential except in combination with its sister arts.

Olin Levi Warner's Viking, carved in terra-cotta over the entrance to Post's Historical Society.

That sisterhood remained a sine qua non well into the twentieth century, especially among the architects of the New York school. With his Long Island Historical Society Building, Post merely introduced into the sisterhood of the arts a new material and a new color, one that was compatible with the ever-popular and practical red brick. Post's Produce Exchange Building followed immediately and was completed in 1884. It stood to the southeast of Bowling Green until it was razed to make way for the present office building at 2 Broadway, completed in 1957.

Red Terra-Cotta

The influence of Post's Historical Society and Produce Exchange buildings was immediate and widespread. During the 1880s, almost all terra-cotta was the same red. The word "terra-cotta," in fact, came to be identified with the vivid red color as well as the material. Between 1885 and 1890 brownstone was largely replaced by red brick and other stones, although there are distinguished exceptions, such as the Villard houses.

Unique examples of Post's influence have been thoughtlessly destroyed, such as the Church of the Messiah in Brooklyn at 80 Greene Avenue, which had a 130-foot-high beehive-capped tower in terra-cotta by R. H. Robertson. But among the superb examples that remain, and these almost side by side in Greenwich Village, are Henry J. Hardenbergh's Schermerhorn Building at the corner of Great Jones and Lafayette streets

of 1888 and the De Vinne Press Building in the next block at Fourth and Lafayette streets by Babb, Cook, and Willard of 1885.

Both buildings are products of the Romanesque revival, with grand barrel arches, thick walls, and massive planes, and they are also distinct. Hardenbergh's masks and fantastic feathered creatures carved and cast are strongly set off from the architectural forms. Carving decorative terra-cotta was an innovation attributed to Isaac Scott in Chicago. In the De Vinne Press Building, Babb, Cook, and Willard decorated the quoins with printing motifs, an ingenious example of architecture *parlante.*

St. Cecilia's Roman Catholic Church, by Napoleon LeBrun and Sons, 1887, at 120 East 106th Street between Park and Lexington avenues in East Harlem has a façade of red terra-cotta of rare quality. A colossal bas-relief of Saint Cecilia, the third-century saint, as a youthful organist is cast and carved over the main entrance. Cecilia is portrayed that way traditionally, as one of the prayers in vespers reads, "To the sound of musical instruments the virgin Cecilia sang to God in her heart."

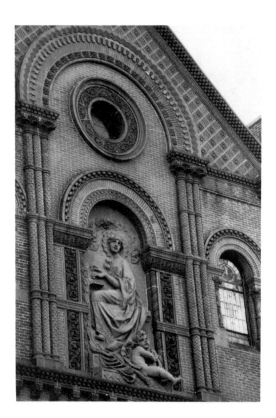

Bas-relief of Saint Cecilia at the organ, St. Cecilia's Roman Catholic Church, East Harlem.

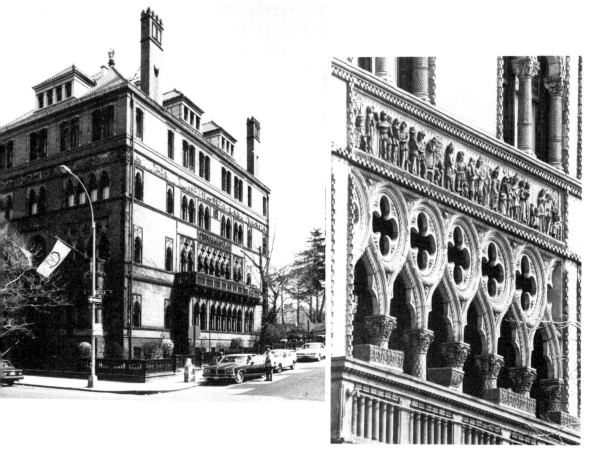

Left: The terra-cotta relief on the Montauk Club at 25 Eighth Avenue in Brooklyn carries elaborate ornamentation. *Right:* Montauk Club detail.

Pioneers of the Picturesque

Francis H. Kimball and Thomas Wisedell, c. 1880, with their design for the New York Casino Theater at Thirty-ninth Street and Broadway in a Moorish style (demolished) evoked mental images of a fairy-tale world. And they created informal patterns of shape, color, and light that carried terra-cotta to new pictorial heights as a decorative medium. An example of Kimball's innovative use of terra-cotta that still stands is the Catholic Apostolic Church, 417 West Fifty-seventh Street between Ninth and Tenth avenues of 1885. The color and texture Kimball achieved in the extensive decorations there were unattainable with other materials. In the Indian names and reliefs that encrust the Montauk Club façade in Brooklyn at 25 Eighth Avenue on the northeast corner of Lincoln Place, of 1891, Kimball added the new dimension of historical narrative to the picturesque style of terra-cotta design that he had pioneered a decade before.

Cyrus L. W. Eidlitz was equally innovative in developing new terra-

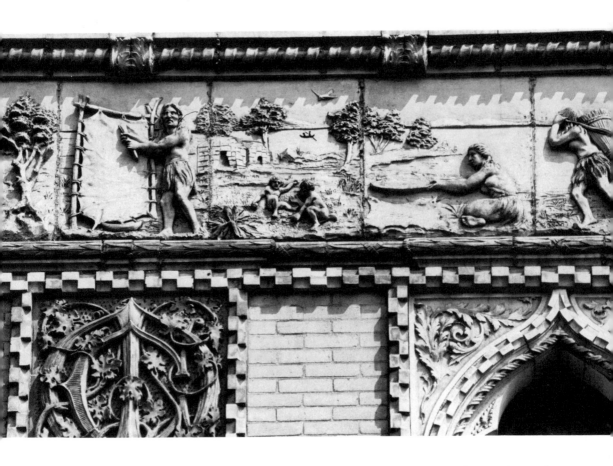

A variety of genre scenes from the life of the native Americans form a decorative frieze beneath the roof cornice.

cotta surfaces. His preference for Romanesque forms precluded old-style smooth surfaces, so he developed combed or crinkled surfaces with a special method he devised to capture the Romanesque character he wanted. Eidlitz's surfaces were soon universally adopted. Eidlitz's use of terra-cotta continued into the twentieth century. The Italian Renaissance cladding in terra-cotta of his Times Tower at Forty-second Street and Broadway of 1904 can only be seen in photographs. It was stripped in 1966 and replaced with marble.

Buff and Limestone

A second period of terra-cotta's heyday as ornament started about 1889 with McKim, Mead, and White's use of a deep yellow or buff terracotta that came to supersede the red formerly so popular.

The yellow-and-buff terra-cotta matched the fashionable limestone that came to distinguish the bases of buildings then. By the turn of the century all architects were using it—D. H. Burnham and Company's Fuller (Flatiron) and Wanamaker's buildings and Cyrus Eidlitz's Times Tower, for example. Among the New York buildings in which the newer material was used were Madison Square Garden, northeast of Madison Square Park, replaced in 1928 by New York Life Insurance Company's headquarters building, and the Century Association building at 7 West Forty-third Street. Their Herald Building at Herald Square followed in 1895 with Renaissance revival ornament in terra-cotta but was razed in 1921.

McKim, Mead, and White's influence is well represented in the Imperial Apartments, c.1892, by Montrose W. Morris, architect, 1198 Pacific Street at the southeast corner of Bedford Avenue in Brooklyn. Paired Corinthian terra-cotta columns and arches in the Alhambra Apartments, c. 1890, at 29 Macon Street, 86 Halsey Street, on the west side of Nostrand Avenue are among the rich assortment of terra-cotta and brick decorations that includes arcades, pediments, mansards, chimneys, and dormers. Architect Henry F. Kilburn's refined use of terra-cotta ornament alternating with striped brickwork in his West End Presbyterian Church at 105th Street and Amsterdam Avenue, 1891, is a veritable primer on how to combine the two materials. In the West End Collegiate Church at West Seventy-seventh Street and West End Avenue, by architect Robert W. Gibson, 1893, terra-cotta's adaptability to a range of styles is demonstrated in the Dutch stepped-gable façade. Some of the ornamental detail of the old American Architectural Terra-Cotta Company, 42–16 Vernon Boulevard between Bridge Plaza South and Forty-third Avenue, west side, in Queens, 1892, has an art nouveau flavor that smacks of Louis Sullivan's elegant friezes. The chimney pots are proud icons to a high water mark of the terra-cotta craft. The picturesque beauty of terra-cotta and brick is well exemplified in the deep purple brickwork and pale green glazed brick trim harmonizing with terra-cotta in a lacelike treatment that produces an elegant façade in the main entrance of St. Aloysius's Roman Catholic Church, 209 West 132nd Street between Seventh and Eighth avenues by W. W. Renwick, architect, 1904.

Post and the Picturesque at the Turn of the Century

George B. Post's College of the City of New York's buildings of 1905 at West 138th to 140th streets and Amsterdam Avenue to St. Nicholas

Pediments, mansards, dormers, and chimneys grace the 1890 Alhambra Apartments at Macon and Halsey streets, on the west side of Nostrand Avenue in Brooklyn.

Architect Henry F. Kilburn's refined use of alternating bands of terra-cotta and brick is exemplified in the West End Presbyterian Church at 105th Street and Amsterdam Avenue, 1891.

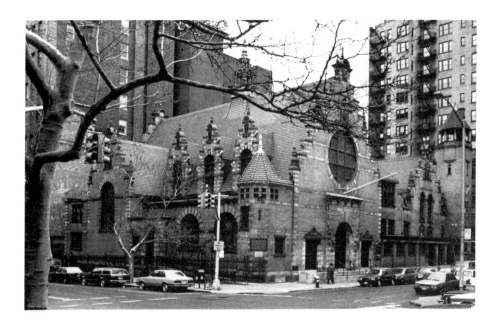

Robert W. Gibson's 1893 West End Collegiate Church at West Seventy-seventh Street and West End Avenue, with its Dutch stepped-gable façade, illustrates terra-cotta's adaptability to various styles.

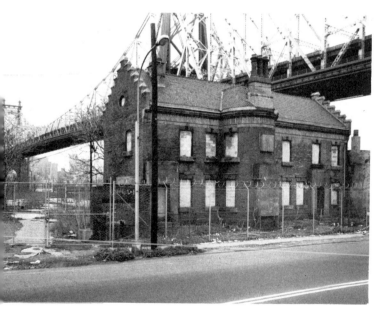

Terra-cotta's flexibility is evident in the art nouveau decoration side by side with decorative chimney pots on the American Architectural Terra-Cotta Company of 1892, located beneath the Queensboro Bridge in Queens.

Terrace are of cream-colored terra-cotta. He achieved variety by sandblasting the terra-cotta around windows, door trim, mullions, cornices, string courses, and dormers. At the time, the tonal difference between the light glaze and the dark, sandblasted surfaces was considered too great a contrast. Time has dealt harshly with the surfaces, and much of the color is obscured by grime from the atmosphere, exemplified in Shepard Hall, encrusted with terra-cotta detail.

Post's use of terra-cotta ornament in City College was criticized for being too picturesque, too much in the character of wall reliefs—that is, decoration applied to walls—instead of ornament that is part of the wall's structure. The implication was that Post was following too closely the della Robbias, founders of the most important workshop in glazed terra-cotta in fifteenth-century Florence.

Glazed terra-cotta in this country was first favored by builders in Chicago and Pittsburgh because glazed surfaces resist the action of smoke in cities, which is ruinous to porous materials. Alas, subsequent generations have found that terra-cotta too succumbs to atmospheric pollution and it requires maintenance.

In four schools, architect C.B.J. Snyder explored the picturesque possibilities of terra-cotta applied to historical revival styles. Buff brick and terra-cotta trim clad the medieval central tower and flanking gables at Morris High School of 1901 in the South Bronx at East 166th Street and Boston Road. Snyder's Manhattan Trade School for Girls of 1919 (now Mabel Dean Bacon Vocational High School), 129 East Twenty-second Street at Lexington Avenue, retains its colorful detailing. His crenellated façade and keeplike towers of the old Hunter High School building of 1913, at Lexington Avenue between Sixty-eighth and Sixty-ninth streets, now part of Hunter College, rake the Upper East Side skyline. And for hands-on proof of how carefully Gothic details were revived even into the twentieth century, Snyder provided the Lexington Avenue entrance with a pair of finials complete with cornets, which appear to have been lowered from some nonexistent tower and can be inspected at close range. Remarkably crisp detail defines the Flemish Renaissance revival façade of the old DeWitt Clinton High School of 1906 (now Haaren High School) on Tenth Avenue between Fifty-eighth and Fifty-ninth streets.

Other Notable Examples

Stoughton and Stoughton, architects for the Soldiers' and Sailors' Monument at West Eighty-ninth Street and Riverside Drive, designed a

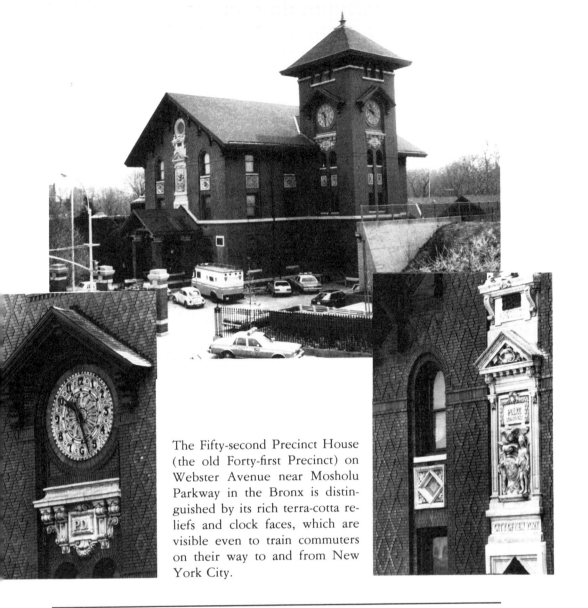

The Fifty-second Precinct House (the old Forty-first Precinct) on Webster Avenue near Mosholu Parkway in the Bronx is distinguished by its rich terra-cotta reliefs and clock faces, which are visible even to train commuters on their way to and from New York City.

Tuscan villalike precinct house in 1906 for the old Forty-first Precinct (now the Fifty-second) at 3016 Webster Avenue at Mosholu Parkway in the Bronx—seen by commuters from the railroad. Gracefully projecting eaves atop its square tower shade richly polychromed terra-cotta clock faces and figural relief below.

Polychromed terra-cotta beneath bracketed cornices reveals the original use of the Elks Lodge No. 22 (now the Oxford Nursing Home) on South Oxford Street between Hanson Place and Atlantic Avenue in Brooklyn. Designed by H. Van Buren Magonigle and A. W. Ross, it was completed in 1912.

In the New York Zoological Park, better known as the Bronx Zoo, in Bronx Park south of East Fordham Road, Heins and La Farge's Lion House of 1903 and their Elephant House of 1911 demonstrate how terra-

cotta can be used to enhance the compatibility of architectural styles. Classical and Byzantine forms, for example, set off by careful detailing beneath a high cone are combined in the Elephant House with striking effect.

A classical portico in terra-cotta and buff brick welcomes worshipers to the Spanish Church of Our Lady of Hope, 1912, at West 156th Street between Broadway and Riverside Drive, by architect Charles Pratt Huntington. Four Ionic columns of terra-cotta are surmounted by a pediment and cross of terra-cotta, and the steps and balustrades are of brick and terra-cotta ornamented with terra-cotta trim.

Ornateness continued in vogue, and when it was applied on a grand scale, it achieved triumphant effects, such as with the Ansonia Hotel between Seventy-third and Seventy-fourth streets on Broadway, by the developer W.E.D. Stokes and the designs of Graves and Duboy of 1904. Many musical stars lived or studied there, including Enrico Caruso, Lily Pons, Arturo Toscanini, Igor Stravinsky, and Robert Merrill. The Verdi Monument erected in 1906 nearby in Verdi Square appropriately portrays the composer surrounded by Falstaff, Othello, Leonora, and Aïda, all carved in marble by Pasquale Civiletti.

Alwyn Court, Unique in Splendor

One notable example stands alone in its splendor. Alwyn Court, 1907–9, 180 West Fifty-eighth Street, at the southeast corner of Seventh Avenue along with the Apthorp by Clinton and Russell, 1908, at 2201–19 Broadway, continued the tradition begun by Henry J. Hardenbergh's Dakota, built in 1884 at 1 West Seventy-second Street, the apartment residence on a grand and elegant scale for upper-income families. Apartment living had originated in France, and Richard Morris Hunt, America's first architect to study at the Ecole des Beaux-Arts in Paris, brought it to New York City in 1869 with his apartment house designs for 142 East Eighteenth Street, the Stuyvesant. (These were thoughtlessly razed.)

Twelve stories high, Alwyn Court originally contained two apartments of fourteen rooms each with five baths on each floor. In 1938, however, the building was completely remodeled, and the music rooms, salons, drawing rooms, libraries, conservatories, and living and dining rooms with their Caen stone, marble, and wood paneling were all removed, leaving nothing inside but the concrete floors; the entrance, which was originally in the rounded corner bay, was moved to Seventh Avenue. Miraculously, the exterior walls of the building were retained. The interior courtyard was

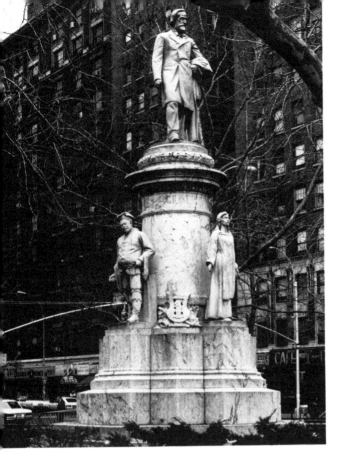

Left: The monument to Giuseppe Verdi between West Seventy-second and Seventy-third streets on Amsterdam Avenue portrays the maestro standing above statues of Falstaff, Othello, and Leonora, and Aïda. *Right:* The Sicilian Falstaff shown here is one of the figures from Verdi's operas. Sicilian sculptor Pasquale Civiletti gives his operatic figures a portraitlike quality. His models were his countrymen.

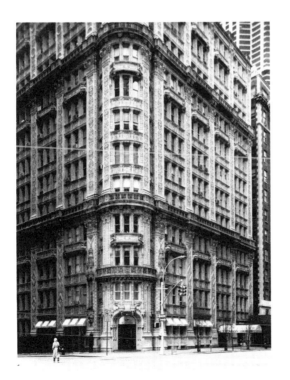

Every square inch of the Alwyn Court, in the style of François I, is covered with ornament.

recently redecorated, and a trompe l'oeil interior façade now surrounds the courtyard.

The entire surface of Alwyn Court is clad in animated terra-cotta ornament. A filigree of terra-cotta lies over the stone that clads the metal skeleton. The decoration's richness and complexity would have been prohibitively expensive if carved in stone. In terra-cotta, motifs are cast and can therefore be reproduced in as large a quantity as desired. The decoration is François I, prominently announced by his symbol, the salamander. The salamander in New York was the nickname for a fireman. The symbol was logically adopted by New York architects as a talisman against fire, a safe building material in a time when fire was a major concern. And the bigger the building, holding many people, the more the concern with fire safety. With the Woolworth Building the salamander also became the

Right: The ubiquitous salamander became a symbol for terra-cotta, a building material transformed by fire. *Left:* The salamander appears again in the Red House apartments, also by Harde and Short.

modern symbol of skyscraper technology. As the salamander was the ancient world's symbol of alchemy, in which baser metals were transformed by fire into gold, so the salamander became the modern architect's symbol of the skyscraper. Terra-cotta and steel are transformed by fire from baser substances into the skeleton and skin of the modern skyscraper.

Alwyn Court's round corner bay offered views of the city never enjoyed before, a progenitor of today's postmodern skyscrapers that reject the rectangular box and provide tenants with more corner offices and new views of the metropolis that through cinema and photography are fast affecting the way contemporary society sees its world.

Alwyn Court was named after Alwyn Ball, Jr., one of the owners of the Heddon Construction Company, which built the building. It was designed by Herbert S. Harde and R. Thomas Short, architects, who have other outstanding apartment houses to their credit. On the northeast corner of Eightieth Street and West End Avenue and at 45 East Sixty-sixth Street, the northeast corner of Madison Avenue, about 1908, for example, are apartments that also have rounded corner bays. Their Red House apartments at 350 West Eighty-fifth Street, between West End Avenue and Riverside Drive, 1904, also carries the salamander and crown motif as at Alwyn Court, and their studio building of apartments at 44 West Seventy-seventh Street between Central Park West and Columbus Avenue, 1909, was stripped of much of its terra-cotta in 1944 but still displays the lacy tapestry of its neo-Gothic façades.

The Prince George, a Survivor

At the turn of the century, a number of family hotels built as alternatives to such rich and sparkling hotels as the St. Regis and the Waldorf failed in their attempt to be like an elegant private house. The Prince George Hotel at Twenty-eighth Street near Madison Avenue of about 1905 is a notable exception. Architect Howard Greenley used terra-cotta, plaster, wood, and paint to set a trend in less expensive but still elegant hotel decoration. Each room had a different architectural style, and to unify the interior design, the dominant color in one room is a minor note in the adjoining room. A combination of plaster approximating groin vaulting and painted panels recalled Genoese palaces. The centerpiece of the Palm Room, one of the principal dining and gathering spaces, is a wall fountain in faience with designs of irises, pond lilies, and a variety of other aquatic plants in natural colors on a soft white glaze. C. J. Barnhorn and W. P. MacDonald, staff sculptors of the Rockwood Company, executed the sculp-

Top left: The Prince George Hotel, now a welfare hotel, at East Twenty-eighth Street near Madison Avenue, set a new trend in hotel design when it was built in 1905. *Top right:* The ballroom has been converted into a basketball court, yet much of the decoration miraculously survives. *Bottom left:* The original oil on canvas paintings of the seasons by George Inness, Jr., remain to decorate the ceilings. *Bottom right:* A wall fountain in faience with designs of assorted aquatic plants is intact in what was the Palm Room, now a storage area.

tural designs. Painted panels, whose lighting was concealed within cartouches, capitals, and pilasters, included seasons of the year painted by the distinguished artist George Inness, Jr.

Born in Paris, he studied in Italy and the United States with his father, the famous painter George Inness, then with Léon Bonnat in Paris. Inness, Jr., spent much of his time abroad, where he was better known than in the United States, and he exhibited frequently at the Salon in Paris. He was an officer of the Paris Academy and an academician in the National Academy of Design in New York. Inness shared his father's willingness to depart from slavish representation in favor of expressive power. Contemporary critics compared his handling of light to the late paintings of Corot, a feature that is still apparent in his Prince George Hotel murals.

The Prince George is now a welfare hotel. Its Palm Room is used for storage, and its ballroom is a basketball court. Inness's paintings are miraculously well preserved—at least, for now.

Terra-Cotta and the Skyscraper

Terra-cotta was an ideal cladding and ornamental material for skyscrapers. Granite and marble deteriorate, but to the builder at the turn of the century terra-cotta would endure forever. It was as if it came from some higher power, like Prometheus' gift of fire to mankind. If terra-cotta had not existed when the skyscraper was born, said some, the tall buildings would have demanded it. It was perfect hollow firebrick for floors, and it was ideal to cover steel frames because it was light, cheap, and fire resistant. Terra-cotta was practical for cornices because it was much lighter than stone. As terra-cotta trim, especially cornices, replaced stone, walls and foundations could be lighter. By the turn of the century terra-cotta technology had improved so that any design, any color, and any texture was available. Designers compared themselves with the ancient Greeks. But instead of painting their buildings brightly as the Greeks had, they encased them in colored tiles of terra-cotta.

A remarkable conflation of old sensibilities and new ideas that incorporated the innovative use of terra-cotta is embodied in Ernest Flagg's Singer Building, now the Paul Building, of 1907 at 561 Broadway between Spring and Prince streets. The building actually has two facades, the second on Prince Street, a common practice at the time. It is called the "Little Singer" Building to distinguish it from Flagg's Singer Tower of 1897, one

of the city's most elegant Beaux-Arts monuments, demolished to make way for 1 Liberty Plaza.

Large areas of glass are set within red brick and red terra-cotta tiles, and the whole ensemble is framed by tendrillike wrought-iron tracery, resembling filigree work. At the corners iron plates with spaces between them to appear like fluted pilasters, define the end bays. Some critics see Flagg's avant-garde handling of glass and iron as anticipating the glass curtain wall of the 1950s. Its combination of brick and terra-cotta and classical forms executed in industrial materials is a lesson in making something new from something old that still has appeal to the most sophisticated designers. Another of Flagg's masterpieces still standing is Scribner's Bookstore of 1913 on Fifth Avenue between Forty-eighth and Forty-ninth streets.

Cass Gilbert and Terra-Cotta

The Woolworth Building of 1913 at 280 Broadway, across from City Hall Park, was not only a tour de force in skyscraper design, but as the tallest office building in the world and the most famous skyscraper until the 1930s, it remained, too, the epitome of what terra-cotta could do: flamboyant Gothic ornament, gargoyles at different levels, colored spandrels tonally graduated to compensate for heights never experienced by spectators before, and an ivory shaft of glazed terra-cotta also graduated in tone so that the sun would reflect from it uniformly (otherwise, the building would appear to swell at the top and seem top-heavy).

Gilbert's West Street Building of 1905, a few blocks to the southwest at 90 West Street, was the forerunner of the Woolworth Building in the use of terra-cotta as well as in overall design. Although its lobby has been ruined, its glazed cladding and colorful exterior ornament retain much of their original splendor. In his Broadway Chambers Building of 1900 at that intersection, Gilbert applied terra-cotta to Renaissance revival forms in a striking use of graded color.

Similar to the way in which Cass Gilbert used glazed terra-cotta on his historical revival confections, Henry Ives Cobb harked back to antiquity for his Liberty Tower of 1909 at 55 Liberty Street at the northeast corner of Nassau, in which the stepped cap of the building is borrowed from the Mausoleum of Halicarnassus.

Another tenet of the color theory that prevailed at the time embodied in Cass Gilbert's three buildings is that one solid color should be used in order to emphasize the building's mass instead of diverting attention from

it. White or gray glazed was considered the best because it reflected more light than dark hues. Gothic ornament remained popular and provided formal as well as coloristic richness to New York City's skyline. Clinton and Russell's 60 Wall Tower of 1932 at 70 Pine Street is glazed and sand-blasted, a technique Cyrus Eidlitz used in his Times Tower, which has since been altered out of existence. Although a parking lot replaced the low-rise part of the building that faced on 60 Wall, the Gothic crown remains a celebration of the excellence of terra-cotta.

The Twenties

Toward the end of Herbert Croly's life (1869–1930), innovations in terra-cotta and brick continued to produce the "vivid masses and patterns" on the surfaces of buildings, which were thereby transforming the city's spaces, as he believed they could.

The change in taste in apartment hotels by the end of the first quarter of the twentieth century is well represented in the building at 28 East Sixty-third Street by Henry S. Churchill and Herbert Lippmann, 1927. The building combines domestic and commercial space. The bottom part of the building, a restaurant and lobby, is wrapped in faience of still brilliant color, and the top part is set off in brick with terra-cotta trim to distinguish it as the residential part of the building. In the original wrought-iron *"parlante"* window grilles near the restaurant entrance, alas long since vanished, a pair of window panels depicted a playful Bacchus and Cherry Ripe, a girl picking cherries from a low-hanging branch.

Color, Texture, and Form

The progressive use of brick in the 1920s and 1930s can be illustrated by comparing Ely Jacques Kahn's 2 Park Avenue of 1927 between Thirty-second and Thirty-third streets with Arthur Loomis Harmon's Shelton Tower Hotel of 1924 on Lexington Avenue between Forty-eighth and Forty-ninth streets. Both buildings set trends with their decoration. The Shelton Tower was one of the first tall buildings (thirty-four stories) to use the setback requirements of 1916 in an imaginative way, and Harmon's devices greatly influenced the architects of the 1920s. By using Romanesque decoration to mark transitions from one mass to another, Harmon kept the Shelton Tower from looking like blocks stacked on blocks. Com-

bining the skilled adjustment of color and intricate craftsmanship in brick-laying, he provided diversity for the large masses of the tower. These decorative techniques made an impact on the Art Deco masterpieces of the following generation, such as Ralph Walker's New York Telephone Company Building, 1926, at 140 West Street.

2 Park Avenue

Kahn's building is composed of fewer blocks. A dominant dark brick shaft on a light stone base is capped with an ensemble of rectangles articulated by brightly colored terra-cotta. The building's austere simplicity is enlivened by subtle tonal variations that identify the various components of the façade.

The main structural mass is the shaft, which is identified by a uniform hue. Elongated pilasters unite the shaft to the lower mass in another tone. There are still other color variations in the spandrels between the windows and the corbels supporting the pilasters. The different tone of each formal element is accentuated by sharp shadows. A virile effect is achieved by the strong colors and dramatic shadows.

Critics observed that through treating the organization of his building

Ely Jacques Kahn's 2 Park Avenue. Subtle and bright shades of terra-cotta are combined to identify the main components of the skin of the variegated shaft.

Kahn's vaulted entrance continues the blend of subtle and strong forms and tonal contrasts.

polychromatically, using red, black, ocher, and greenish blue, Kahn devised a distinctive system of ornamental design. The ocher pylons at the corners of the building frame its dark-colored brick shaft and act as a liaison between the light stone at the base of the building and the red, blue, and black terra-cotta group at the top. Bands of black terra-cotta, the only shiny element, reflect the light of the sky and thereby frame the colorful terra-cotta rectangles that echo the forms below.

To arrive at the harmony of glazes that he used in his decoration, Kahn experimented with full-size plaster models, which he set up on rooftops and then painted them, standing back some 250 feet from the models to view them. Revision after revision of colors and shades finally produced what we see today.

Kahn's use of superimposed ornamental silhouettes was not just a departure from the conventional use of terra-cotta; it also opened up a vast range of polychromatic possibilities for architectural ornament.

Critics were quick to note that the wealth of fascinating invention with which Kahn vested his lobby of 2 Park Avenue reflects the ornamental principles of his exterior. From the gilded bronze entrance, the vault mosaics, and the colorful ceiling of the lobby to its lighting fixtures, mailbox, and building directory, the repeated motifs are superimposed, silhouetted, and echoed in diminishing dimensions in every detail to produce a new trend in lobby design.

The Shelton Towers as a Base for Sculpture

While 2 Park Avenue could be seen as a great sculpture, contemporary sculptor Roy Van Auken Sheldon saw the Shelton Towers Hotel as an ideal base for sculpture—but then he saw almost all skyscrapers as bases for sculpture. The walls at the ground level are battered (slanted) so that the building appears to grip the ground. The tower that emerges is given entasis—that is, the almost imperceptible swell the Greeks imparted to the shafts of their columns. There are great twisted heads at the transitional angles of the building, which adds interest to the thin, hard lines of the architecture. The carved decoration at the ground level belies the Shelton's original purpose, a club for men. Reminiscent of the historiated capitals of medieval architectural decoration, crouching above the entrance to the Shelton, twentieth-century man holds a racket instead of the keys to the kingdom of heaven.

Cities as Monuments

American cities, Roy Sheldon reasoned, had become gigantic, and their monuments had become tiny. Observing that the new architecture was more simplified and more colossal, he proposed that we should explore its monumental possibilities. He saw skyscrapers making up the central core for the city as bases for sculpture—sculpture that would form a logical crown of the city itself considered as a monument. These architectural monuments could be seen from great distances, while the traditional monuments, such as the Pulitzer Fountain in front of the Plaza Hotel and the honorific column in Columbus Circle, would be suitable for viewing from the street.

While the ground-level monument would retain a connection with traditional styles of sculpture and architecture, that designed for the new towers would require the use of the new skyscraper technology. The engineer would become a collaborator with the sculptor, for they would doubtless build the new sculpture of steel, like the buildings of which they would form a part. They would even be anchored to the steel skeleton of the skyscraper itself. In simplified style and painted like the buildings, the sculpture would be cubist rather than realistic. In Sheldon's city, both the avant-garde and the academic tradition would coexist.

The slanted walls of the building's base makes the old Shelton Towers appear to grip the ground. Its decoration at the base is both parlante and ornamental.

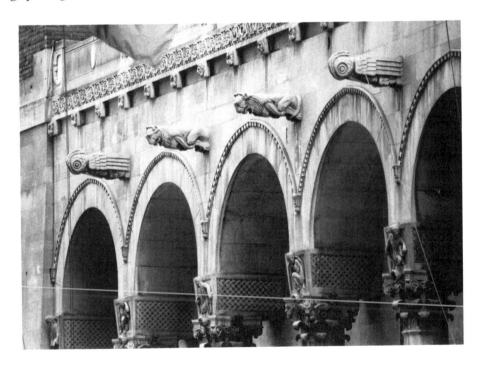

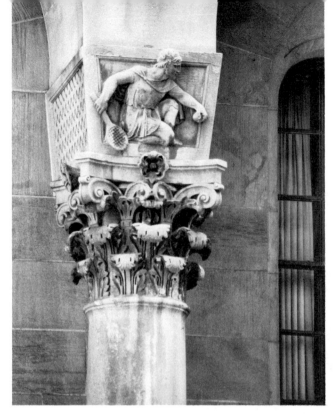

Left: Originally designed as a men's club, the Shelton's spandrels carry reliefs of athletes holding rackets or drying themselves with towels.

Below: The popular symbol of service, the pellican piercing its own heart to feed its starving young, alternates with the lion above the arched entrance to the lobby.

A New Age

Terra-cotta lost its popularity by the 1940s. When James Stewart Polshek and Partners restored Carnegie Hall in the mid-1980s and sought to restore an original terra-cotta entrance arch that had long ago been destroyed, they had a difficult time finding anyone who could make it. Terra-cotta is not as impervious as the early builders thought. It can crack, and when it does, water damage can be deadly. Consequently, New York City's repository of terra-cotta buildings and decoration is threatened and is disappearing.

Such groups as Friends of Terra-Cotta have been vigilant in sounding the alarm to save the terra-cotta buildings that should be saved and in educating the public through programs and seminars on the preservation of terra-cotta.

History and Color Underground

The public is kept ever mindful of the riches of terra-cotta decoration even beneath the city's streets. Colorful and informative terra-cotta decoration beautifies the city's more than 450 subway stations. Portrayed in the tiles are Dutch dwellings of the 1650s at the Wall Street stop, Christopher Columbus's ship the *Santa Maria* at Columbus Circle, and steamboats at Fulton Street, and beavers at the Astor Place subway station remind commuters that John Jacob Astor built a fur-trading empire selling the beaver's pelt.

CHAPTER 28

Samuel Yellin: Poet in Iron

With the rich building campaigns of the turn of the century, coupled with the revival of historical styles in architecture, there came an enormous production of ornamental ironwork in New York. The major master of wrought iron was Samuel Yellin, a Polish immigrant whose artistic genius, entrepreneurial skills, understanding of human nature, and intense drive enabled him to create a workshop and body of work that opened a new era in ornamental ironwork in America. Yellin's name became so synonymous with quality that patrons came to demand "Yellin quality," even when they employed another ironworker. Yellin's iron enhances many buildings and public places in New York City, while many others bear the stamp of his influence.

Apprenticeship and America

At the age of seven Samuel Yellin was apprenticed to the forge in the village of Mogiler, Poland. He distinguished himself early as being able to make or fix anything from tools to fittings and all kinds of repair work. He worked spontaneously and fast. Yellin became a perfectionist, but he was never fussy. For him, the irregularities of iron were the medium's chief appeal. In working with the metal, instead of restricting it too closely to

Interior of the Arch Street Studio of Samuel Yellin.

preconceived shapes, Yellin learned to draw from it what he later described as its poetry and rhythm.

At seventeen Yellin set out on his *Wanderjahre,* the artisan's "traveling years." In the European system it is customary for the apprentice to work under the close supervision of a master for a period of one or two years. Then, for four or five years, he works with various masters in workshops throughout his own country or in other countries, the traveling years. For five years Yellin worked in metal shops in Poland, Russia, Austria, Germany, Belgium, and England.

Following his apprenticeship, the artisan prepares a piece of work that demonstrates superior ability (his masterpiece), in order to become a master craftsman. The new master then sets out to build his career either on his own or in an established studio. Once Yellin became a master craftsman, he followed some of his family to the United States in 1905 and settled in Philadelphia.

The Arch Street Studio

To learn the state of the craft in America, Yellin began studying at the Pennsylvania Museum School of Industrial Art, and he was almost immedi-

ately placed in charge of the ironworking classes. At the same time he opened up his own shop in a rented attic and started traveling to New York City to seek business from the architects there. Commissions came, and in 1910 Yellin opened his Metalworkers Studio on Arch Street in Philadelphia, which became famous as the Arch Street Studio and still stands, producing work by some of Yellin's followers.

In 1911, through the distinguished New York architect Christopher La Farge, Yellin was commissioned to make a gate for the J. P. Morgan estate in Long Island, which in turn attracted additional business and established his reputation for high-quality design and workmanship. By 1915 the Arch Street Studio was well established, and five years later Yellin had to build another complete studio next door to accommodate the largest commission of ornamental ironwork of the period—two hundred tons of ornamental ironwork for the Federal Reserve Bank Building in New York City, designed by York and Sawyer. Yellin had more than two hundred men working for him on the job, craftsmen who had immigrated from all over the world.

It was not unusual for Yellin to meet incoming ships from Europe to find good ironworkers. His knowledge of several languages, the common bond of his craft, and the fact that he paid the highest wage assured him of a dedicated shop.

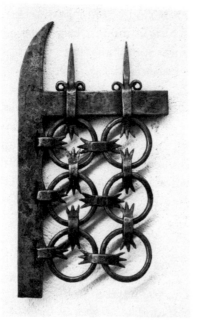

Samuel Yellin's "sketches in iron" are works of art as well as solutions to problems.

The Federal Reserve Bank wanted its building to be a symbol of economic strength and security. To convey that image, therefore, York and Sawyer's design was based on the great fifteenth-century Florentine palaces in Italy, but on an even grander scale. Five stories of the fourteen-story building, for example, are beneath ground and rest on bedrock eighty feet below the street. At its completion in 1924, it was one of the largest banking facilities in the world, occupying the entire block bounded by Nassau, Liberty, and William streets and Maiden Lane. The combination of Indiana limestone, Ohio sandstone, and Yellin's ironwork achieves a polychromatic effect to give variety to an otherwise ponderous stone mass. Moreover, the image of financial security is strengthened by Yellin's iron-work. His gates and grilles not only provide the building and its labyrinth of halls and rooms with security unmatched at the time, but his designs for everything from lamps to door latches and from clocks to finials and railings reinforced the historical association with the great merchant princes of the early Renaissance in Italy.

Lamps and Grilles

Toward that end, Yellin created a complete array of fixtures. His Strozzi lamps that flank the main entrance on Liberty Street are perhaps the most distinguished. Based on the Renaissance designs of Nicolò Grosso (called Caparra, referring to his requirement to be paid in advance) for the Gaudagni Palace and the Strozzi Palace (thus the name of the lamps), both in Florence, they are six feet high and fabricated of an abundance of pierced iron bars and woven straps of iron that frame a modern lens. Yellin's lamps were the largest and most elaborate such lamps that had yet been crafted in America, and they remain today unsurpassed in design and workman-ship.

Yellin's mammoth window grilles for the Federal Reserve Building are tours de force not only for their design of forged iron, split and beaten into a basket weave, called basket grilles for that reason, but also for their method of installation. A technique employed in ancient times, it was used here for the first time in the United States. Yellin simply forged the bars so that the ends terminated in a "Z" shape. Then, by heating the metal at the moment of installation at the site, he bent the "Z"-shaped end into a bracket, or " ⌐ " shape, thereby extending the top member of the "Z" into the hole drilled in the limestone to receive it. Thus, the grille is anchored all the way around, each bar inserted into a two-thousand-pound block of stone that surrounds the window opening. Inspection of most iron grilles

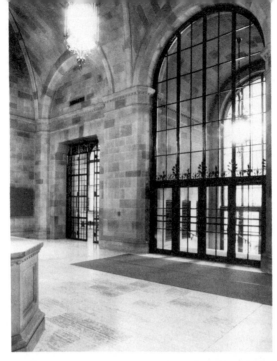

Left: Massive wrought-iron fixtures complement York and Sawyer's palatial spaces in the Federal Reserve Building. *Below:* Wrought-iron screens enclose the teller areas.

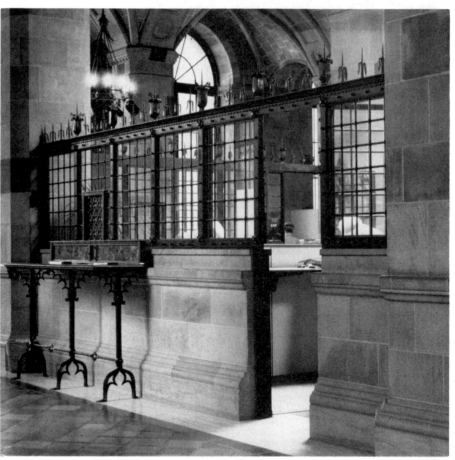

The finials are evocative of animal forms.

on windows in the city reveals that the grilles are fastened to iron frames and the entire fixture, as one unit, is simply set into the window space and anchored with bolts or screws. Such grilles are easily pulled loose, even though they appear to be secure. Yellin's grilles cannot be removed without removing the wall with them.

Whimsy in a Grasp

In the bank's fixtures, Yellin captures the medieval sense of ornament and whimsy that carried over into early Renaissance design. Animals, birds, gargoyles, grotesques, and rosettes abound on door latches, lamps, tellers' cages, and railings. The long, sturdily wrought handrail just inside the main entrance gives the immediate assurance that it will render support up the steps. The perceptive observer, however, notices that two animal heads—a mother nuzzling her offspring—ornament the end of the railing. The railing itself is an uninterrupted span of beautifully wrought iron with a sturdy and smoothly beaten toruslike molding, comfortable and reassuring to the grasp. At the end of the railing at the top of the stairs, the hand slides over a configuration of two pairs of tails intertwined—those of the two figures below, logically completing the railing design.

Grates, Finials, and Rosettes

The entrance hall, off Liberty Street, is a two-story-high groin-vaulted space lighted by wrought-iron lamps hanging from central and lateral groins. The space is lined with Guastavino tile, a ceramic surface, buff in tone. The light and space conjures up associations with medieval and early Renaissance palaces, castles, and cathedrals. Two giant latticelike wrought-iron gates, designed by Samuel Yellin, lead ahead to the elevator banks to the vaults below and the executive offices above. Large convector grilles repeat the pattern of the gates. To the left and right of the great lobby, gates open into groin-vaulted passageways to the public banking rooms. There, five hundred feet of continuous wrought-iron screen enclose the teller areas. Wrought-iron frames of a simple basket-weave design contain glass panels, capped by decorative finials with animal forms, each one unique. Close examination reveals one of the essential appeals of wrought iron— the uniqueness of each piece. Even though each finial and each corner rosette is the same design, no two are identical because each is wrought by hand individually and therefore has its own character.

Yellin's whimsy and warmth are evident in the mother nuzzling her cub on this railing.

Francis Whittaker, now one of America's leading blacksmiths, whose work is in great demand, was employed by Samuel Yellin in 1923 as a young man just beginning as an artisan, and he made many of the rosettes for the tellers' cages in the Federal Reserve Bank Building. Whittaker and Max Segal are the only two ironworkers living who once worked with Yellin.

Simple and True

In addition to Yellin's natural gifts as an ironworker, his greatness and influence owed much to his respect for and use of tradition. Having been trained in a workshop tradition that went back to the Middle Ages, Yellin recognized the importance of tradition as the foundation of his art. He believed that designs not based upon a tradition were "purely inventive and not creative." He sought inspiration from the work of the masters of the past. As he said, "They saw the poetry and rhythm of iron." And he told his blacksmiths and students, "We should go back to them for our ideas in craftsmanship, to their simplicity and truthfulness." By this he did not mean to copy from the old masters. "Anyway," he believed, "it is impossible to copy anything." "It is never a copy," he would say, "it is either better or worse than the original." But the work of the old craftsmen is there "to be studied for inspiration, for one's own creative faculties," he wrote in one of his two articles for the *Encyclopaedia Britannica* on ironwork.

Among a new generation of ironworkers in America that came out of

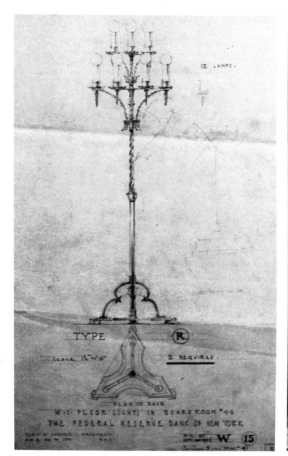
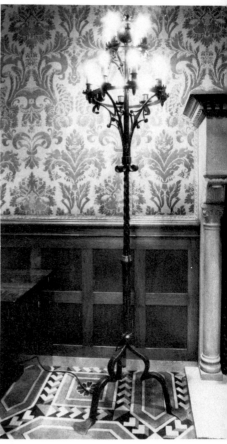

Left: Yellin's drawings helped him develop his designs. *Right:* His drawings, however, were not blueprints for his works.

the 1960s and 1970s are those who look to Yellin's art as he looked to the earlier craftsmen. By studying Yellin's work, they learn how he worked iron for contemporary purposes by studying not only his finished works, but also his "sketches in iron," as he called them. Yellin believed that the craftsman should first make a fragment or portion of the piece he intended to see how the material and the design work together, to be able to see the idea materialized in three dimensions and in the material. Then he would make drawings from which to fabricate the finished piece. He insisted on working from drawings because that allowed the craftsman greater individuality. Working from an iron sketch was too much like attempting to reproduce the model, a practice he abhorred. He made many drawings, which were guides to the finished product, but were never slavishly copied.

Yellin became the acknowledged authority on ironwork in America,

and he was commissioned by the *Encyclopaedia Britannica* to write the two articles, long accepted as the definitive statements on the subject, for its fourteenth edition in 1929.

Yellin's Collection and Library

In the early 1920s Yellin began traveling to Europe, collecting the finest examples of ironwork he could find from all styles and periods. He not only developed the leading collection of ornamental ironwork in America, but created a living encyclopedia of the world's history of ironwork and a repository of models from which he got ideas for his own designs. The collection was also an indispensable aid to his teaching workshop, as he described the Arch Street Studio. Choice pieces of that collection remain in the Yellin family, and other pieces are in the Metropolitan Museum of Art. The rest of Yellin's collection was sold after his death. Selected examples of Yellin's key commissions and a collection of models, which helped to inspire them, now make up the two-room museum in the Arch Street Studio building, which also houses Yellin's remarkable library of books on ironwork, another basis of his designs.

In 1935 Yellin was made visiting professor of design and craftsmanship in the School of Fine Arts at the University of Pennsylvania, where he taught the history of metalwork. A natural-born teacher, he was always teaching—his craftsmen, his patrons, and the architects with whom he worked. His teaching aids were his collection of the finest examples of ironwork from all over the world, his library of the leading publications on ironwork from all ages, and his own sketches in iron.

Yellin's Dream

When the Great Depression hit, following the stock market crash of 1929, building was sharply curtailed. Coupled with the rise of the International Style, which eschewed ornament, decorative wrought-iron work was all but ignored. Yet Yellin retained most of his blacksmiths even when there was no work. He kept them busy making sketches. A friend warned him that if he did not let the craftsmen go, he would lose all his money, to which Yellin is reported to have answered, "If you want to know what God thinks of money, just look at the kind of people he gave it to."

Although this anecdote shows Yellin's generosity to his people and dedication to his work, it is not an entirely accurate appraisal of his attitudes

toward the wealthy. He was blessed to know generous patrons who had a great deal of money, and he appreciated them. For example, Edward Bok of Philadelphia not only commissioned Yellin to do important works, but also had contracted Yellin to make a plan for a wing of the Philadelphia Museum of Art to be set aside for a working wrought-iron studio complete with forge and a full contingent of blacksmiths and iron craftsmen who would actually work on real commissions right there in the museum for the public to watch. It would be a school as well—a studio, a school, and a museum all in one. But Bok died suddenly, the Depression hit, and the studio remains to be built. Yellin never really got over the profound disappointment at the failure of his dream. He died in 1940, following complications from a heart condition he had for many years. In one way, fate was kind. With the Depression and architects' preference for the International Style, Yellin's days of big commissions were over, and he no doubt knew that. He had lived in a period when an idea's time had come. He had gotten the most from life, and he had given it the best he had. It was over—at least, for a while.

Historian and critic Royal Cortissoz wrote, "I can conceive of Yellin as the leader of a group, the founder of a school, and I would be grateful for such an eventuality." That was Yellin's dream. He wanted his shop to be the origin of a crafts revival to produce a generation of American masters. That is why he opened his shop to the public, and that is why Bok's support was so important to him.

A Wrought-Iron Revival

With the Second World War came the popularization of the acetylene torch and the arc welder to build the necessary war machine. Cutting metal, then, and sticking it back together became easy. These two tools eclipsed the blacksmith craft, the product of four thousand years, until the late 1960s, when a revived interest in blacksmithing began to take hold among artists and patrons. This revival led to the formation of The Artist-Blacksmith's Association of North America (ABANA), which now has more than 3,500 members, most under forty years of age. For many of its members, Samuel Yellin is their principal model. And they look to the many examples of Yellin's work for their models.

After the Federal Reserve Bank Building project, Yellin received commissions from all over, and examples of his work are found in various parts of the United States. One of his most successful commissions in New York is the ironwork for the Central Savings Bank (now Apple Bank for

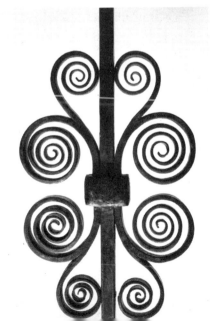

Yellin's iron gates for the J. Walter Thompson Company were incorporated into the new design when the agency moved its offices.

Savings) at Seventy-third Street and Broadway, called the "Little Federal Reserve" because of its similarity in designs and ironwork. Unfortunately, Yellin's ironwork is painted over, obscuring its superb imagery. Other commissions in New York include Brick Presbyterian Church, Cathedral Church of St. John the Divine, the Cloisters, Columbia University, Cunard Building, Dime Savings Bank of Brooklyn, Hall of Fame in the Bronx, Morgan Library Annex, St. Thomas Church, Seaman's Bank for Savings, St. Vincent Ferrer, and Temple Emmanu-El.

The agency's new conference room was built around Yellin's bronze repoussé doors, whose panels tell the history of printing—a tribute to the vision of Stanley Resor who built the modern agency and commissioned the doors.

Fruits of an Advertising Man's Vision

Yellin's gates for the J. Walter Thompson Company are among the finest and best-preserved examples of his work, partly because they are inside, but also because the agency loves the gates and respects Yellin's workmanship. A repoussé bronze door for the agency's conference room in the Graybar Building, along with the gates, was brought to the agency's new offices up the block, and the new conference room was designed around the door, a fitting acknowledgment of Yellin's 1929 masterpiece, whose panels tell the story of printing. The doors were commissioned by Stanley Resor, who built the agency into the largest in the world and the most sophisticated in management. He was the first, for example, to establish a modern profit-sharing plan in an advertising agency. "Our inventory walks out the door every night," he noted. And he introduced the "open-door policy" at Thompson with his gates by Yellin, so he could keep an eye on business—and on the inventory!

An art lover of good taste, Resor wanted his policy to be translated in good taste. Iron gates were the answer, and Samuel Yellin was the best, so he should make them. Although the agency maintains them beautifully, some have been placed in storage because the new offices do not accommodate all of them.

Samuel Yellin's son, Harvey Yellin, became an architect and carried on his father's business until he died in 1985. Harvey Yellin established a foundation to assure the continuity of his father's contribution to the ironworker's art and craft. Moreover, he continued the high level of workmanship, and Yellin's work found its way westward, even to the Panhandle of Texas.

PART X

Street Furniture: Creative Treatment of Space, Light, and Time

CHAPTER 29

Benches, Sidewalks, Fixtures, and Fountains

Artistic "street furniture" helps people to relate more comfortably and productively to their environment through its creative treatment of space, light, and time.

The 1980s saw a revived interest in the quality of street furniture in New York City, in both the private and public sectors. Street furniture is the term that describes useful or decorative additions to public spaces that provide something necessary or desirable. Street furniture is usually fabricated of such traditional materials as wood, metal, glass, and plastic. It is the term for street clocks, signposts, lampposts, benches, and even sidewalks—utilitarian objects that are necessary in a city but can enhance the quality of life at the same time. A similar surge of practical and aesthetic vigor early in this century produced a body of distinctive furniture. It drew on some of the city's most talented professionals in the arts, crafts, and industry to produce clocks, benches, drinking fountains, hack stands, and streetlights that helped improve the quality of the city's streets and public spaces.

Benches

Sometime in 1938, ironmaster Kenneth Lynch recalled forty-seven years later, Robert Moses telephoned him. "Could you meet with me and my friend Bernard Baruch to talk about building a park bench to our

specifications?" Baruch, who loved to sit in the park, insisted that the bench should be comfortable, so Lynch consulted a medical doctor, Dr. Harry Stack, who said that the secret to making a comfortable bench is in properly accommodating it to the human back and legs. He and Lynch set about doing that. Baruch liked the Lynch-Stack bench, and Moses ordered ten thousand of them for the 1939 world's fair. Central Park has been using the bench ever since. Lynch also exports the bench to six foreign countries.

Another style of bench was selected for the promenade around the park. Olmsted and Vaux conceived of the easement that surrounds Central Park as an integral part of the park design. It is an ample and picturesque border to the park. In the 1920s, to make sure that proper seating was available along Fifth Avenue from 60th to 110th streets, Carrère and Hastings, the architectural firm whose outstanding designs include the New York Public Library at Forty-second Street and Fifth Avenue and the Frick residence at 1 East Seventieth Street facing Fifth Avenue, was commissioned to design a bench. In cast-concrete and wood, 190 benches were produced in handsome proportions that also afforded comfortable seating. These were replaced in 1935 with a similar design. Although most are in poor condition now, they are to be restored in the rebuilding of Central Park that is now under way.

The rebuilding campaign also includes restoring the only rustic shelter in the Ramble still standing of the original fifteen built in the 1860s. Others will be completely rebuilt in the same style, called by some the Adirondack style, a name that is somewhat misleading. The rustic shelter that became popular with the great camps in the Adirondacks, thus the name, was largely derived from designs of A. J. Downing, whose writings shaped the landscape design movement in America. The designs were used by Olmsted and Vaux, whom Downing brought to New York, for their rustic shelters in Central Park. Downing's designs spread to the Catskills and Adirondacks and beyond. Now, the craftsmen at such places as Mohonk Mountain House in New Paltz, New York, who build, maintain, and restore their own rustic shelters after the designs of Downing, have helped in Central Park's restoration of the Ramble shelter, an example of an influence coming full circle.

Streets and Sidewalks

Cast-Iron

Iron sidewalks were a common feature of New York City's streets in the nineteenth century, but few remnants are in decent condition. Al-

Left: Vault lights at Broome and Mercer streets. *Right:* And at 101 Spring.

though the iron sidewalks have vanished, many extant iron vault covers, stoops, and light platforms convey a sense of what they were like when New Yorkers walked on iron. Patented by Thaddeus Hyatt in 1845, iron vault covers with glass windows, tinted circles of glass (called vault lights) set in cast-iron treads and risers, allowed natural light into the vaulted basement space beneath the sidewalk and street. With the advent of the electric light, vault lights became obsolete.

Extant examples in SoHo provide a sense of the variety of vault lights. Traditional vault lights are found at Broome and Mercer streets. The vault lights at the Whyte Building at 101 Spring Street are a diamond pattern. With the coming of the subway system at the turn of the century and new construction, many of the vaults were filled in and the vault covers either removed or eclipsed by resurfacing.

Remnants of New York City's early streets and sidewalks still provide a sense of their variety and what our forebears walked on and looked at in the nineteenth century. For example, there are many early granite and bluestone sidewalks and curbs left right next to more recent granite curbs and still more recent concrete ones with metal edging. Some rare examples of streets paved with Belgian blocks exist at Crosby Street and Howard Street. In Greenwich Village, more bluestone and granite are found because there has not been as much tearing down and rebuilding as uptown in the hotel areas.

Decorative Sidewalks

Since the 1980s commercial establishments have taken an interest in decorating the sidewalks in front of their stores, inspired by a desire to advertise their names but also to make the walks safer and to avoid lawsuits. Travertine and terrazzo, preferred for many years, get slippery when it rains or snows. The trend now, therefore, is to textured surfaces for surer footing, as at the former Union Carbide Building on Park Avenue between Forty-seventh and Forty-eighth streets. The new designs feature monograms and logos of the business establishment as well as a variety of geometric and fanciful designs that distinguish the space and surface. Examples include Inter-Continental Hotel (Barclay), Forty-eighth Street and Lexington Avenue; Trump Tower, Fifth Avenue at Fifty-sixth Street; Tiffany's at Fifth Avenue and Fifty-seventh Street; the IBM Tower at Madison Avenue and Fifty-seventh Street; Westbury Hotel's Polo Bar, Madison Avenue between Sixty-ninth and Seventieth streets; and the Sherry-Netherland, and Pierre Hotel, near the southeast corner of Central Park. The trend to more imaginative sidewalks is encouraged by the proliferation of arcades and plazas and atriums in the city, where the design underfoot frequently flows from the street into the building.

On June 25, 1985, the Second Avenue Deli (156 Second Avenue) at the corner of Tenth Street, near the Cafe Royal, long a famous gathering place for Yiddish actors and intellectuals, dedicated a "sidewalk of the stars," the thirty-five-foot sidewalk in front of the delicatessen embedded with granite plaques bearing names of fifty-eight great performers who made Second Avenue a Yiddish Broadway. Among those honored are Paul Muni and the Burstyn family.

Fixtures

Traffic Lights

Traffic signals are an integral, if overlooked, part of city furniture. None of the first traffic signal towers to use colored lights still stand. A bit too elaborate to survive, the seven that were erected between Fourteenth and Fifty-seventh streets were replaced in 1930 with a simpler traffic signal. The original lights were designed in 1921, by Joseph Friedlander for a

system of colored lights developed by Dr. John A. Harriss, deputy police commissioner for traffic.

Fire-Alarm Boxes

The modern fire-alarm boxes throughout the city derive from an elaborate cast-iron 1914 design by the New York Fire Department and a committee of art experts, which included print collector and author of the *Iconography of Manhattan Island,* I. N. Phelps Stokes. The cast-iron boxes and lanterns painted red carried fire alarms to central units. Modernized alarm machinery is more compact, thus the smaller unit.

Hack Stand Posts

Another of the city's amenities has long ago disappeared—the hack stand posts of 1913. That year legislation designated certain locations as hack stands to pick up passengers. The Bureau of Licenses was required to erect signs identifying the hack stands, and the hack stand posts were designed by the Brooklyn firm of J. L. Mott Ironworks and the Baltimore Enamel and Novelty Company.

Drinking Fountains

Exotic lamps were often combined with drinking fountains. Some were enormous in scale and elaborate in design, featuring copies of famous neoclassical sculpture. Statues of Hebe by both Antonio Canova and Bertel Thorvaldsen soared eighteen feet six inches. For popular taste, there was G. Moretti's *Fireman,* a modest six feet three inches, with uniform. In addition to grand or famous sculpture, there were extraordinary ornamental bases with lamp pillars and brackets for electric lights.

Designs for drinking fountains for people and for animals were often accompanied by controversy, due largely to the appropriateness of design and materials. The Art Commission, founded in 1898 to approve any work of art to be placed on city property, for example, felt cast iron would be appropriate for one area and not for another, or a curved basin for animals would be a traffic hazard, and so on. Nonetheless, many striking designs

were approved, and some remarkable ones still exist. Two examples illustrate the riches lost and those restored.

A Memorial Fountain

The Livingston Fountain, designed in 1907 by noted architect Charles R. Lamb, was a memorial fountain fabricated for people, dogs, and horses, and it was handsomely (and electrically) illuminated.

Bronze dolphins rising from a large basin supported a small basin on the backs, and their noses held buckets for watering horses. Nozzle connections provided for hoses to spray the horses. Completed in 1908, the fountain was erected in Long Acre Square (now Times Square) at Broadway and Forty-seventh Street. In 1911 it was moved to Riverdale, and the fountain was probably destroyed when the Henry Hudson Parkway cut through the area in the 1930s.

Cherry Hill Fountain

The design for a lamp for Cherry Hill Fountain illustrates how the spirit of the creators of Central Park, Olmsted and Vaux, has been kept alive. Cherry Hill Fountain in Central Park was built for watering horses. It is located just west of the Mall and Bethesda Fountain on a high knoll overlooking the lake and the Ramble beyond to the north.

Cherry Hill Fountain, with the Dakota Apartments in the background.

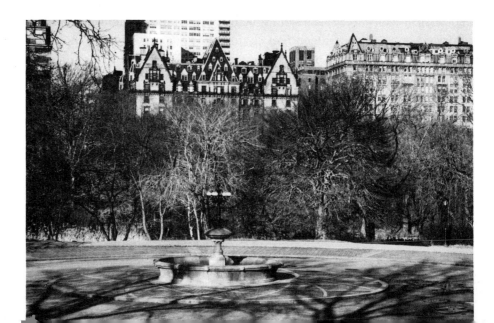

In designing the pavement around the fountain, architect Gerald Allen drew inspiration from Michelangelo's design for the Campidoglio, the plaza at the top of the Capitoline Hill in Rome. Michelangelo's ingenious device of elliptic paving that orients the visitor so successfully to an irregular space was adapted to the Cherry Hill restoration. As Michelangelo's elliptic paving carries the eyes around the plaza and over the façades of the enclosing buildings, so Allen's circular design focuses attention on the centerpiece—the fountain—and relates it to its park setting. The stone ribs spiral into the fountain in a design that repeats such surrounding natural forms as flowers and eddies of water. Travelers and art history buffs will recognize its reference to Michelangelo's Campidoglio. Cherry Hill's paving is not Michelangelo's travertine of Rome, but the gray granite and brown brick of the Bethesda Terrace, thus further tying it to its Central Park site.

The cast-iron lamp for the fountain was approved and planned, in the original design, but apparently never fabricated. That design was discovered in a Central Park commissioner's report of the 1860s, from which the architect was able to execute the design. A sensitive alarm system has been installed to protect the light fixture from vandalism.

Street Furniture at the Millennium

As we approach the millennium, the present administration plans to improve the street furniture in the city by redesigning the city's more than 3,000 bus shelters, more than 300 newsstands, and introducing several dozen public toilets, as well as litter baskets and public telephones. The administration would do well to look at New York City's rich repository of designs that graced the city streets in the nineteenth and early twentieth centuries. As this section of the book illustrates, New York City has traditionally drawn on its enormous range of talented professionals in the arts, crafts, and industry, who created street furniture that has not only beautified the city's streets and public spaces but also made them "user friendly."

CHAPTER 30

Public Lighting

Early Design

Two types of street lighting were experimented with in the early years of this century—arches and festoons spanning the streets and posts or standards along the curb. Posts won out to give the streets more of an open look, less like it is roofed over. A row of lights creates a rich sense of vista, lengthening the sense of perspective; arches and festoons shorten perspectives. And since light has always been the emblem of progress, culture, and morality, the critics reasoned, the lamppost should have an uplifting effect.

In line with the classical revival of the late nineteenth and early twentieth centuries, J. L. Mott, a major designer and supplier of ornamental cast-iron work, insisted that lampposts should have the character of fine architecture and monuments in the classical mode. Because the clarity in the detail of the motifs was essential to high quality, Mott claimed cast iron was the most suitable material for acanthus leaves, fluted shafts, and the like. Early experiments with wooden and sheet-iron lampposts were cheap-looking and shoddy. Cast iron affords a smooth surface in which the detail of a pattern can be faithfully preserved. The lamppost was not only to be a handsome carrier of light at night, Mott pointed out, but by day it should have an elegant architectural bearing, since it would be conspicuous. Mott

designed such a light pole in 1912 for major thoroughfares and commercial areas in Brooklyn: along Flatbush Avenue, Bedford Avenue, and Coney Island. The pole in front of the Brooklyn Museum by the Mott Ironworks is a variation of the approved pole.

It is noteworthy that some stems of nineteenth-century cast-iron lampposts existed until recently at the southwest corner of Broom and Mercer streets, the southwest corner of Grand and Greene streets, the northeast corner of Grand and Greene streets, the northwest corner of Mercer and Grand streets, the southeast corner of Mercer and Grand streets, and the southeast corner of Broome and Greene (was used as a traffic signal). Unfortunately, all have been replaced with modern poles. A shepherd's crook lamppost in front of 148–152 Mercer Street (east side between Prince and West Houston) has been altered. The stem remains in a deteriorated state, and a modern luminaire has been added.

Practical Aesthetics

Mott insisted that proper lighting was essential not only for safe and easy travel, but for the city's prosperity as well. Artistically lighted streets attract trade, which adds to real estate values, all of which contribute to making a prosperous city. The color of light and the light's diffusion were important. The light should be soft and enclosed in a globe of diffusing glass to hide the outline of the tungsten lamp, source of illumination.

In 1911 Mott published a catalog entitled *Good Street Lighting,* observing, "The electric light has revolutionized the modern city," lamenting the quality of public lighting, and admonishing that what electricity can do for advertising it can also do for the city as a whole. Mott also published a catalog entitled *Lamp Pillars,* which featured elegant fixtures alongside fantastic ones. The main periods in the history of art were represented, including Renaissance, medieval, classical, and Louis Quatorze.

The amount of light the fixture provides has always been essential. Empirical methods sometimes gave solutions. For example, in 1911 a light pole design was approved by the Art Commission only after a foot had been added to its height to increase the amount of light. Similarly, in 1981 the American Museum of Natural History replaced older lights surrounding its building with new lampposts that have a light over the sidewalk and another that extends over the street, which increases illumination for both automobile and pedestrian traffic.

Strozzi Lamp

The Strozzi lamp is in a class by itself. The name is taken from the Palazzo Strozzi in Florence, one of the great Florentine palaces (palazzi) of the Italian Renaissance to survive. Its great iron lamps, fashioned by Nicolò Grosso ("Caparra"), like those he made for the Palaze Gaudagni, were copied the world over and came to be known as Strozzi lamps. New York's most remarkable examples are those wrought by Samuel Yellin on the Federal Reserve Bank Building in lower Manhattan's financial district. The Strozzi lamp inspired those lamps that in early New York marked the residence of the mayor—and so were called mayors' lamps. Stanford White designed some of New York's most elegant mayors' lamps—in Gramercy Park, for example. Inherent in the successful design of a Strozzi lamp is its relationship to spectator from all vantage points, especially from multiple views as seen from below.

Advertising and Information

A shortage in street signs in 1902 led to the city's approval of an illuminated street sign box of blue glass with white letters to be affixed to light poles. The design was by J. T. Tubby, Jr., and noted architect Charles R. Lamb. The Electrical Reflector Company produced the boxes, which were replaced in 1912 because changes in the city's lighting system made them obsolete.

In the gaslight days, an unusually compact and attractive piece of street furniture was one in which a streetlight, letter box, and street sign were consolidated. The change from gas to electricity, however, made these old gas posts obsolete, and the Post Office Department, Con Edison, and the Art Commission could not agree on a new design until noted sculptor Charles Keck proposed a design the commission approved, only to have it rejected by the Post Office Department as too expensive to produce. The whole matter was eventually settled when the Post Office Department decided to keep the original letter box.

So-called advertising lighting produced another category of lamppost that has given way to modern fixtures. The poles, erected by merchants in front of their stores in the late nineteenth and early twentieth century, were owned, operated, and maintained by the individual merchants under a permit by the Department of Water Supply, Gas, and Electricity. The merchant benefited from a better-lighted store at night with his name brightly illuminated, and the city got better-lighted streets.

Central Park's New Lights

The Rebuilding of Central Park is a multimillion-dollar program that is designed not only to restore Central Park but to establish a maintenance program to assure the park's continued use and usability. The campaign involves restoring the park's street furniture, which includes lighting. More than one thousand new halide streetlamps, for example, have been produced and installed from designs by architect Gerald Allen and designer Kent Bloomer. Although less ornate than Calvert Vaux's original design of 1872, Allen and Bloomer's curvilinear design captures Vaux's spirit. The new lamps are replacing those designed in 1910 by architect Henry Bacon, who is best remembered as the architect of the Lincoln Memorial in Washington, D.C., even though he also designed subway signs and kiosks that still stand in New York City. Few of Bacon's lamps survive. Over the years, as the lamps were broken, the sturdiest and most economical lighting replaced the old, and no standard design governed their replacement. With the rebuilding program's emphasis on appropriate aesthetics, one of the jobs is to replace the luminaires (the top part) with an appropriate design compatible with Bacon's original base (the post or bottom part, which is being retained) and one that embodies the latest technology, allowing maximum illumination most economically.

Allen and Bloomer's design for the new luminaire are installed above

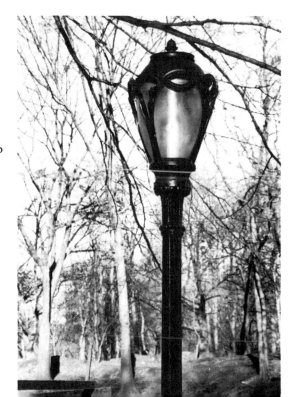

Central Park's new streetlamp fixture.

Bacon's earlier posts; it blends with Bacon's classical design. The metal halide lights with ellipsoidal lenses of textured, clear plastic designed by Howard Brandston replaces Bacon's mercury vapor ones and are not only brighter but cast a wider diffusion of light with no glare. By eliminating lights in obscure places in the park not suitable for night use, the lamps can be more efficiently relocated and the total number of lights reduced to approximately one thousand.

ACTIVITY BRINGS LIGHT

Olmsted and Vaux's lighting design did not encourage nighttime visitors, but with the advent of electricity Central Park was more fully lighted. During the John V. Lindsay administration in recent history, nighttime events in the park became numerous, requiring more illumination. A growing contingent of park users believes that greater nighttime use will drive out the unsavory element that populates the park at night and make it safe for all people to enjoy.

For the new Central Park lights, Allen and Bloomer's task was to design a housing to surround Brandston's lens that would fit in with and complement Olmsted and Vaux's aesthetic that all of the interrelationships in the park are meant to be contemplated "down to the shape of a twig or the veins of a leaf."

A LIFE OF ITS OWN

The designers took their cue from Bacon's lamppost, which was inspired by the public streetlamp of the day. Instead of using classical motifs from ancient Greece and Rome as in the streetlamps, however, Bacon used organic forms appropriate to the park—leaves, buds, and seeds. And he designed them so that the forms seemed to grow out of each other. It was that botanical analogy that guided Kent Bloomer and Gerald Allen in the new design.

How to create a housing that would be at once sufficiently protective and aesthetically appropriate was, then, the challenge for the designers. Bloomer and Allen designed a collar of leaves as a transition from the post to the luminaire that repeated in reverse Bacon's design of leaves on the base of the lamp. From this collar springs the frame that holds the lens. The frame is composed of four elliptic hoops repeating the molding of the pole. Leaves climbing the sides of the hoops soften the line and continue the growing motif. The hoops are united by a serpentine molding and capped by a domed crown that is adorned with an acorn finial, a motif appropriate to the park and one that has been used in New York since the Federal

period. Acorns can still be found on the iron fences of some of the city's 1820s row houses.

The aim of the design was not simply to re-create Bacon's design, but to create a design that was in keeping with the spirit of Olmsted and Vaux and would convey that spirit to the park visitor today, while providing the best and most economical lighting. Thus the analogy of a growing thing. Allen and Bloomer's design further achieves that end by providing each visitor with his or her own sense of discovery while walking through the park as they pass by or around the lamp. As the spectator circles the lamp, the elliptic hoops that hold the lens appear to open and close like a flower in a time-lapse movie and present different views of the luminaire like a series of cubist still lifes. As the architects have pointed out, their design complements Olmsted and Vaux's spirit in today's visual language, a language of time-lapse photography and cubism that did not exist in Olmsted and Vaux's day.

CHAPTER 31

Clocks

Street Clocks

A close kin of the advertising lighting pole is the street clock or sidewalk clock, a cast-iron pole twelve to fourteen feet high supporting a double-faced round clock whose face is from twenty-four inches to forty-eight inches in diameter with the name of the store or business in front of which it stood. They were usually ten inches deep to accommodate the clockworks.

The popular use of these clocks began in the 1860s and grew with the advent of electricity in the 1880s. They were common features on the sidewalks of New York in the 1920s; then, with the Great Depression, sales declined until the once common street clock was almost extinct. Only a handful survived into the 1980s, which saw a surprising renascence of the street clock.

The sidewalk clock is a more complex piece of furniture than the advertising light pole. It was produced through the cooperative technologies of the clockmaker and ironmaster, and it was sold through catalogs. The leading clock manufacturers of the nineteenth century were the Seth Thomas Company and the E. Howard Clock Company. One of the most successful collaborations in America, which produced scores of these sidewalk clocks, was the team of Howard and Lynch. They created hundreds of the clocks for the five boroughs of New York City. Kenneth Lynch and

Sons of Wilton, Connecticut, have continued the tradition, and they have been contributors to the recent renascence of the sidewalk clock in New York, which can be dated to 1981, when the New York City Landmarks Preservation Commission designated eight of New York City's few surviving clocks official landmarks.

Three of those eight clocks are in Queens. The Dental-Medical Clock at 36–34 Main Street, Flushing, was installed c. 1920, by Henry B. Conovitz, jeweler. The face still bears the word "jeweler," but the new designations, "Dental-Medical" and "Building," obscure the clock except for the face and base. Moreover, the fluting of the shaft is obscured by the signs, and the sign and its letters are incompatible with the style of the clock.

The clock at 161–11 Jamaica Avenue, probably installed by Busch's Jewelers, is a typical double-faced sidewalk clock with paneled base, fluted column post, and splendid acroteria. The words "Tad's Steaks" have been added in neon and are incompatible with the clock design in style, scale, and taste.

The Wagner's Jewelers clock at 30–78 Steinway Street was erected by that concern in 1922 and has a typical beveled base and fluted column topped by scrolls, supporting a double-faced dial, and crowned by a contemporary sign. Purchased secondhand by Edward Wagner, owner of the store, it was transported from Manhattan to its present site.

Brooklyn's only surviving sidewalk clock to become a landmark is the Bomelstein's Jewelers clock at 735 Manhattan Avenue in Greenpoint. It is typical in design, composed of a rectangular, beveled base, fluted column, and double-sided face. Part of the clock surround has been obscured by a sign.

A handsome, classically designed clock in Manhattan is at Fifty-ninth Street and Fifth Avenue in front of the Sherry-Netherland Hotel. This clock was manufactured by the E. Howard Clock Company and may have been installed in 1927, when the hotel was built. A high, rectangular beveled base with gilded panels supports the slender, fluted column and large, double-faced dial set over small scrolls.

The Howard Clock at 1501 Third Avenue near Eighty-fifth Street in front of the Reimann and Bresse furniture store dates from the 1880s. The store was occupied by a pawnbroker for many years, and the clock was probably installed as an advertisement for that business. With its paneled base, fluted column, and scroll top, this clock is almost identical with the Sherry-Netherland clock. The dial, however, is crowned by a giant stem and watch fob ring, creating the illusion of an oversize pocket watch. Above the fob are three arms that once supported golden balls, symbol of the pawnbroker. This clock was to be restored in 1985, when it mysteriously

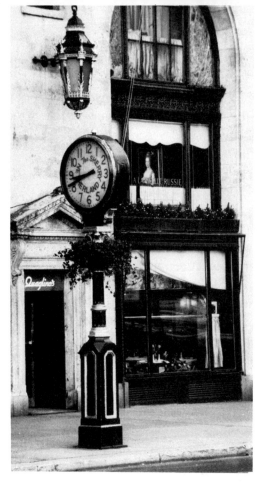

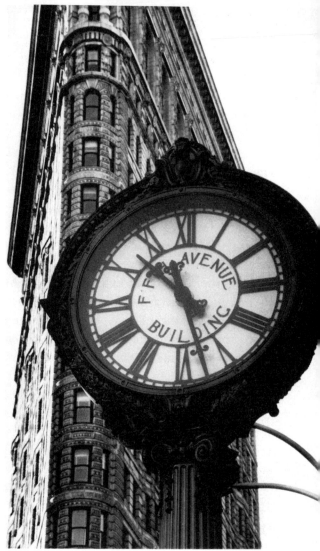

Above: Sidewalk clock at East Fifty-ninth Street and Fifth Avenue in Manhattan. *Right:* And at 200 Fifth Avenue.

disappeared. Located in Long Island a short time after its disappearance, the clock was returned and the planned restoration carried out by restorer Lou Agrusa. The cast-iron base and pole were stripped of their paint and refinished. Its hammered copper crown was also stripped, and it was then gilded. New wood hands (the originals were lost) were made, the clock face was restored, and the glass was replaced.

Soon after the story of the missing clock was told in *The New York Times,* Seiko Corporation installed a sidewalk clock at Fifth Avenue and Fifty-seventh Street. It has a solar quartz mechanism, and the company has donated similar street clocks to locations in Hawaii, Tucson, and Chicago.

The clock in front of 200 Fifth Avenue between Twenty-third and Twenty-fourth streets was installed c. 1909, when the building was erected. Originally called the Fifth Avenue Building, replacing the old and elegant Fifth Avenue Hotel, it housed fashionable stores and a bank on the first floor. The double-faced clock with "Fifth Avenue Building" still on its dial

was a stylish advertisement and replaced an earlier timepiece installed by the hotel. One of the most ornate of New York's cast-iron street clocks, it is composed of a rectangular, classically ornamented base and fluted Ionic column with Scammozzi capital. The two dials with Roman numerals are framed by wreaths of oak leaves and crowned by a cartouche. Manufactured by Hecla Iron Works, the base and capital are of the same height, and the shaft is equal to the sum of both.

The double-faced clock at 522 Fifth Avenue near the southwest corner of Forty-fourth Street in front of the Morgan Guaranty Trust Company was manufactured in 1907 by the Seth Thomas Company. A stately nineteen feet tall, it originally stood in front of the American Trust Company at the southwest corner of Fifth Avenue and Forty-third Street. When that bank merged with the Guaranty Trust Company in the 1930s, the clock was moved to its present location. The clock faces rest on foliate scroll brackets atop a fluted post and base decorated with classically inspired ornament. The dials have Roman numerals, and they are rimmed by an acanthus-leaf molding and crowned by an ornate pineapple motif.

In 1983 octogenarian Kenneth Lynch, who still runs his company, produced the sixteen-foot clock in front of Tishman-Speyer at Fifty-third Street and Madison Avenue in Manhattan. The design is a Rolex wristwatch enlarged to monumental scale. Rolex designed the battery-run clock works, Lynch the housing for it. In 1984 Quennell-Rothschild Associates, landscape architects, commissioned Lynch to produce the street clock that stands in front of the Saratoga apartment house at 330 East Seventy-fifth Street.

Kenneth Lynch's father, who came from Ireland, established a connection with the E. Howard Clock Company in the 1870s. Howard made the movements, Lynch the cases. Lynch has continued making these clocks and supplies them throughout the United States and Canada. While Lynch's designs have not changed, he now uses Plexiglas instead of glass for the clock faces, and the clocks have modern setting devices.

From Early Times

Public clocks in New York City go back to colonial times. In 1716 clockmaker Joseph Phillips made a clock for the town hall, the site of today's Federal Hall at Wall and Nassau streets. The clock was a gift of Assemblyman Stephen de Lancey, who gave his £50-a-year salary to pay for it. So prized a possession was it that John Wright, a watchmaker, was paid

£3 (later raised to £10) a year to maintain the clock. He serviced the clock for sixteen years until June 29, 1734, when for no explained reason there is no more record of the clock.

David Lockwood designed a musical clock in 1742, which played the "Chaucer airs and opera" and which had been demonstrated for the king of England, and Richard Breckell produced a clock that animated an entire cast of characters in a play, colonial progenitors of the popular Delacorte clock in Central Park.

Subscribers of the Merchants' Exchange commissioned a large clock for the Exchange Building at their own expense. By the early nineteenth century church steeples had clocks, and the city helped to finance them and even had a superintendent of public clocks who was responsible for maintaining and regulating the church clocks.

When the new City Hall was built in 1811, provision was made for a public clock in the center of the attic story. By 1829 the plan had been altered to incorporate an octagonal section beneath the cupola with four dials facing north, south, east, and west. The clock faces by B. & S. Demilt were glass and illuminated to light the cupola, thereby enhancing John Dixey's statue of Justice standing on top.

On the night of August 18, 1858, during the fireworks on the roof of City Hall celebrating the laying of the Atlantic cable, fire broke out and destroyed the cupola and the clock along with it. The clock was replaced by Sherry and Byram clockmakers on December 11, 1859.

The Clock as Monument

Minerva and the Bell Ringers

The Bell Ringers Clock, as it is called, in Herald Square is an ongoing tribute to James Gordon Bennett, whose passion for wisdom and work inspired this monument. The monument is an extension of his private collection of owls and old charts and maps, which reflected his belief in the ultimate wisdom of better understanding of all nations by all nations. He thus carried on the tradition of his pioneering father, James Gordon Bennett, who founded the *New York Herald* in 1835.

The elder Bennett was born in Scotland and came to America at the age of twenty-four. Eight years later, having taught school and worked at various newspaper chores, he became a Washington correspondent for the *New York Enquirer.* After two unsuccessful attempts to launch his own

one-cent daily newspaper, in 1835 he founded the *Herald,* which operated out of a rented cellar on Wall Street. Except for setting type, he was a one-man business and editorial staff and the paper's sole reporter. The *Herald* expanded until during the Civil War it employed sixty-three war correspondents, though even then its founder continued to write and edit a sizable portion of the paper. Bennett pioneered the use of pictures, extended news coverage to include politics, business, sports, society, fashion, church, sex, conventions, and crime, and was the first to fully implement telegraphed stories. Young Bennett, born in New York City and named after his father, succeeded him as publisher and is credited with making the *Herald* one of the world's great newspapers. He founded the English-language Paris *Herald* for Americans traveling abroad. In 1869 he dispatched correspondent Henry Stanley to Africa to begin what was to become a spectacular two-year search for the missing missionary Dr. Livingstone. Bennett contributed to George Washington De Long's historic

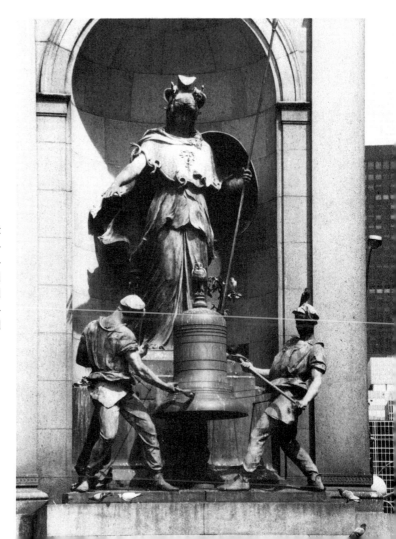

Minerva, with her ever-present owl, surveys her two blacksmiths tolling the hour at Herald Square. This group stood atop McKim, Mead, and White's Herald Building nearby until the building was razed in 1921.

arctic expedition, which provided essential research into polar drift, he encouraged Marconi, and he supported international sports programs.

THE "DIGNITY OF WORK"

Bennett's fifty-foot-high monument set within a colossal granite niche at Herald Square consists of a great bronze sculpture group consisting of Minerva, goddess of wisdom and invention, bearing a spear and shield, with serpents entwined around her arms and breastplate. The goddess's ubiquitous owl is perched on top of a large bell. She oversees two muscular blacksmiths, naked to the waist, who swing great sledgehammers to ring the bell on the hour every hour. The sturdy smiths represented for Bennett the "stalwart dignity of work." That work is a wise and beautiful pursuit is conveyed through the beautiful Minerva, who presides over the work of the blacksmiths.

The bronze group is grandly framed by two colossal pilasters and stands on a granite base ten feet above Herald Square. Above the niche a simple granite housing shelters a double-faced clock. On either side of the five-foot illuminated dial, facing outward, two green-eyed bronze owls are provided with an internal lighting system so that they blink continually—eighteen times a minute (that is, when the mechanism functions).

On the south face of the ten-foot-high granite base, a brief history of the monument is incised. The small bronze door on the north side of the granite base provides access to the interior of the monument for maintenance.

A CROWN FOR WHITE'S DESIGN

When the clock was installed, it was wound each week by hand—240 turns took the attendant almost three hours to wind. Now the clock is automatic, but it must be set each week. Close examination reveals that the sledgehammers of the blacksmiths do not actually hit the bell—they stop about three inches short of the surface. A ringing device hits the bell from the inside. Precise synchronization, however, gives the illusion that the strike is made by the sledgehammers wielded by the great lifelike bronze blacksmiths. *Minerva and the Bell Ringers* was a commission given by Bennett to sculptor Jean Antonin Carles, in Paris, who made the model and supervised its casting in bronze there in 1894. Bennett had it made to crown the main façade of the Renaissance revival building designed in 1893 by his friend architect Stanford White. The building, which housed Bennett's newspaper, stood on the triangle directly north of the monument's present location. For twenty-six years many New Yorkers set their watches by the blows of Scuff and Guff, as they were nicknamed (other popular names included

Gog and Mgog and Alpha and Omega). Then, in 1921, White's building was razed to make way for a modern but nondescript four-story office building. The sculpture group became the property of William T. Dewart, president and publisher of *The Sun.* Because the sculpture was symbolic of the old *Herald,* Dewart felt an appropriate, and permanent, civic site should be found for it as a tribute to Bennett. He was unable to raise sufficient funds for his plan, but in 1928 a place at New York University was found for the sculpture in the distinguished James Arthur Collection of time-pieces, where it remained until 1940. That year it was returned to Herald Square.

RELOCATION

The sculpture became part of a rehabilitation of the hourglass intersection of Broadway and the Avenue of the Americas (in 1945) between Thirty-second and Thirty-fifth streets, Herald and Greeley squares. The squares were redesigned by architect Aymar Embury II, who also designed recreation areas for the city in Harlem, Brooklyn, Staten Island, and the Bronx, as well as two of the city's great bridges—the Triborough and the Bronx-Whitestone—and numerous private residences. Embury's design for Herald Square was carried out by the WPA.

The Horace Greeley statue of 1890 by Alexander Doyle was placed

William Earl Dodge by J.Q.A. Ward once stood at Herald Square in front of the old building. The figure was part of a complex that included a fountain, a reference to his active participation in the temperance movement. The statue now stands in Bryant Park.

at the south end of Greeley Square facing north and framed by four hawthorn trees. The old Herald Square, bounded by Sixth Avenue and Broadway and Thirty-fifth Street, was enlarged on the Sixth Avenue and Broadway sides to provide an adequate setting for the new fifty-foot-high granite monument housing *Minerva and the Bell Ringers.* They are at the north end of the square on the spot previously occupied by the statue of William Earl Dodge by J.Q.A. Ward, which is now in Bryant Park behind the New York Public Library. The monument looks south so the Bell Ringers and the Greeley statue face each other and serve as focal nodes for the hourglass shape of the intersection.

The restoration of the old Herald Square clock and the Bell Ringers was financed by neighborhood businessmen, and an unveiling ceremony was held on November 19, 1940, at the end of the working day from 5:45 to 6:00 P.M. Two thousand people crowded to listen as civic leaders spoke, and Mayor La Guardia pulled the chord that dropped the flag from the monument just as the Bell Ringers struck their first blow in nineteen years.

ON LOAN TO PARKS

Although the clock belongs to New York University, it was placed on indefinite loan to the Parks Department of the city of New York on February 27, 1939. NYU stipulated that *Minerva and the Bell Ringers* will remain installed in the park as long as the site remains a park, and that the city must provide whatever maintenance is necessary to keep the sculpture and the structure in good condition and to keep the clock working properly.

In 1983 a consortium of businesses in the neighborhood financed cleaning the monument, repairing the clock, and landscaping the park grounds. Without a perpetual maintenance program supervised by specialists the clock works are in jeopardy and the bronze sculpture and stonework are threatened by pollutants in the atmosphere, and by destructive cleaning practices.

Carl Milles and the Clock as Fable

In the main lobby of 1 Rockefeller Plaza, a kind of modern cuckoo clock signals each hour with song. Nelson Rockefeller thought this clock was the finest piece of art in the center's art program. Installed in three parts along the broadly concave plaster wall, Carl Milles's relief is carved in pressed northern Michigan pine and features a man on horseback, a tiny

bird, and two curious figures to the left and right. The rider pauses in the forest to listen to the exquisite song of a nightingale perched in a nearby tree. Legend maintains the nightingale's song to be the most beautiful of any bird. On the hour, every hour, from 8:00 A.M. to 6:00 P.M., the bird sings for two minutes, to the delight of tenants and visitors alike. The tones are actually of a clarino, or Mexican thrush, which was owned by Fairfield Osborn, president of the New York Zoological Society, when the sculpture was installed. The song was recorded in Mr. Osborn's home by NBC sound specialists. As the clarino sings, it flutters its wings and opens its beak. The bird is covered with silver leaf, a process similar to gilding, so when animated it is highly visible against the subdued wood surfaces of the rest of the figures in the relief. The sculpture was hailed as the first work of art to introduce sound and motion in permanent decoration in an American building.

Milles left the wood unpainted and unvarnished in the woodworking tradition of Bavaria, the Tyrol, and Switzerland, which he so loved, and it is allowed to darken with age. Milles designed the piece to be lighted from the left, as if the sun were shining on it. The sculpture then makes a long, beautiful shadow on the wall and establishes the direction of movement he wanted in the relief. When Milles visited the sculpture in April 1948 and discovered that additional lighting from the right had spoiled the proper effect of the sculpture, he notified Hugh Robertson, executive manager of Rockefeller Center, who immediately had the lighting corrected. Unfortunately, a later lighting system once again prevents the piece from being seen properly.

Beauty and ugliness are personified as a nymph and satyr on either side of the rider. The nymph moves toward the song, the satyr recoils from it. The scene animates the admonition of German writer Johann Gottfried Seume (1763–1810): "Where song is, pause and listen; evil people have no song." This was one of Milles's favorite passages and one that had particular meaning for the period in which Rockefeller Center was being built and the sculpture was being installed—the Great Depression and World War II.

Symbol for All Time

At the unveiling ceremony on February 5, 1941, Henry R. Luce, head of *Time, Life,* and *Fortune* magazines, related Milles's piece to the spiritual and material needs of the time. Ten years ago on this site, he noted, there were shabby, four-story brownstone houses. "I remember that there was

nothing here but stagnation and decay before, but that men came here with a vision and built with courage at a time when half the world had lost its courage and the vision was gone.

"It is thus doubly appropriate that we are met here today to honor a great artist of our age, to dedicate his work here—in this center of American communications. It is doubly significant that here on this continent—with half a world in darkness and ourselves girding to defend our way of life, so innocently happy a figure as that of Mr. Milles's forest rider should be brought into being—to typify that dream of beauty without which man's bread is dust."

Cranbrook's Blend of Art, Craft, and Modernism

Milles executed this work where he taught sculpture—at the Cranbrook Academy in Bloomfield Hills, Michigan, a suburb of Detroit. Cranbrook is sometimes called the American Bauhaus. Founded in 1924 by Detroit newspaper magnates George Booth and Ellen Scripps Booth, it was developed as an art colony by Finnish architect Eliel Saarinen. Cranbrook derives in part from the Arts and Crafts Movement originated in England in the mid-nineteenth century in the establishment of schools to reform industrial design by better relating art to everyday life.

The structure of the academy was loosely modeled on the American Academy in Rome. Cranbrook was conceived as a place where students would learn by working in ateliers with master artists, who were encouraged to pursue their own ideas.

Saarinen's ideas and training were rooted in both the arts and crafts movement at the turn of the century and the modern movement. Although interested in the industrial arts and mass production, he was attached to the craft tradition, so he was always attentive to detail, materials, and excellent craftsmanship and execution of design. Saarinen was primarily interested in the totality of design—everything should be integrated within the whole, and architecture was the mother art that established the order within which the other arts had their place. The Cranbrook Academy was a vital forum from its founding in 1924 until 1950, when it lapsed following the deaths of Saarinen and Booth.

Some of the better-known students of the academy are Ray and Charles Eames, architects and designers; Florence Knoll, interior designer; Harry Bentoia, sculptor and designer; and Saarinen's illustrious son, Eero, who pioneered Cor-Ten steel and gave the twentieth century some of its

outstanding architecture in the Dulles International Airport in Washington and the CBS tower in New York City.

Milles almost did a clock for the lobby of the RCA Building, which would have been the principal lobby decoration. The centerpiece of Milles's design was a clock face flanked by allegorical figures in bronze. The ensemble was to be set against a black marble background with a sculpted glass figural relief lighted from within. This proposal would have required additional structural reinforcing because of its enormous weight and was, therefore, rejected. Milles's clock as the central motif in the lobby of the RCA Building, however, was appropriate, because material and spiritual progress set within the measure of time and space, which the clock would epitomize, was at the heart of the Rockefeller Center art program.

The Cultivation of Soul and Mind

Dr. George Vincent and Professor M. I. Pupin (Columbia University's Pupin Hall was named for him) formulated the ideas with J. D. Rockefeller for the artistic themes of Rockefeller Center. They argued that the creative power of our civilization is the offspring of the power age, which began with James Watt's steam engine, patented in 1769. They further reasoned that the power age's conquest of geographical frontiers had had a vital effect on the growth and shaping of American civilization. Now, they concluded, the new frontiers were within one's spirit. The cultivation of the soul and mind would be accomplished by broadening and deepening one's relation with one's fellow humans in common endeavor. In order to achieve this cultivation, one must have a fuller comprehension of the meaning and mystery of life and the eternal forces behind it, to foster with new insight the territory within oneself. This was the real significance of today's civilization, the spiritual essence of life. The new frontier, then, was human relations as expressed in capital and labor, medical science, general science, education, international relations, travel, and communications.

The art program for Rockefeller Center should present an artistic entity, unified and comprehensive, which could be read and understood by the great masses of reasonably intelligent people. It should depict in graphic symbols the present mental and spiritual interest and aspirations of the American people. The art should interpret American civilization at the moment—what the country has gone through and where it is going, physically, mentally, and spiritually.

While Milles's clock invites the contemplation of beauty, for example,

Lee Lawrie's *Atlas,* in front of the International Building on Fifth Avenue facing Saint Patrick's Cathedral, holds a giant armillary. The object of the sculpture is to show the earth's path around the sun, the change of the earth's axis on its orbit, and the equinoxes—that cosmic processes affect and influence all the peoples of the earth.

Lee Lawrie's colossal bronze monument to the intellectual and scientific frontiers of the mind and Carl Milles's intimate monument to man's contemplation of beauty provided the public, in an age of depression, with an optimistic vision of the world and a dream for the future. The need of a dream for man's ultimate survival is expressed in Eugene O'Neill's words, "It's the dream that keeps man fighting, willing to live," which are inscribed on the O'Neill medal awarded each year for outstanding artistic achievement.

AT&T and the Clock as a New York Tradition

Two major time centers in early New York were located on the site of AT&T's former headquarters at 195 Broadway. One was the old Western Union Building by George B. Post of 1873–75, and the other was Benedict's Jewelers. Precisely at noon every day, a great "time ball" was lowered from atop the Western Union Building. Controlled by a signal from the Naval Observatory in Washington, D.C., it was *the* correct time by which many New Yorkers in downtown Manhattan set their watches. Next door, Benedict Brothers Jewelers displayed a clock in their window with the correct time, known as "Benedict's time" from the early nineteenth century, when Benedict Brothers Jewelers had a store at the juncture of William and Wall streets. That location was also the terminus of one of New York City's stage lines. On its northbound trips, the stage line schedule ran according to the clock in Benedict Brothers' window. Benedict's time was synonymous with accurate time and even dependability ("He's as dependable as Benedict's time").

When Benedict Brothers went out of business in 1939, AT&T razed the old store and built an extension of 195 Broadway on the site. Then, in a ceremony on November 9, 1939, AT&T opened a new precision clock in their window on the spot where "Benedict's time" had been displayed before. AT&T president Walter S. Grifford announced the telephone company's great pleasure in maintaining an old New York tradition. He was especially pleased that the continuance of this correct time center would be associated with the public service traditions of the telephone company.

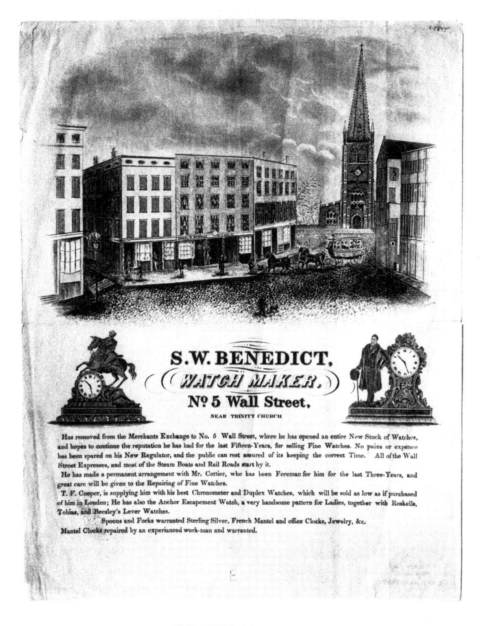

S.W. BENEDICT,

WATCH MAKER,

Nº 5 Wall Street,

NEAR TRINITY CHURCH

Has removed from the Merchants Exchange to No. 5 Wall Street, where he has opened an entire New Stock of Watches, and hopes to continue the reputation he has had for the last Fifteen-Years, for selling Fine Watches. No pains or expence has been spared on his New Regulator, and the public can rest assured of its keeping the correct Time. All of the Wall Street Expresses, and most of the Steam Boats and Rail Roads start by it.

He has made a permanent arrangement with Mr. Cottier, who has been Foreman for him for the last Three-Years, and great care will be given to the Repairing of Fine Watches.

T. F. Cooper, is supplying him with his best Chronometer and Duplex Watches, which will be sold as low as if purchased of him in London; He has also the Anchor Escapement Watch, a very handsome pattern for Ladies, together with Roskells, Tobias, and Beesley's Lever Watches.

Spoons and Forks warranted Sterling Silver, French Mantel and office Clocks, Jewelry, &c. Mantel Clocks repaired by an experianced work-man and warranted.

Generations of New Yorkers in the nineteenth century ran on ''Benedict's time.''

Now that AT&T has moved uptown, the clock unfortunately has disappeared and with it another New York tradition.

The Clock with Nursery Rhymes

Above the arched walkway leading from the seal pool and the Arsenal at Sixty-fourth Street and Fifth Avenue, south of the children's zoo, is the Delacorte animated clock tower unveiled on June 24, 1965. At the top of the clock tower two monkeys strike a great bell with large hammers to sound the hours of the day. Beneath a canopy below, six bronze animals revolve around the tower, each one rotating on its own axis to give the appearance of a group of dancing animals. The bronze figures were created by Italian sculptor Andrea Spadini and were cast in Rome.

On the north and south sides of the tower are circular clock faces. Three separate mechanisms drive the monkeys striking the bell, the platform that carries the animals around the tower, and each one of the animals rotating on its own axis. A heating system keeps the mechanism from freezing during winter so that the clock is operative the year round. The movements of each component are synchronized with the Schulmerich Carillons electric bell system. The Schulmerich system uses a generator that produces an inaudible tone, which is magnified a million times to create a peal that simulates that of an actual bell. The peal that Schulmerich Carillons of Sellersville, Pennsylvania, created for the Delacorte clock simulates the chimes of Westminster in England. The mechanisms for the sound and movement systems, which were updated in 1969, are housed in the clock tower and in the lion and monkey houses.

Each hour the monkeys tell the time, and each half hour the animals move around the clock and play children's songs. Their repertoire consists of thirty-two different melodies, such as "Three Blind Mice," "Ding Ding Bell," and "Hickory, Dickory, Dock," so that no single melody is repeated during a twenty-four-hour period. The complex was designed by Fernando Texidor, and the architect was Edward Coe Embury.

Time Through the Eyes of the Child

Fernando Texidor also designed the *Alice in Wonderland* in Central Park that George Delacorte donated in memory of his wife, the former

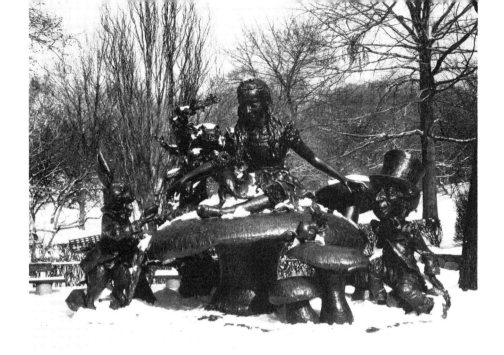

A latecomer to Central Park, José de Creeft's *Alice in Wonderland* has become one of Central Park's main attractions.

The Mad Hatter is shown at the equally mad tea party.

Margarita Von Doenhoff, who died in 1957. The landscape design for the setting is the work of Hideo Sasaki and Associates, and the sculpture was created by José de Creeft, a fitting monument to the world of the child where time stands still.

De Creeft has modeled the figures of Alice, the Mad Hatter, the March Hare, and the Cheshire Cat in the mad tea party scene from *Alice's*

Nearby, *Hans Christian Andersen* by Georg Lober reads the "Ugly Duckling." *Below:* Detail of *Andersen*.

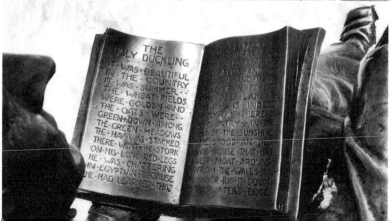

Adventures in Wonderland by Charles L. Dodgson, the mathematician and clergyman better known as Lewis Carroll, who wrote the piece for the daughter of a friend.

The sculpture is eleven feet high and sixteen feet in diameter. Landscape architect Hideo Sasaki has placed the sculpture group on a circular base several inches above the surrounding walkway and sitting area, making the sculpture and site inviting and accessible and enabling children to climb on the sculpture. The shiny finish of the bronze testifies to the many youngsters who accept the invitation to approach and play. Greenery surrounds the enclave, whose broad and low stairs open easily onto the promenade around Conservatory Pond. The Dormouse is perched on his mushroom, the White Rabbit and the Mad Hatter sit on rocks, and the Cheshire Cat, the Lizard, and the Caterpillar sit on a tree trunk. A short walk westerly takes the stroller to the Hans Christian Andersen monument by Georg Lober, where fairy tales are told when the weather permits.

EPILOGUE

Timeless Values Preserved and Celebrated

This book opens with a discussion of gravestones, a sculptural form that celebrates eternal life, thereby providing the living with a way to deal with the separation and isolation connected with death. It closes with sculpture about fairy tales, an art form that, among other things, deals with the desperate emotions of loneliness and isolation the child feels about death.

More broadly, as Bruno Bettelheim has demonstrated through his writings and his pioneering work with both disturbed and healthy children, fairy tales reveal the deeper meaning of life to a child. In terms he or she can understand, the child is confronted directly with the inner conflicts produced by infant fantasies, primordial drives, and violent emotions. In fairy tales, psychologists explain, the child learns to face the often-repressed problems of being human, and through fairy tales he or she learns how to make coherent sense out of the bewildering turmoil within the unconscious.

When fairy tales inspire public sculpture, they provide artist, patron, and public alike with yet another opportunity to preserve and celebrate the timeless values that are the common denominator of New York City's many monuments and masterpieces.

Glossary

Armature. An interior framework or skeleton that supports a model or a finished sculpture.

Atelier. French word for "studio," refers to an artist's studio where models and instruction were available.

Base. The bottom part of a sculpture that supports the piece.

Beaux-Arts. Literally "Fine Arts," from the Ecole des Beaux-Arts (School of Fine Arts) in Paris, the term describes a style of architecture, sculpture, and decoration that was taught there and that derived from classical, Renaissance, and baroque sources.

Bronze. An alloy of copper and other metals such as tin, lead, and zinc.

Cartouche. An ornamental panel in the form of a scroll, paper, or parchment, usually inscribed.

Caryatid. A sculptured female figure that is an architectural support. A male figure as an architectural support is an atlas (*plural,* atlantes).

Cast. To give material a particular shape by pouring it into a mold and allowing it to harden; that which is produced by the process.

Contrapposto. Italian word to describe the asymmetrical composition of the human figure in motion; developed by the ancient Greeks. Anatomical elements are counterpoised around a central axis.

Corbel. A projecting block to support a beam or other horizontal member. Corbels are often carved with decoration or with symbols or figures (historiated).

Faience. Earthenware decorated with opaque, colored glazes and associated with Faenza, Italy; hence the word.

Finial. A terminating or capping ornament.

Finishing. Removal and repair of seams and flaws in casting; treatment and decoration of the surface of the cast with tools such as chisels and files.

Frieze. The decorated band beneath the cornice, or any continuous band of sculptural or painted decoration.

Gable. A triangular area created by a cornice below and raking cornices above. *See* **pediment.**

Gilding. Covering a surface with gold leaf.

Glazed. Furnished or fitted with glass.

Lost-wax process (*cire-perdue* process). A process of casting in which the surface of the original model is reproduced in a thin coat of wax. The wax is melted (lost) and replaced with molten bronze, usually, producing the bronze cast.

Lunette. A semicircular surface or opening; found beneath a vault or above a window or door; common in medieval churches, in which the form is called a tympanum.

Maquette *(Fr.)* or **bozzetto** *(It.).* A sketch model usually in clay, wax, or plaster.

Molding (moulding). In architecture a continuous, contoured surface in various recessed and projecting profiles to create decorative effects by the play of light and shadow.

Patina. The surface coating derived from the chemical action of metal and its atmosphere; the color or finish that results.

Pattern book. Books of architectural, sculptural, and decorative plans and motifs that served as models or patterns for artists, builders, and architects.

Pedestal. An architectural support for a sculpture.

Pediment. In classical architecture a low-pitched gable above a portico framed by a cornice below and two raking cornices above, usually carrying sculpture.

Plaster cast. A subject or object cast in plaster (busts, figures, and anatomical details were most common in the nineteenth century) from an original work in clay and usually intended as the model from which to produce a marble replica.

Plinth. A square or rectangular block serving as a base or used to support a plaque.

Pointing machine. A mechanical device by which points are transferred from a plaster model to a block of marble with absolute accuracy in order to replicate the plaster model in marble.

Portico. A porch with columns and pediment.

Relief. Sculpture in which the forms are relieved above or below a surrounding surface, as opposed to freestanding sculpture or sculpture in the round. Low and high relief advance above the surface toward the viewer; sunken relief retreats below the surface away from the spectator.

Rustication. Masonry composed of large blocks with beveled edges to emphasize the joints.

Schiacciato (stiacciato) *(It.).* Very low relief in which the images appear to be scratched into the surface.

Sculpture. One of the three major arts (sculpture, painting, architecture) that

consists of creating form in three dimensions, either in the round or in relief (*see* **relief** and **schiacciato**). Sculpture is conceived in two modes: carving (glyptic) and modeling. Carving is a subtractive process in which material is removed to reveal form. Modeling is an additive process in which plastic material is shaped to create form.

Spandrel. The triangular surface between two arches or between an arch and a pier and usually decorated with relief sculpture; also, the wall panel beneath a windowsill extending to the top of the window of the story below.

Wrought iron. Iron that is hammered into shape by hand in contrast to iron cast in molds (cast iron).

Bibliography

Adams, Adeline. "The Memorial Tablet." *The American Magazine of Art* 10, no. 7 (May 1919): 262–68.

Adams, Herbert. "Karl Bitter: Sculptor." *Art and Progress* 6, no. 9 (July 1915): 305–6.

———. "Relation of Sculpture to Parks and Buildings." *The Monumental News* 25 (1913): 120–21.

Adams, W. S. "The Return to Stone." *Architectural Record* 9, no. 2 (October–December 1899): 207–9.

Ahlstrom, Sydney E. *A Religious History of the American People.* New York, 1979.

Akeley, Carl E. "An Episode of a Museum Expedition." *The American Museum Journal* 14, no. 8 (December 1914): 305–8.

Allen, William H. *The American Civil War Book and Grant Album.* Boston: William H. Allen, 1894.

Alpern, Andrew. *Apartments for the Affluent.* New York: McGraw-Hill, 1975.

"Alwyn Court, Harde, and Short, Architects." *The Architects and Builders Magazine* 10, no. 9 (June 1910): 335.

Alwyn Court Designation Report (LP-0254). New York: New York City Landmark Preservation Commission, 1966.

Ames, Charlotte. "Rededication to Peace, at Civil War Memorial in Bayside." *Long Island Press* (May 20, 1973): 3.

Anderson, Susan Heller, and David Dunlap. "Landmark Sold." *The New York Times* (September 6, 1985): B4.

———. "Putting Time Back on Its Feet." *The New York Times* (September 17, 1985): B3.

Andrews, Jack. "Samuel Yellin, Metalworker." *Anvil's Ring* (Summer 1982): 2–21, reprint.

Annese, Domenico, ed. *Clarke and Rapuano, Inc.* New York: Clarke and Rapuano, 1972.

"An Apartment Hotel at 28 East 63rd Street, New York." *Architectural Record* 61, no. 5 (May 1927): 406–8.

"An Architectural Aberration." *Architectural Record* 21, no. 4 (April 1907): 295–300.

Architectural and Decorative Features of St. Bartholomew's Church in the City of New York. 3rd ed. New York: St. Bartholomew's Church, 1956.

" 'Auld Lang Syne,' by Robert Thompson." *Annual Report,* Department of Parks (1869): 49.

Bacon, Henry. "Six Good Memorials." *The American Magazine of Art* 10, no. 7 (May 1919): 260.

Baldwin, Charles C. "Stanford White." DaCapo Press Series in *Architecture and Decorative Art,* Adolf K. Placzek, gen. ed. New York: DaCapo Press, 1971.

"Balto, Damn Fine Dog," *Oskar* 1, no. 1 (October 1969): 18–19.

Bassi, Elena. *La Gipsoteca di Possagno, Sculture e Dipinti di Antonio Canova.* Venice: Neri Pozza, 1957.

Beaux, Cecilia. "The Spirit of War Memorials." *The American Magazine of Art* 10, no. 7 (May 1919): 270–72.

Bettelheim, Bruno. *The Uses of Enchantment: The Meaning and Importance of Fairy Tales.* New York: Vintage, 1977.

Betts, Mary Beth, and Susan K. Freedman. "Furnishing the Streets: 1902–1922." Exhibition, Art Commission of the City of New York, 1983.

Bittermann, Eleanor. *Art in Modern Architecture.* New York: Reinhold, 1952.

Bogart, Michele H. "Maine Monument and Pulitzer Fountain—A Study in Patronage and Process." *Winterthur Portfolio* 21, no. 1 (Spring 1986): 41–63.

Boger, Louise Ade. *Dictionary of World Pottery and Porcelain.* New York: Scribner's, 1971.

Bordeaux, Vahdah. "Notes and Comments: Monumental Sculpture of the Future." *Architectural Record* 59, no. 2 (February 1926): 188–90.

Bottomley, H. L. "The Story of St. Thomas Church." *Architectural Record* 35, no. 2 (February 1914): 5, 104–31.

"Bowery Savings Bank." *The American Architect* 74, no. 4 (October 1901): 16.

Bragdon, Claude. "The Shelton Hotel, New York." *Architectural Record* 58, no. 1 (July 1925): 1–18.

Briggs, Kenneth A. "With Hopes High as a Cathedral, Many Seek to Work on St. John's." *The New York Times* (December 10, 1978): 1.

Brilliant, Richard. *Roman Art: From the Republic to Constantine.* London: Phaidon Press, 1974.

Bronze Works for Mausoleums. New York: Mott Iron Works, 1901.

"Brooklyn War Memorial Restoration." *Italian-American Review* (October 1976): 7.

Brown, Glenn. *History of the United States Capitol.* Washington, D.C.: United States Government Printing Office, 1900–1903.

Brown, Henry Collins. *Fifth Avenue Old and New, 1824–1924.* New York: Fifth Avenue Association, 1924.

Brown, Milton, Sam Hunter, John Jacobus, Naomi Rosenblum, and David M. Sokol. *American Art.* New York: Abrams, 1979.

Brumbaugh, T. B. *Horatio and Richard Greenough.* Ann Arbor, Mich.: University Microfilms, 1969.

Brunner, Arnold W. "The Permanent Memorial." *The American Magazine of Art* 10, no. 7 (May 1919): 248–50.

Brush, Edward Hale. "Karl Bitter—An Appreciation." *Art in Progress* 6, no. 9 (July 1915): 295–305.

———. "Statues of Booth and Beecher." *Art in Progress* 6, no. 5 (March 1915): 158–60.

Butler, John V. *Churchyards of Trinity Parish in the City of New York.* New York: Trinity Church, 1948.

Byne, Arthur G. "The Salient Characteristic of the Work of Charles Keck." *Architectural Record* 32, no. 107 (August 1912): 121–28.

Caesar, Gene. "The Strange Obsession of Preacher Beecher." *True: The Man's Magazine* (February 1965): 47, 109–10.

Callas, May, and Wallace Randolph. *Inside Forty-second Street.* New York: Preservation Press, 1978.

"Career of Yellin, America's Cellini, Reviewed." *ArtDigest* 16 (December 15, 1941): 9.

"Central Park's New Monument." *The New York Times* (July 23, 1911): 8.

Chinard, Gilbert, ed. *Houdon in America: A Collection of Documents in the Jefferson Papers in the Library of Congress.* Baltimore: Johns Hopkins Press, 1930.

Chorley, E. Clowes. *A Short History of St. Bartholomew's Church in the City of New York.* New York: St. Bartholomew's Church, 1960.

Cikovsky, Nicolai, Jr. *George Inness,* Praeger Publishers. New York, 1971.

Clark, Kenneth. "The Building of the American Telephone and Telegraph Company." *Architectural Record* 55, no. 1 (January 1924): 81–92.

"Clock Landmarked, Restoration Funds Needed." *Our Town* (June 16, 1985): 3.

Clocks. New York City Landmarks Preservation Commission Designation Reports: LP-1171 (522 Fifth Ave.), LP-1172 (200 Fifth Ave.), LP-1169 (1501 Third Ave.), LP-1170 (783 Fifth Ave.), LP-1173 (753 Manhattan Ave., Brooklyn), LP-1174 (30-78 Steinway St., Queens), LP-1176 (761-11 Jamaica Ave., Queens), LP-1175 (36-34 Main St., Queens).

Cobb, Josephine. "Photographers of the Civil War." *Notes and Documents* (1963): 127–35.

Cochran, Warren B., ed. *A Church in History: The Story of Plymouth's First Hundred Years.* Brooklyn: Plymouth Church, 1949.

Colford, Paul D. "From Another Time," *Newsday* (March 8, 1985): 2–3.

"Columbus Monument." *National Geographic* 34, no. 1 (July 1918): 32.

Compilation of Works of Art and Other Objects in the United States Capitol. Washington, D.C.: U.S. Government Printing Office, 1965.

Connick, Charles J. *Adventures in Light and Color—An Introduction to the Stained Glass Craft.* New York: Random House, 1936.

"Construction on the Cathedral of St. John to Be Resumed." *The New York Times* (December 5, 1978): A1, B9.

Cooper, Jeremy. *Nineteenth-Century Romantic Bronzes.* Boston: New York Graphic Society, 1975.

"Cops Bust Four in Heady Park Caper." New York *Daily News* (January 25, 1974).

Cornelius, Charles Over. "War Memorials, Part III: Monumental Memorials." The *Architectural Record* 47, no. 2 (February 1920): 119–31.

Cortissoz, Royal. "A Great Exhibition of American Sculpture." *The American Magazine of Art* 14, no. 6 (June 1923): 289–300.

Costley, Jim. *The House We Live In.* New York: New York Telephone Co., 1969.

Crane, John. *San Martín, Liberator of Argentina, Chile, and Peru.* Washington, D.C.: Government of Argentina, 1948.

Crane, Sylvia. *White Silence.* Coral Gables, Fla.: University of Miami Press, 1972.

Craven, Wayne. *Sculpture in America.* New York: Crowell, 1968.

Croly, Herbert, D. "The Advantages of Terra Cotta, II." *Architectural Record* 18, no. 4 (October 1905): 315–23.

———. "Glazed and Colored Terra-Cotta." *Architectural Record* 19, no. 4 (April 1906): 313–23.

———. "A New Dimension in Architectural Effects." *Architectural Record* 57 (January 1925): 93–94.

———. "New York as the American Metropolis." *Architectural Record* 13 (March 1903): 193–206.

———. "The Proper Use of Terra Cotta, III." *Architectural Record* 19, no. 1 (January 1906): 73–81.

———. "The Use of Terra Cotta in the United States, How It Has Increased." *Architectural Record* 18, no. 1 (July 1905).

———. "What Is Civic Art." *Architectural Record* 16, no. 1 (July 1904): 47–52.

Cudahy, Brian J. *Under the Sidewalks of New York: The Story of the Greatest Subway System in the World.* Brattleboro, Vt.: Greene Press, 1979.

Daniec, Jadwiga Irena. "In the Footsteps of Stanislaw K. Ostrowski, 1879–1947." *The Polish Review* 27, no. 1, 2 (1982): 77–91.

Davis, Myra Tolmach. *Sketches in Iron: Samuel Yellin, American Master of Wrought Iron, 1885–1940.* Washington, D.C.: Dimock Gallery, George Washington University, 1971.

deKay, Charles. "Gargoyles Old and New." *Architectural Record* 19, no. 6: 419–24.

Dennis, James M. *Karl Bitter: Architectural Sculptor, 1867–1915.* Madison: University of Wisconsin Press, 1967.

"Dermody Square Out of Obscurity," *Bayside Times* (May 10, 1973): 1, 24.

Desmond, Henry W. "The Work of Messrs. McKim, Mead, and White." *Architectural Record* 20, no. 3 (September 1906): 153–246.

Devlin, Gerard. "Ceremony Honors an Amiable Child." *The News World* (July 16, 1981): 1A, 14A.

"Digging-In for Our New West Street Building." *Telephone Review* (January 1924).

Dorr, Charles Henry. "A Danish-American Sculptor: The Work of Johannes S. Gelert." *Architectural Record* 33, no. 4 (April 1913): 333–38.

———. "A Sculptor of Monumental Architecture." *Architectural Record* 33, no. 6 (June 1913): 519–32.

———. "A Study in Church Decoration—The Paulist Fathers Church in New York City and Notes on the Work of W. L. Harris." *Architectural Record* 33, no. 3 (March 1913): 187–203.

Drinking Fountains. New York: Mott Iron Works, 1901.

Dryfhout, John. *Augustus Saint Gaudens: The Real and the Ideal.* Catalogue of Exhibition (November 14–December 18, 1984). New York: Cooper Union, 1984.

"Eighty-Six-Year History of Cathedral's Construction." *The New York Times* (December 5, 1978): B9.

Eisen, Gustabus A. *Portraits of Washington,* 3 vols. New York: Robert Hamilton and Associates, 1932.

Fairman, Charles Edwin. *Art and Artists of the Capitol of the U.S.A.* Washington, D.C.: U.S. Government Printing Office, 1927.

Fifty Years of Fifth. New York: Fifth Avenue Association, 1957.

Finegold, Diana. "The Return of General Fowler—A Civil War Hero Unknown Today." *The Fort Greene Paper* 2, no. 4 (February 1975): 2.

Fiske, J. W. *Fiske Illustrated Catalogue.* New York: J. W. Fiske, 1891.

Fowler, Glenn. "The Sidewalks of New York." *The New York Times* (December 8, 1983): 1, 14.

Frary, I. T. *They Built the Capitol.* Richmond, Va.: Garrett and Massie, 1940.

———. *Thomas Jefferson, Architect and Builder.* Richmond, Va.: Garrett and Massie, 1939.

Fraser, James Earle. "Akeley, the Sculptor." *Journal of the American Museum* 27, no. 2 (March–April 1927): 115–72.

Furniss, R. MacDonald. "Augustus Lukeman, A Representative American Sculptor." *Architectural Record* 35, no. 5 (May 1914): 415–24.

"Further Tribulations of the Soldiers' and Sailors' Monument." *American Architect and Building News* 59, no. 1149 (January 1, 1898): 1.

Fusco, Peter, and H. W. Janson, editors. *The Romantics to Rodin.* New York: Braziller, 1980.

Gardner, Albert Ten Eyck. *A Catalogue of the Collection of the Metropolitan Museum of Art.* Greenwich, Conn.: Metropolitan Museum of Art, 1965.

———. *Yankee Stonecutters: The First American School of Sculpture.* New York: Metropolitan Museum of Art, 1944.

Gardner, Herb. *A Thousand Clowns.* New York: Samuel French, 1961.

Gayle, Margot. "Changing Scene." *Sunday News Magazine* (August 16, 1981): 4.

Geerlings, Gerald K. *Wrought Iron in Architecture.* New York: Dover, 1929.

"General William Jenkins Worth." *Double Eagle Digest* 11, no. 2 (April–May 1985). Reprinted by Arvin William Turner, Jr., Fort Worth, Texas.

"George Inness, Jr.—His Art," *American Art News* 1, no. 12, (January 1, 1910): 5.

Gerdts, William H. *American Neo-Classic Sculpture: The Marble Resurrection.* New York: Viking, 1973.

———. *A Survey of American Sculpture.* Newark, N.J.: Newark Museum, 1962.

Giovannini, Joseph. "How Design Was Decided for Central Park's Lamps." *The New York Times* (August 28, 1984): 52.

Goldberger, Paul. "Terra Cotta Adds Color to City Buildings." *The New York Times* (September 15, 1983): C1, 10.

Good Street Lighting. New York: Mott Iron Works, 1911.

Green, Vivien M. "Hiram Powers's Greek Slave: Emblem of Freedom." *The American Art Journal* (Autumn 1982): 31–39.

Greene, Dorothy S. "Carl Akeley—Sculptor-Taxidermist." *The American Magazine of Art* 15, no. 3 (March 1924): 125–30.

Greenthal, Kathryn. *Augustus Saint Gaudens, Master Sculptor.* New York: Metropolitan Museum of Art, 1985.

Haldane, Suzanne. *Faces on Places: About Gargoyles and Other Stone Creatures.* New York: Viking, 1980.

Hamlin, Talbot. *Benjamin Henry Latrobe.* New York: Oxford University Press, 1955.

Hariton, Edith. "Texas Traces Life of General Worth." *Register Star* (August 20, 1981): A1. Reprinted by Allied Fence, Fort Worth, Texas.

Harrington, Ty. "The Wizardry of Samuel Yellin, Artist in Metals." *Smithsonian:* 66–74.

Hart, Charles Henry. "Life Portraits of George Washington." *McClure's* 8, no. 1 (1897): 296.

———, and Edward Biddle. *Jean Antoine Houdon.* Philadelphia: DeVinne Press, 1911.

Hawes, Elizabeth. "The Annals of Apartments: Courtyards." *The New York Times* (September 12, 1976).

Henderson, Rick. "Fence of Swords." *World Fence News* (February 1986).

Hibben, Paxton. *Henry Ward Beecher, an American Portrait.* New York, 1927.

Hiss, Tony. "Frimbo's Peak." *The New Yorker* (August 8, 1983): 39–45.

"History of the Firemen's Memorial at Riverside Drive and 100th Street." *International Association of Fire Engineers:* 53–57.

Hodges, George. *Henry Codman Potter, Seventh Bishop of New York.* New York: Macmillan, 1915.

Holderbaum, James. "Portrait Sculpture." In *The Romantics to Rodin.* New York: Braziller, 1980.

"Houdon's Washington." *Harper's Weekly* 12 (1868): 772–73.

Hubbard, William. "Reassessing the Art of Landscape Design." *Architectural Record* 172, no. 10 (September 1984): 69–75.

Hunter, G. Leland. "Notes on Gargoyles, Grotesques, and Chimeras." *Architectural Record* 35, no. 2 (February 1914): 132–39.

Hunter, Wilbur H., Jr. "Salvage of 1810 Sculpture." *Journal of the Society of Architectural Historians* 14, no. 4: 27–28.

"Immense Throng Sees Monument to Maine Heroes Unveiled." *New York Evening Journal* (May 31, 1913): 3.

Janson, H. W. *Nineteenth-Century Sculpture.* New York: Abrams, 1985.

"Jeanne d'Arc." *The American Magazine of Art* 7, no. 4 (February 1916): 129–30, 313.

Jenkins, Stephen. *The Greatest Street in the World.* New York: Putnam's, 1911.

Klaber, John J. "Paul W. Bartlett's Latest Sculpture." *Architectural Record* 39, no. 3 (March 1916): 265–78.

José Martí. New York: Avenue of the Americas Association, 1965.

Korshak, Yvonne. "The Liberty Cap as a Revolutionary Symbol in America and France." *Smithsonian Studies in American Art* 1, no. 2 (Fall 1987): 53–69.

Lamp Pillars. New York: Mott Iron Works, 1881.

Lancaster, Clay. *Prospect Park Handbook.* New York: Long Island University Press, 1972.

Lane, Don. "The Siberian Husky—Dog du Monde." *Dog Fancy* (February 1977): 13–14.

Lederer, Joseph, and Arley Bondarin. *All Around the Town: A Walking Guide to Outdoor Sculpture in New York City.* New York: Scribner's, 1975.

Levy, Florence, ed. *Art in New York.* New York: Art Service, 1922.

Lewis, Charles Lee. *David Glasgow Farragut, Our First Admiral.* Annapolis, Md.: U.S. Naval Institute, 1943.

Licht, Fred. *Canova.* New York, 1983.

Lombardo, Josef Vincent. *Attilio Piccirilli, Life of an American Sculptor.* New York: Pitman Publishing, 1944.

Lucie-Smith, Edward. *Eroticism in Western Art.* New York: Praeger, 1972.

Mackay, James. *The Dictionary of Western Sculptors in Bronze.* Suffolk Antique Collectors' Club, 1977.

MacMonnies, Frederick W. "Typical Memorials." *The American Magazine of Art* 10, no. 7 (May 1919): 258–60.

Macrae-Gibson, Gavin. "Reflections Upon the New Beginnings at the Cathedral Church of Saint John the Divine." *Architectural Record* (November 1979): 119–26.

"Maine Monument Unveiled." *The New York Times* (May 31, 1913): 1.

"Maine Shaft to Rise in Columbus Circle." *The New York Times* (August 6, 1911): 11.

Major-General William Jenkins Worth. New York State Senate Committee Reports: no. 85 (April 20, 1835), (April 17, 1835), no. 65 (February 14, 1855), no. 5 (January 15, 1858).

Mâle, Emile. *The Gothic Image, Religious Art In France of the Thirteenth Century.* New York: Harper and Row, 1958.

Manhole Frames and Covers. New York: Mott Iron Works, 1900.

Marceau, Henri. "William Rush." *Pennsylvania Museum of Art* (1937).

Mark, Jacob. *Jacob Mark Catalogue.* New York, 1884.

"Master Draftsman, IX, Welles Bosworth." *Pencil Points* 6, no. 1 (January 1925): 59–60.

McAneny, George. "Karl Bitter: Citizen." *Art in Progress* 6, no. 9 (July 1915): 308–9.

McCabe, L. R. "Our Lady of Hope." *Architectural Record* 33, no. 1 (January 1913): 14–21.

McFeely, William S. *Grant.* New York: Norton, 1982.

"Memorial Dedication," *Bayside Times* (May 31, 1973): 4.

Michelani, Alex. "Update (Bellringers')." New York *Daily News* (January 1, 1984): 44.

Milburn, John G. "Karl Bitter: Exposition Builder." *Art and Progress* 6, no. 9 (July 1915): 306–3.

Moore, Charles. "Memorials of the Great War." *The American Magazine of Art* 10, no. 7 (May 1919): 233–47.

Moore, N. Hudson. *The Old Clock Book.* New York: Frederick A. Stokes Co., 1911.

Morris, Rebecca. "He Combines History to Trace the Life of Fort Worth's Namesake." *Fort Worth Star-Telegram* (July 19, 1981). Reprinted by Allied Fence, Fort Worth, Texas.

"Naval and Military Parade Next Thursday." *The New York Times* (May 25, 1913): 11.

"New Court-House of the Appellate Division, East 25th Street and Madison Avenue, New York, New York, Mr. James Brown Lord, Architect, New York, New York." *American Architect and Building News* 68, no. 1271 (May 5, 1900): 40.

"A New Memorial to Heroes Urged." *West Side News* (June 11, 1959): 1.

"New York's Maine Monument Unveiled." *The Monumental News* 25 (1913): 480–81.

"Notes and Comments: Color in Architecture." *Architectural Record* 63, no. 1 (January 1928): 80.

Official Catalogue of the Polish Pavilion at the World's Fair in New York, 1939. Warsaw: Drukarnia Polska, 1939.

Oliver, Richard. *Bertram Grosvenor Goodhue.* Cambridge, Mass.: MIT Press, 1983.

Onís, José de. "José Martí." *Abroad in America—Visitors to the New Nation, 1776–1914.* Edited by Marc Pachter and Frances Stevenson Wein. Washington, D.C.: National Portrait Gallery/Addison Wesley, 1976.

Opitz, Glenn B. *Dictionary of American Sculptors: Eighteenth Century to the Present.* Poughkeepsie, N.Y.: Apollo, 1984.

Ornamental Iron Work. New York: Mott Iron Works, 1915.

Osborn, Gardner. *The Streets of Old New York.* New York: American Bank Note Co., 1939.

"Pageant to Renew 1865 Tree Symbols." *The New York Times* (May 4, 1935).

Palmer, Brooks. *A Treasury of American Clocks.* 2d ed. New York: Macmillan, 1968.

Payne, Frank Owen. "Notable Decorative Sculptures of New York Buildings." *Architectural Record* 47, no. 2 (February 1920): 99–118.

Placzek, Adolf K., ed. *Macmillan Encyclopedia of Architects.* New York: Free Press, 1982.

Post, George B. "The College of the City of New York." *Architectural Record* 21, no. 3 (March 1907): 165–85.

Proske, Beatrice Gilman. "Joan of Arc by Anna Hyatt Huntington." *Joan of Arc.* New York: Municipal Art Society of New York, 1986.

Pyke, E. J. *A Biographical Dictionary of Wax Modellers.* London: Oxford University Press, 1973.

"Racing the 'Black Death' of Alaska for 11,000 Lives." *The Literary Digest* (February 21, 1925): 42–46.

Rapp, Kenneth. "Haughty Bill, the Army Officer Who Instituted High Standards of Military Bearing and Drill Precision in the United States Corps of Cadets." In *West Point.* Naperville, N.J.: Caroline House Publishers, 1979.

Rawson, Jonathan A., Jr. "Evelyn Beatrice Longman." *International Studio* 45 (November 1911–February 1912): 99–103.

"Recent Modernization of Alwyn Court for the Dry Dock Savings Institution by Ellinger Construction Corp." *Buildings and Building Management* (March 1939), reprint.

"Recent Sculpture by A. Stirling Calder." *Art in Progress* 9, no. 8 (June 1918): 319–20.

Reed, Henry Hope. *The New York Public Library—Its Architecture and Decoration.* New York: Norton, 1986.

Reiley and Steinbeck, Architects. "The Chapel of the Queen of All Saints." *Architectural Record* 35, no. 4 (April 1914): 356–74.

"Repeat Performance: Telephone Murals." *Telephone Review* (December 1951).

Reports on the Erection of a Monument to the Memory of William Jenkins Worth, Late Major-General of the U.S. Army, by the Special Committees Appointed by the Common Council of the City of New York. New York: Charles W. Baker, 1857.

Reynolds, Donald Martin. *The Architecture of New York City, Histories and Views of Important Structures, Sites, and Symbols.* New York: Macmillan, 1984.

———. *Cambridge Introduction to the History of Art: The Nineteenth Century.* London: Cambridge University Press, 1985.

———. *Hiram Powers and His Ideal Sculpture.* New York: Garland Publishing, 1977.

———. "The 'Unveiled Soul': Hiram Powers's Embodiment of the Ideal." *The Art Bulletin* 59, no. 3 (September 19, 1977): 394–414.

Richman, Michael. *Daniel Chester French, An American Sculptor.* New York: Metropolitan Museum of Art, 1976.

Robbins, Daniel. "Statues to Sculpture: From the Nineties to the Thirties." *Two Hundred Years of American Sculpture.* New York: David R. Godine/Whitney Museum of American Art, 1976.

Robertson, E. Graeme, and Joan Robertson. *Cast Iron Decoration, A World Survey.* New York: Watson-Guptil, 1977.

Robinson, Charles Mulford. *Modern Civic Art.* London: Putnam's, 1904.

Robson, John William, ed. *A Guide to Columbia University.* New York: Columbia University Press, 1937.

Roth, Leland. *A Monograph of the Works of McKim, Mead, and White, 1879–1915.* New York: Arno Press, 1977.

St. Clair, William. *Lord Elgin and the Marbles.* New York: Oxford University Press, 1967.

Saint Gaudens, Homer. "Essentials in Memorial Art." *The American Magazine of Art* 10, no. 7 (May 1919): 258–60.

Schuyler, Montgomery. "Recent Church Building in New York." *Architectural Record* 13, no. 6 (June 1903): 509–34.

———. "Trinity's Architecture." *Architectural Record* 25, no. 6 (June 1909): 411–25.

———. *New York City Public Sculpture by Nineteenth-Century American Artists.* New York: Metropolitan Museum of Art, 1974.

"Sculpture for Bored Bankers." *Progressive Architect* 46 (December 1965): 136–41.

Seaton-Schmidt, Anna. "Daniel Chester French, Sculptor." *The American Magazine of Art* 13, no. 1 (January 1922): 3–10.

Selections from the Work of Barnet Phillips Co., Architectural Decorators. New York: Architectural Catalog Co., 1930.

"Service to the Nation." *The Architect* 11 (October 1928–March 1929): 155.

Sharp, Lewis I. *John Quincy Adams Ward, Dean of American Sculpture.* Newark, N.J.: University of Delaware Press, 1985.

San Martín. New York: Avenue of the Americas Association, 1951.

Shepard, Richard F. "Streetwise." *The New York Times* (June 25, 1985).

Shrady, George F. "John Wolfe Ambrose." *Valentine's Manual of Old New York.* New York: H. C. Brown, 1919.

Silberman, Robert. "Thoroughly Moderne Manship." *Art in America* (January 1986): 111–84.

Simón Bolívar, Man of Vision. New York: Bolivarian Society of the U.S., 1951.

"Soldiers' and Sailors' Monument." *National Sculpture Review* 11, no. 3: 3, 24.

Solon, Leon V. "The Park Avenue Building, New York City, Buchman and Kahn." *Architectural Record* 63, no. 4 (April 1928): 289–310.

Southworth, Susan, and Michael Southworth. *Ornamental Ironwork.* Boston: Godine, 1978.

Stein, Susan R., ed. *The Architecture of Richard Morris Hunt.* Chicago: University of Chicago Press, 1986.

Stokes, Isaac Newton Phelps. *The Iconography of Manhattan Island, 1498–1909,* 6 vols. New York: R. H. Dodd, 1915–1928.

Storer, Douglas Frederick. "Pictorial Living." *New York Journal-American* (August 1, 1965): 1–3.

Story, William Wetmore. "The Mask of Washington." *Harper's Weekly* 31 (1887): 144–46.

Stratton, Howard Fremont. "American Wrought Iron." *The American Magazine of Art* 3, no. 7 (May 1916): 273–76.

———. "Samuel Yellin, Iron Worker, Receives the Philadelphia Award." *The American Magazine of Art* 17 (May 1926): 228–34.

Stuart, James, and Nicholas Revett. *The Antiquities of Athens,* Vol. 1. London: Priestley and Wale, 1825.

Sturgis, Laurence. "Architectural Faience." *Architectural Record* 2, no. 7 (January 1907): 63–72.

Sturgis, R. Clipston. "War's Teachings." *The American Magazine of Art* 10, no. 7 (May 1919): 251.

Sturgis, Russell. *The Appreciation of Sculpture.* New York: Baker and Taylor, 1904.

———. "Façade of the New York Stock Exchange." *Architectural Record* 16, no. 5 (November 1904): 465–82.

———. "A Fine Work of American Architectural Sculpture." *Architectural Record* 15, no. 4 (April 1904): 293–311.

Surrogate's Court (Hall of Records). New York City Landmarks Preservation Commission Designation Report LP-0926, no. 2 (May 11, 1976).

Swan, Mabel Munson. *The Athenaeum Gallery, 1827–1873.* Boston: Boston Athenaeum. Boston, 1940.

Taylor, C. *Artist's Repository; or, Encyclopaedia of the Fine Arts.* London: C. Taylor, 1808.

Taylor, James. "The History of Terra Cotta in New York City." *Architectural Record* 2, no. 2 (October–December 1892): 137–48.

———. "Terra Cotta—Some of Its Characteristics." *Architectural Record* 1, no. 1 (July–September 1891): 63–68.

Tharp, Louise Hall. *Saint Gaudens and the Gilded Era.* Boston: Little, Brown, 1969.

"The Abolitionists." *The New York Herald Tribune* (June 9, 1963): II3.

"The Brooklyn War Memorial." *The Brooklyn Eagle* (1945).

"The Farragut Statue." *The New York Herald* (May 25, 1881): 4.

"The Farragut Statue." *The World* (May 26, 1881): 4.

"The Farragut Statue in Madison Square." *Frank Leslie's Illustrated Newspaper* (June 11, 1881): 251.

"The Fifth Avenue Presbyterian Church." *Architectural Notes.* New York: Fifth Avenue Presbyterian Church, n.d.

"The Maine Monument." *The New York Times* (July 25, 1911): 6.

"The New Custom House." *The New York Times* (November 8, 1903): 9.

"The Salient Characteristic of the Work of Charles Keck." *Architectural Record* 32, no. 167 (August 1912): 121–28.

"The Soldiers' and Sailors' Monument for New York." *American Architect and Building News* 58, no. 1145 (December 4, 1897): 76.

"The Swords of the Late General Worth." *Daily Picayune* 13, no. 217 (October 14, 1849): 2. Reprinted by Arvin William Turner, Jr., Fort Worth, Texas.

"The Travelers 100 Years." *Protection* and *The Travelers Beacon,* anniversary publication. Kansas City, Mo.: Travelers Insurance Co., 1964.

Thompson, W. F. *The Image of War.* New York: T. Yoseloff, 1960.

Thorne, Dorothy. "Electricity: The Statue on the Tower of the New Telephone and Telegraph Building." *Telephone Review* (November 1916).

Trachtenberg, Marvin. *The Statue of Liberty.* New York: Viking, 1976.

"Unveil Memorial to Maine Heroes." *The New York Times* (May 31, 1913): 3.

"Unveiling the Statue." *The New York Times* (May 26, 1881): 8.

Van Pelt, John. "The Church of St. John of Nepomuk, New York." *Architectural Record* 58, no. 6 (December 1925): 517–29.

Van Rensselaer, Marianna. "The Farragut Monument." *American Architect and Building News* 10 (July–December 1881): 119.

Van Rensselaer, Mrs. Schuyler. "Appropriateness in War Memorials." *The American Magazine of Art* 10, no. 7 (May 1919): 274–75.

Vases. New York: Mott Iron Works, 1905.

Villard, Oswald G. "Karl Bitter, Immigrant." *Art and Progress* 11, no. 9 (July 1915): 310–12.

Walker, R. T. "Foundations of the Barclay-Vesey Telephone Building." *The American Architect* 130, no. 2509 (November 20, 1926): 414–17.

Watson, Ernest W. "Hildreth Meiere, Mural Painter." *American Artist* (September 1941), reprinted as pamphlet.

Wattenmaker, Richard J. *Samuel Yellin in Context.* Flint, Mich.: Flint Institute of Arts, 1985.

Weinbrenner, Don. "Grave Still Echoes with Love for a Child." New York *Daily News* (December 13, 1981).

"West Street Excavation Yields Interesting Relics." *Telephone Review* (January 1923): 370–75.

Wheeler, Candace. "Decorative Art." *Architectural Record* 4, no. 4 (April–June 1895): 409–13.

Wheeler, Charles V. "The Sculpture of Paul Bartlett." *The American Magazine of Art* 16 (November 1925): 573–85.

Whitaker, Francis. *Blacksmith's Cookbook.* Aspen, Colo.: James Fleming, 1986.

White, Norval, and Elliot Willensky. *AIA Guide to New York City,* rev. ed. New York: Collier Books, 1978.

Wilkinson, Burke. *Uncommon Clay, the Life and Works of Augustus Saint Gaudens.* San Diego: Harcourt Brace Jovanovich, 1985.

Wilson, James Grant, ed. *The Memorial History of New York.* New York, 1893.

Winkler, Franz, and Montgomery Schuyler. "Mitigating the Gridiron Street Plan—Some Good Effects Achieved in New York City." *Architectural Record* 29, no.5 (May 1911): 379–96.

Wittkower, Rudolf. *Allegory and the Migration of Symbols.* London: Thames and Hudson, 1977.

———. *Gian Lorenzo Bernini.* London: Phaidon Press, 1966.

———. *The Impact of Non-European Cultures on Western Art,* Donald Martin Reynolds, ed. New York: Cambridge University Press, 1988.

"World's Greatest Custom House Soon to Be Completed." *The New York Times* (January 4, 1906): 3.

"Worth Swords." *Journal of Regents Meeting,* University of the State of New York (March 24, 1953): 400, 408.

Yellin, Samuel. "Iron Art." In *Encylopaedia Britannica,* 14th ed., 1940.

Archives consulted include Arch Street Studio, Philadelphia; Department of Parks and Recreation, New York City; Federal Reserve Bank of New York; Fiebiger Iron Works, New York City; Kenneth Lynch and Sons, Wilton, Connecticutt; Municipal Archives, New York City: U.S. Custom Service, New York City.

Index

Also by Donald Martin Reynolds:

The Architecture of New York City: Histories and Views of Important Structures, Sites, and Symbols

Nineteenth-Century Art (2 volumes)

The Ideal Sculpture of Hiram Powers